TYPE ADDICTED

THE NEW TREND OF A TO Z TYPO-GRAPHICS

First published and distributed by viction:workshop limited

viction:ary

Unit C, 7th Floor, Seabright Plaza, 9-23 Shell Street, North Point, Hong Kong URL: www.victionary.com Email: we@victionary.com

Edited and produced by viction:workshop limited Foreword by Stefan Gandl, Neubau (NeubauBerlin.Com)

Book design by viction:design workshop Concept and art direction by Victor Cheung

© 2007 viction:workshop limited The copyright on the individual texts and design work is held by the respective designers and contributors.

Third edition ISBN 978-988-98229-4-1

All rights reserved. No part of this publication may be reproduced, stored in retrieval systems or transmitted in any form or by any means, electronic or mechanical, including photocopying, recording or any information storage and retrieval systems, without permission in writing from the copyright owner(s).

The captions and artwork in this book are based on material supplied by the designers whose work is included. While every effort has been made to ensure their accuracy, viction:workshop does not under any circumstances accept any responsibility for any errors or omissions.

US edition Printed and bound in China

ACKNOWLEDGEMENT

We would like to thank all the designers and companies who made significant contribution to the compilation of this book. Without them this project would not have been possible.

We would also like to thank Stefan Gandl from Neubau (NeubauBerlin.Com) for writing the foreword and all the producers for their invaluable assistance throughout. Its successful completion also owes a great deal to many professionals in the creative industry who have given us precious insights and comments. We are also very grateful to many other people whose names do not appear on the credits but have made specific input and continuous support the whole time.

FUTURE EDITIONS

If you would like to contribute to the next edition of Victionary, please email us your details to submit@victionary.com

350

PRODUCED AND EDITED BY VICTION:ARY

© 2007 VICTION:WORKSHOP LTD. ISBN 978-988-98229-4-1

FIRST PUBLISHED AND DISTRIBUTED BY VICTION:ARY

viction:ary*

Typography is the hybrid of type and graphics, which brings dull languages alive and makes the whole design shine on stage; yet it always stays at the last row, being neglected and ignored. You may pass over typography which does not refer only to the design of types, but also the play with words as well as the arrangement and appearance of different elements on 2-dimensional printed matters and 3-dimensional spatial design. Humans think and perceive everything that they can feel consciously: we see when images come into our eyes, we hear when sound waves reach our ears, and we feel when objects are rubbed on our flesh... but we always overlook what lies intrinsically.

Audiences always think that they are captivated by the fascinating graphics but they would never be aware of what really hooks them up with the message behind. Languages deliver messages that are what we cannot live without, though we are often fed up with languages. Sometimes we prefer going for movies rather than reading books. Children draw cartoons on their textbooks. Most of us seek visual impacts besides languages. Do you prefer reading from line to line of a passage like this for your whole life? Sure you don't although many of us immerse ourselves in the written world; we can never live without tedium in a pure-word world. Typographic elements convey messages and create a much stronger bombardment to audiences by creative arrangement and combination of languages with different graphic ornaments. Typography saves us from boredom. It visualizes languages in physical forms and makes the whole language world dazzle.

Different typefaces give different mood, and we should choose the proper one for different occasions. Remember when you type the job application letter, you use 'Times New Roman' or 'Arial' rather than 'Comic Sans MS' or 'Shorthand,' don't you? You play with funny handwritings and lovely symbols in letters for your best friends, and you write neatly when you have to drop your boss a line. Your kids love to have their names 'written' with different embellishment on the door of their rooms, showing the particular characters of their little domain. Everyone uses type with purposes; indeed one and all are unconsciously typographers.

Throughout human history, artists evoke audiences' attention by bringing memorable mood from the hybrid. Posters with eye-catching graphics and types can stay longer in your mind. Typography is the glare of publicity that spotlights identity and gives spirit to creative brands by integrating languages and visual collision, which ultimately reaches the finest

stage of aspiration. The easiest recognizable examples are the definable typographic designs of different brand names. Typographers play an important role in establishing brand identity through the blending of brand images into types and the creation of distinctiveness. Let's grab a can of coke for example. The typographer of 'Coca-cola' did a brilliant job. One can easily recall the red Coca Cola package with its Spencerian script type which was developed in the mid-19th century. It was once a dominant form of handwriting in the United States, which presented a 'daily' and 'friendly' image to the brand and resulted in a huge success. In contrast, the largest competitor of Coca Cola, Pepsi, develops a totally different image in order to secure a place in the market. In 1991, the brand started to be in italic capital typeface which runs vertically up the blue package brings 'cool' and 'fashionable' perception and a triumph in the market.

Besides, typography helps storytellers give amazing stories everyday. It doesn't only refer to the typeface design but as well how we put everything together in the layout or space. Pick a magazine and flip. What makes you go through the lines - controversial headlines, creative graphics, or interesting layout with good pictures in attractive topic? Headlines or graphics may not make an editorial stand out of the crowd. Layout with graphics and words arranged wisely outstands the whole story. Like Sylvia Tournerie who designs layouts for the free contemporary art magazine '02,' she made very good examples through the arrangement of graphics and words which catches our eyeballs.

Typography does not survive only in the 2-dimensional world. Designers also tell stories by applying typography spatially. Oded Ezer suggests a playful and entertaining attitude in his work 'Tybrid' by releasing himself freely and intuitively, forming a Hebrew word 'Typography' in 3-dimensional context. Tsang Kin-wah integrates poem with great music by embedding typography in a stage design for the event 'Clavecin + Percussion III.' Typographic designs are like pillars of a stage where storytellers give their best stories.

The typographic world as well provides opportunities for designers to intermingle sundry cultures. By mixing languages with characters from different cultures and even religions, designers create a brand new stage of amazement. Milkxhake designers mesmerize everybody in the poster 'pray&pay' by combing Chinese traditional religious beliefs with English characters to show the relationship between God and human. With the words that made up of 'Yuen Bo,' a Chinese traditional

paper money made for ancestor, designers wisely demonstrate the belief of traditional Chinese: people worship and contribute (in terms of money) in order to show respect and responsibility. Other than exhibition posters, typography on top walks into our daily lives with cultural and religious elements. Designers apply their talents in what we can come across everyday: signages, logos, calendars, T-shirts, you name it. Here comes a good example from Khaki Creative & Design, Inc. With more and more people come to the capital of China - Beijing, the designer welcomes prospective visitors with creative typographic tour by creating various logotypes 'Welcome to Bejing.' Sixstation in Hong Kong also did an excellent job in typographic T-shirt graphics. Commissioned by Atomicsushi, the talent expresses respect to the 60's Hong Kong film's fighting scene by combing visuals with the word 'Shaolin,' a mark of Chinese kung fu.

The digitalization of technology has helped typography rise to a new level too. Typesetters and designers no longer need to make up new types on drawing boards or with letterpress, and more possibilities appear with new technologies such as digital printing and filming. More types come into life with computerized effects and tones. Take a look at the different styles in the 'Safe As Milk Festival' created by the talents of Grandpeople. The designers fused Egyptology with psychedelic approach by printing types with gold folio embossment so as to focus on the festival's theme 'Money.' The designers grasped a totally different approach for the festival in the following year. With computerization, they came up with the stimulation of putting experimental music together with B-film horrible elements. The idea is used in the festival's promotional items and made all and sundry call to mind.

Over the pages, Type Addicted looks at the allure of type from different perspectives; from 2-dimensional designs on printed matters like album cover, poster, promotional material to 3-dimensional display, stage design and installation, type-addicts from all over the world inspire us with the wisdom of how they create new typefaces and how they deal with different types of fonts in the arrangement of layout; it certainly explores the new wave of typography. Artists like Atelier télescopique, Conor & David, Dainippon Type Organization and Neubau (NeubauBerlin.Com) will tour you around with the 26 alphabets; playful yet connotative, subtle yet rousing, each of those represents great works in the field, and delicates how creative languages can be made and evolved when they are assimilated in the horizon of typography.

Neubau (NeubauBerlin.Com) with the 26 alphabets; pl subtle yet rousing, each great works in the field, creative languages can be when they are assimilated typography.	ayful yet connotative, of those represents and delicates how made and evolved		

P005 PREFACE

INTRODUCTION

When being asked to do the foreword for this book and while considering its title 'Type Addicted,' I thought it would be helpful to start by defining the term 'type addiction.' In addition I would use myself as an example patient to define the nature of this sort of 'disease.'

Thanks to the digital age and the inventions of the revolutionary platform-independent page description language 'Post-Script,' the typographic virus has spread from a small group of very specialized individuals to a much larger group of specialists and non-specialists within the last 20 years.

The liberalization of technology and type-production tools made it possible for almost everyone - including myself - to be infected. And even though there are thousands of different digital typefaces available today, the demand for individual expression seems to be stronger than ever. 'Type Addicted' will help you keep an overview of the current global typographic 'epidemic.'

BUT WHAT IS 'TYPE ADDICTION?'

'Type addiction' could be described as a periodic compulsion to an individual (i.e.: a typographer, typesetter, graphic artist, designer, etc.) who occupied by the art and techniques of type design and its possibilities of glyphs-modifications and type arrangement.

GANDL'S ANAMNESIS STAGE 1

My personal anamnesis started very much unconsciously. In fact it could be compared to a kind of creeping 'infection' and perhaps it is important to foreclose that no matter what people say (like 'you're not talented,' 'stop it' etc.) it won't change your vicious habits once you are infected.

Although I really tried very hard, the teachers at elementary school weren't happy at all with my calligraphical output. I got bad marks on a regular basis. But that didn't stop me from what I was doing and I started drawing bold glyphs (characters) all over my notebooks. It got even worse during the 70s when I started to 'design' the covers of my own mix tapes myself. My pocket money wasn't sufficient to purchase the original records.

GANDL'S ANAMNESIS STAGE 2

Circa 79/80 a school friend gave me her Beatles single 'Help' on vinyl as a present. Unfortunately the cover jacket was missing so I needed to design it myself. My first typographical work for a record sleeve found me re-drawing all the modern grotesque characters by hand contained in the original record's sleeve-design.

During a time-consuming crisis and after the third black felt pen marker went out of business, I kind of successfully managed to combine cut-out imagery of black & white photocopy machines with my own drawings and rub-off typography.

GANDL'S ANAMNESIS STAGE 3

Unfortunately the result wasn't really that bad which gave me further confidence to go on experimenting with my new found toys - the dry transfer sheets of Letraset - which put my addiction to a new level.

Sadly enough these expensive sheets that were full of typography were available to me through one of my aunts who was an architect in those days.

GANDL'S ANAMNESIS STAGE 4

To cure me from type-infection, I was sent to Grafische Lehr - und Versuchsanstalt Wien 14 - a high school for applied graphic design in Vienna (Austria), which was a complete failure. The first few Apple Macs were available at school - a real revolution. These amazing computers were a temptation I couldn't resist and I buried my piles of Letraset sheets.

In order to safe us from total occupation by the disease we used these powerful tools for destroying existing typesets instead of creating new ones. Needless to say that it didn't help it.

GANDL'S ANAMNESIS STAGE 5

February 1992. I was tasked to digitize hand-drawn logos from the 60s and incorporate them into a corporate font. It was a final eye opener and my painful experience with Fontographer began.

At that time, the Fontographer manual was only available in English. It contained a lot of complicated terms that were indecipherable to me, yet my experiments with the software sparked off a new enthusiasm.

Internet and search engines weren't available in those days, so I was mainly following the trialand-error method. Two weeks later, with a couple

of achievements and twice as many failures under my belt, I was helplessly addicted to the package. Ever since, I have worked on creating programmed typography on a regular basis, while my own handwriting gets worse and worse.

THERAPY

Typo-graphic and typography is an integrated element of my profession - Special projects require special typography. Still I wouldn't consider myself a typographer but I definitely dig into the experiment.

Over the years I developed some automatisms with the available software in combination with geometric forms that helps me producing typefaces within some hours now. Usually I find myself producing simple display typography that has become more or less a necessary and playful gymnastic for my system in order to keep my body calm and relaxed.

The biggest problem to get cured is that impossible to describe the feeling when you install your own typeface on your computer and see your glyphs running over the screen - letter by letter, word by word, sentence by sentence - for the very first time.

In order to prevent me from further damage I started to produce letter stamps lately.

Boredom hasn't kicked in yet but eventually it will help me by going back to the roots of my addiction.

RECOMMENDATION

Unless you are of a particularly strong and resilient constitution I recommend that you stop reading here and cease reading this book or accept the risk of 'infection' and perhaps of becoming a type-addict too.

P007 FOREWORD	
BY STEFAN GANDL NEUBAU (NEUBAUBERLIN.COM)	

P008 CONTRIBUTORS

Design 3 Deep Design Adam Hayes Andrew Byrom Apirat Infahsaeng artless Inc. Artroom - Commercial Atelier télescopique Byggstudio Claire Scully Conor & David Corp.Unit Dainippon Type David Lane desres design group FromKtoJ/FromJtoK gggrafik Grandpeople Guy Haviv Gyöngy Laky Hamlet Au-Yeung HAWAII DESIGN London Hjärta Smärta Iceland Academy of the Arts, graphic design graduation class of 2006 Jo Ratcliffe Khaki Creative & KOKOKUMARU, Co Ltd. Lizzie Ridout Made Manuel Kiem

Misprinted Type mylifesupport™ NB: Studio (NeubauBerlin.Com) Noa Bembibre Non-Format Oded Ezer Typography Paulo Garcia/Lodma. Location Doesn't Matter Anymore pleaseletmedesign Post Typography Si Scott Design Thorhannesson Studio8 Design Tommy Li design Workshop Limited Topos Graphics Tsang Kin-wah Whaa Widmest Will Perrens Yokoland

Key
T:title
D:design
P:photography
C:client
W:type of work
L:language
M:measurement
Y:year

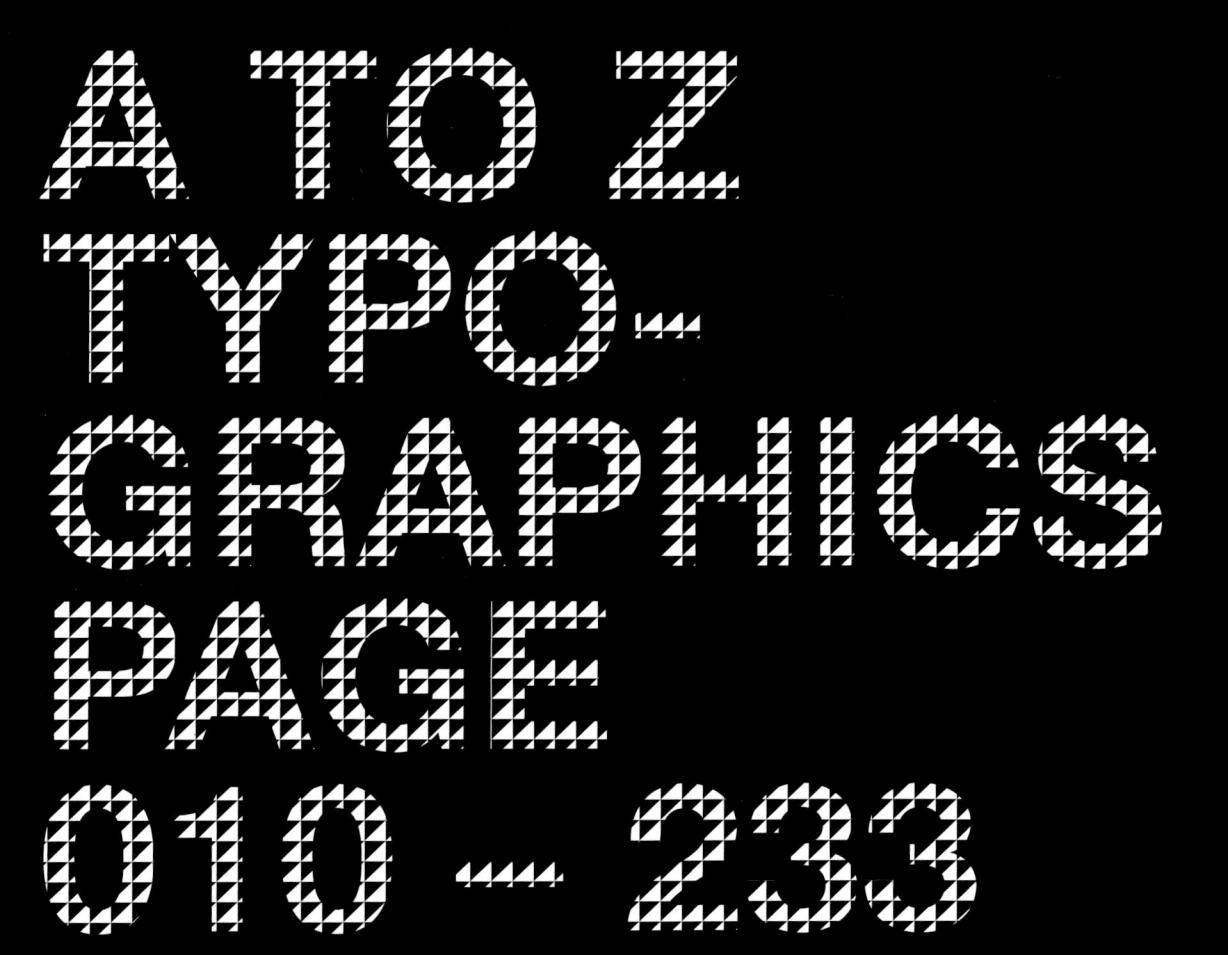

'Adult'

Poster announcing Adult's performance.

T:Adult.
D:Apirat Infahsaeng in collaboration with Mary Banas
C:Bar for Adult.
W:Poster
L:English
Y:2007

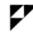

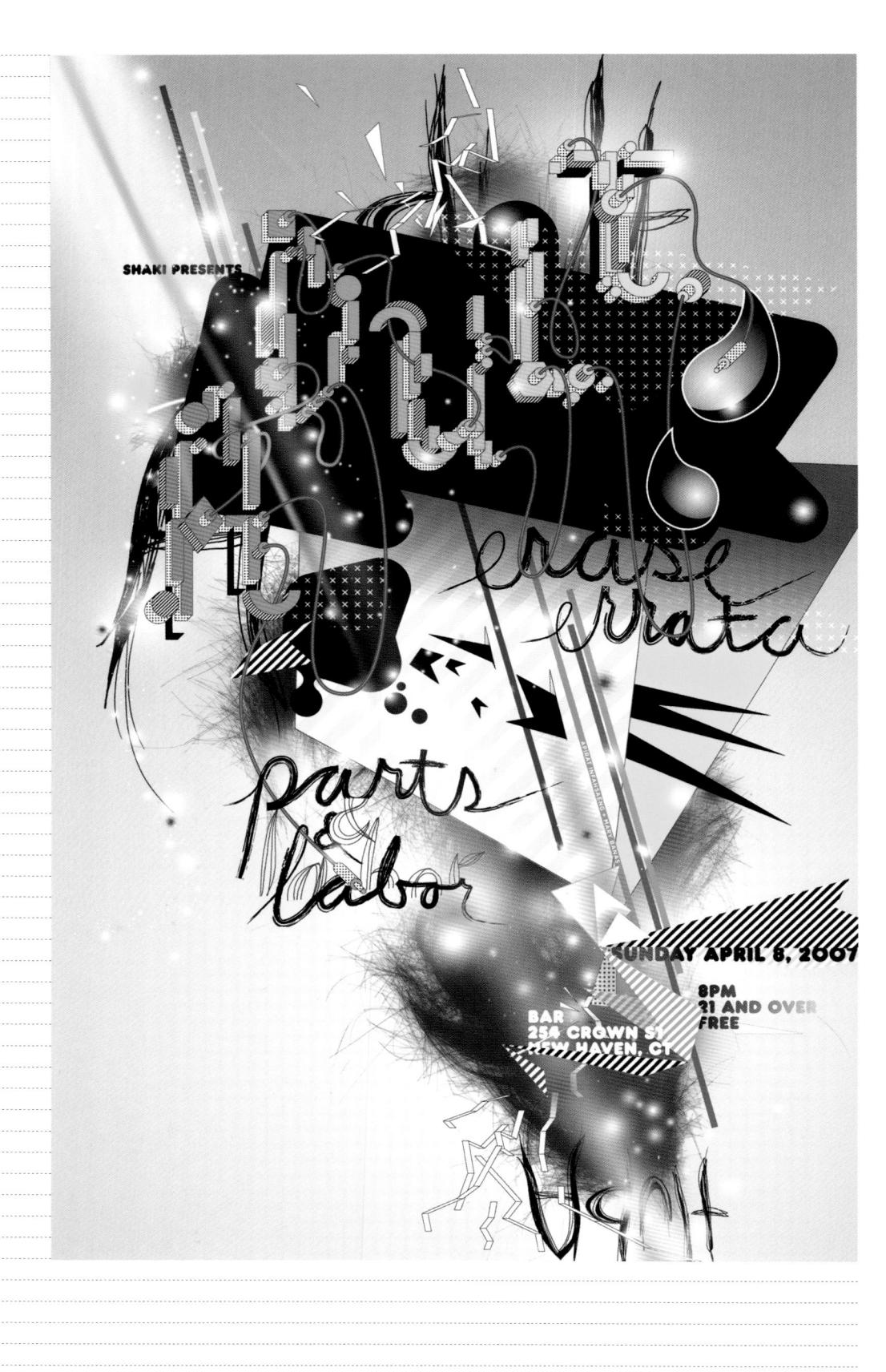

'Agility'

Agility type has been created for the communication of an agility dog contest. The idea of the race is symbolized by jumps, which gives a 3-dimensional effect to the typeface.

T:Agility Typeface (Com munication for an Agility dog contest) D: David Stettler (Whaa) C: Ecal (University of Arts of Lausanne) W:3D typeface L: French Y:2005

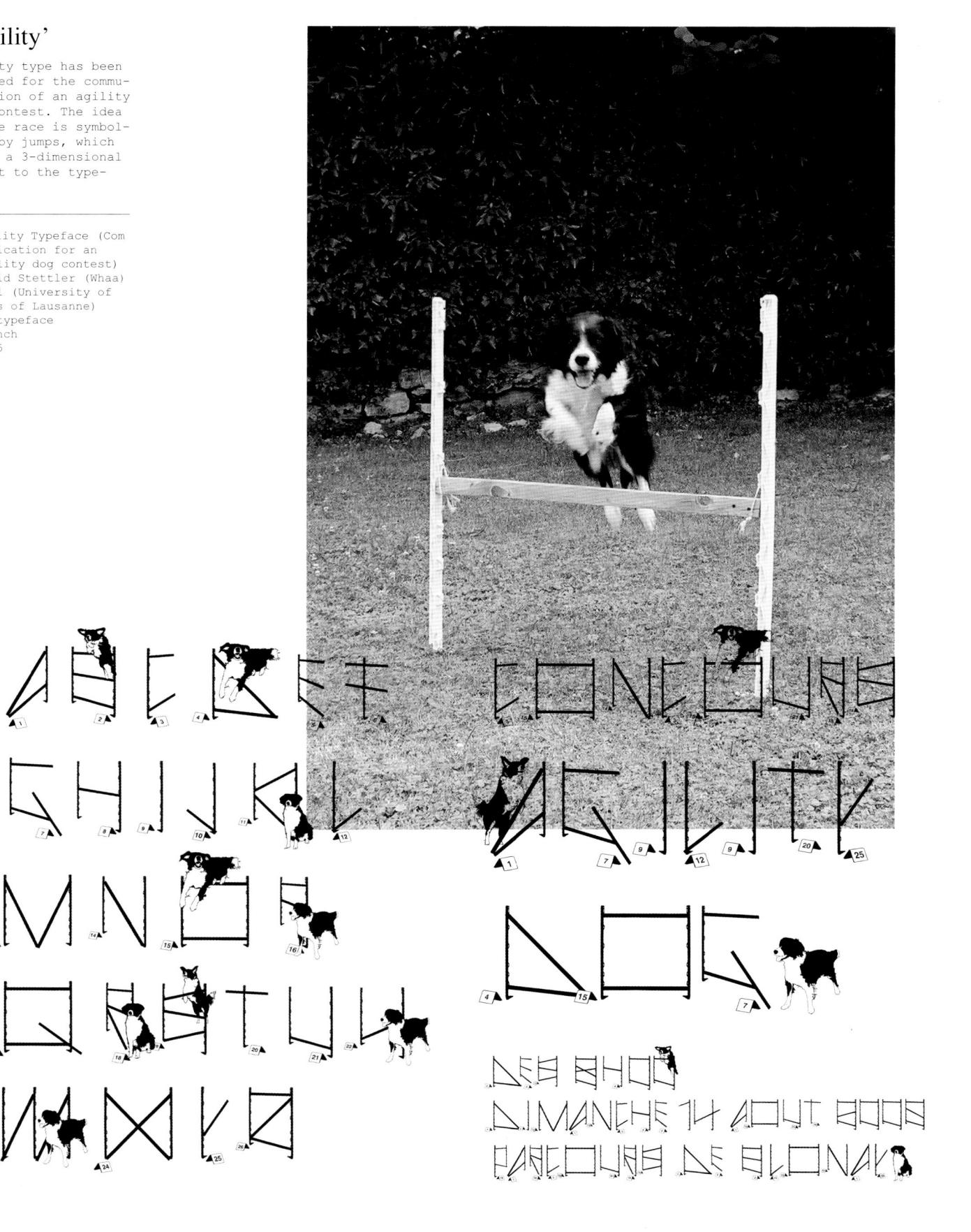

'Amazon'

A booklet and poster produced to raise awareness of the destruction of the Amazon rainforest for the US-based charity Rainforest Action Network (RAN). Copies of both the booklet and poster will soon be available at Magma bookshops, with all proceeds going to RAN. Each booklet is made from only 1 sheet of FSC certified paper, folding out from the cover into a 12-page concertina, maximizing the sheet and minimizing waste.

T:At This Rate
D:Studio8 Design
P:Giles Revell
C:Rainforest Action
Network (RAN)
W:Editorial
L:English
Y:2007

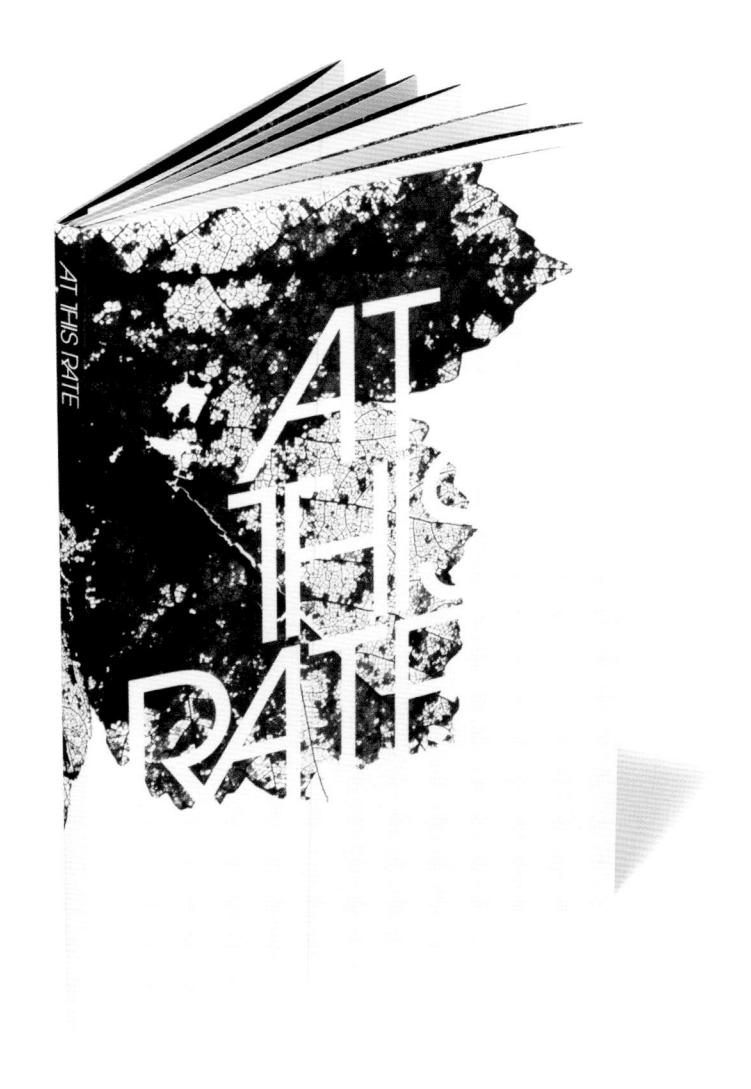

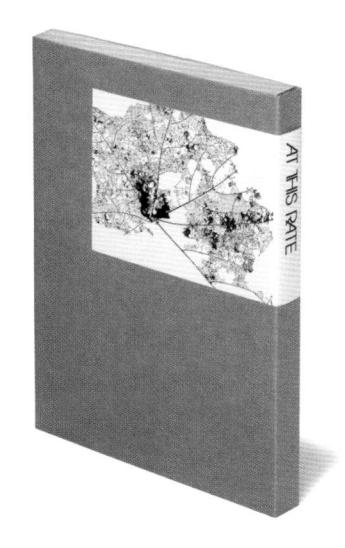

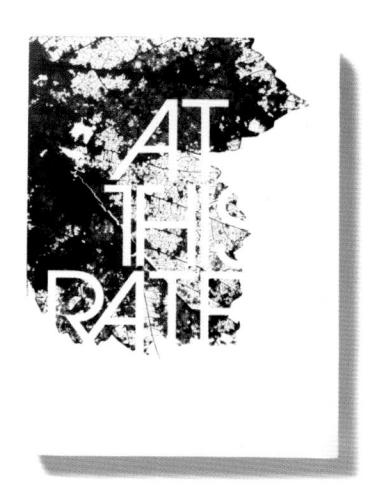

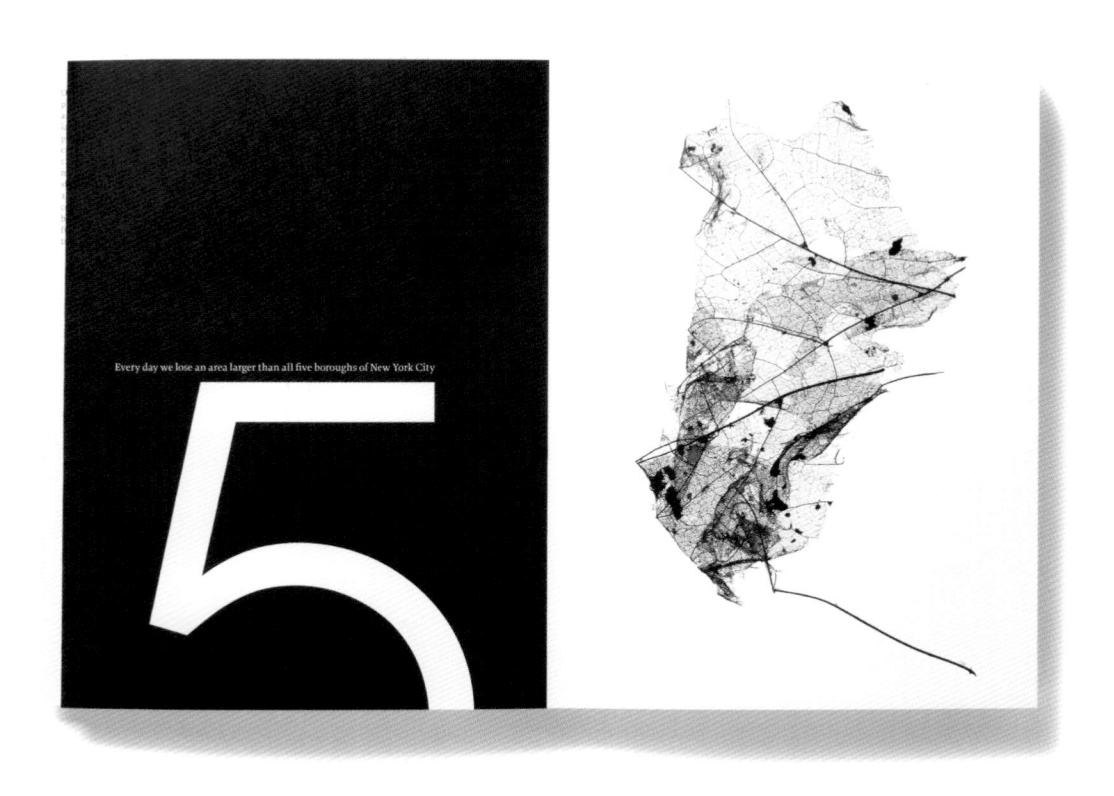

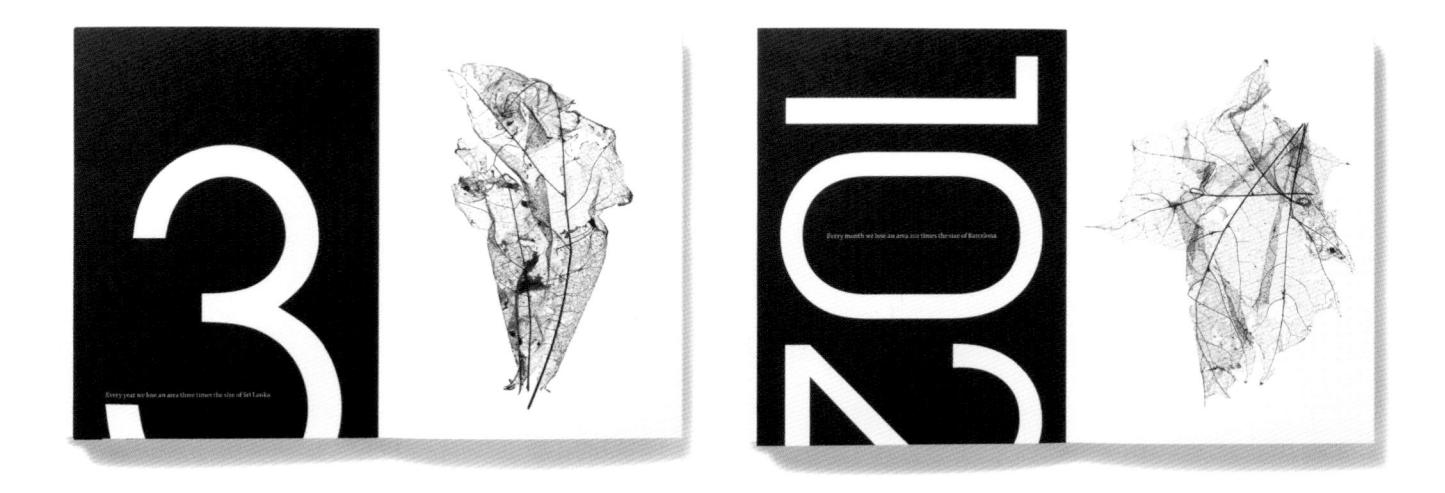

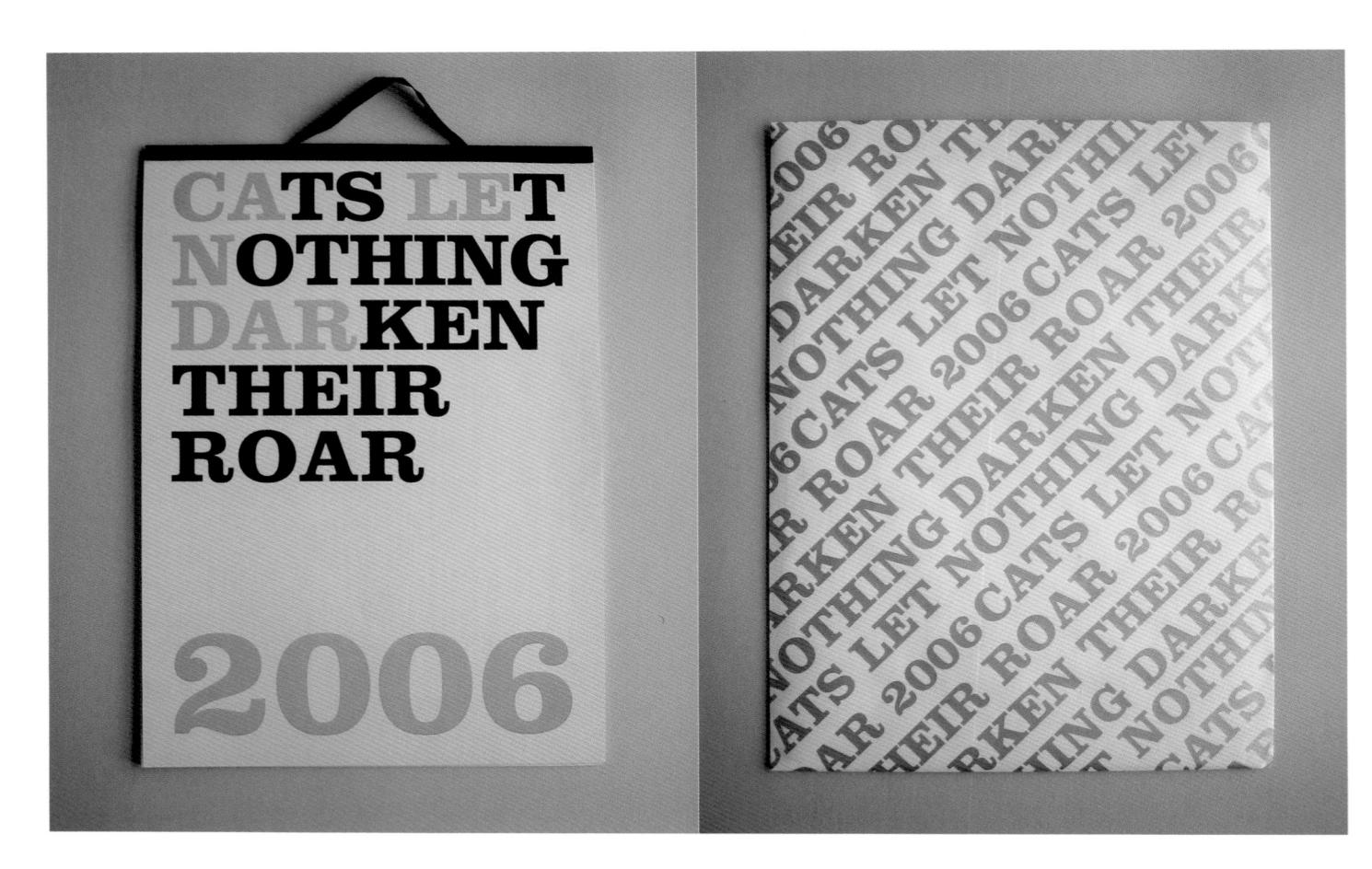

'Amusement'

Cats Let Nothing Darken Their Roar 2006 is a self promotional calendar for the designer's just launched company. It was intended to be sent to friends and colleagues on the Christmas of 2005. The idea was to create an everyday tool that would provoke, surprise, shock and amuse every month throughout the year.

T: Cats Let Nothing Darken Their Roar 2006 D: Noa Bembibre C: Noa Bembibre W: Calendar L: English Y: 2006

MARS APRIC FETCH JAWS, THE IS OTS NUTS BROOM, MADE AND AND A YOU LUBIN OF DIARY ARE CHIPS DEARY M T W T P S S M T W T P S S 1 2 3 4 5 6 7 8 9 10 11 12 10 14 15 10 17 18 10 20 21 22 23 24 25 01 27 28 AU! JULIA AMA JUST LOVES A BIT ZING THE ELL SKY NEBR OW ME ASKA M T W T P S S M T W T P S S S 1 2 5 4 5 6 7 8 9 10 10 11 12 13 14 15 16 17 18 19 80 81 28 85 88 25 26 26 27 88 29 30 31 LETS NOTHING THE DELIGH SEPARATE LIKE A OCTO TFUL THE VEST. CEMENT. TEDDY **PUSS** MUSIC ROBERT BEARS AND A FROM IS THE BEER. SOBER AMBER M T W T P S S M T W T P S S S 1 2 3 4 5 6 7 8 9 10 11 13 13 14 15 16 17 18 19 20 21 22 23 24 25 26 M T W T P S 0 M T W T P S 5

1 2 6 4 5 5 7 8 9 10

11 12 13 14 45 16 17 18 19 20 21 22 23 24

33 16 87 28 29 20 51

'Analogue'

NBGrotesqueNo9™ is the headline typography of the 'Remember/Revolver' book project. The project and typeface are the collaboration between the artist and musician Klaus Voormann (designer of legendary Beatles Revolver sleeve 1966) and the designer Stefan Gandl. NBGrotesqueNo9™ was designed on the computer and later on laser stenciled in order to receive single character stamps. These character stamps were used to fit with the analogue feel of the illustrations within this project.

T: NBGrotesqueNo9™ D: Neubau

(NeubauBerlin.com)

C: Voormann.com W: Illustration,

Promotion L: English

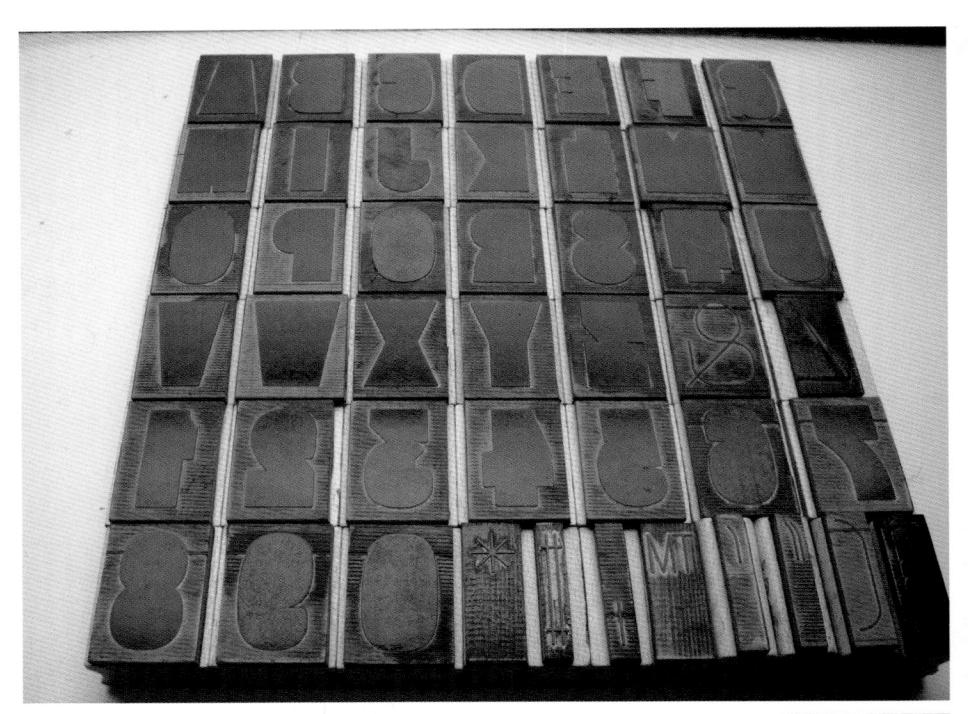

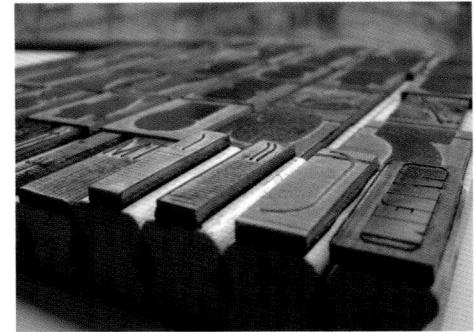

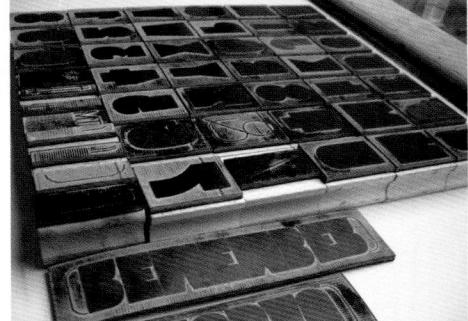

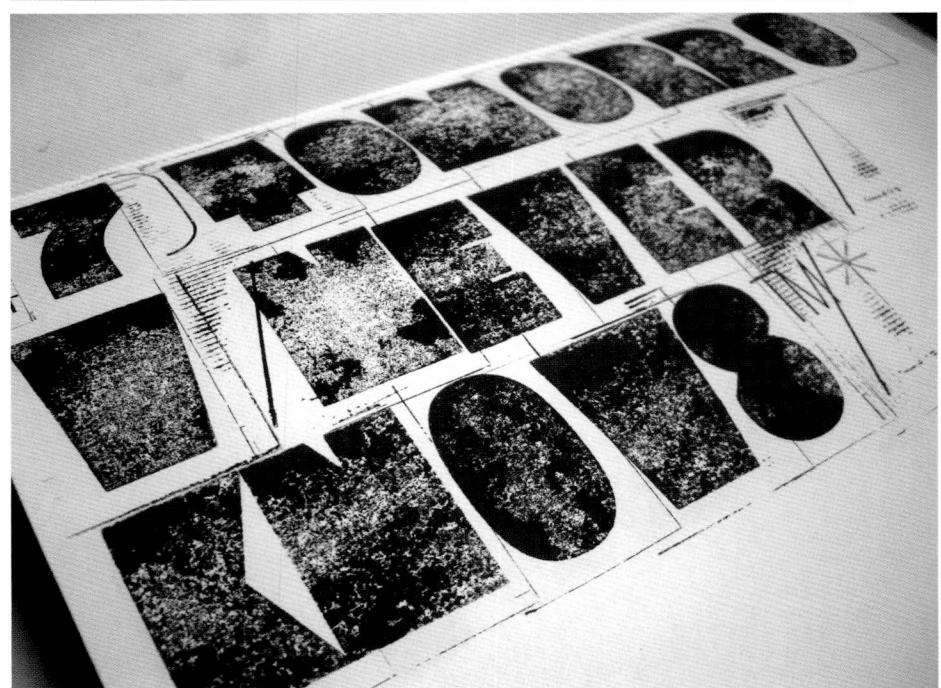

BAUMSCHLAGER BERLE ARCHITEKTEN

V GRAMAN

9.3 16.3 TESTDED STUDIO VAN DELLE &

MEDINA

DORIE MANDRUP

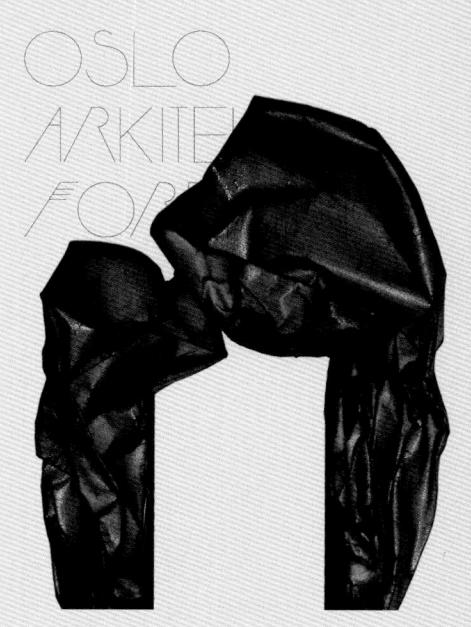

20.4-22.4 11.5 OCA CONFERENCE: IS/IS C//+QS

GENERALFORSAMLING D-ARCHITECTEN

1.6 RICK /OX

SOMMERFEST

lakelor 23 33 24 90 Epost pol@enkishure

ARKITEKT ORENING 100 ÅR.
65 ARTISETER OG
RINGTANTOLOG

Transporter om
Wilder og konne plan
Her og konn

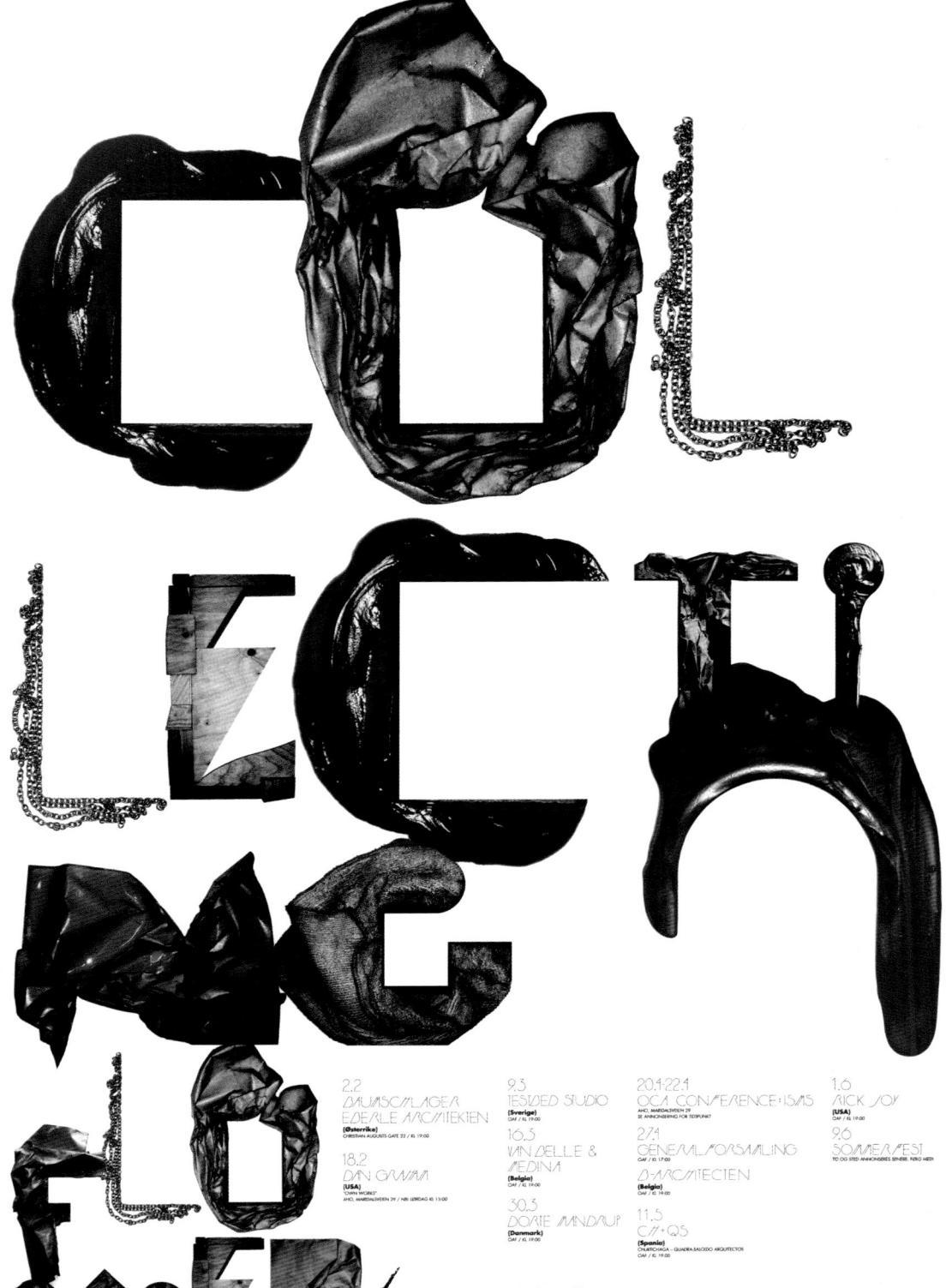

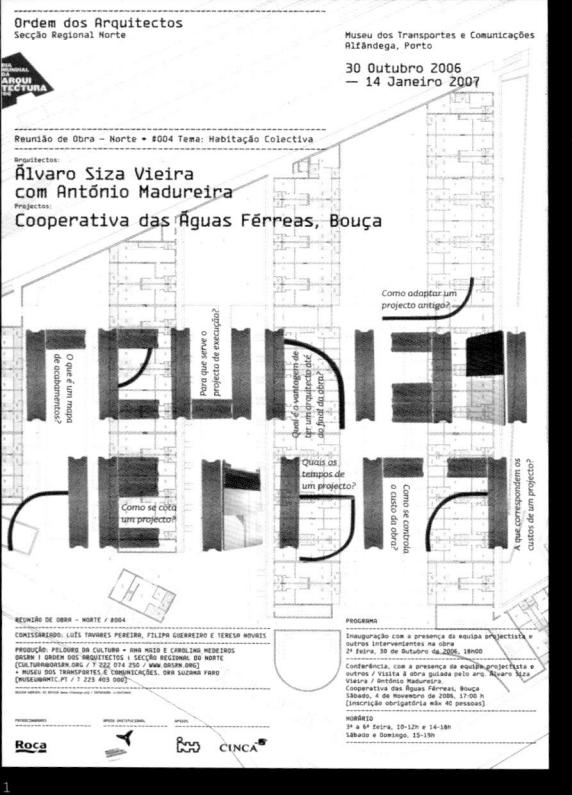

'Architecture'

for exhibition of architecture aimed at showing the public the great importance of the architect's presence on site. Each exhibition features a Portuguese Architect.

(Architect Siza Vieira)
2.Site meeting #02
(Architect João Paulo dos Santos)
D:R2 design
C:Northern Regional
Branch of the
Portuguese Architects
Association
W:Poster
Y:1.2007
2.2006

T:1.Site meeting #04

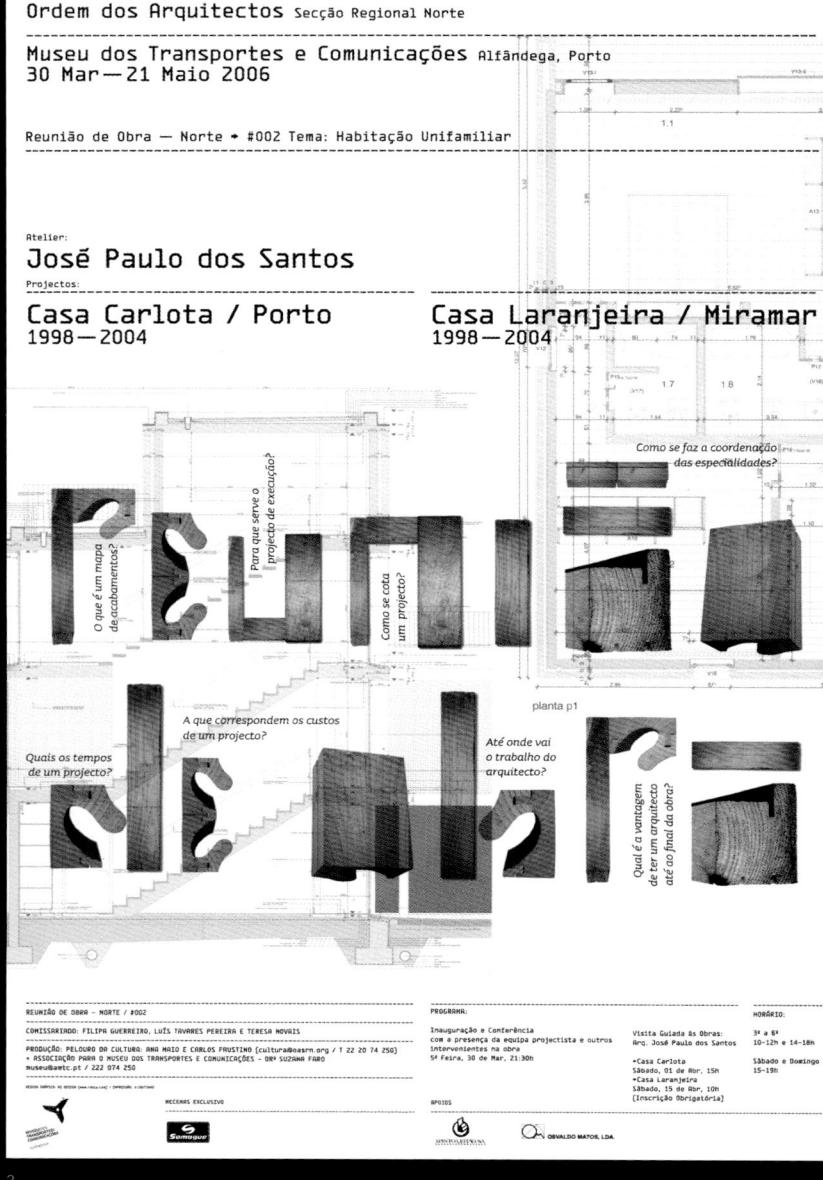

'Army'

Army theme of T-shirt design for Shanghai T-shirt store 'Shirt-Flag,' with the Chinese character '銃' (Chong) which is a kind of Chinese firemans.

T: \$\foating(Chong)\)
D: Sixstation
C: Shirt-Flag
W: T-shirt graphic
L: Chinese
Y: 2006

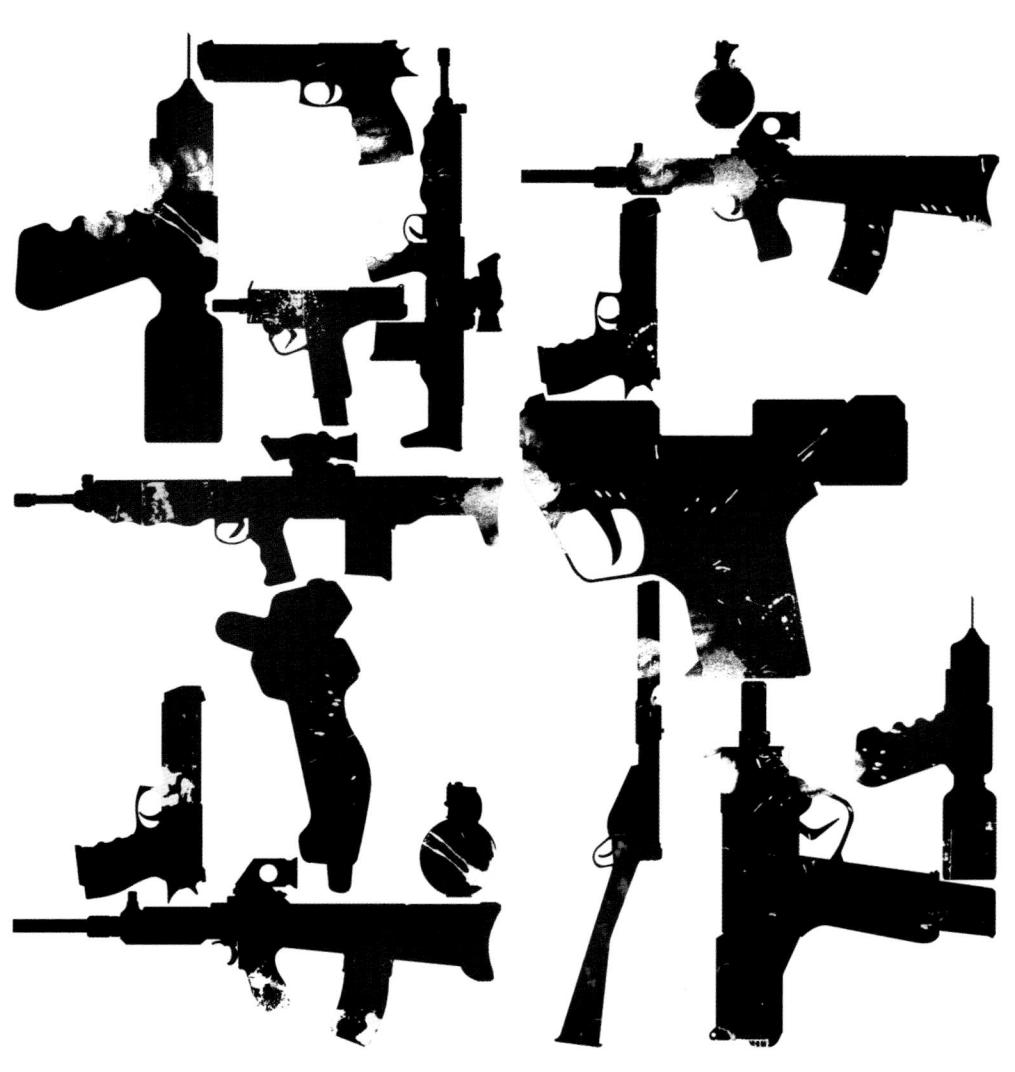

STATE OF STATE

'Art'

T-shirt design for ChinaShadow. It is exhibited in Shanghai design biennial exhibition. This project event aims to promote and protect Chinese traditional art - shadow puppet.

T:一人唱盡天下事, 雙手對舞百萬軍

(ChinaShadow)
D:Sixstation
C:ChinaShadow
W:T-shirt graphic
L:Chinese
Y:2006

'Band'

3 different style logo designs for Singapore indie band 'Wu Feng Ling.'

T:Wufengling D:Sixstation C:Wu Feng Ling W:Logo L:Chinese Y:2006

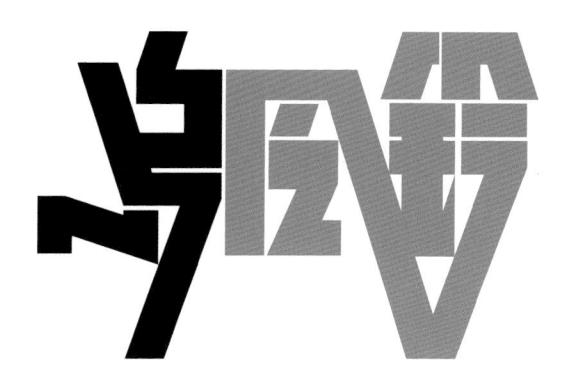

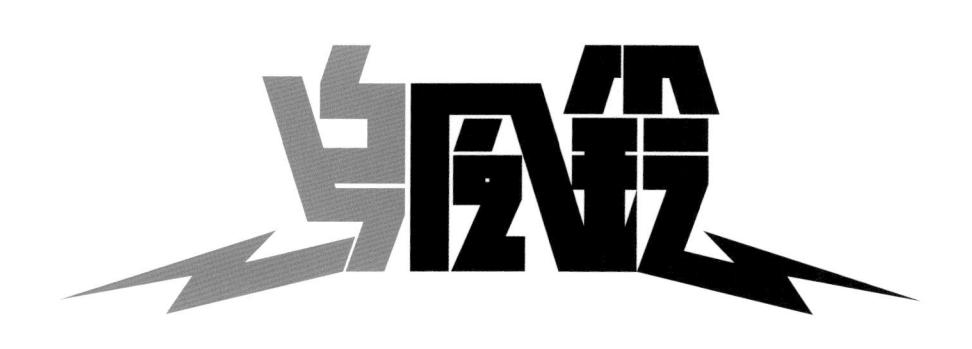

'Base'

Poster and visual identity for Contemporary Dance Company HVDZ, Base 11-19 show.

T:Base 11-19
D:Atelier télescopique
C:Cie Guy Alloucherie,
 Culture Commune
W:Poster
L:French
Y:2006

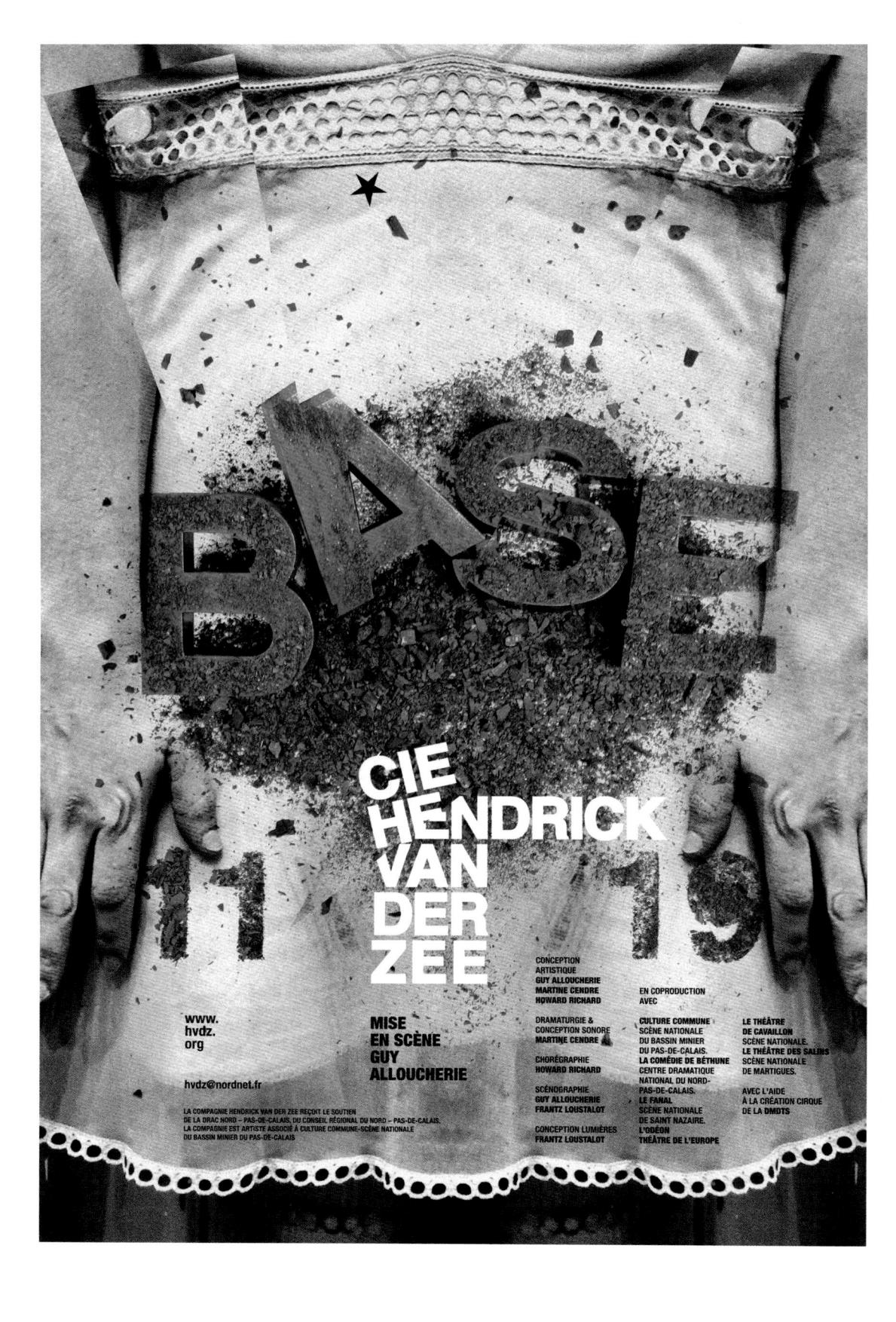

'Basketball'

Type development for the launch of LeBron James's new basketball shoe Zoom LeBron III. Art direction by Michael Spoljaric at Nike Brand Design.

T:LeBron James, Zoom LeBron III D:Non-Format C:Nike W:Typeface L:English Y:2005

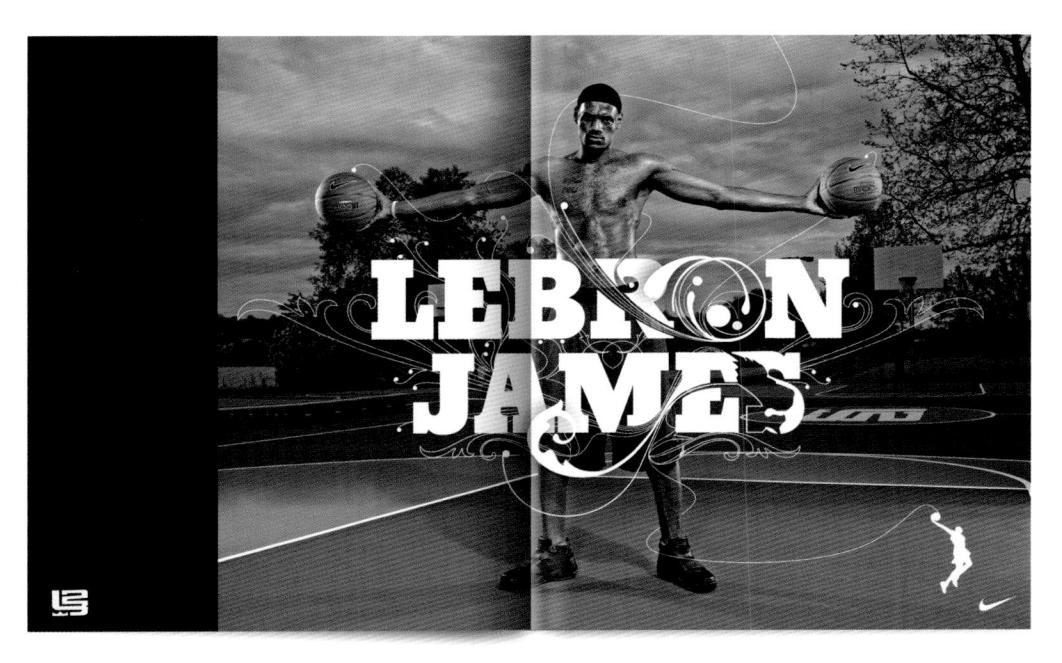

'Beijing'

Beijing is an up-andcoming city with too
much flavour not to
share with the rest
of the world. Given
that more and more
people are coming to
the city, many of whom
might be in need of a
suggestion or two, the
designer thought he
might provide a short
typographical tour
for any prospective
visitor.

- T:Welcome to Beijing! D:Khaki Creative & Design, Inc.
- C:Khaki Creative & Design, Inc.
- W: Logotype L: Chinese
- L:Chines Y:2007

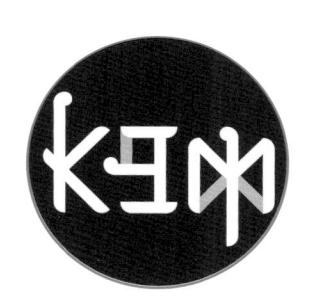

'Black'

The brief was to create a personal statement under the theme 'Black.' The statement was to portray the influence of the black colour when applied to graphics.

T: Everything Looks
Better in Black
D: Paulo Garcia/Lodma.
Location Doesn't
Matter Anymore
C: Revista Colectiva,
Costa Rica
W: Poster, Flyer
L: English
Y: 2007

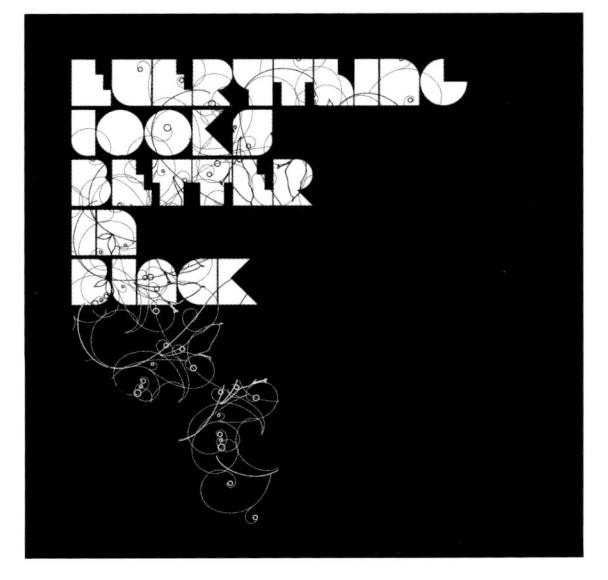

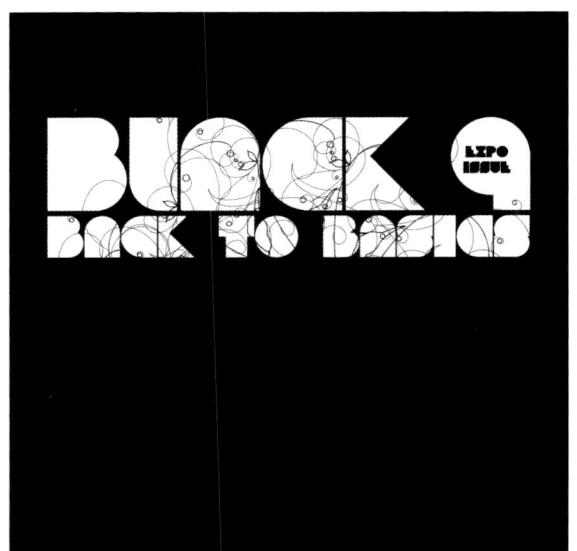

'Blending'

Portmanteau words come from blending 2 existing words into a new one. So this is the result: 6 strange blocked words in different typography at backlight.

T:Portmanteau D:Serial Cut™ C:Perplex City (MindCandy) W:3D Typeface L:English Y:2006

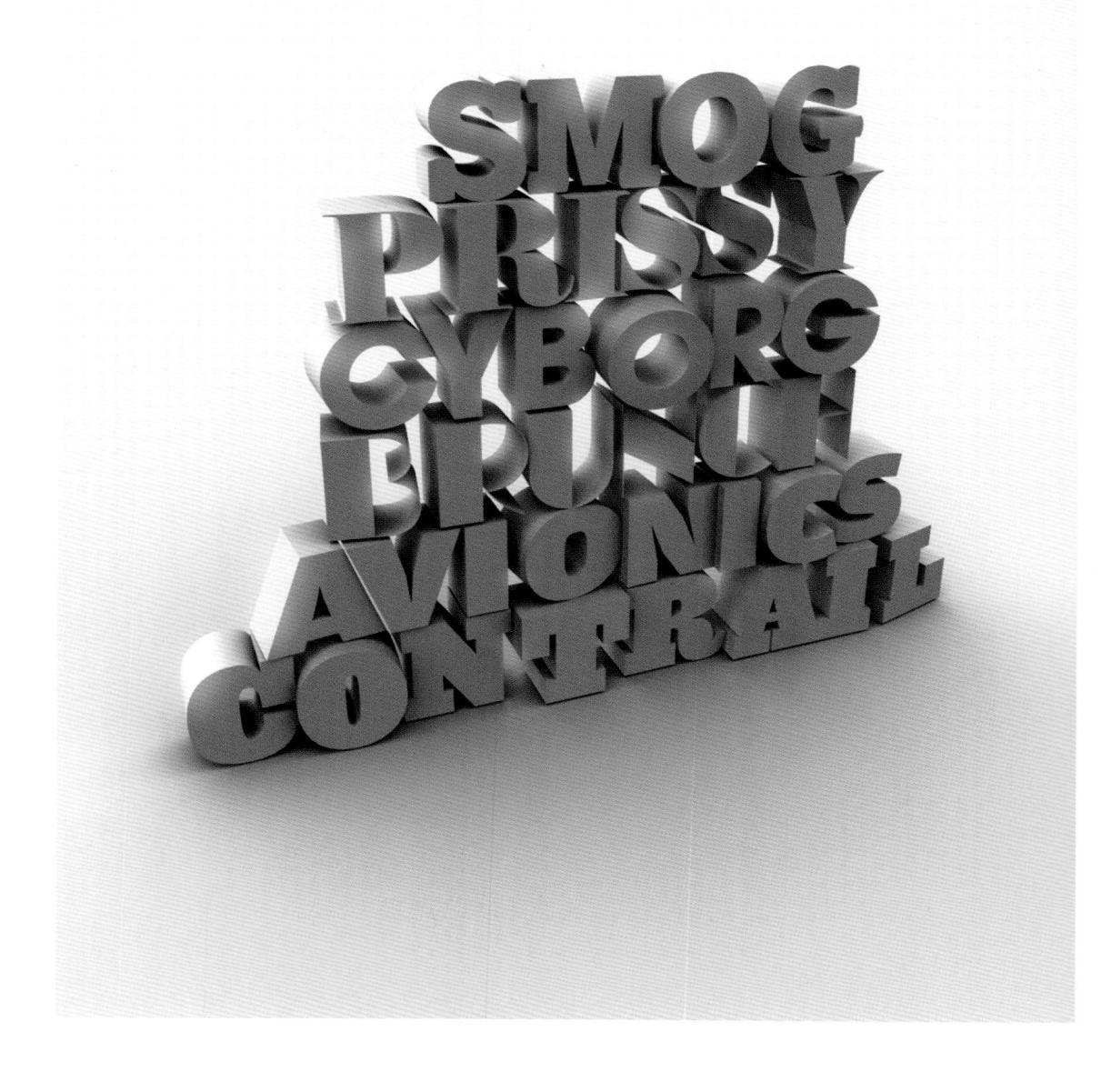

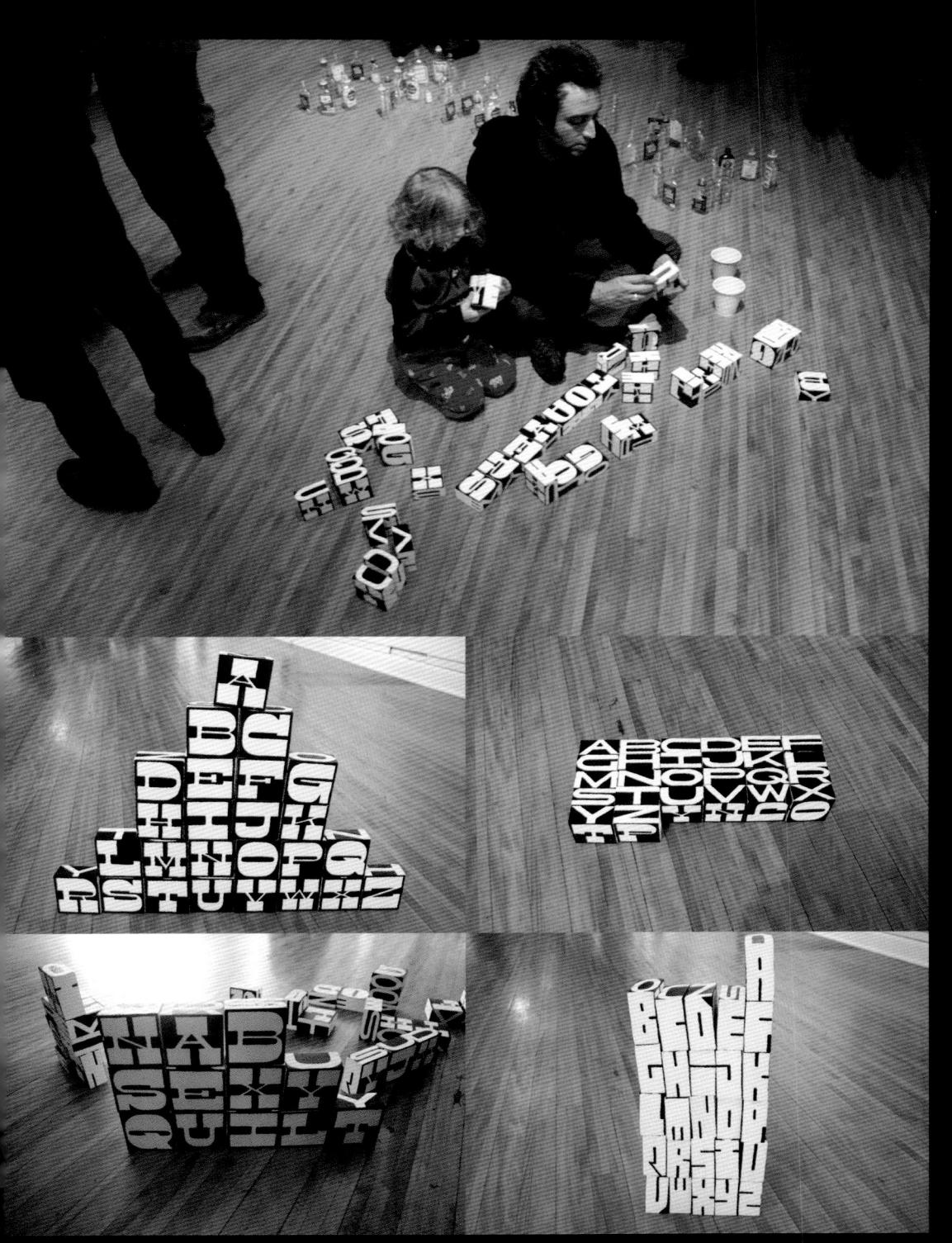

'Blocks'

Set of hand-painted wooden letter blocks loosely inspired by children's alphabet blocks. Instead of being cubes, these blocks are rectangular and feature 3 different styles of lettering.

T:Alphabet Blocks
D:Post Typography
C:Post Typography
W:Hand-painted letter
blocks
L:English
Y:2004

'Book'

1. The Bygg Books font (photographed real books) is a further experiment of the Book Club font using real books stacked on each other to form the letters of the alphabet.

2. The Book Club font (vector) was originally made as a school project for a literary dictionary. The book is about books, and the font is made by books itself. The idea is simple - to clearly communicate the content of the book and at the same time make it look a bit less heavy and more playfully pleasant than those kind of books normally do.

T:1.Bygg Books Font 2.Book Club Font D:Byggstudio C:Byggstudio W:Typeface Y:2006

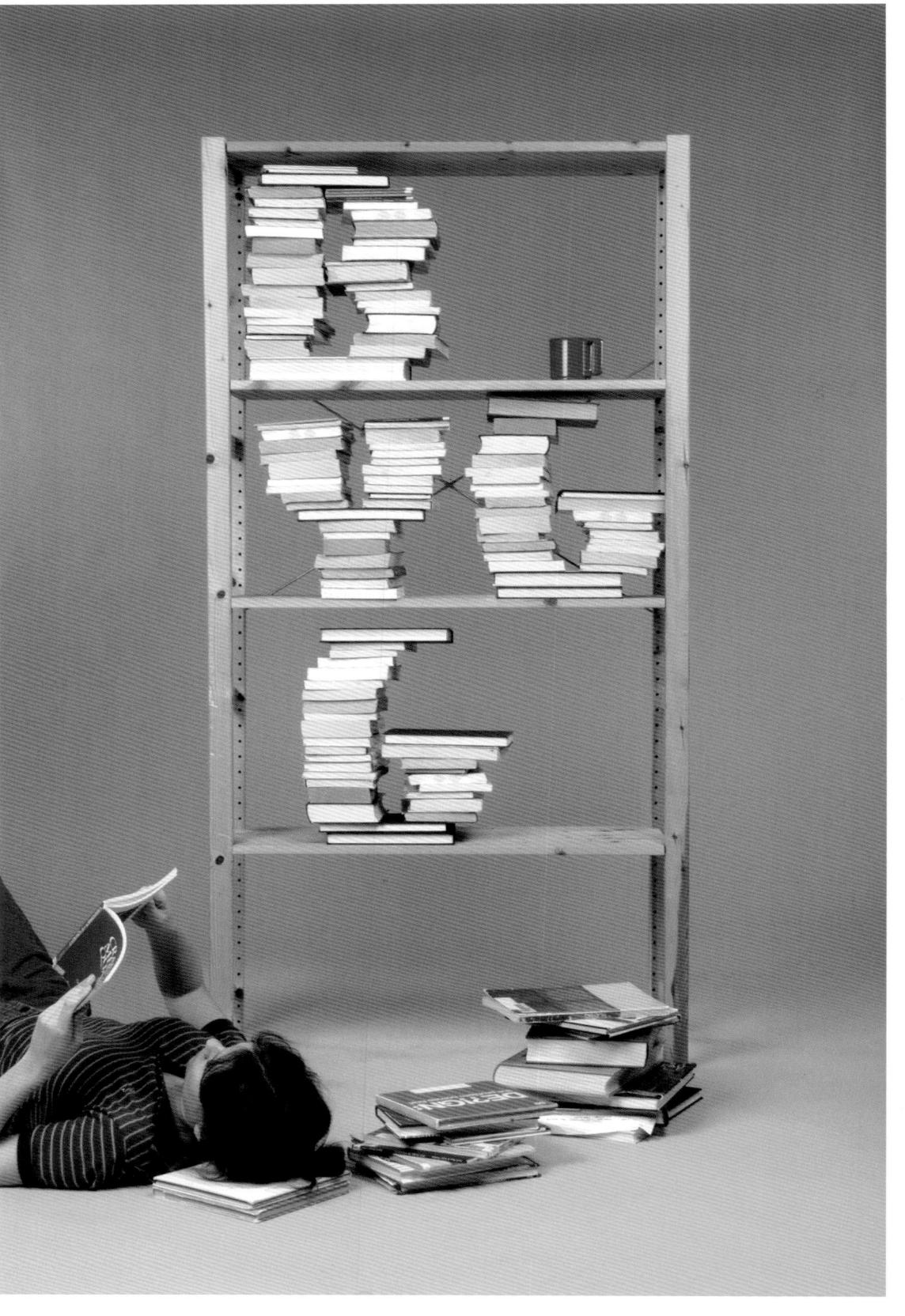

120 y 24 y 180 y

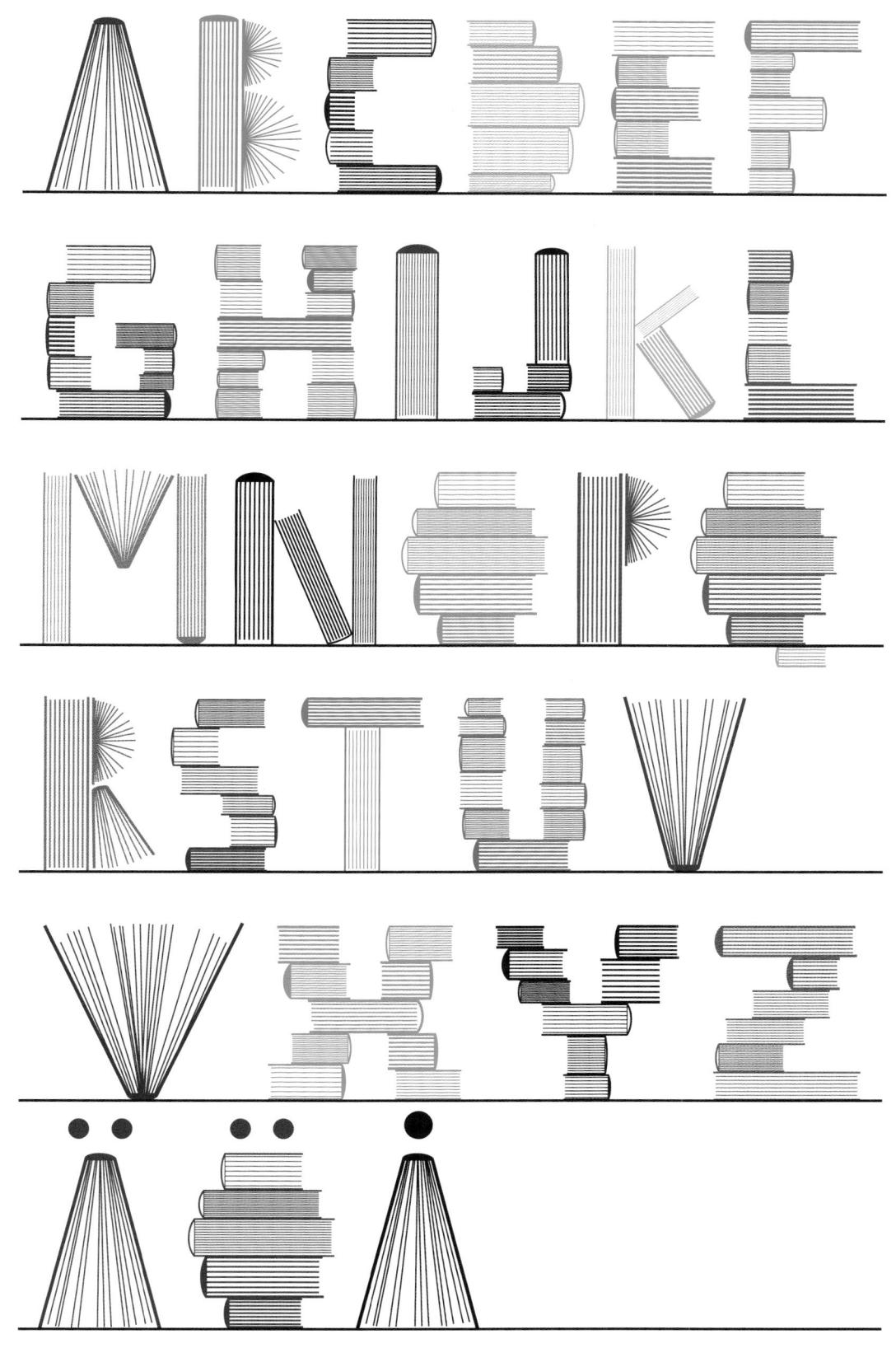

2

EN LITTERÄR UPPSLAGSBOK Återger innehållet i över 700 verk

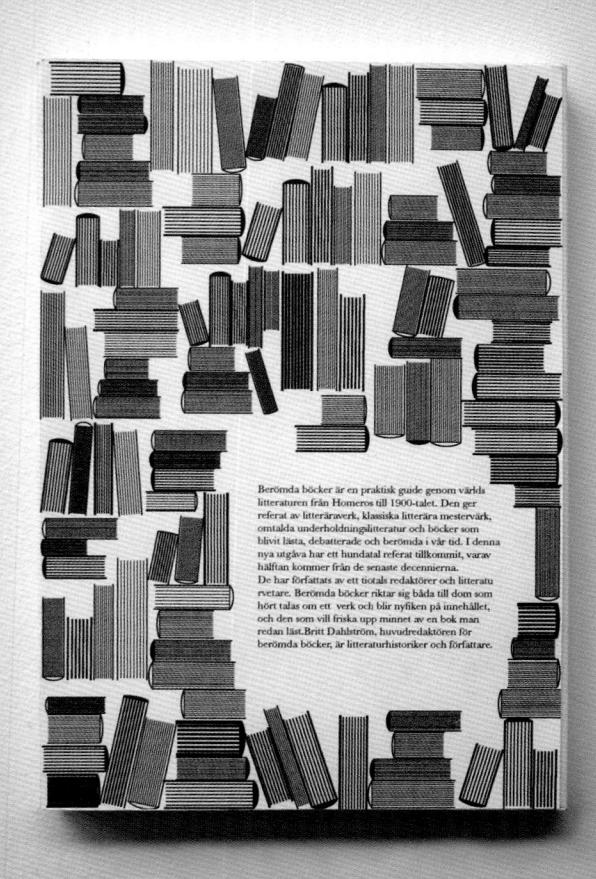

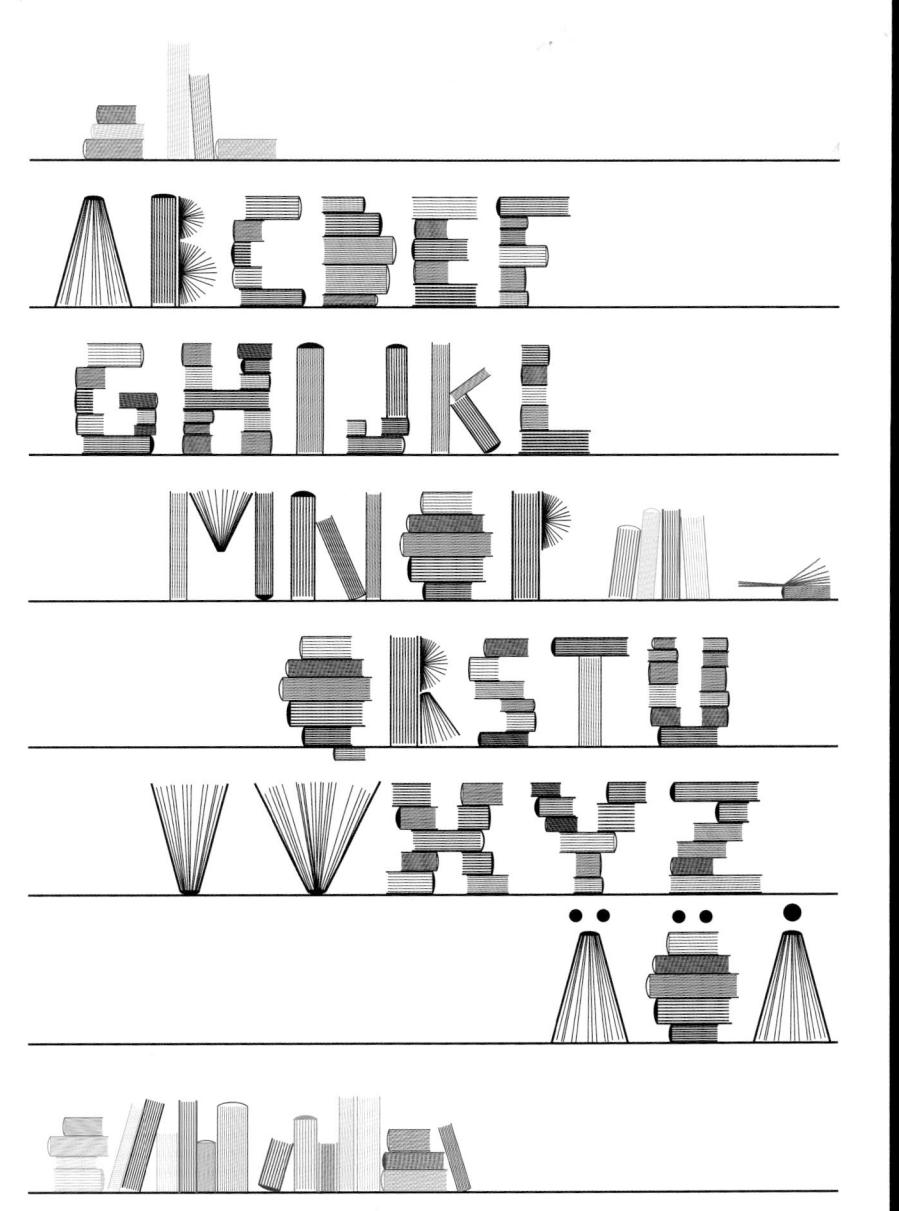

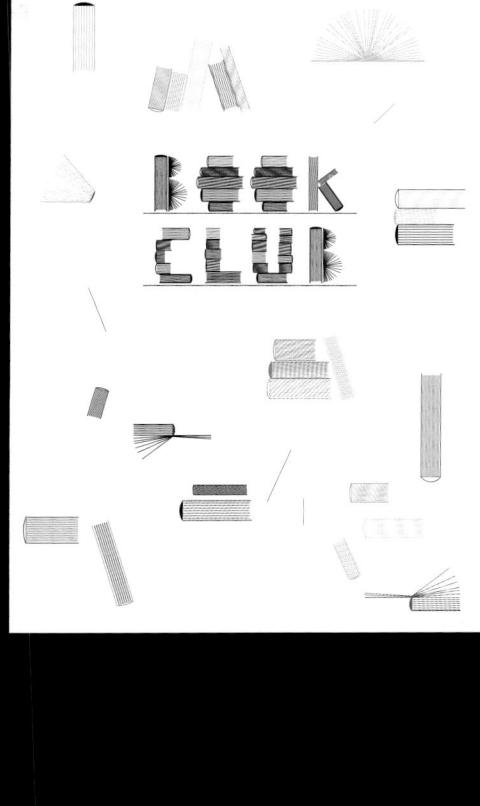

'Borderline'

Poster and visual identity for Borderline Festival 2004.

T:Borderline
D:Atelier télescopique
C:le Manège - Maubeuge
(fr)/Mons (be)
W:Poster
L:French
Y:2004

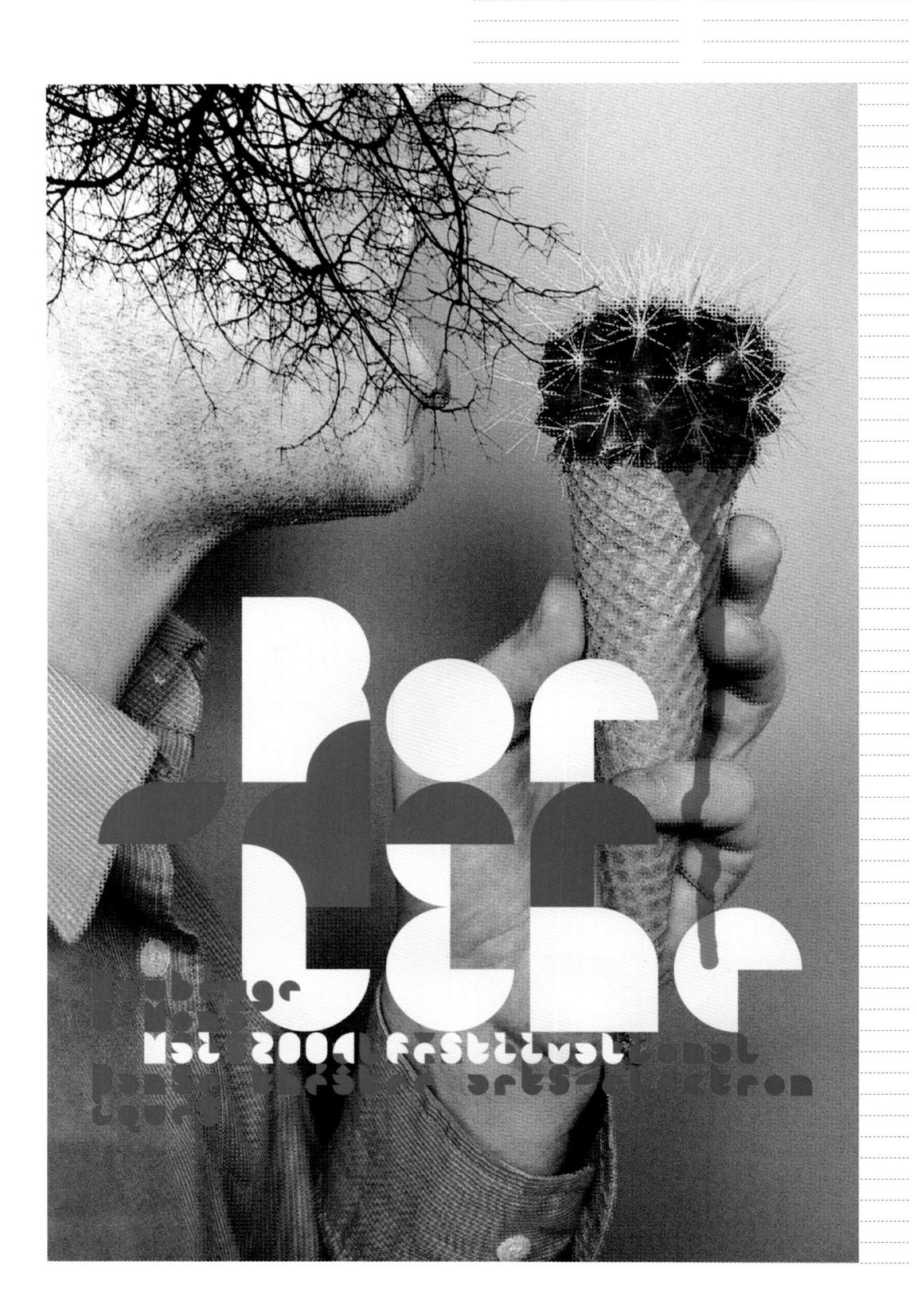

'Circuit'

To present the different activities of this association, the designers decided to make a big poster, folded into a small flyer. They like the idea of people unfolding it in the middle of a concert area.

T:Court Circuit D:pleaseletmedesign C:Court Circuit W:Poster, Flyer L:French Y:2006

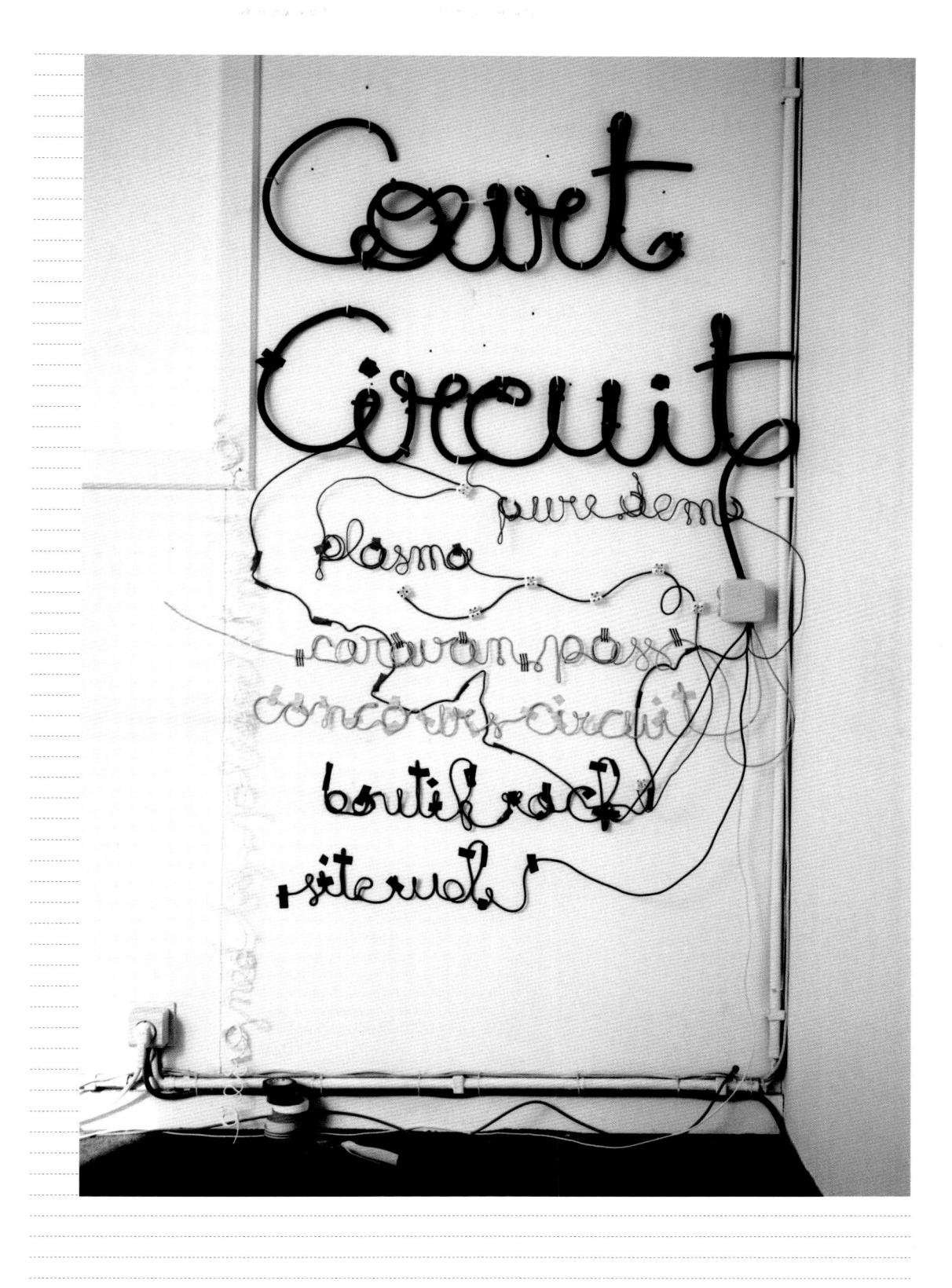

'Collage'

The designers asked a simple question on 'how do you express the scope and energy of the Channel 4 network?' when Channel 4 asked the studio to present their best stories of the year. The designers suggested taking the entire Review online, allowing people watch the programmes so as to create noise. Supported by a print version, the online Review succeeds in reflecting the diversity and energy of the Channel 4 network. Punctuated with small video screens, the site allows viewers to watch short clips of the biggest stories from 2006 with small screens set within collage frameworks comprising real objects and cardboard models representing specific programmes and campaigns. Constructed by hand, the collages suggest the creative flair of the network, providing an engaging, witty backdrop for the screens.

T:Channel 4 Annual Report D:NB: Studio C:Channel 4 W:Annual report, Poster, Online application L:English Y:2007

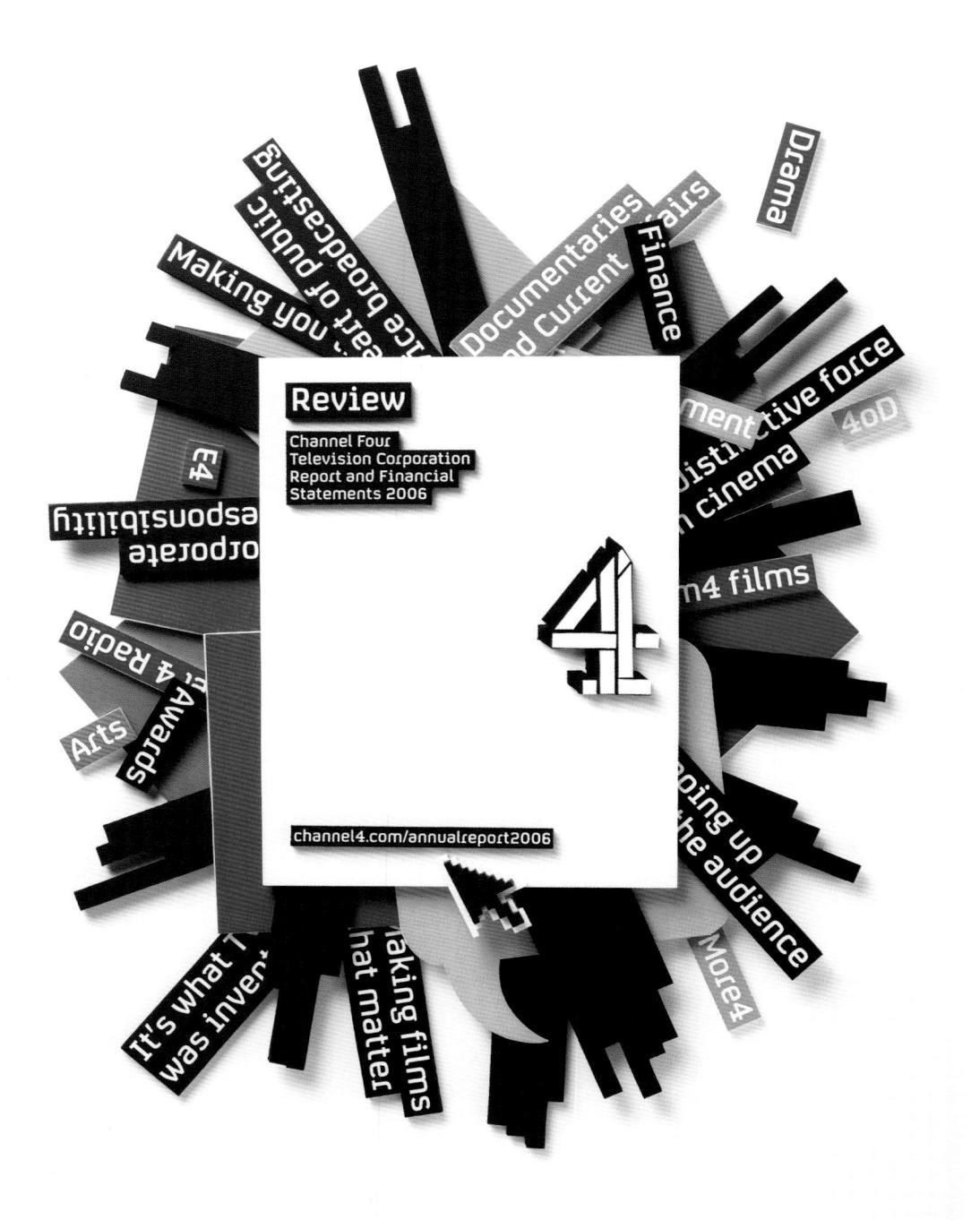
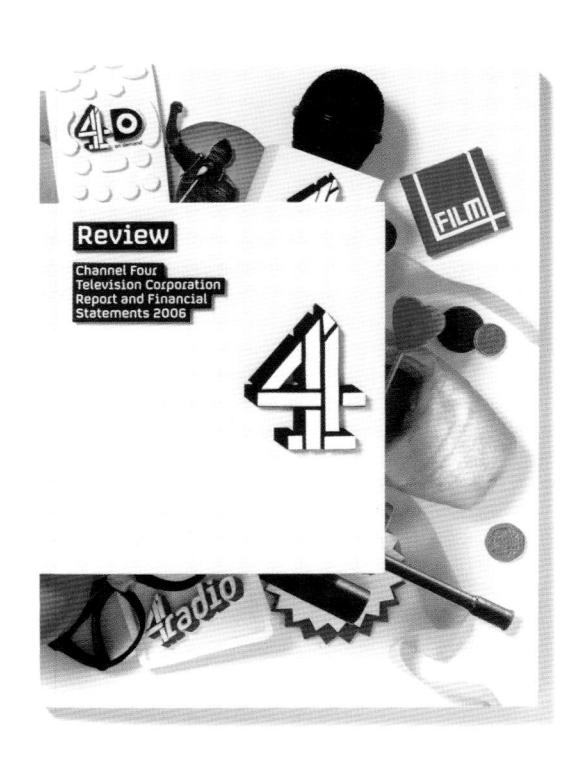

'Contacta'

Invitation card of an exhibition for the photographer Bisse. The text is silverfoiled on rough brown cardboard. The font used is a modified Contacta.

T:Bisse
D:Zion Graphics
C:Bisse Bengtsson
W:Invitation card
L:English
Y:2005

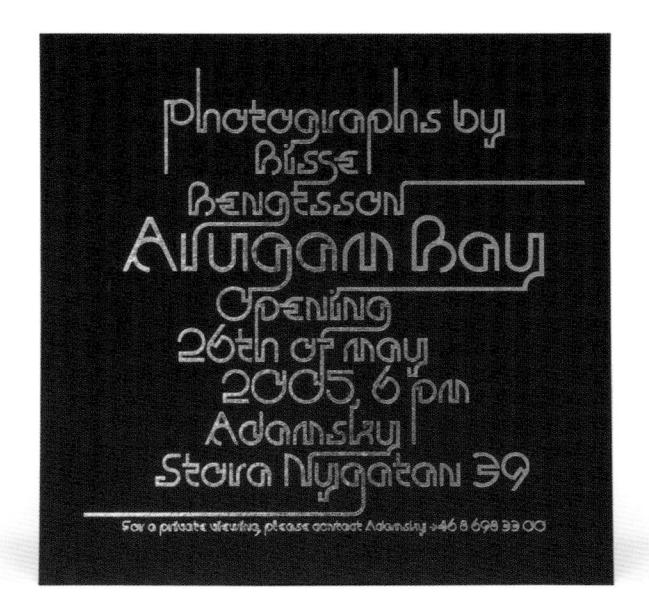

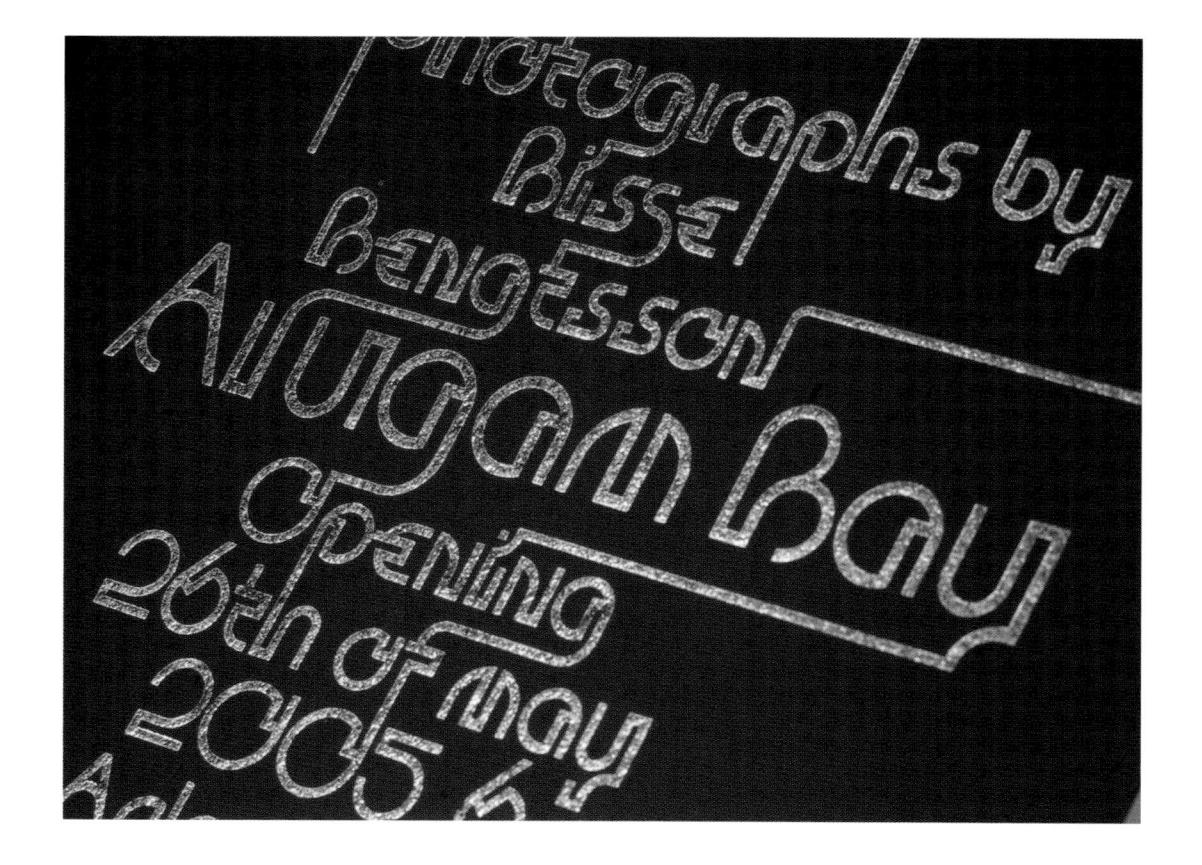

'Creation'

The custom-made book cover was orginated from the motif of the creation of Chinese characters.

T:Book Cover Exhibition D:Taste Inc. C:Japan Typography Association W:Custom-made Japanese Font

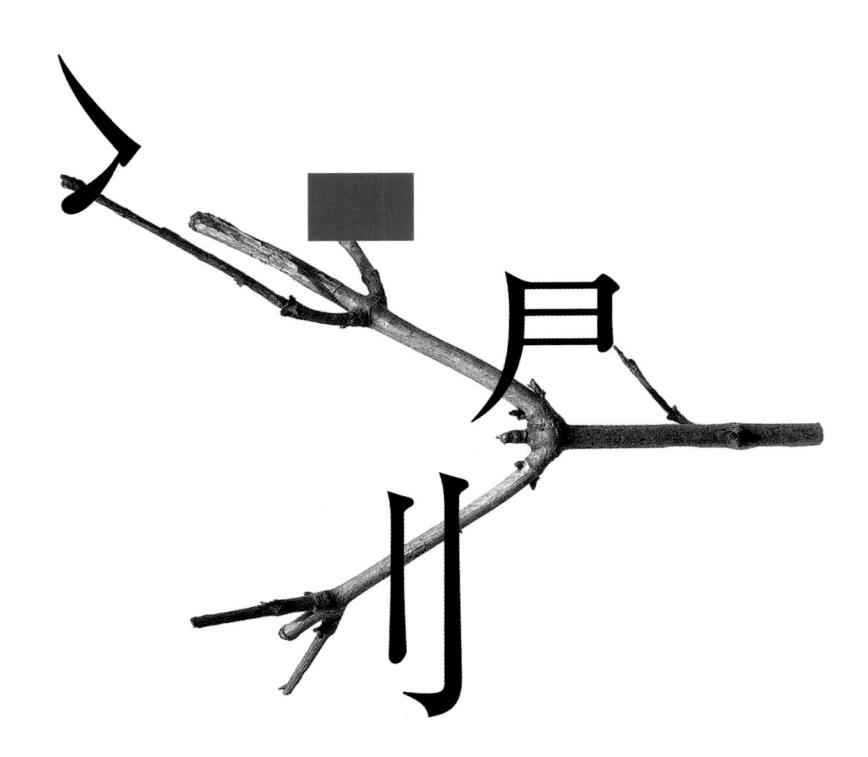

'Cube'

A divided cube consists of 16 sides with different signs on each section. By using these signs in variable combinations the whole alphabet can be generated. The prototype of this cube can be used as a 'writing tool' for stamping letters on paper or on other surfaces. The functional medium is inspired by the relevance of multiple cases and repetitions in everyday life.

T:Typecube
D:Manuel Kiem
C:Manuel Kiem
W:Experimental
typography
Y:2006

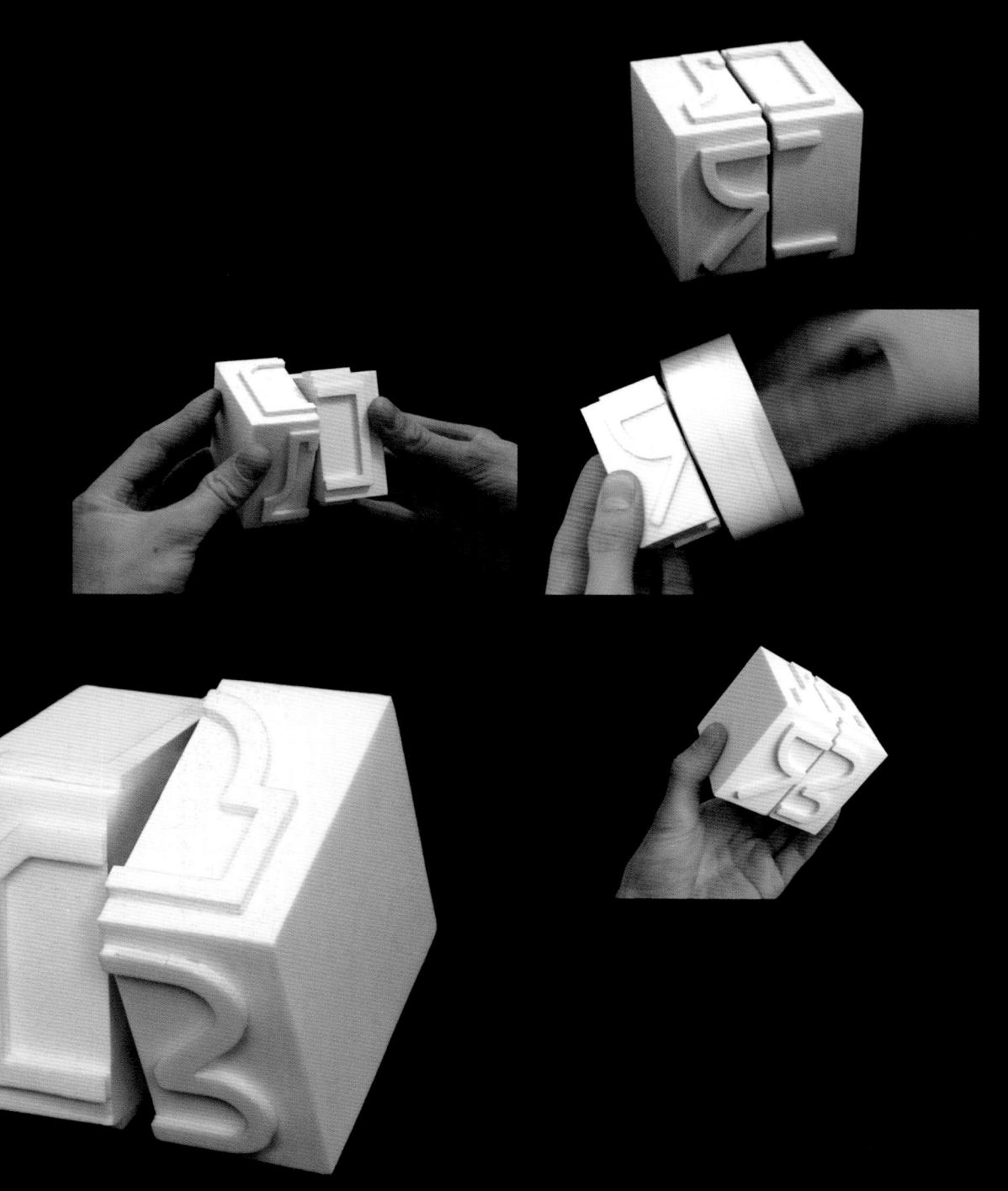

DEEELDE

'Drawing'

Typeface made from random drawings.

T:Drawing Typeface D:Michael Perry

C:Michael Perry

W: Typeface

L: English Y:2003

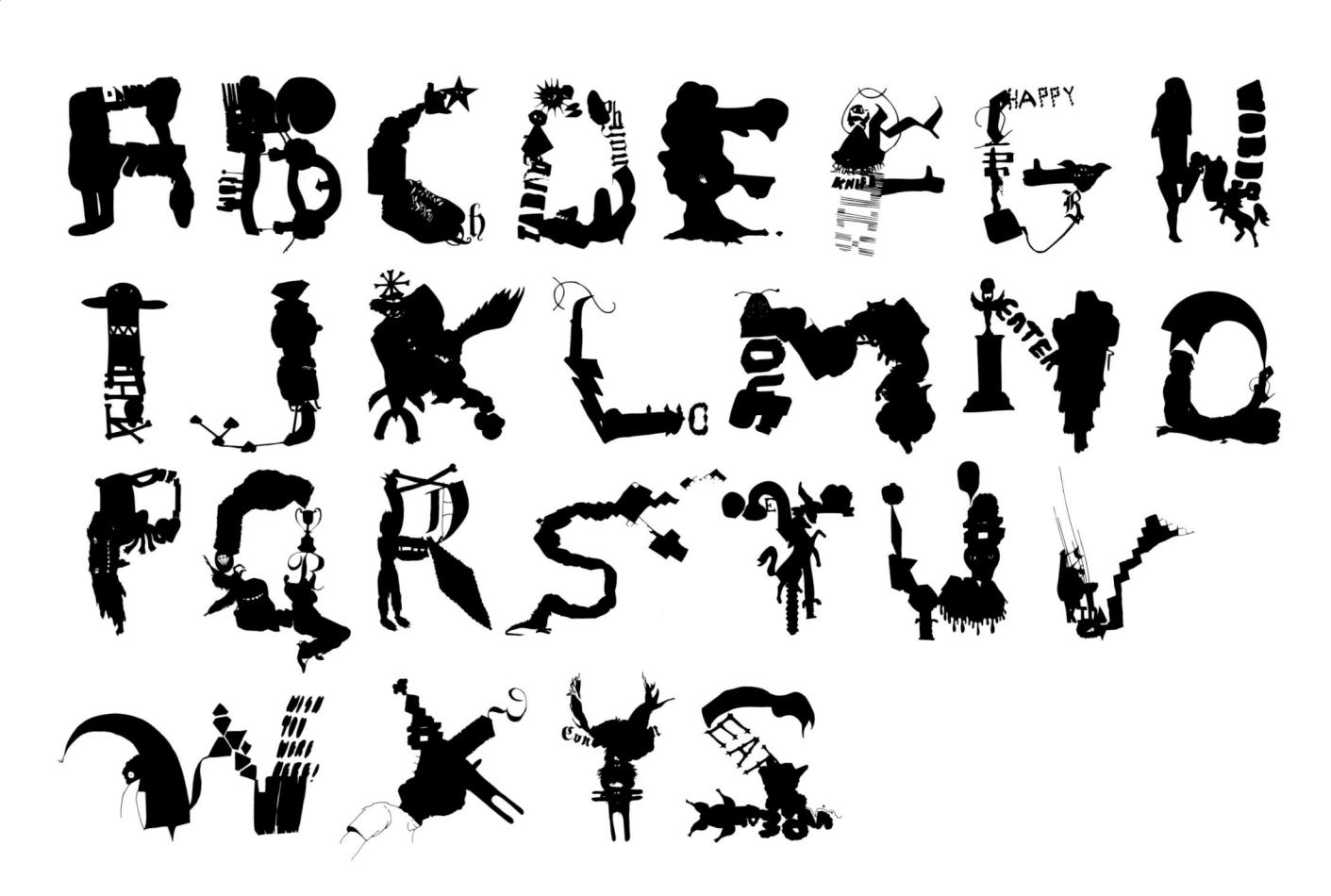

'Dream'

It was the ambition in 2004 which means 'conquer the world.'

T: Dream
D: Dainippon Type
Organization
C: RELAX Magazine
W: Editorial
L: Japanese
Y: 2004

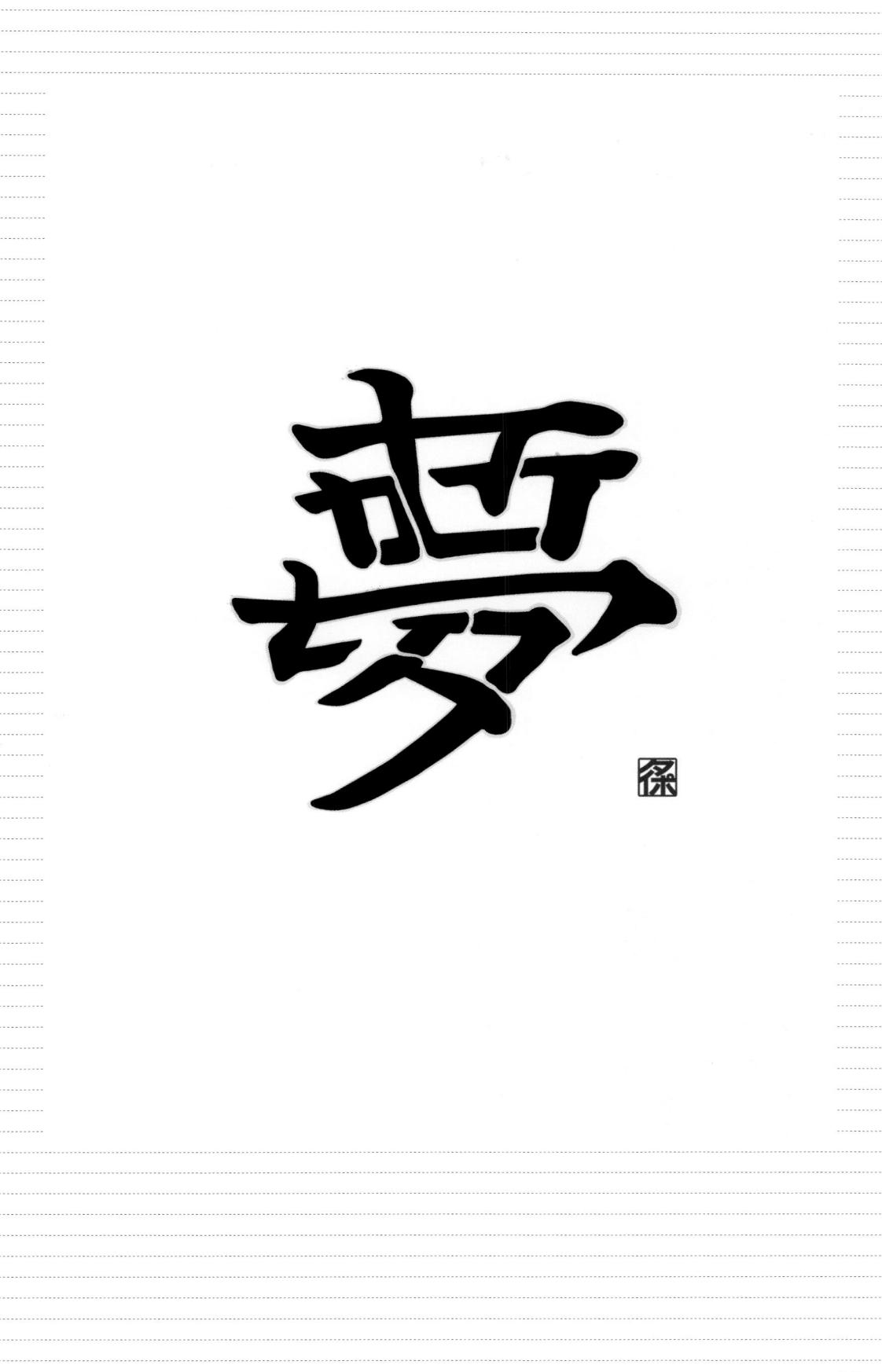

(D : C:)	
Drift	
Concept for a display	
Concept for a display font.	
T:Drift D:Will Perrens	
C: Will Perrens	
W:logotype	
L:English Y:2004	
1.200	

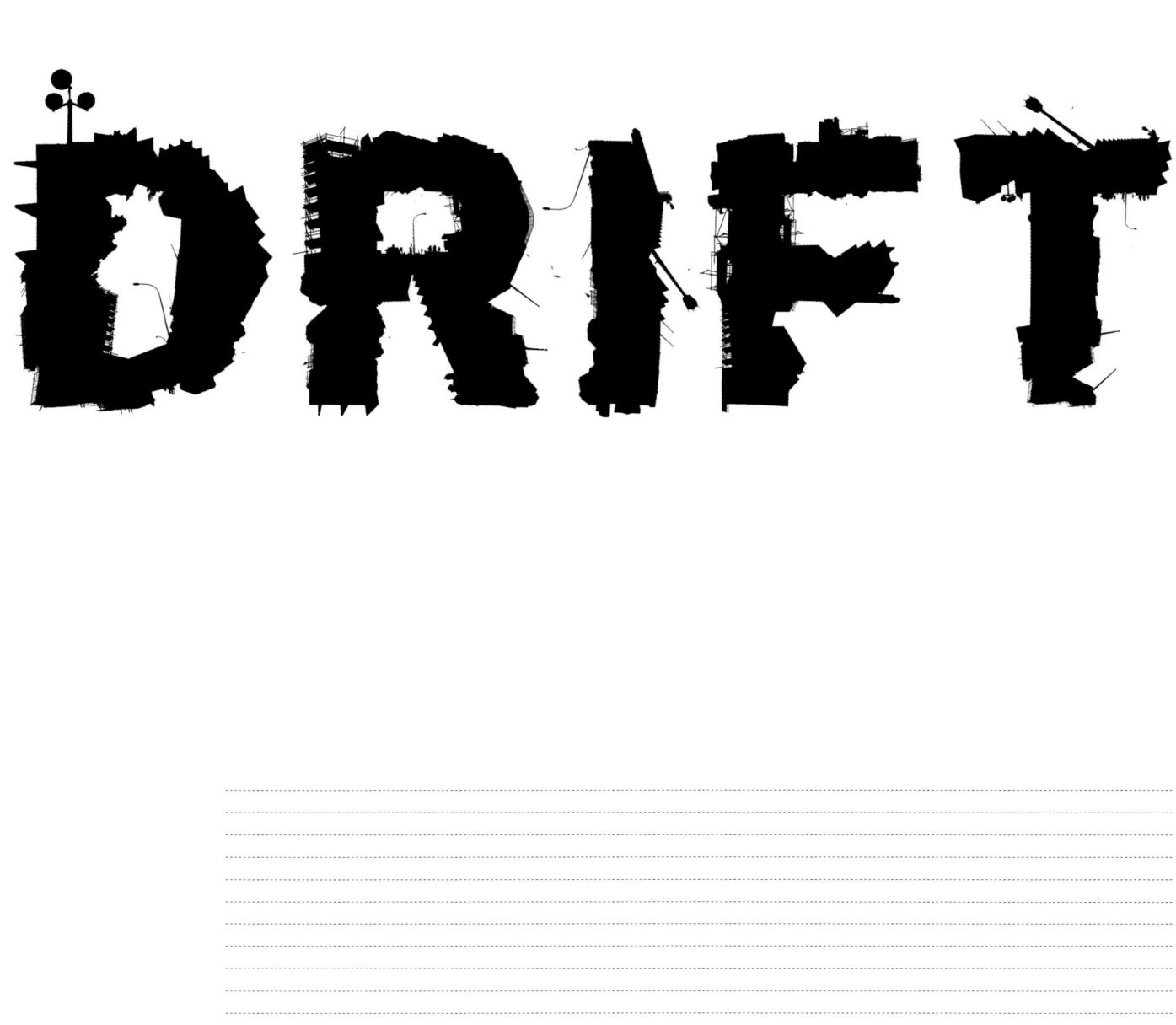

'Earring'

A typerface made of earrings. The designers use it for their own graphic identity.

T:Earring typeface D:Hjärta Smärta C:Hjärta Smärta W:Typeface L:English Y:2004

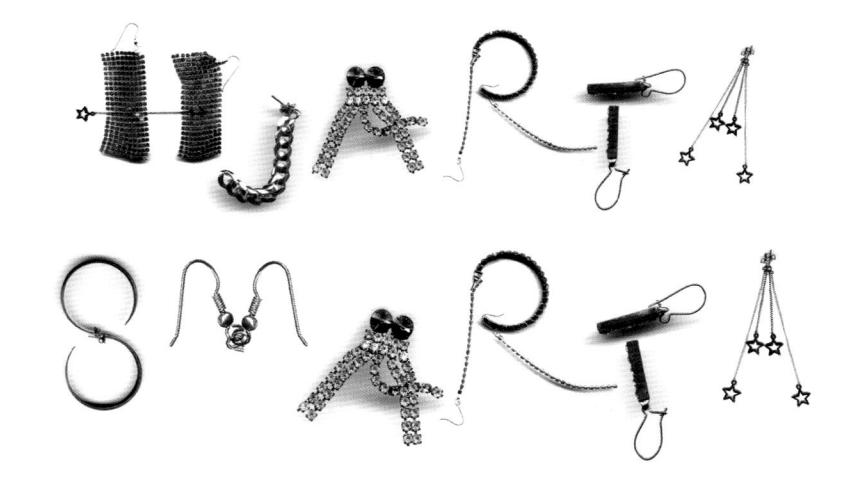

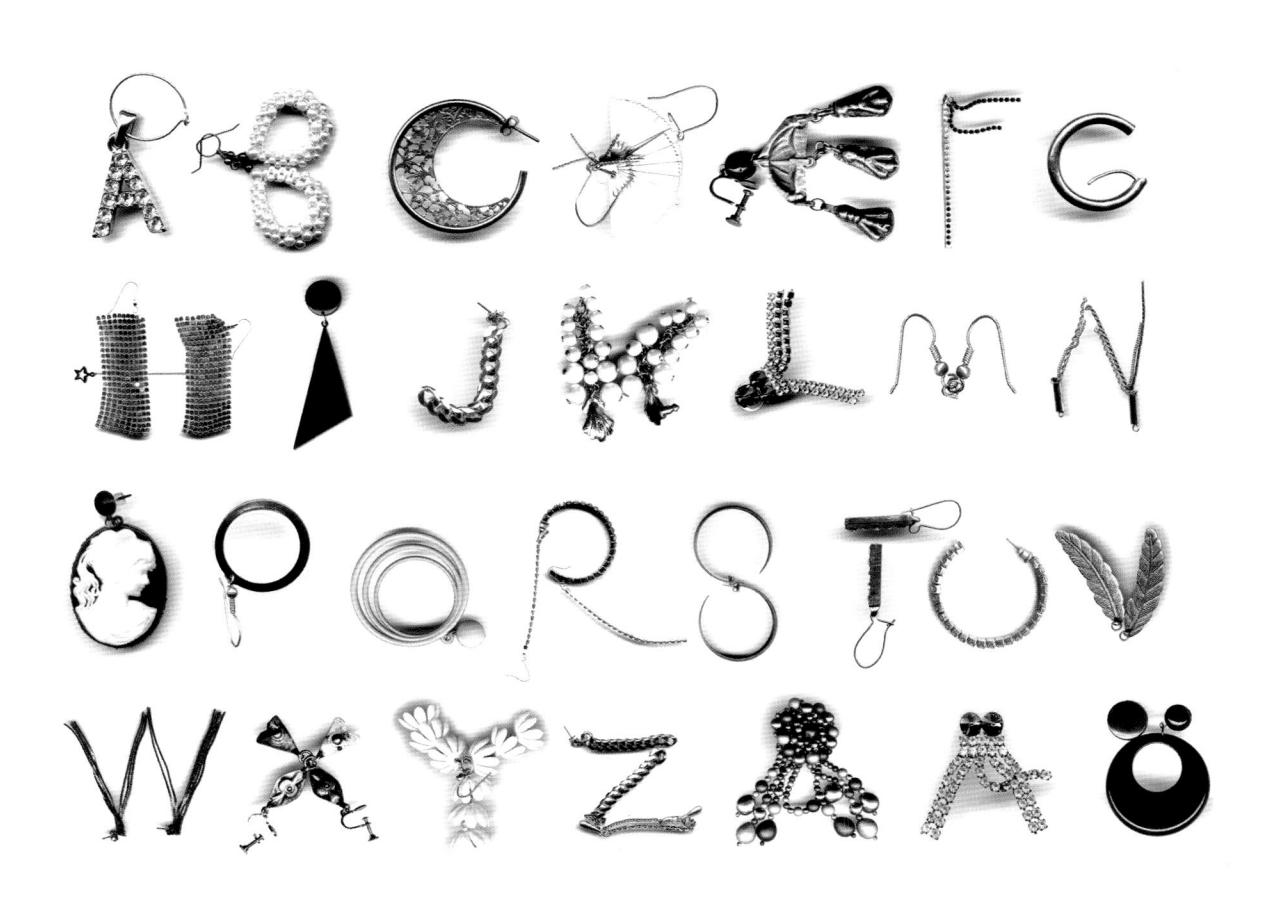

'Editorial'

1,2.Editorial work for Rojo magazine.

3-6.Editorial work for Bloodwars magazine.

- T:1.Design Is The Lie
 - 2.Gorilla
 - 3.Meat
 - 4.Amok
 - 5.Hustler
- 6.Danger Lurks
 D:{ths} Thomas Schostok Design
- C:1,2.Rojo Magazine
 - 3-6.Bloodwars
- Magazine
- W: Editorial
- L: English
- Y:1,2.2003
- 3-6.2006

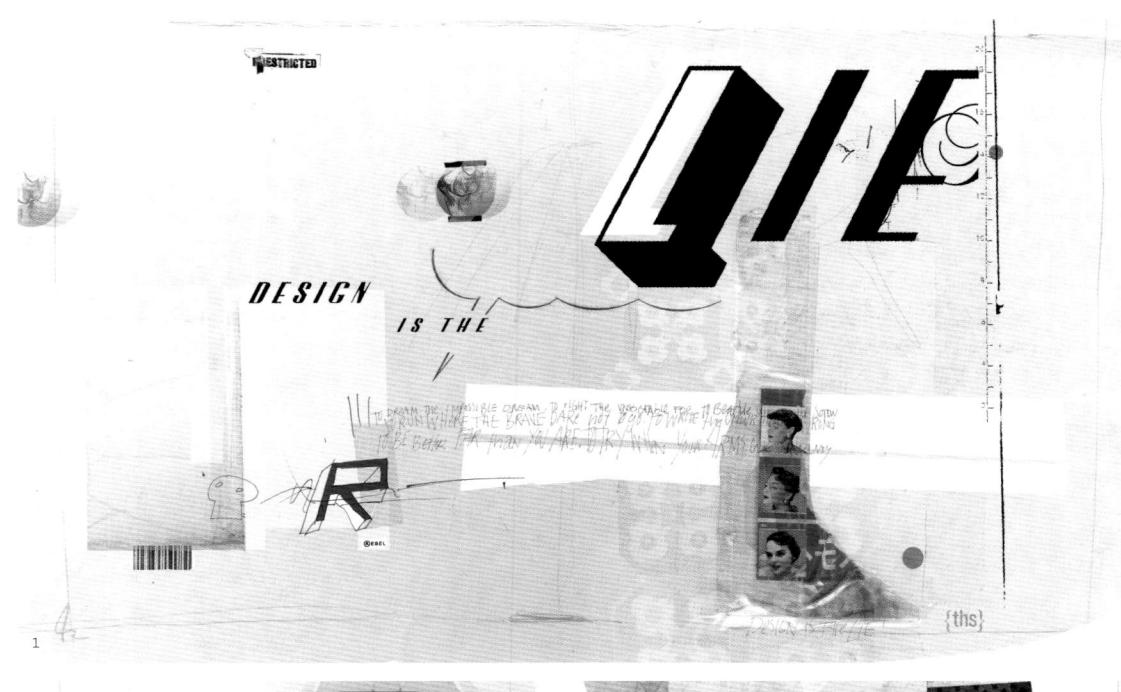

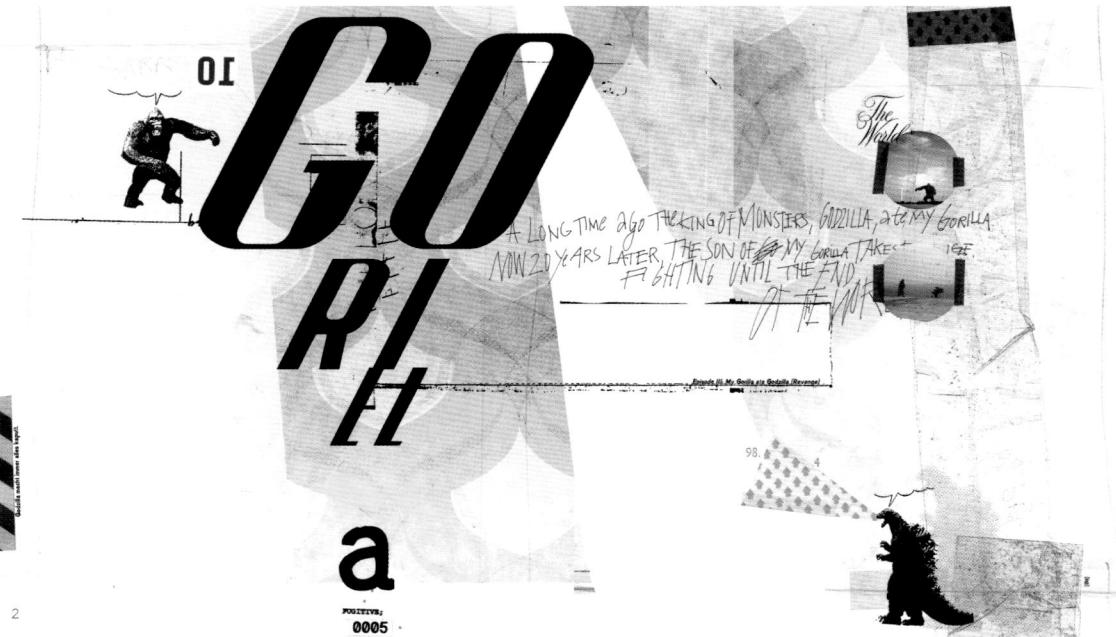

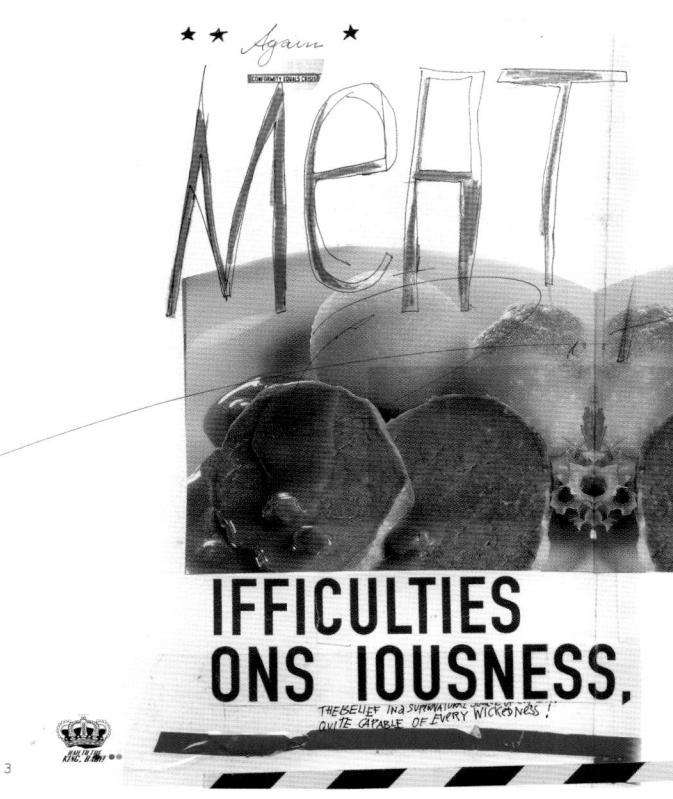

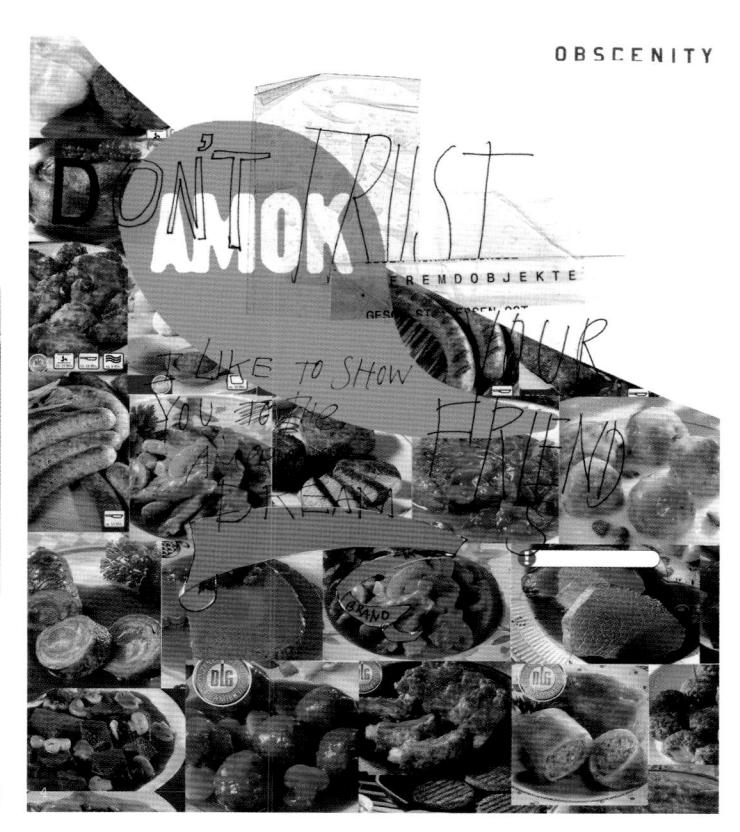

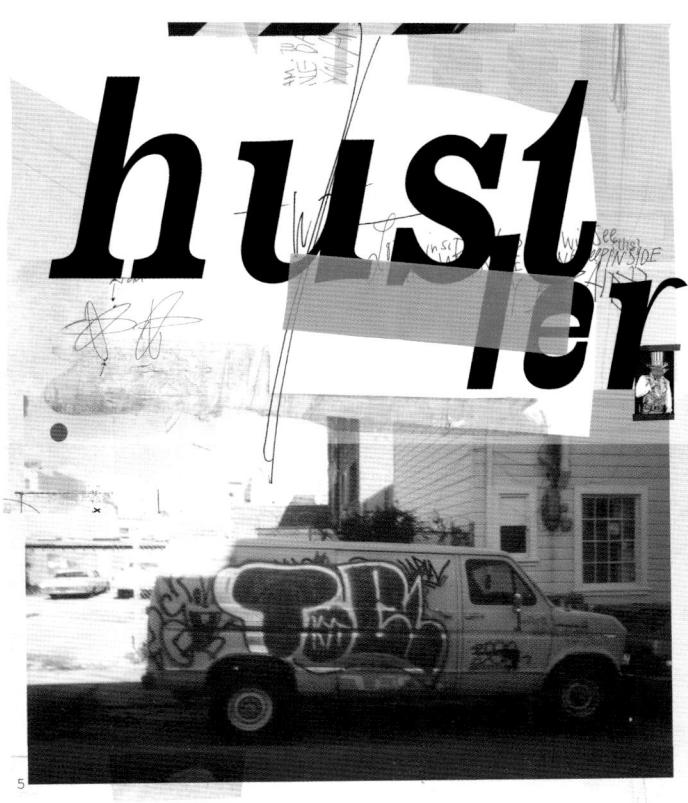

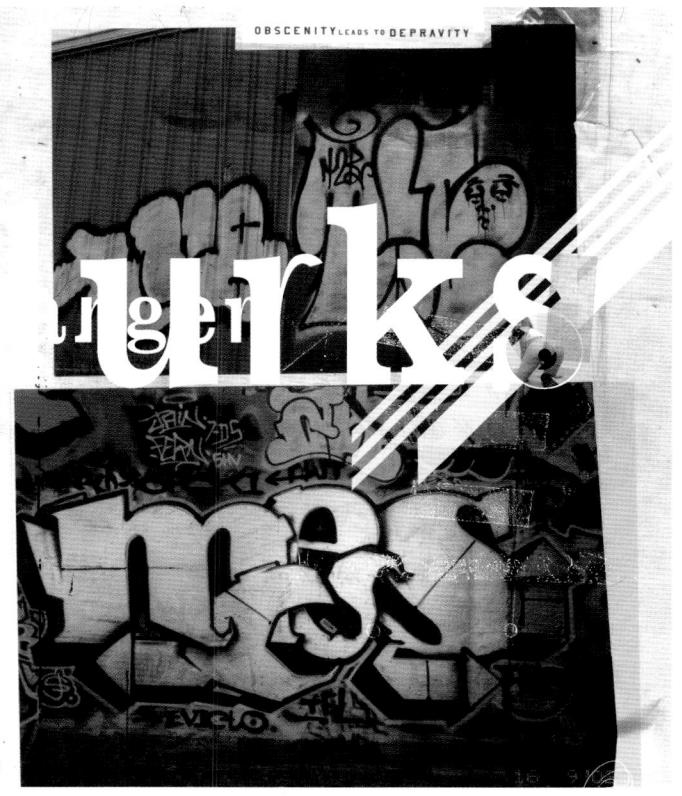

'Environment'

CO2 problem is a major problem for the ecology of the Earth. The typography on the wall surface expresses that CO2 problem and ecology are the same when it is viewed from a regular place. The typography is designed on the wall surface so as to materialize 2-dimensional typography in 3-dimensional space.

T:ECO2
D:KOKOKUMARU,Co Ltd.
C:Osaka University
of Art
W:Typeface - DIN
L:English
Y:2005

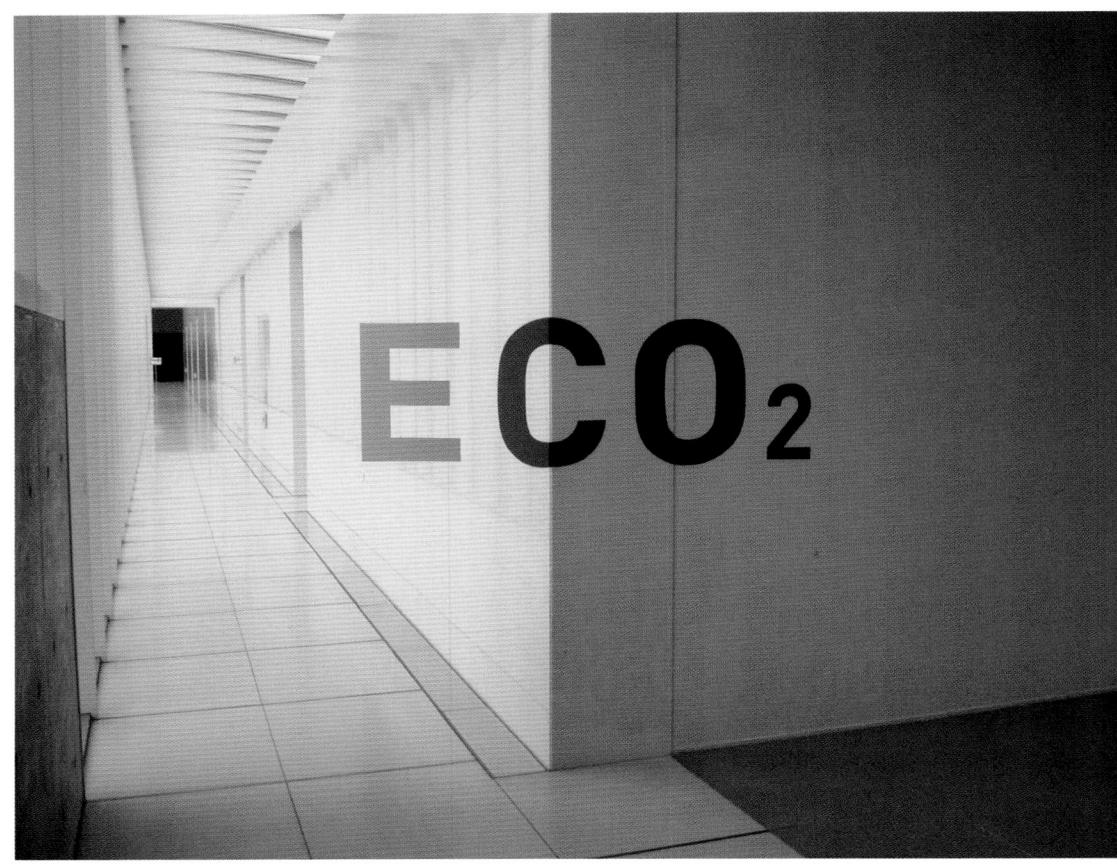

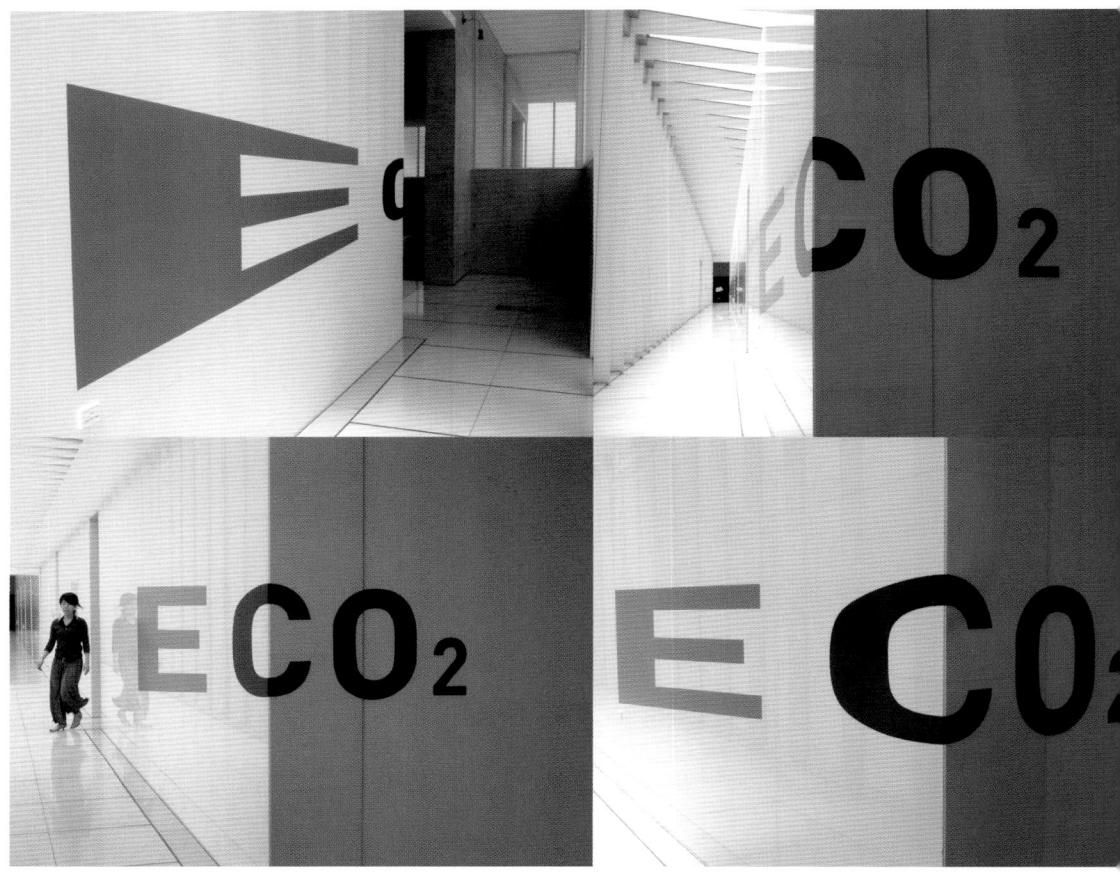

Market transfer a grant of the second of the

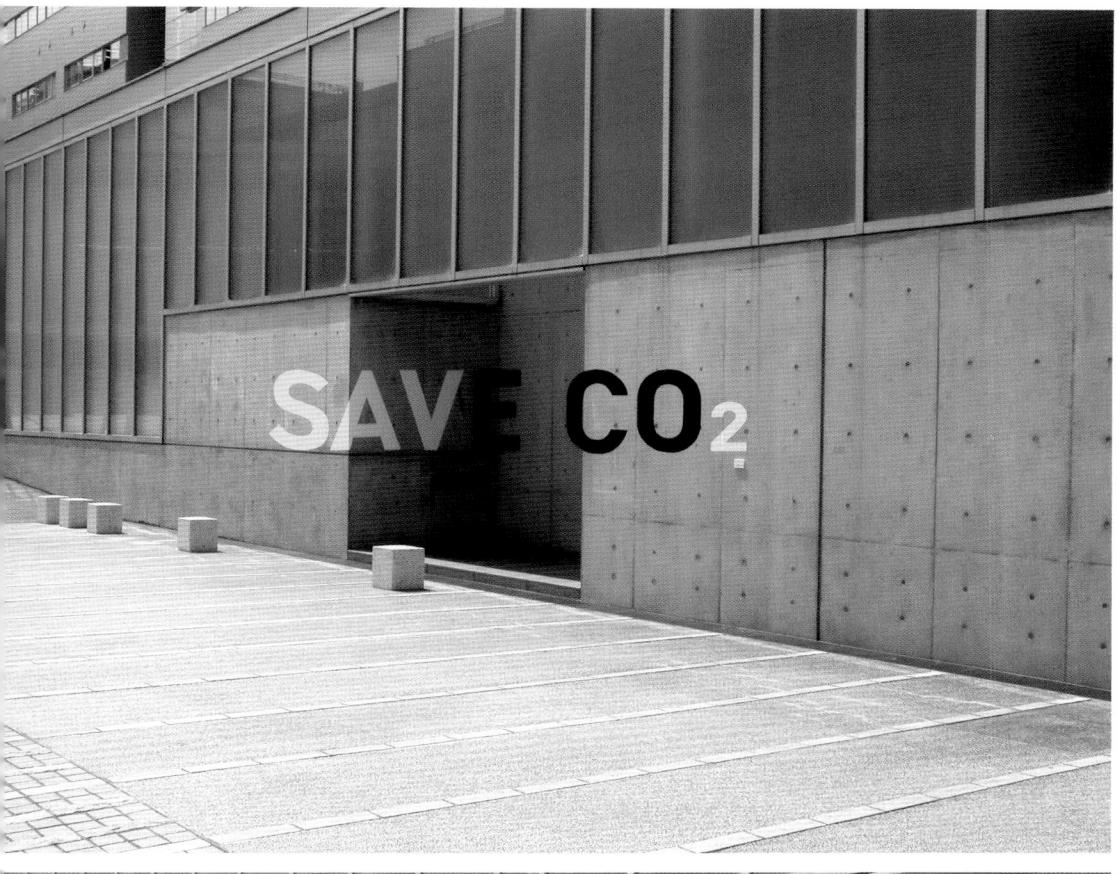

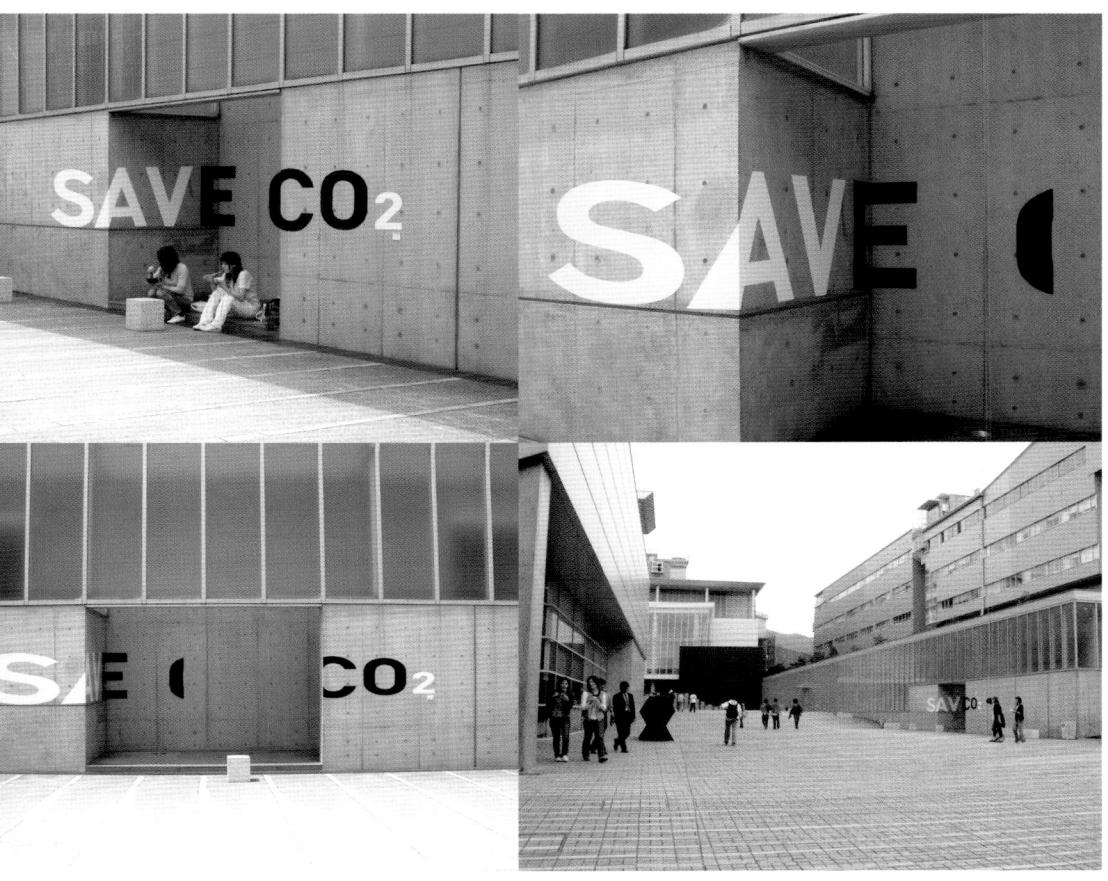

'Etymology'

Self-initiated typographic poster celebrating the etymology and form of the ampersand.

T: &
D: Conor & David
C: Conor & David
W: Installation, Poster
L: English, Gaeilge
Y: 2006

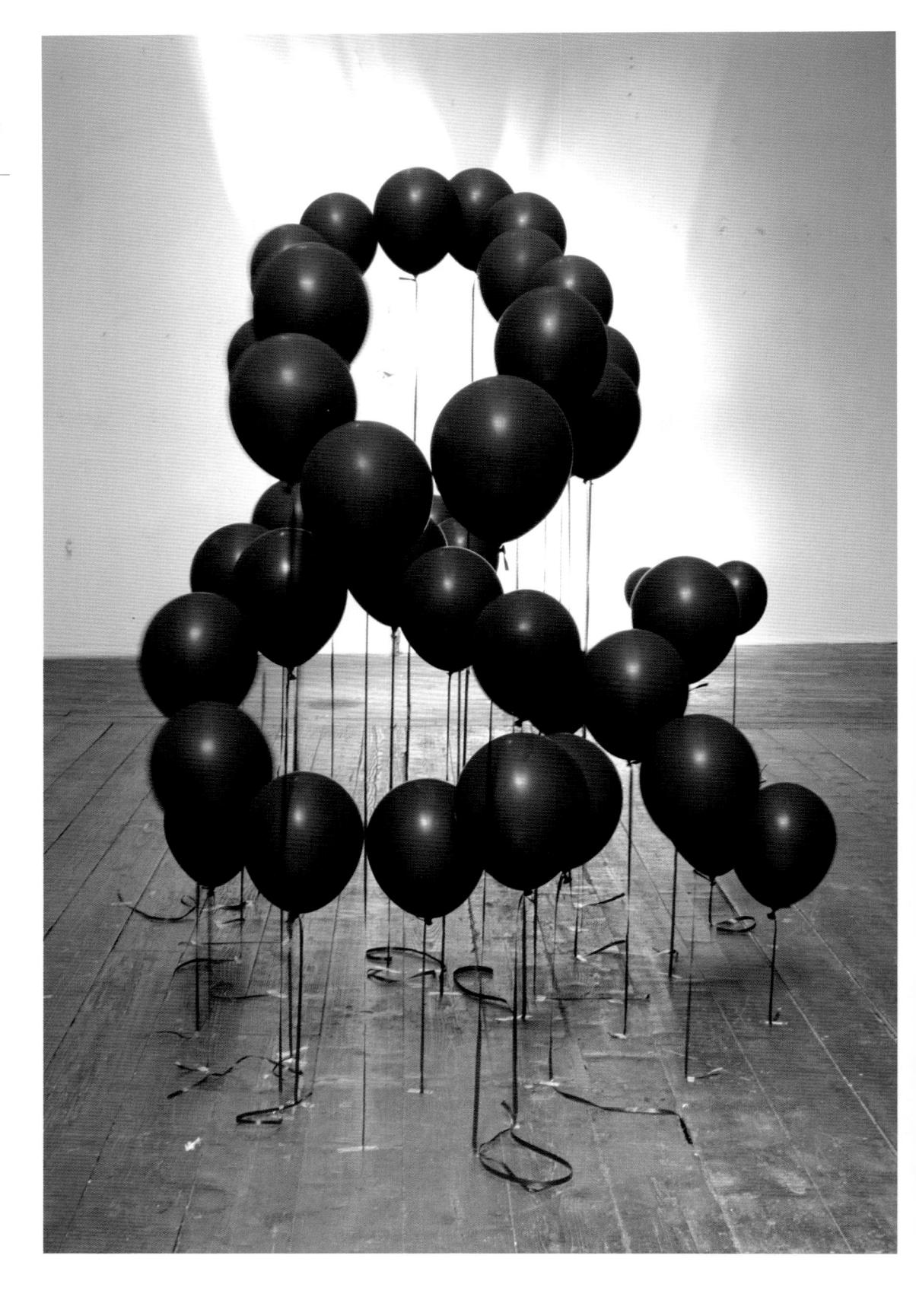

'Eyes'

This shirt design functions as both an abstract geometric pattern as well as clever cultural reference, thanks to the fragmented nature of the typeface. The phrase reads 'Les Yeux Sans Visage' which means 'Eyes Without A Face' in French, a reference to both the classic film of the same name and the Billy Idol song which followed. More directly, the phrase extends from the concept of the type 'face' which is purposefully incomplete, mirroring the 'face' in the phrase.

T:Eyes Without A Face D:Wyeth Hansen C:2K By Gingham W:T-shirt graphic L:English, French Y:2006

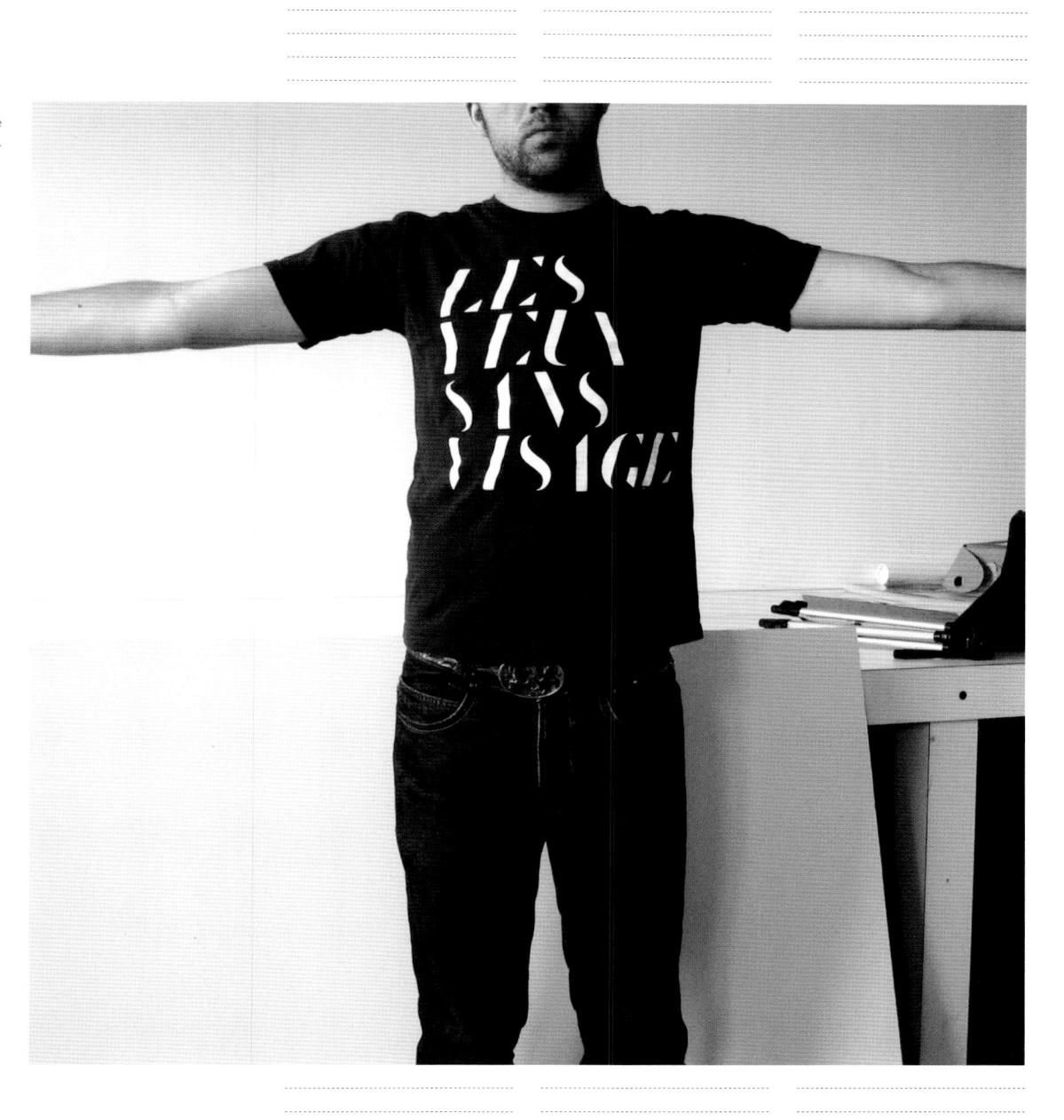

'Fadar'

A typographic interpretation of the lyrics for 'Where Are They Now' by Nas.

T:Where Are They Now? D:Non-Format C:The Fader W:Editorial L:English Y:2006

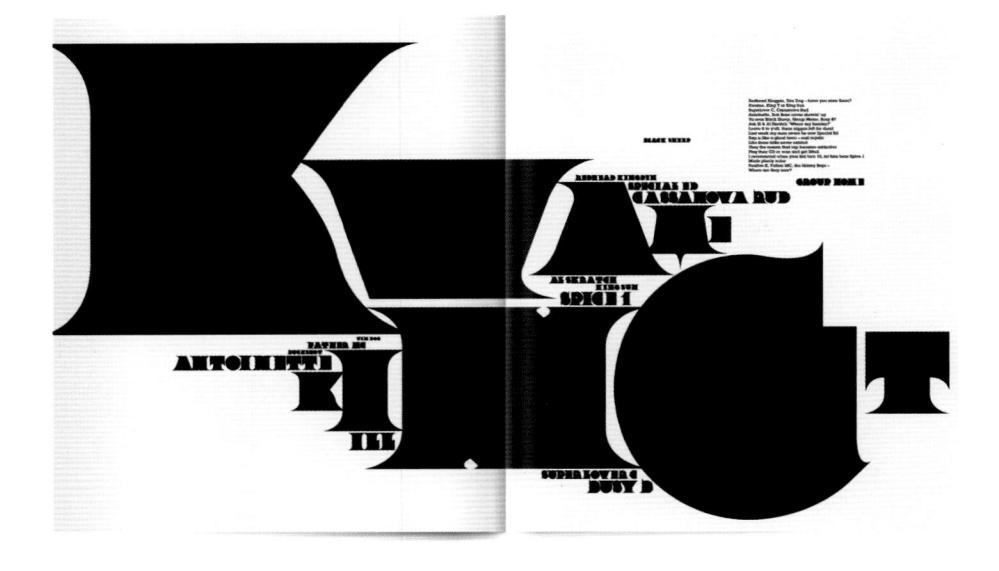

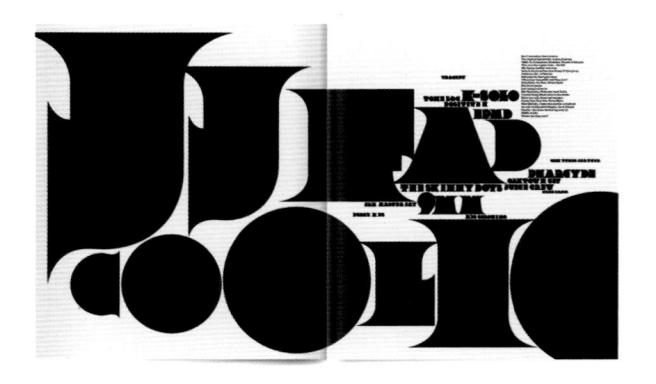

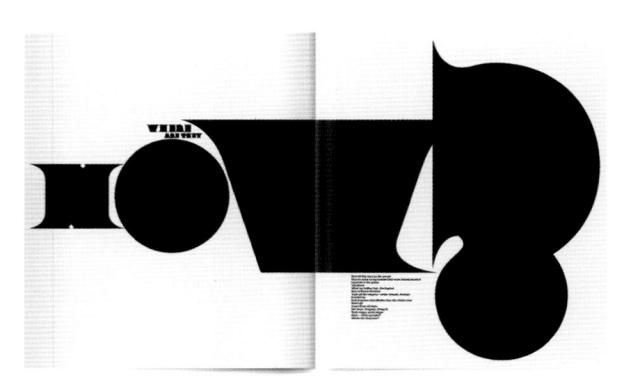

'Felt-tip'

Hand drawn poster for Grafik Magazine's Felt-Tip exhibition.

T:I Did Mediocre Stuff
While You Were Still
At School
D:Non-Format
C:Letraset, Grafik
Magazine
W:Poster
L:English
Y:2006

'Festival'

Safe As Milk is an annual festival for experimental music. In 2007 the designers used tools as a reference to proletarian propaganda iconography, in an effort to establish a connection to Bfilm horror movies and mysticism. These imagery stems from the obscure notion of Safe As Milk as a developing 'state within a state.' As the one in 2006 referred to currency, the designers revolves around ideology and state religion in 2007.

T:Safe As Milk #9 D:Grandpeople P:Magne Sandnes C:Safe as Milk Festival W:Promotion Y:2007

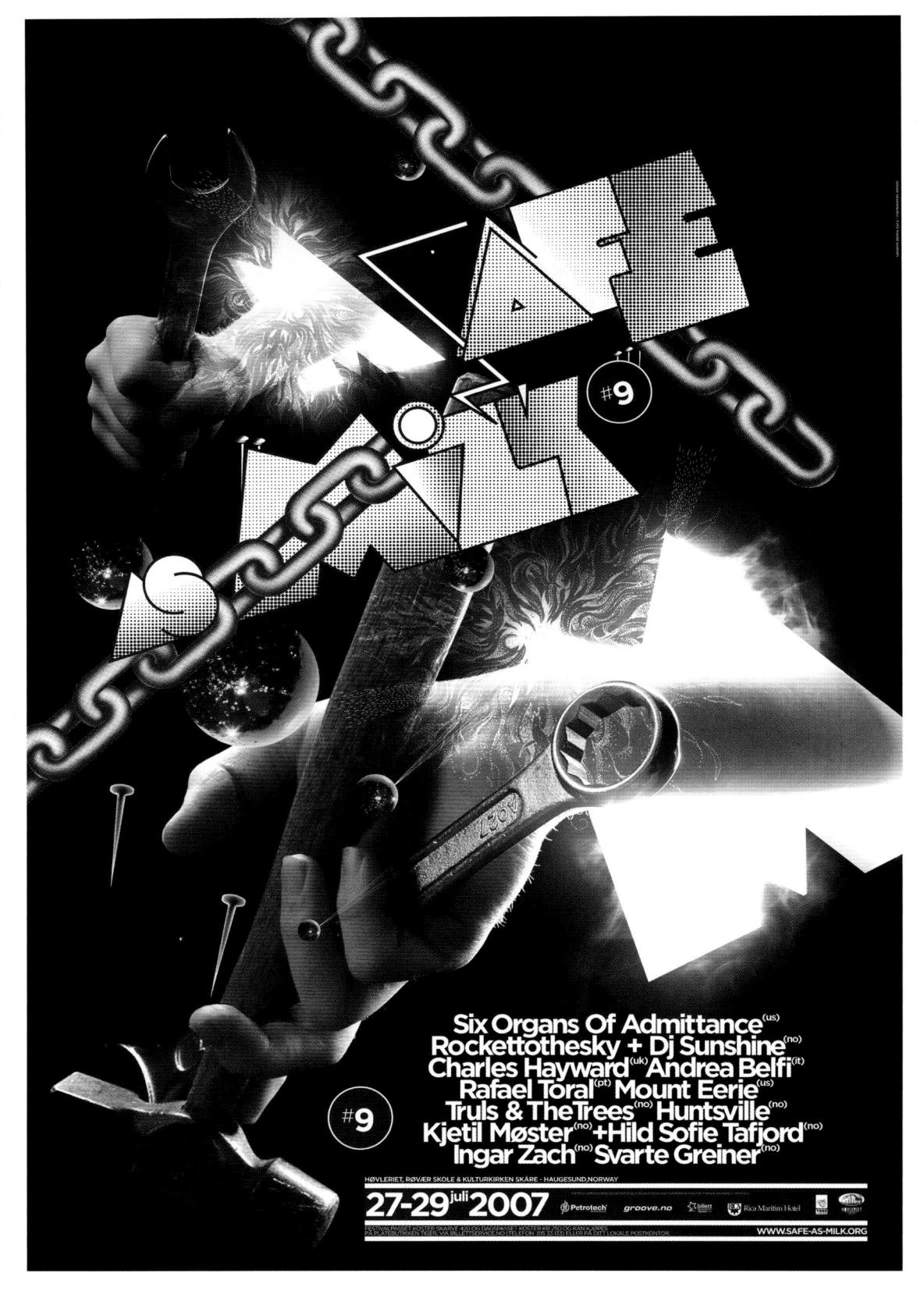

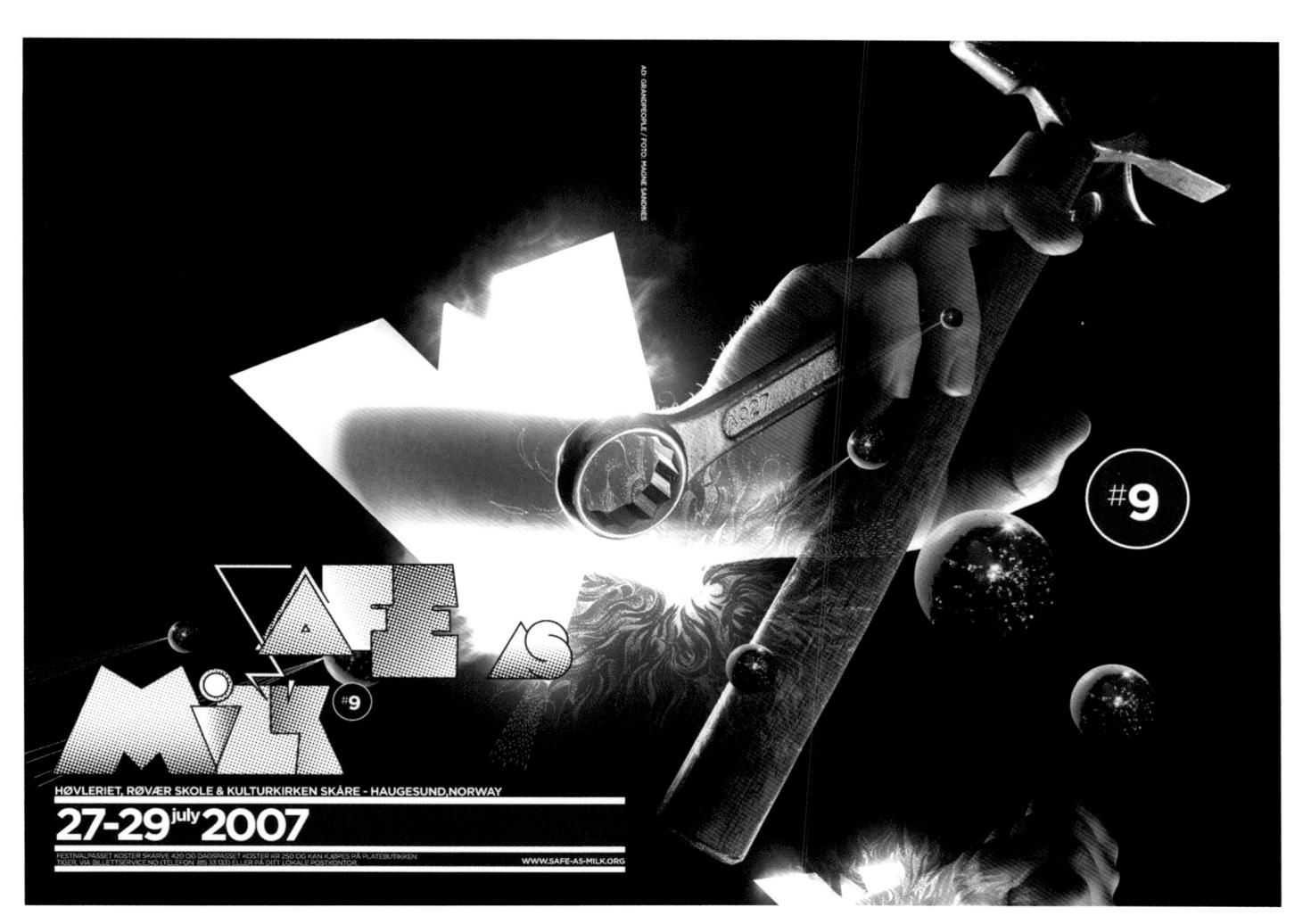

'Fifty'

A poster for a Swiss poster contest, concerning the 50th anniversary of the Swiss font Helvetica. For the designer, Helvetica is not bad and also not good. In German speaking countries, '0815' means standard or regular, it is not really top stuff.

T:50 0815 D:gggrafik C:gggrafik W:Poster L:German Y:2007

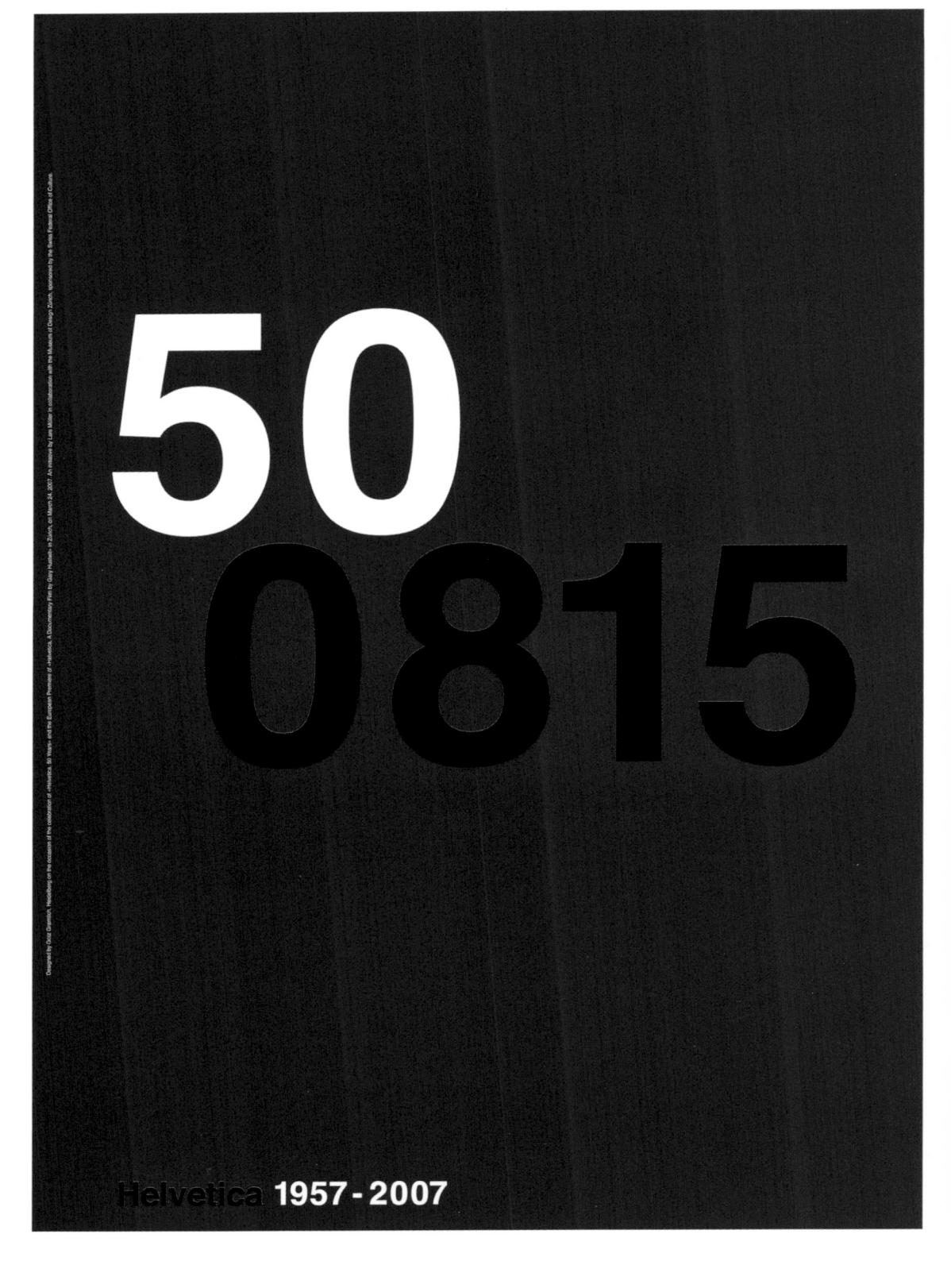

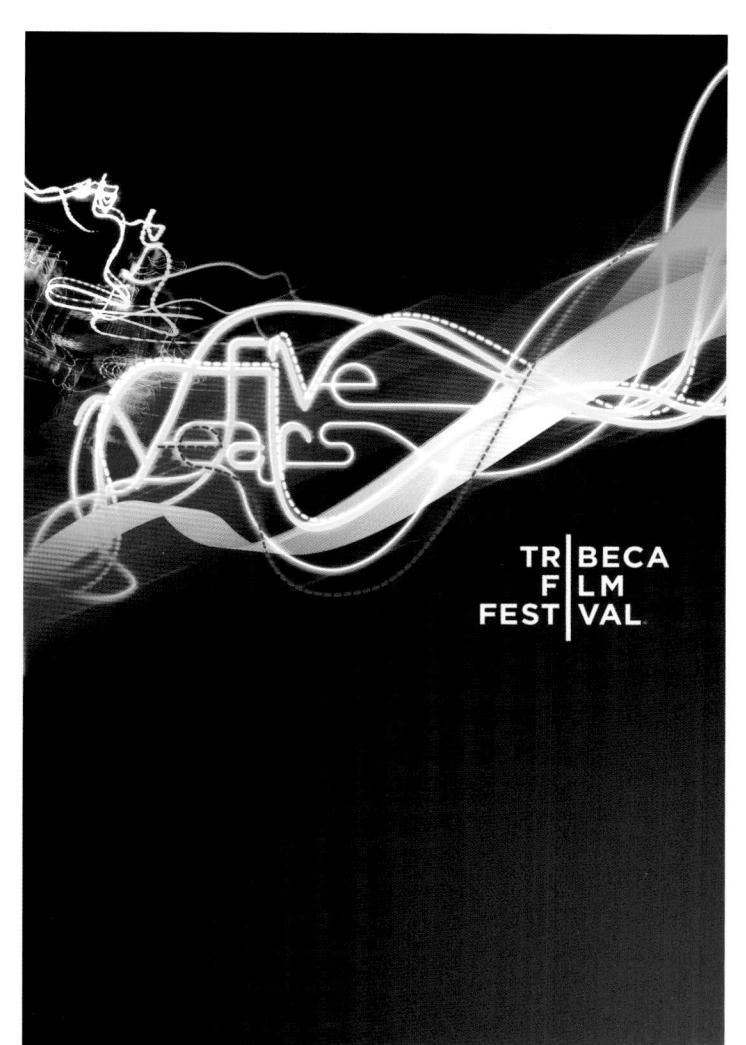

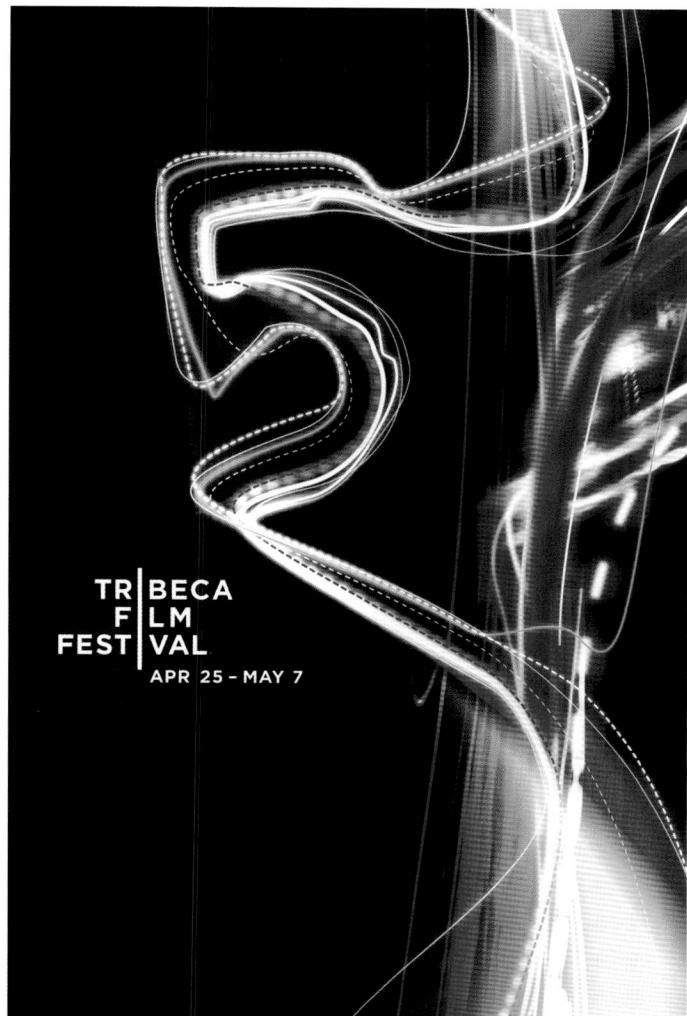

'Film'

Proposed visual identity, posters, and banners celebrating the 5th anniversary of the Tribeca Film Festival in New York City.

T:Tribeca Film Festival
5th Anniversary
(Unused)
D:Apirat Infahsaeng
C:Tribeca Film Festival
W:Visual identity,
Poster, Banner
L:English
Y:2006

'Folklore'

AOI's new magazine
'Varoom' was launched
on the 11th of May with
a party and exhibition
in London. Among Ed
Fella, Genevieve
Gauckler and others,
Grandpeople contributed
with 2 custom-made
posters for this event.
The posters have forms
taken from Norwegian
nature and folklore.

T: Grandpeople's Typography Troll D: Grandpeople C: AOI, Varoom Magazine, Grandpeople W: Poster Y: 2006

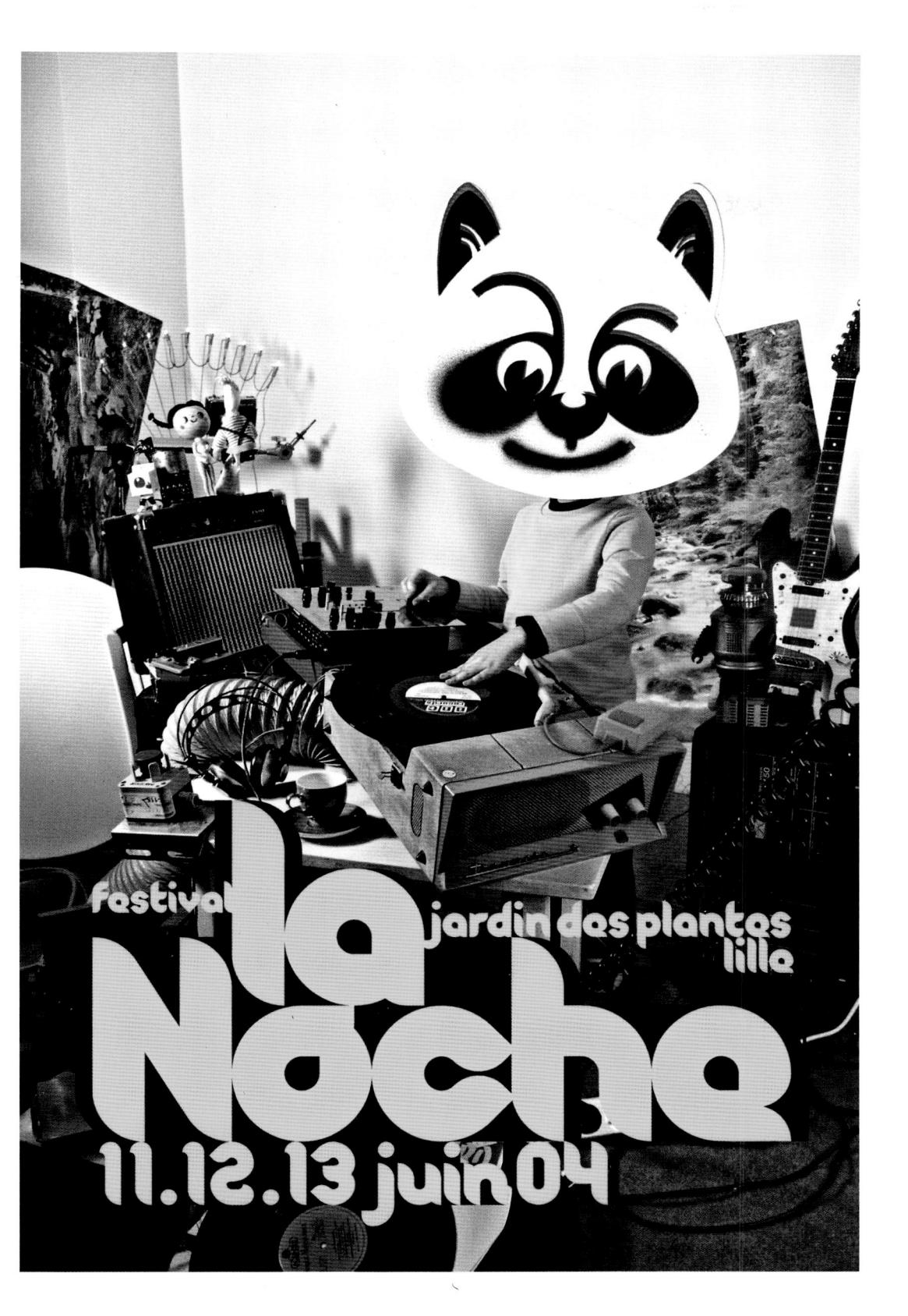

'French'

Poster and visual identity for La Noche Music Festival 2004.

T:La Noche
D:Atelier télescopique
C:RIF Association
W:Poster
L:French
Y:2004

'Freezer'

In summer, the Freezer DJ sets were spread out over 3 days, so a 3-dimensional typography solution transmitted this idea clearly: Freezer Starts, Freezer Fresh and Freezer Finale! were represented by a huge type block based on the Avantgarde font.

T:Triple Freeze D:Serial Cut™ C:Freezer Morning Club W:3D typeface L:English Y:2006

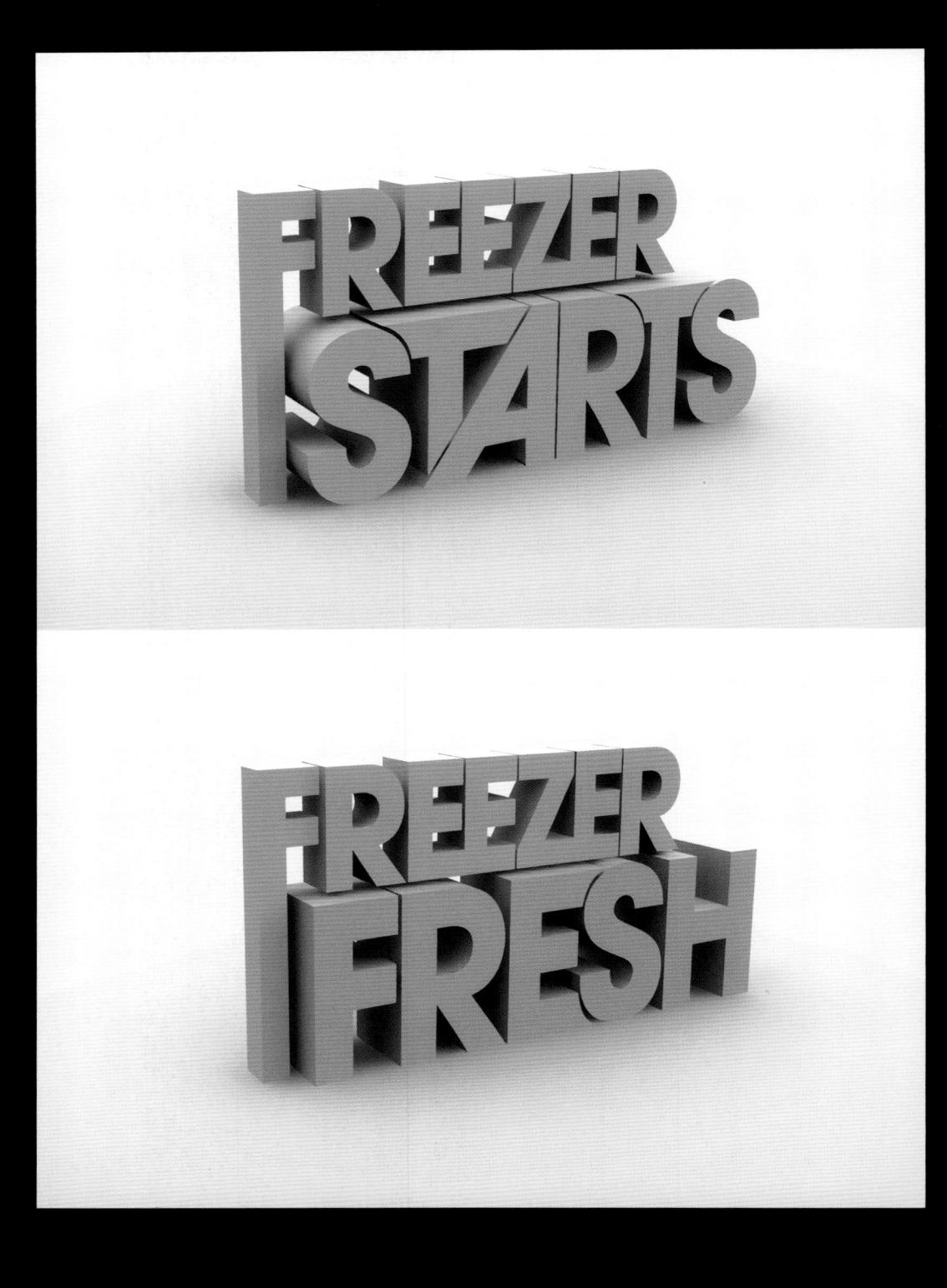

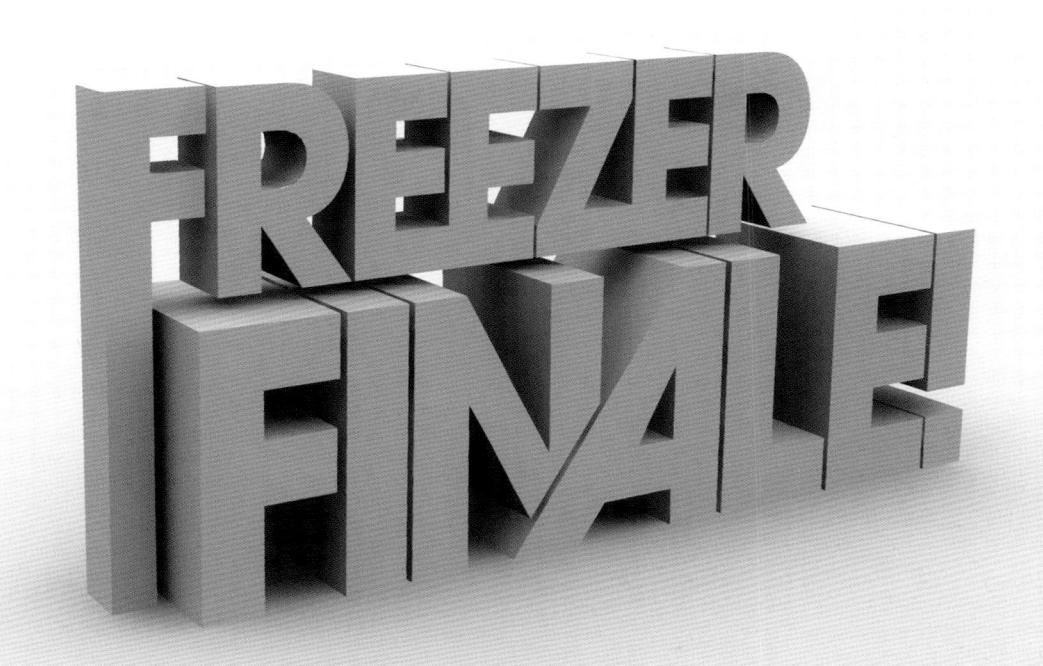

'Funky'

This is a promotional poster for a US street fashion store based in Hong Kong. Milkxhake took a funky and bold approach and developed a tailor-made typeface as the key visual for the launching poster.

T: The Studio by Pro Wolf Master D: Milkxhake C: The Studio by Pro Wolf Master W: Poster L: English Y: 2006

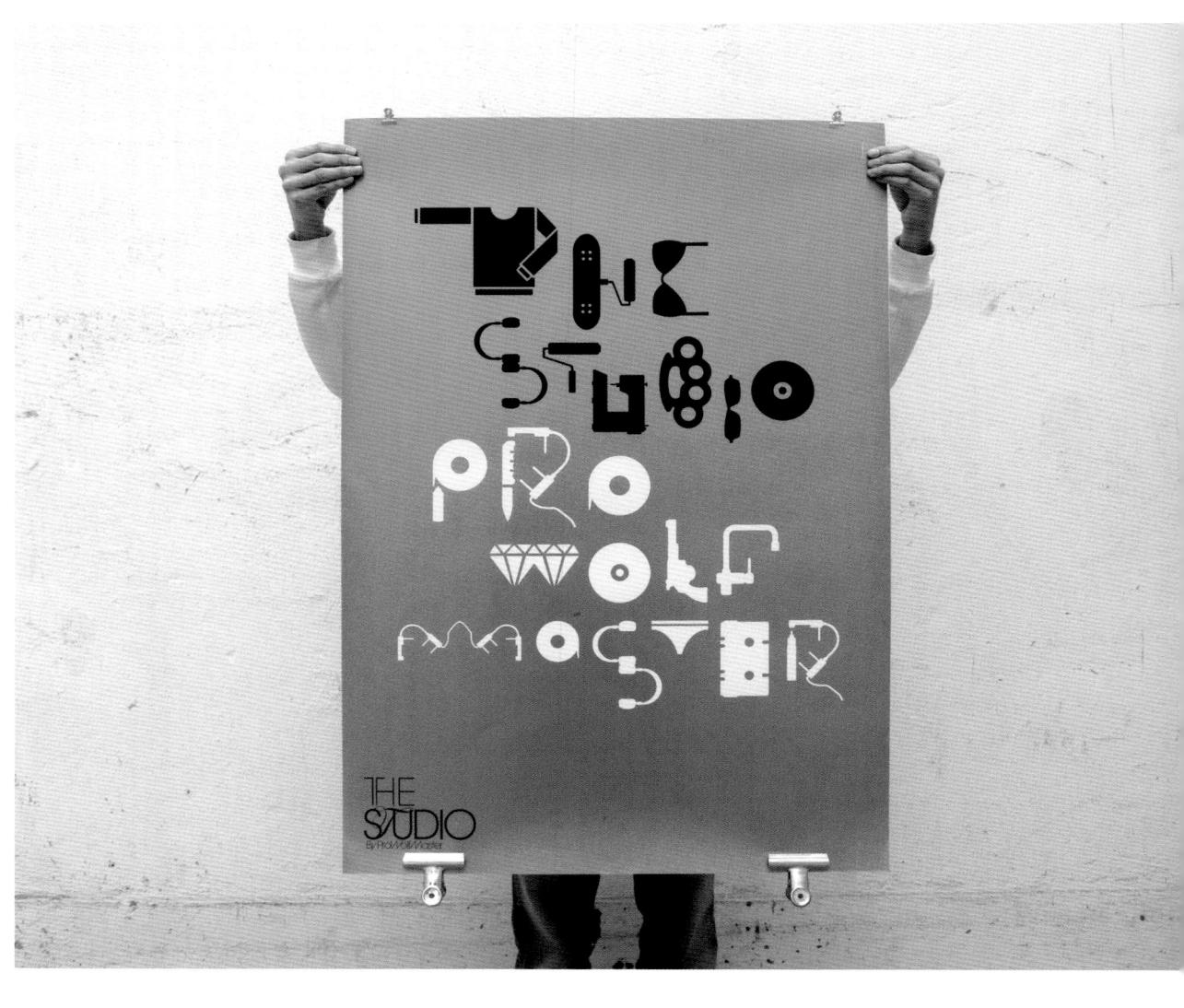

'Fuss'

Non-Format's 2006 exhibition 'Make A Fuss' at Vallery Gallery, Barcelona, Spain.

T:Make A Fuss D:Non-Format C:Vallery Gallery W:Poster L:English Y:2006

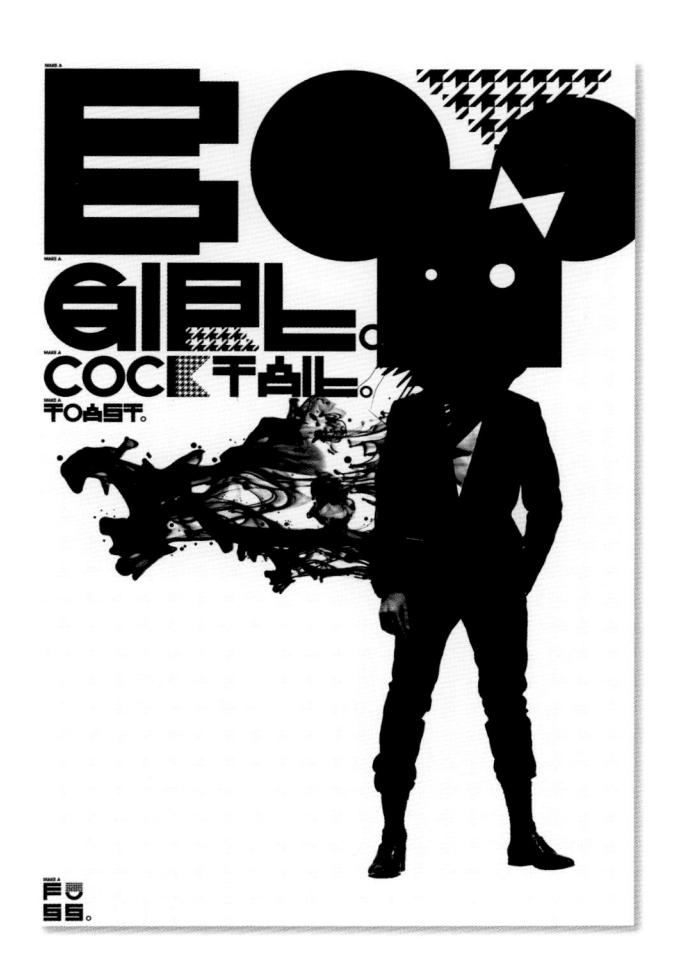

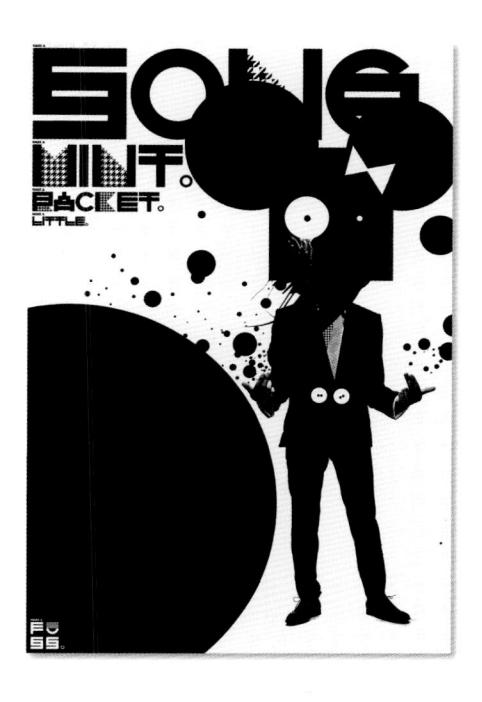

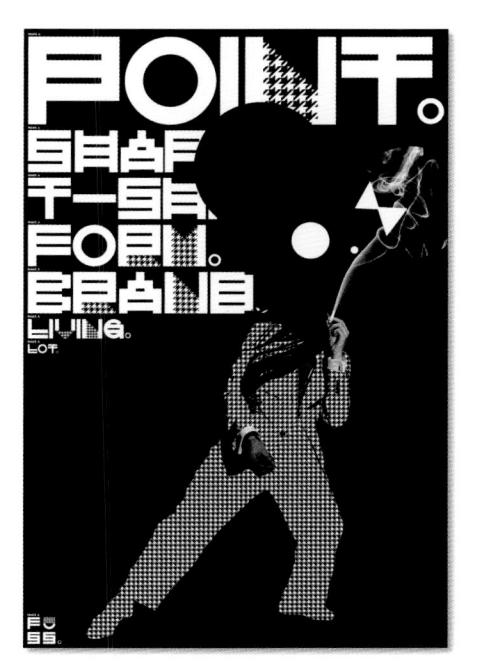

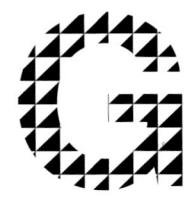

'G'

Designer's drawing on the letter G.

T: The Letter G D: Michael Perry C: Michael Perry W: 3D typeface L: English Y: 2006

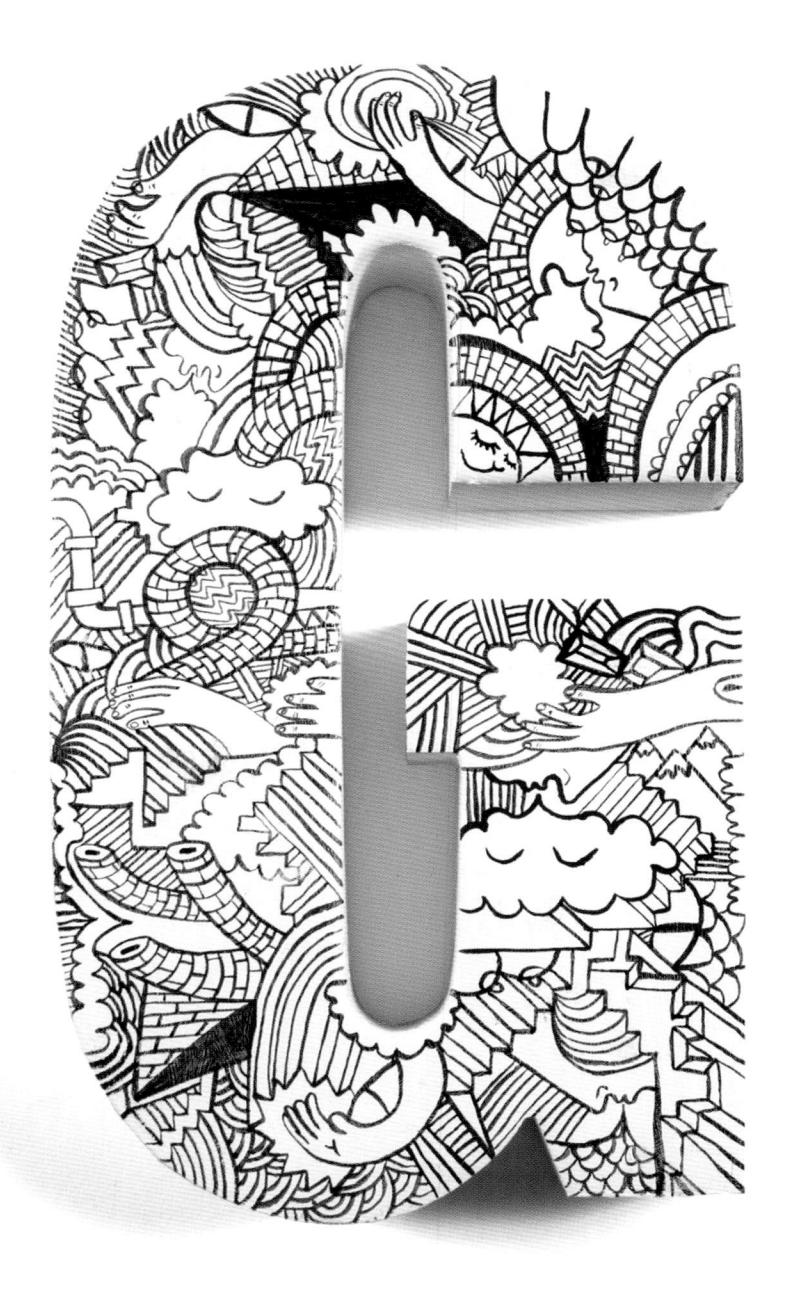

'Game'

A collection of 8 hand-painted ceramic dishes for the book and exhibition 'Game Paused: A Creative Celebration of the Videogame.' For a project on this theme you could imagine pixels, LED screens and joysticks, but this aesthetic can also be represented in more organic ways. Pac-Man, Mario Bros, Donkey Kong, PaperBoy, Bubble Bobble and Sonic. The dishes can be used as collector pieces. Vector based first, hand-painted after, the Retro Game Icons are the traditional vision of the most memorable heroes.

T:Retro Game Icons D:Serial Cut^m C:Game Paused W:Ceramic

L: English

Y:2006

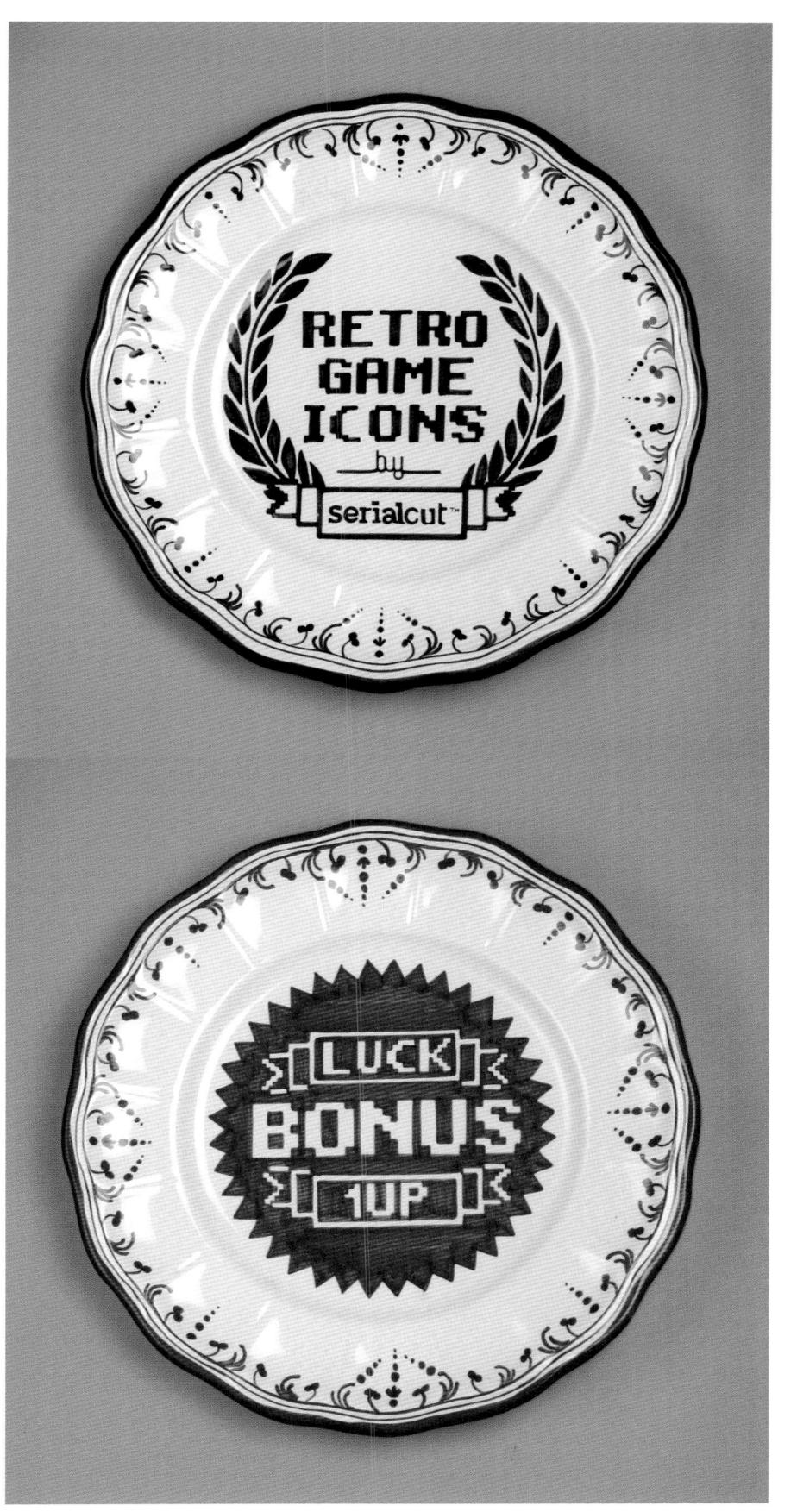

'Gold'

The client wanted the designers to focus on money for the festival, so they used currency as a thematic approach for the visual profile. Amongst the promotion material was a single colour bank note with gold folio embossment to ensure authenticity. The visual profile derived from a mixture of Egyptology and psychedelic.

T:Safe as Milk #8 D:Grandpeople C:Safe as Milk Festival W:Promotion Y:2006

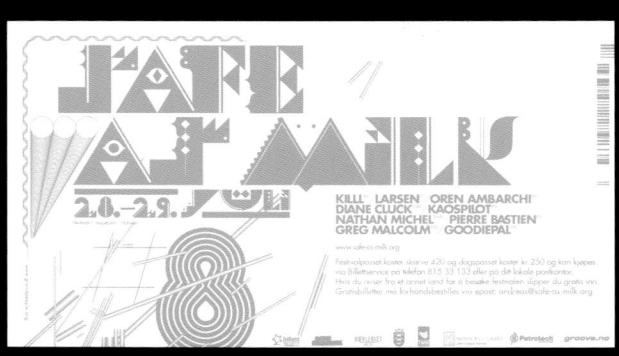

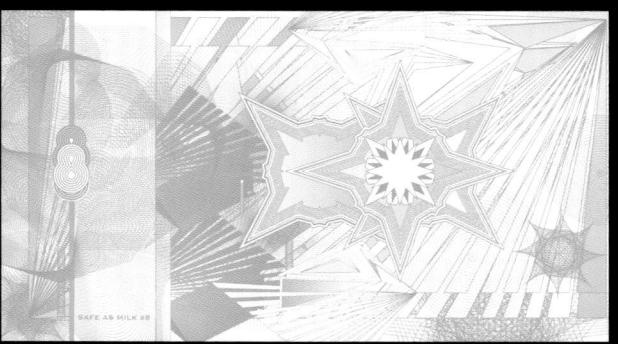

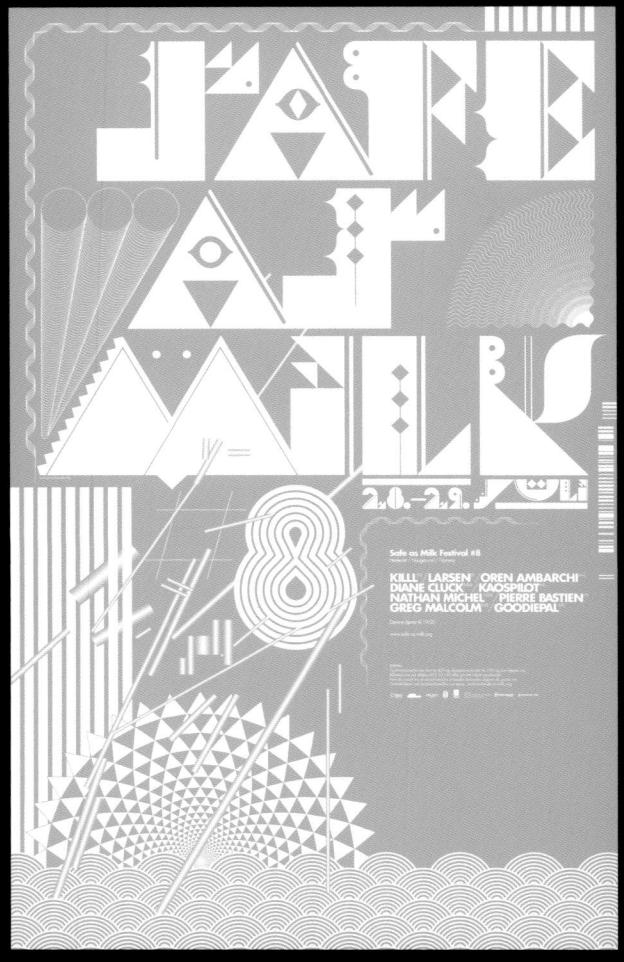

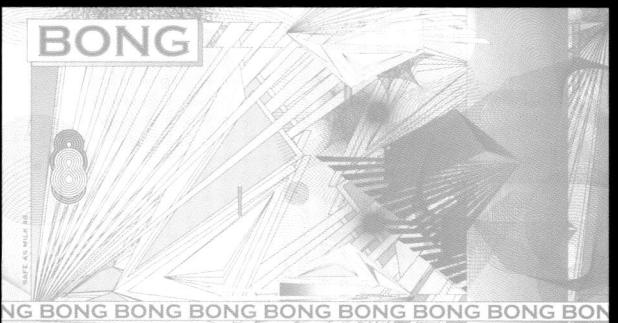

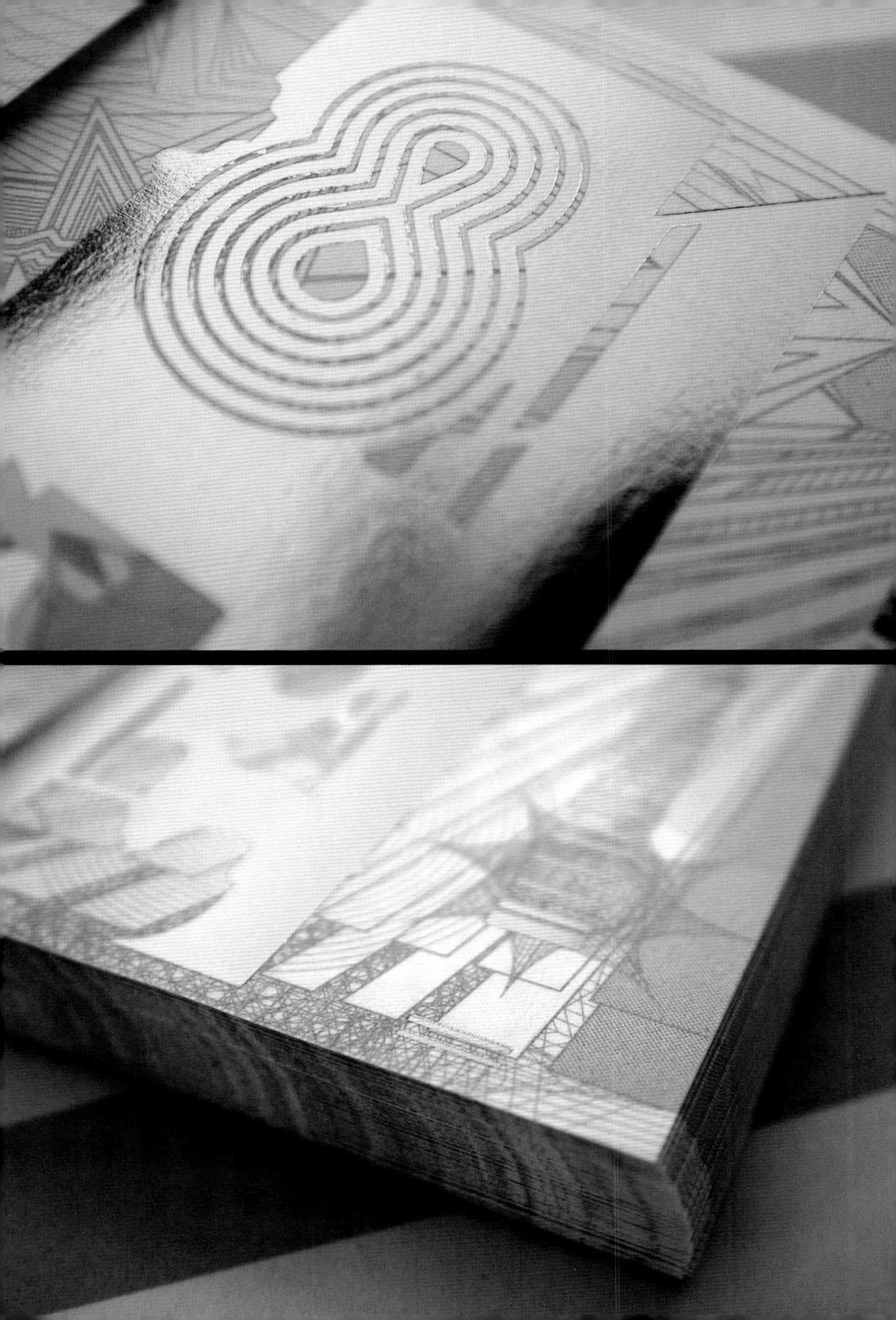

'Grab'

The initial idea for 'Grab-Me' came from studying the design of stencil letters. This developed into a 3-dimensional (lowrelief) version that kept the breaks/support bars needed in a paper stencil. The breaks in a stencil design adhere almost perfectly made for the wall brackets needed in bathroom grab bars. The finished handrails are intended to make for the use in swimming pools or bathrooms.

T:Grab-Me
D:Andrew Byrom
C:Andrew Byrom
W:3D typeface,
Hand-rail design
L:English
Y:2006

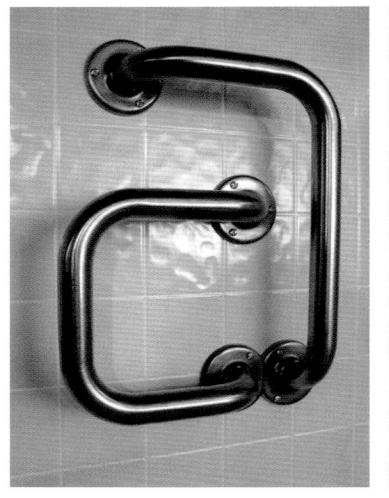

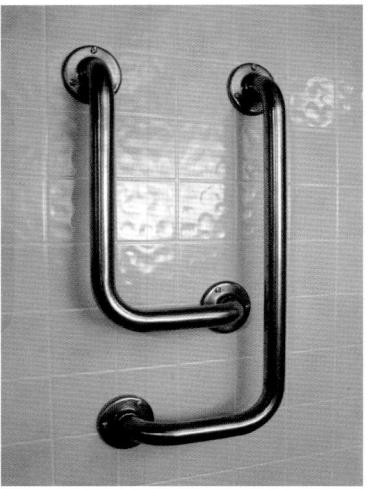

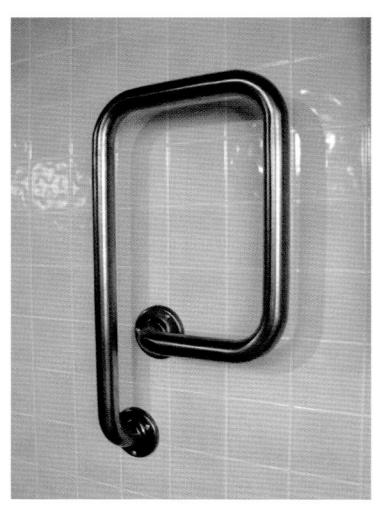

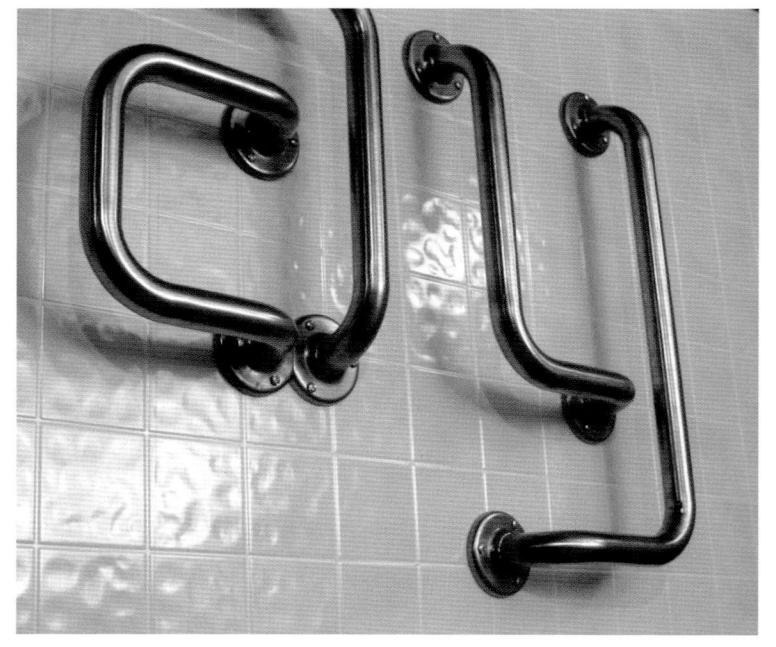

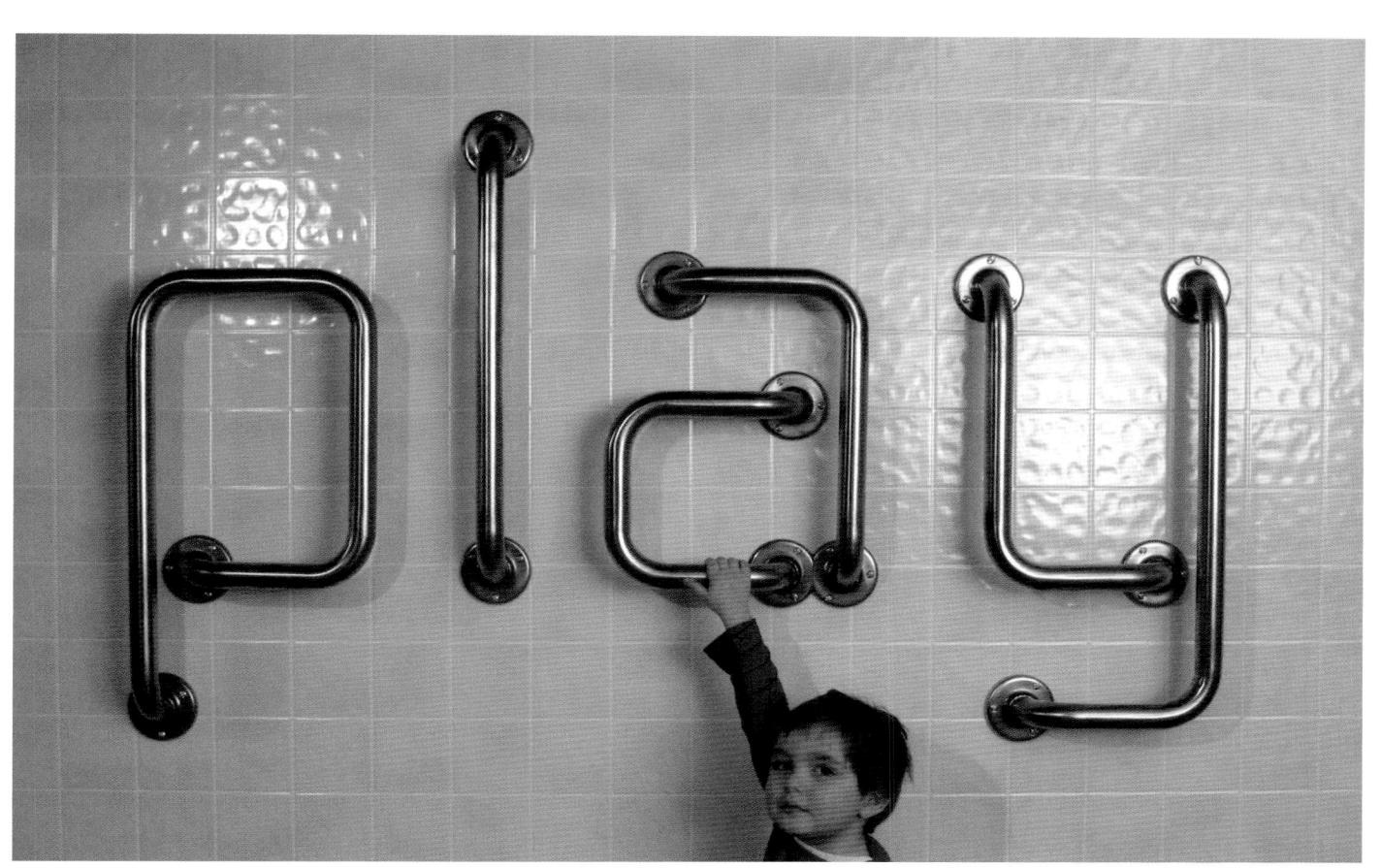

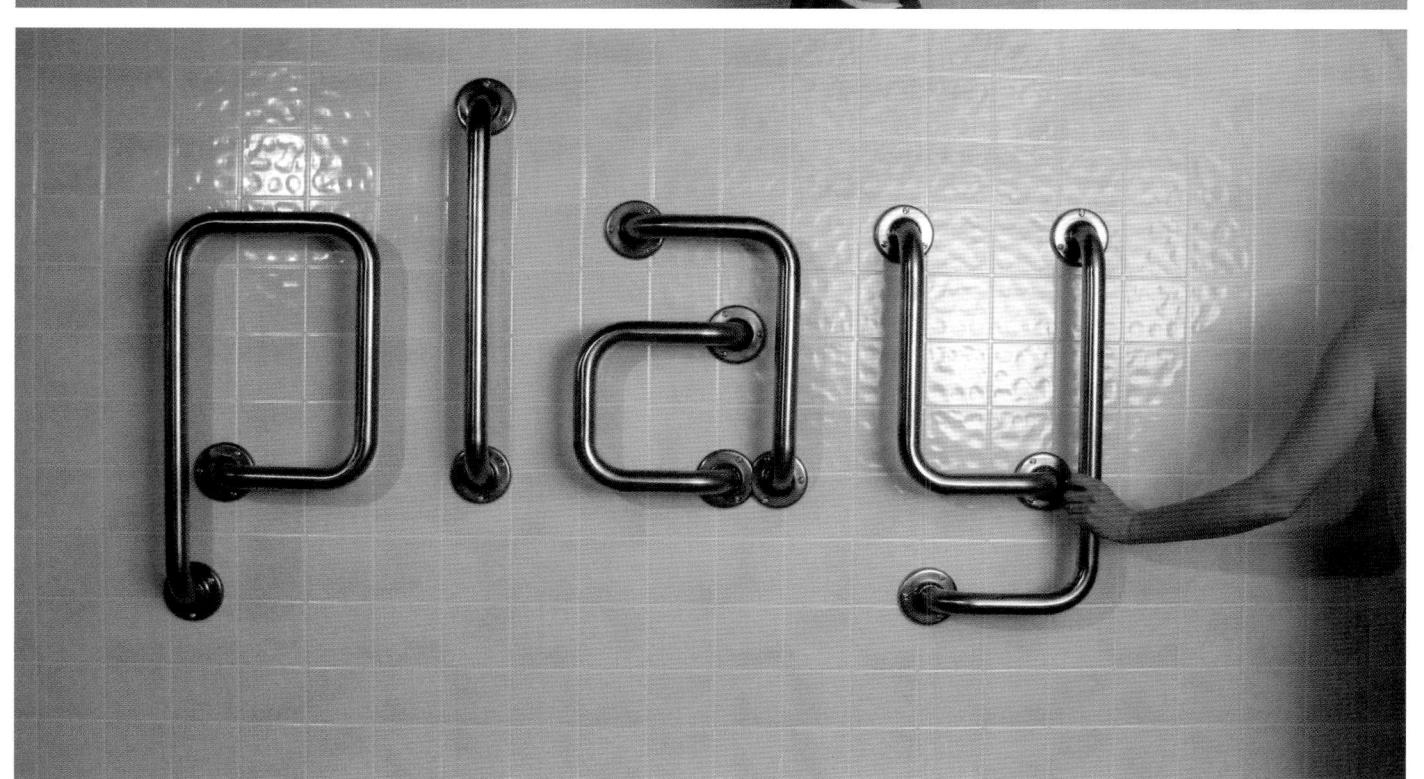

'Graduate'

Catalogue designed for the Fashion & Textiles graduates at the University of Brighton.

T:Fashion & Textiles Catalogue D:Will Perrens C:University of Brighton Fashion &

Textiles Graduates

W:Brochure design L:English Y:2006

2006

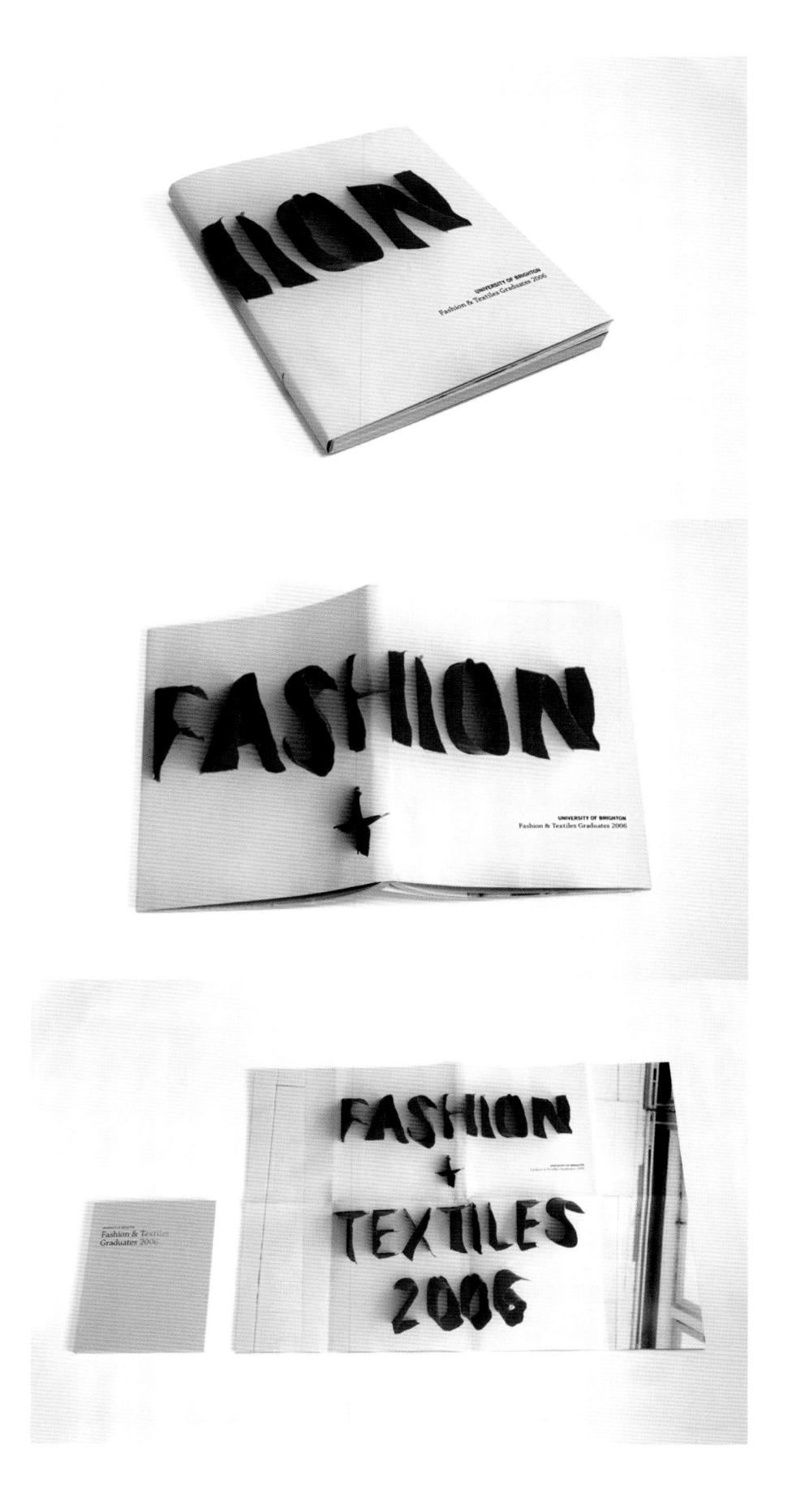

FASHION FEXTILES 2008

'Grid'

Mind block was created from an old pscocanalytical block game. There are 6 elements that can be used to create patterns. After some experiments the designer found that a 6x2 grid worked best and allowed a whole uppercase alphabet. The blocks were scanned and bitmapped.

T:Mind Block D:David Lane C:David Lane W:Font design L:English Y:2006

4

MIND BLOCK CAPS/

TYPE FACE MADE US-ING BLOCKS FROM A PSYCHOLOGY TEST/

Each of the six sides of the blocks has a different pattern.
When all the blocks are arranged on the same side a
complete pattern is produced.
This caps alphabet is made up using four of the six

sides/patterns that were available

The original set was produced by the National Foundation of Educational Research uk and The Psychogical Corperation, New York.
'Hand-drawn'

All work submitted was part of a personal project to create illustrative fonts from the standpoint of an illustrator.

T:1,2.Experimental
photographic Font
3.Leaf Font
4.Trunk Font
D:Claire Scully
C:Claire Scully
W:Hand-drawn typeface
L:English
Y:2007

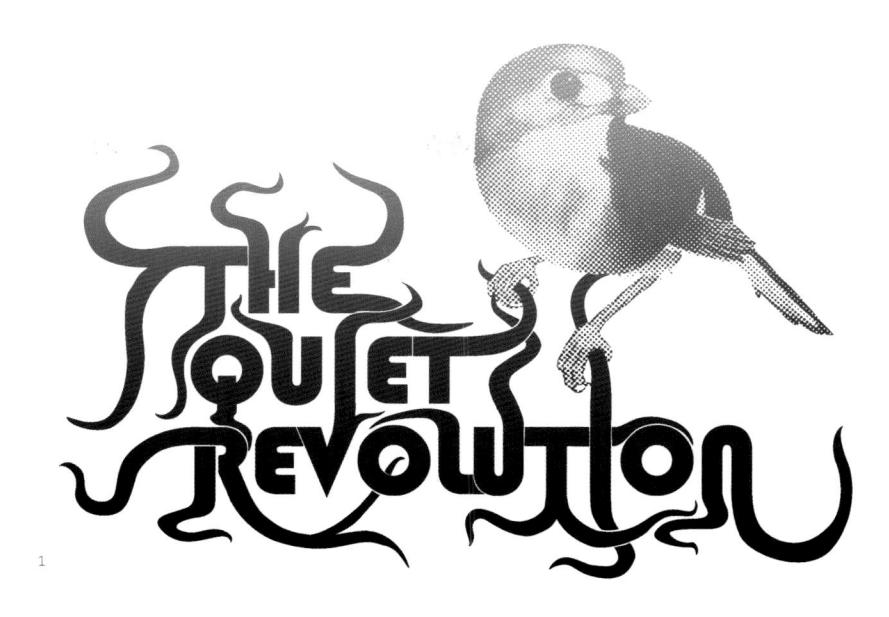

ARREST STATE

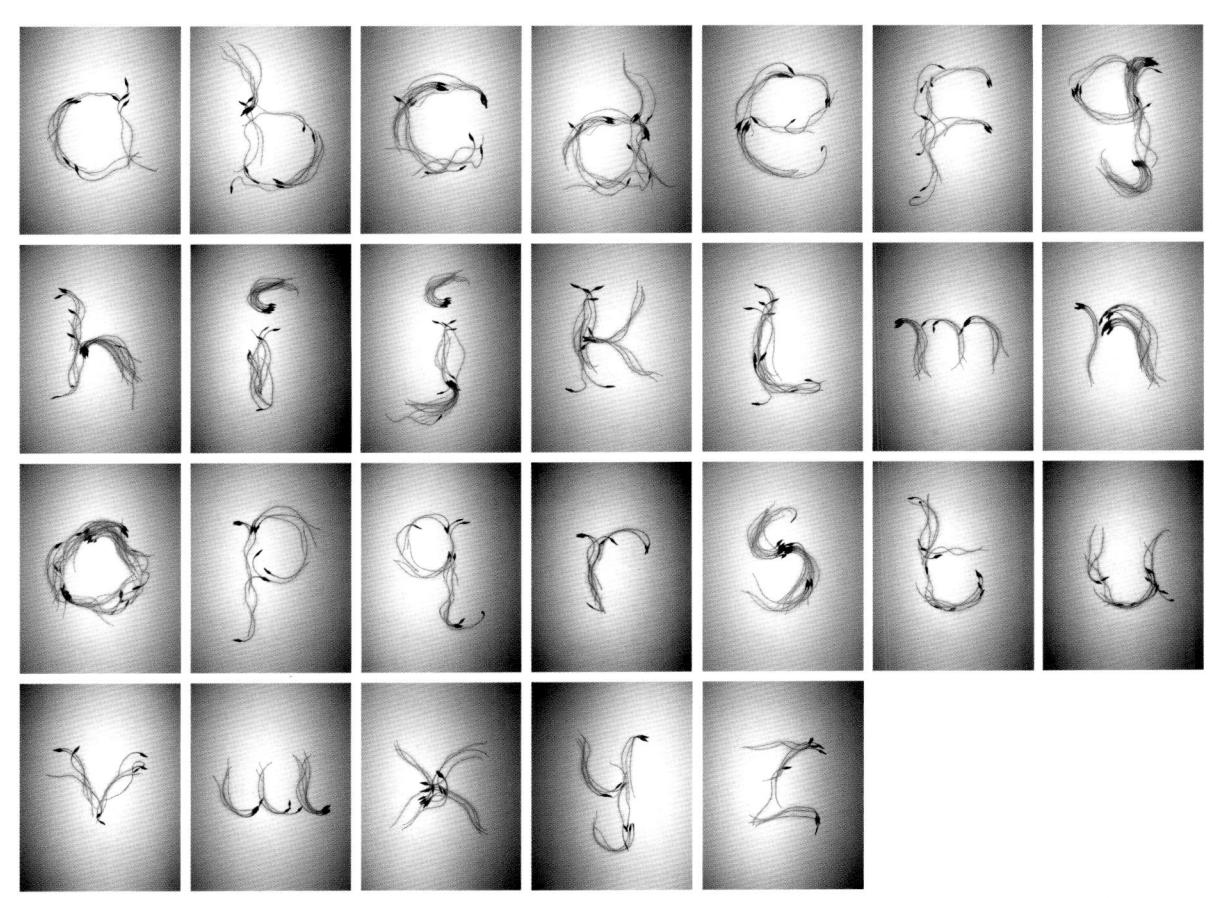

- 074 -

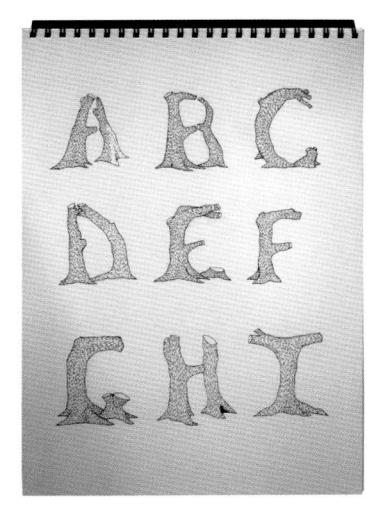

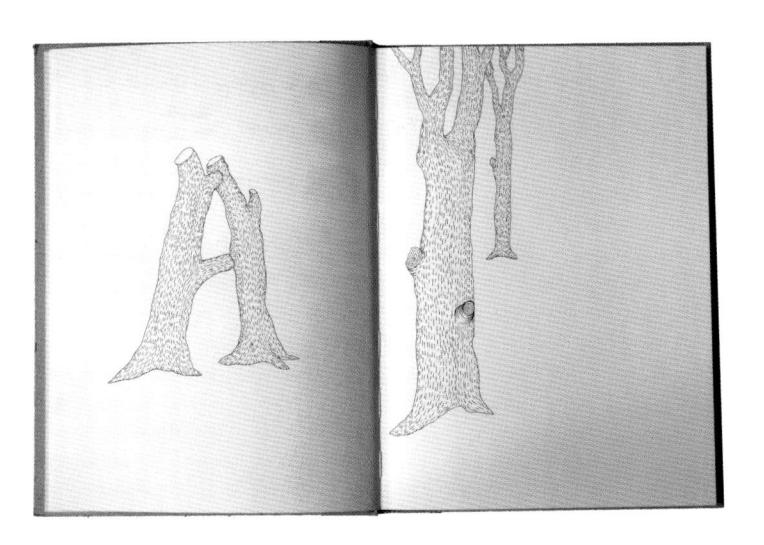

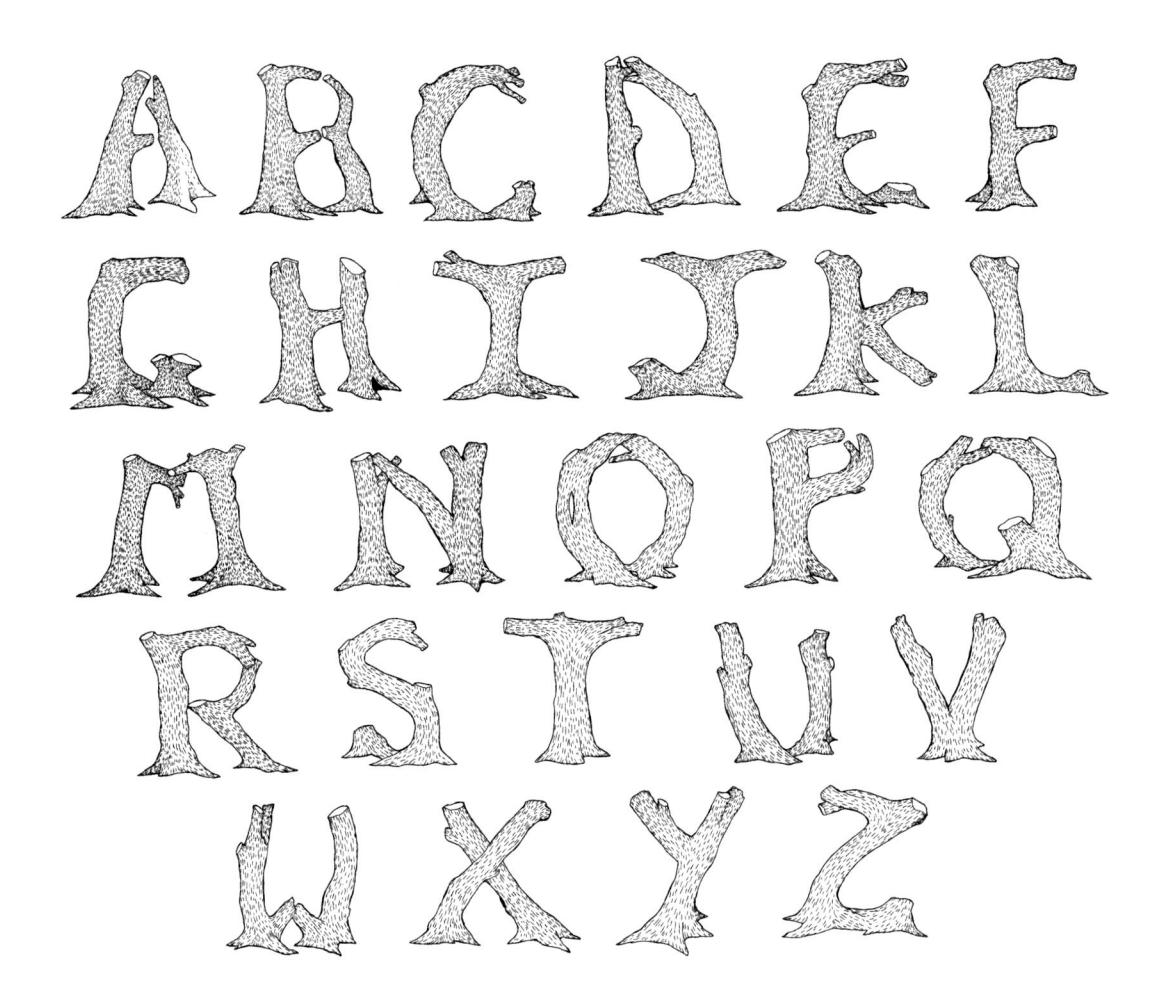

'Help'

The 'Designed To Help' project was launched by UK designers iLovedust. The idea was to produce a book of graphic design, illustration and photography; and to raise money for charities that deal with the tsunami crisis in Asia.

T: A book Designed To Help D: Atelier télescopique C: DGV W: Book Cover L: English Y: 2005

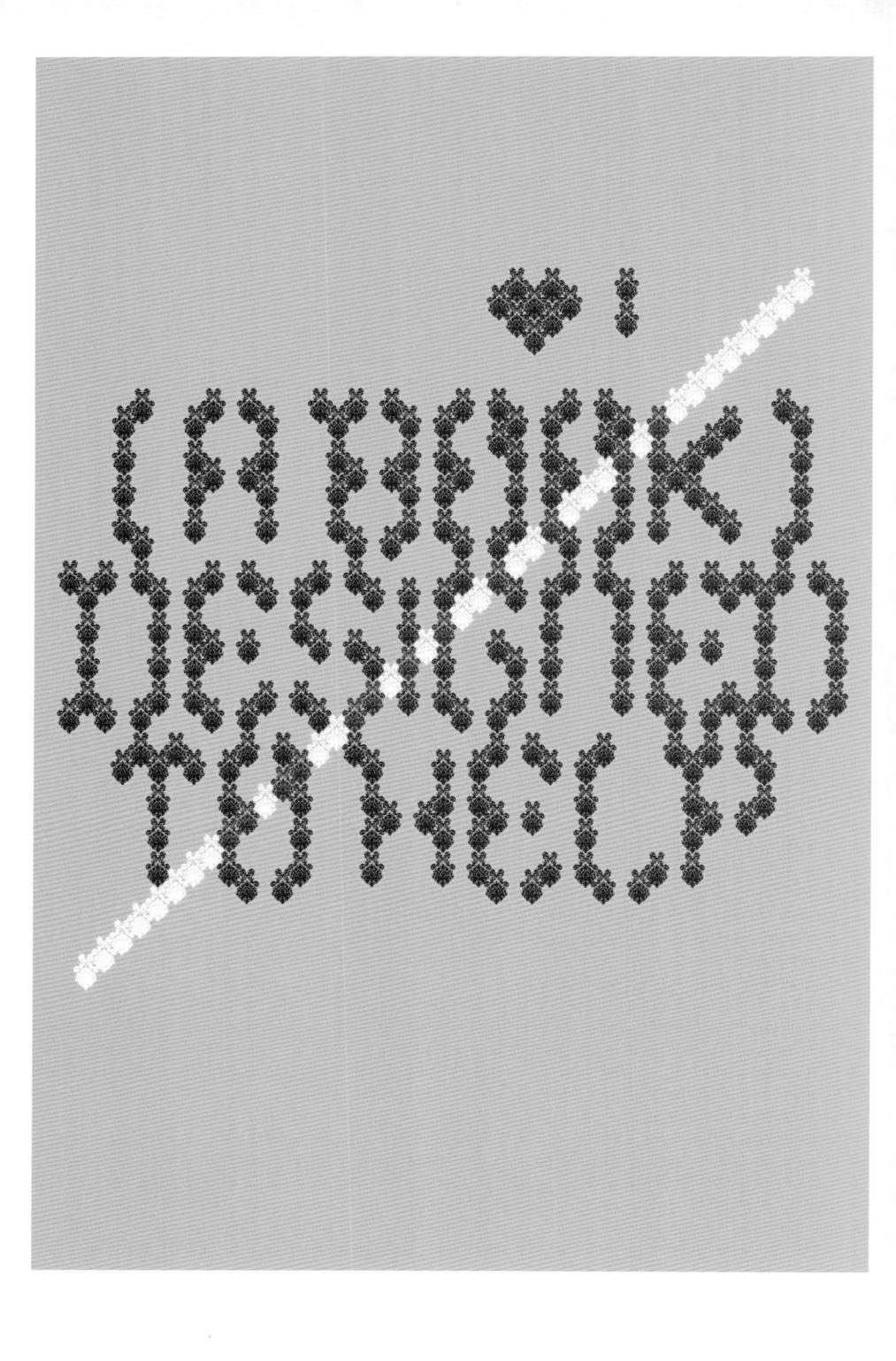

'Holiday' This was the 2006 holiday card for

nollday card for Columbus Bank and Trust Co. The snowflakes were designed using the bank's 'C' logo, and those are all recipes for cookies - the most universally relevant language for the holidays. The paper acts as a kind of window where the flakes gather on the Happy Holidays glass, and the other side (the inside) sports 'Warm Wishes' and kitchenesque sentimentality.

T:Warm Wishes!
D:Topos Graphics
C:Columbus Bank at
Trust Co.
W:Holiday Card
L:English
Y:2006

'Home'

with the theme and title 'HOME,' the designer rearranged a wall of bookshelves in his apartment to spell the word 'HOME. This photo was used cinvitations, postcard and promotional materials.

D: Post Typography C: Nancy Froehlich W: Lettering L: English

4

ίΙ'

Poster design for 'Hompage to Helvetica Exhibition'. It is an exhibition in the new shopping mall 'Cantonyama.' In this project the designer was invited to create alphabet Helvetica 'i.'

T:I D:Sixstation C:Cantonyama W:Poster L:Chinese Y:2005

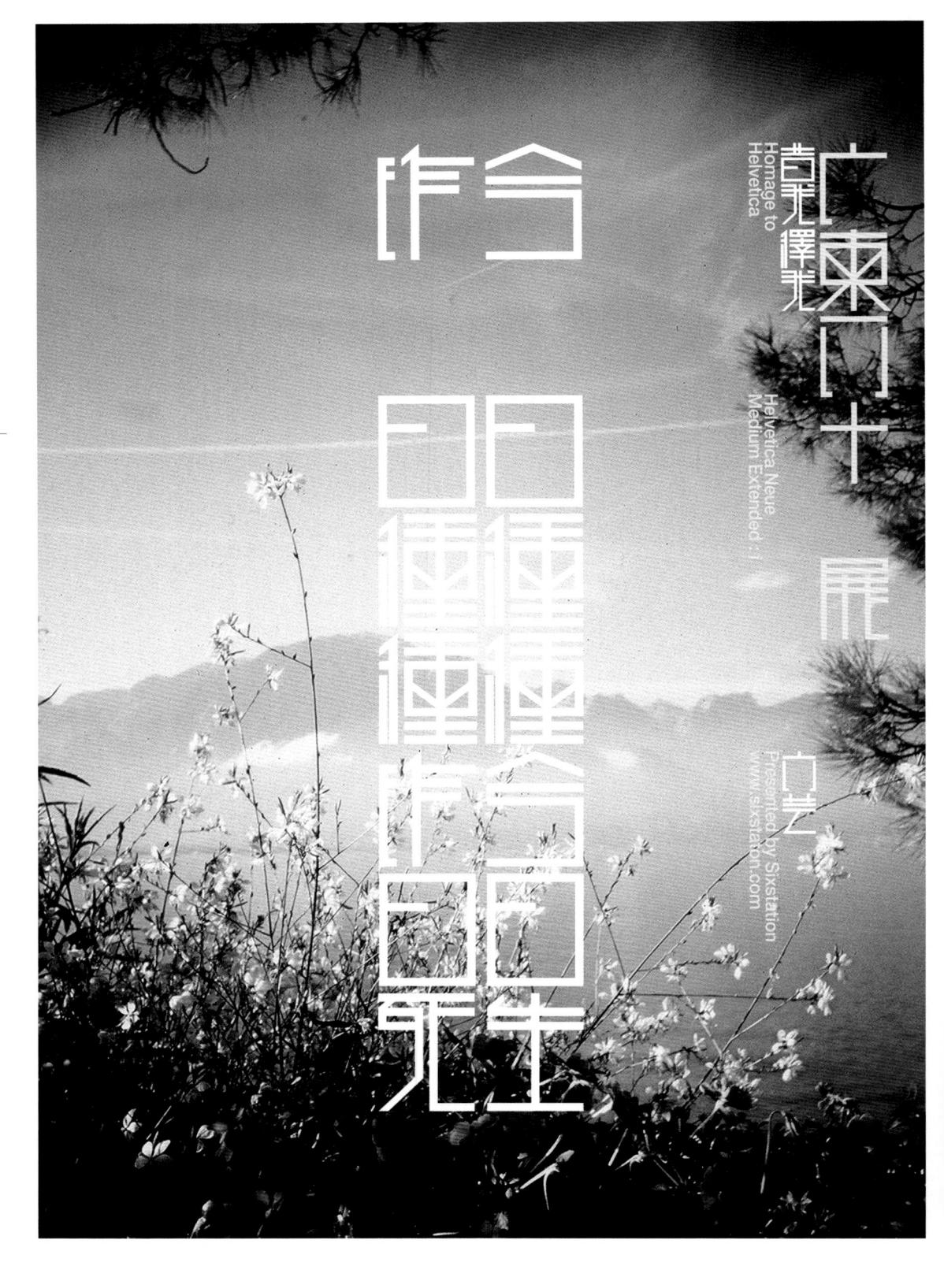

'Ice'

Christmas and New Year card designed with a custom-made typeface inspired by ice cubes and gift box. An examination of readability.

T: Seasons Greetings D: Hamlet Au-Yeung C: Hamlet Au-Yeung W: Promotion L: English Y: 2006

'Icelandic'

The idea was to create a look that would relate to music, the different countries participating and Iceland. The designers researched the basic forms of Höfðaletur, a unique Icelandic font of wood-carved capital letters dating back to the 16th century, and used its base to design their own type, Rich Hard. This type was then used to make the whole design concept of the music festival. Like Höfðaletur, the designers used Rich Hard as a decorative font and write Icelandic names of the instruments, by that relating to music as well as to raise foreign guests' interest to visit the country for the festival.

On the poster as well as the cover you can read the Icelandic names of the instruments, from the top left downwards. This also made the design 'fun' in a way since there could be hidden words in Icelandic. It is not easy to read like Höföaletur was, unless you give yourself some time to look at it.

T:Nordic Music Days Iceland D:Siggi Orri Thorhannesson C:Nordic Music Days W:Promotion L:English, Icelandic Y:2006

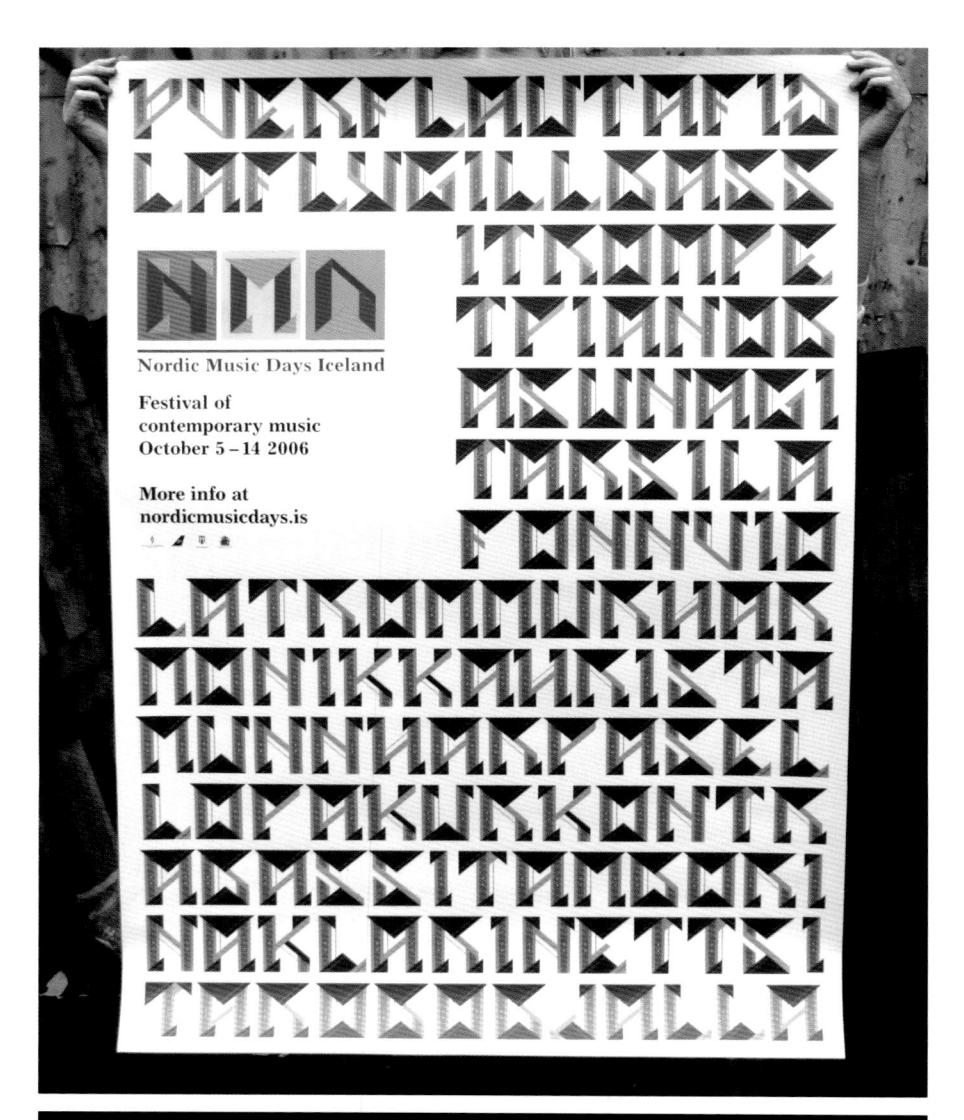

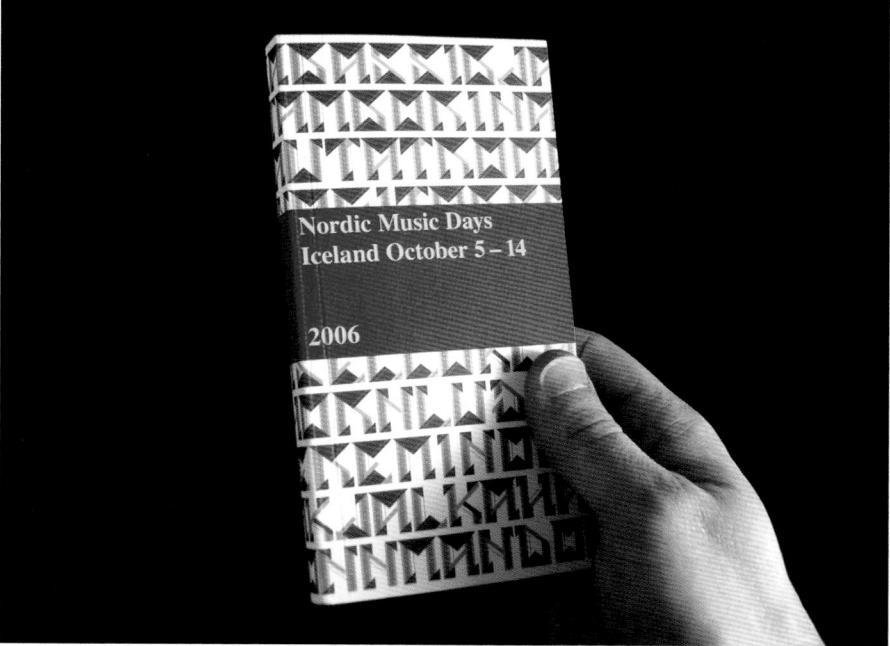

MAKAE MAKAE MAHAI MAHAI KUMMA MAKAT MAKAT MAKAT MAKAT MAKAT MAKAT MAKAT MAKAT MAKAT

'Identity'

3 different projects for the contemporary art gallery Loevenbruck, Paris. The designer usually works on their invitation cards for collective exhibitions, or when the idea is not to reproduce the artists' visuals on the card. It is more a typographic project, without photos, to create an identity for the exhibition itself.

T:1.5 ans seulement déjà
2.Big
3.Bruno Peinado. Me,
buysellf & I
D:Sylvia Tournerie
C:Loevenbruck gallery,
Paris
W:Preview cards
Y:2006

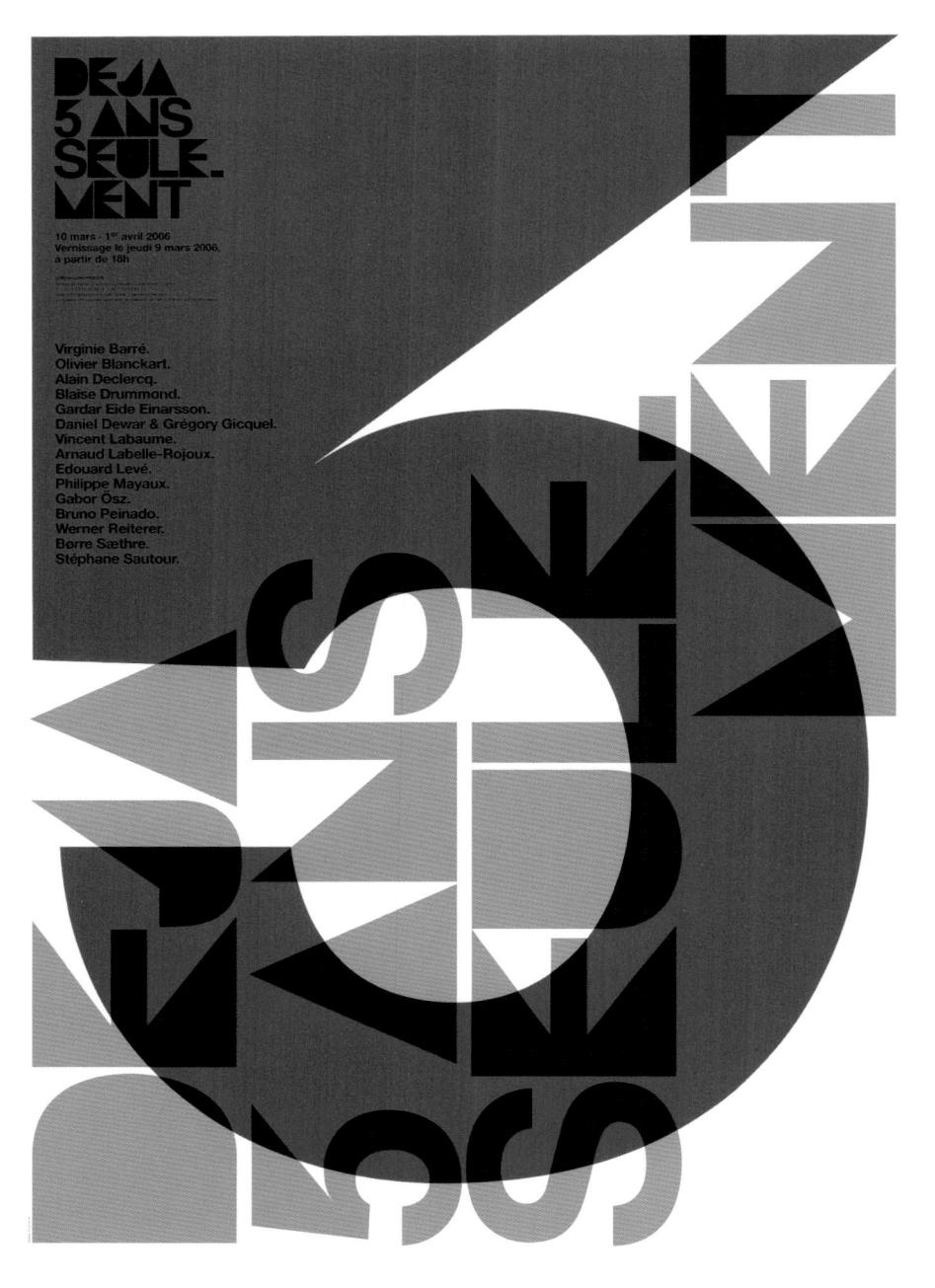

1

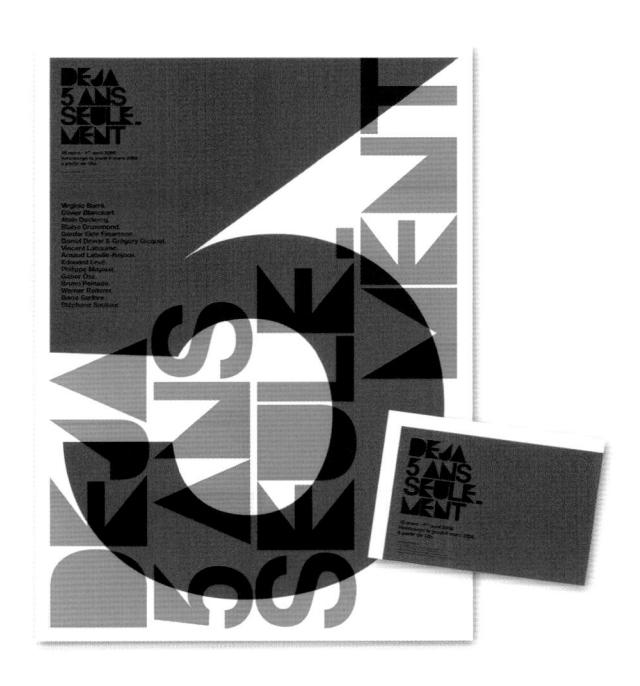

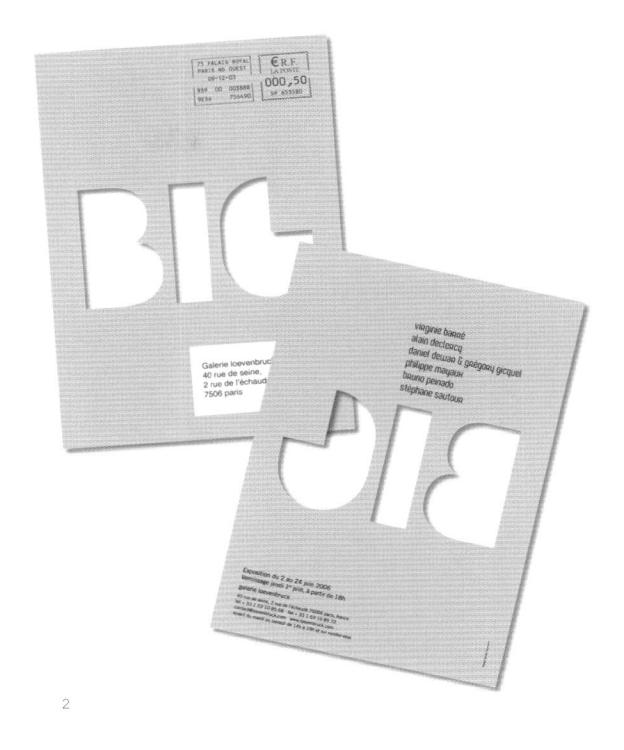

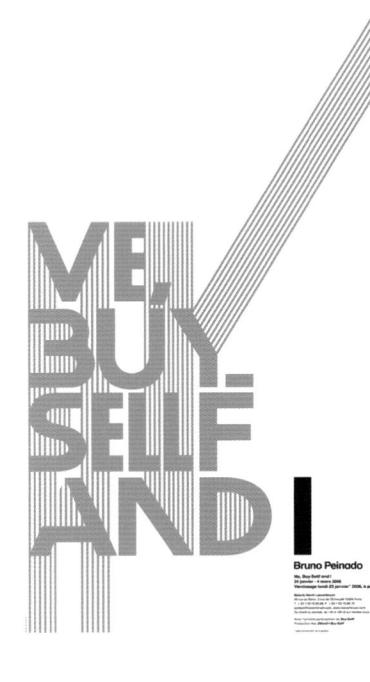

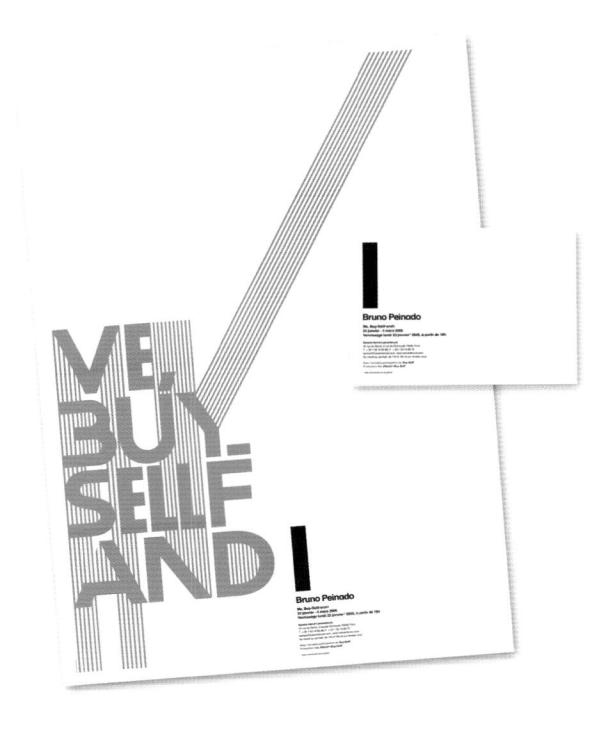

3

'Illusion'

This 'drama' poster parallels death, love and sleep. The little set is built around a store bough picture frame and uses paper to construct the physical lettering.

D:FromKtoJ/FromJtoK C:FromKtoJ/FromJtoK W:Poster L:English Y:2006

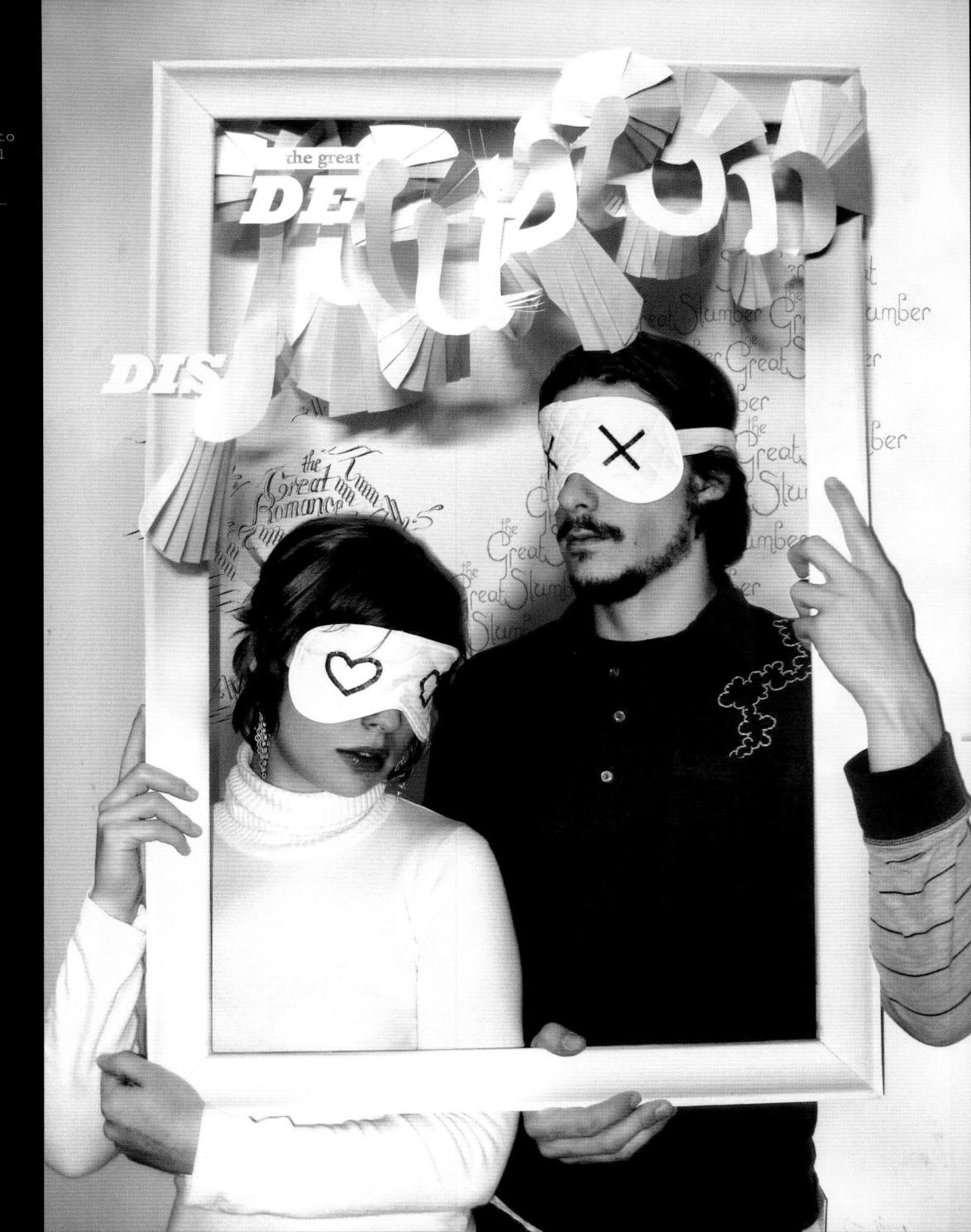

'Implements'

This display typeface is designed with glass installation in mind. Ideally the 2 colours could be applied to different panes of glass. By place the pains no more than one foot apart the blue and beige patterns allow 2 levels to read. From one perspective the typeface serves as ornamentation. From another perspective, by aligning the blue and beige patterns, legible messaging is revealed.

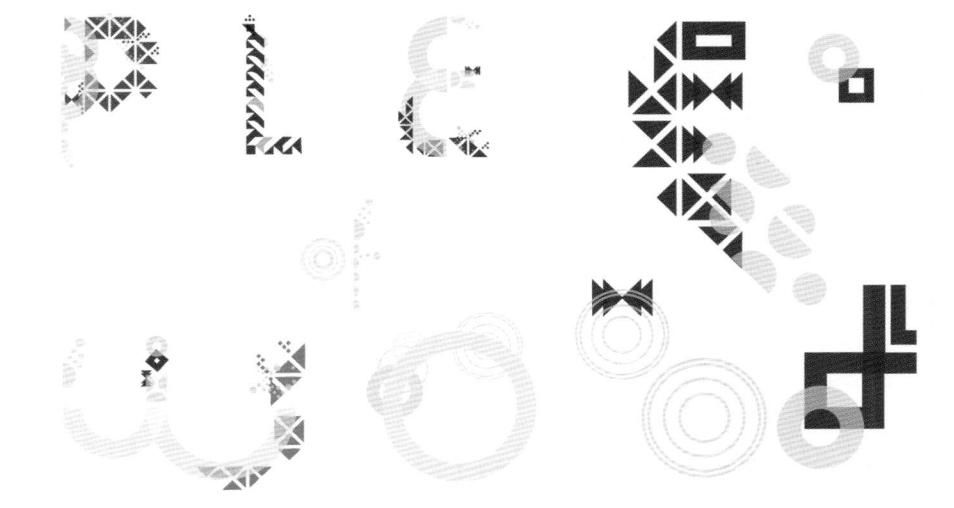

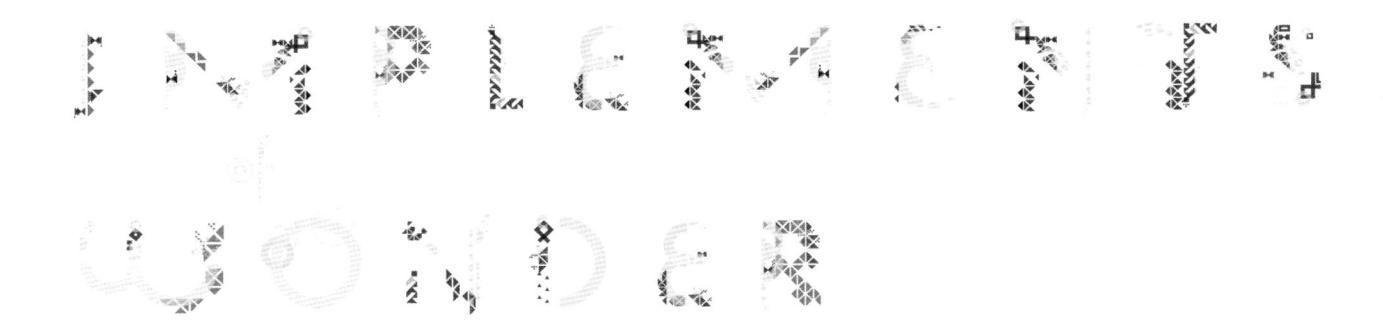

T: Implements of Wonder Type D: FromKtoJ/FromJtoK C: FromKtoJ/FromJtoK W: Display typeface L: English Y: 2007

'Installation'

year. In order to show the promotion slogan are competition grades for the award as well designers decided to photo-shoot them as spent a huge portion of the budget on they found that the promotion of the MTV Music Awards was same approach as they satisfactory props understand that this happens occasionally, at the end.

T:USCA (Ultimate
Song Chart Awards)
Presentation 2006
D:Artroom - Commercial
Radio Productions Ltd.
C:Manhattan Id
W:Installation, Poster
L:Chinese, English
Y:2006

7

OS年度 比咤樂壇流行榜 頒獎典禮 Ultimate Song Chart Awards Presentation 2006 ABCD—點映光樂壇亮燈由你主持

06年度 化定樂壇流行榜

Ultimate Song Chart Awards Presentation 2006 **ABCD一點即光 樂壇亮燈由你主持**

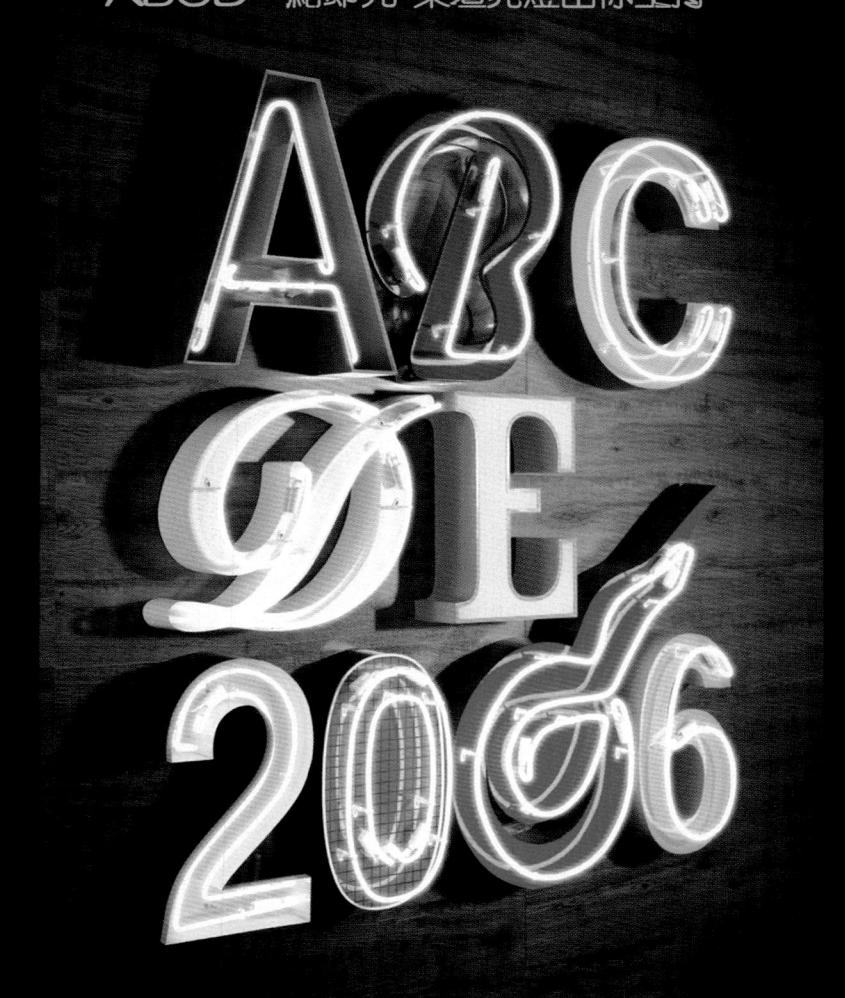

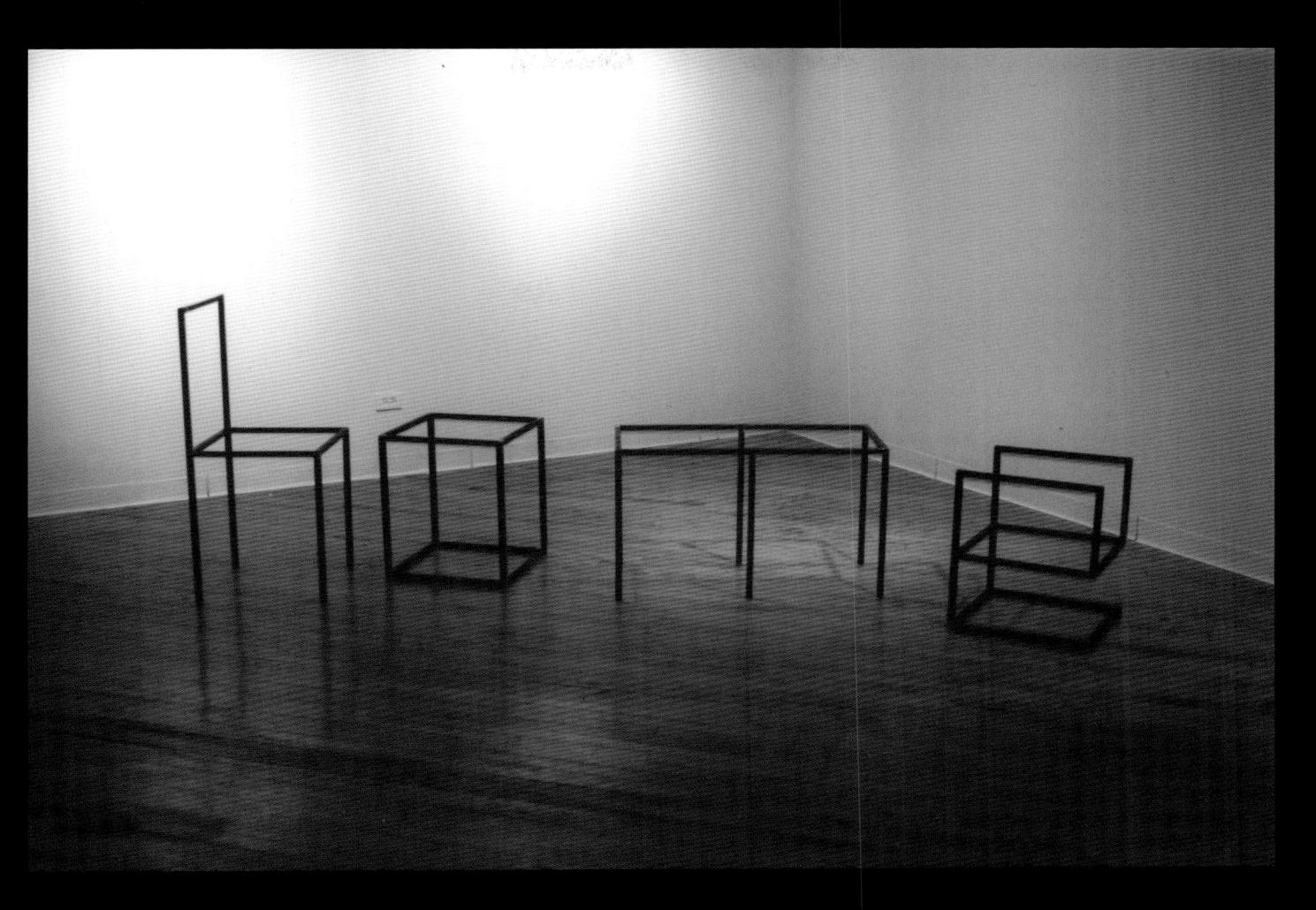

'Interiors'

'Interiors' was originall conceived as a digital font and was inspired by an old wooden chair in the corner of Byrom's office that, when looked at it from a certain angle, resembled the letter 'h.' Using the 3-dimensional principles and closely adhering to type design conventions, 26 letters of the alphabet were drawn and generated. Later the characters were constructed in

three dimensions using tubular steel into full-scale furniture frames. The end result becomes almost freestyle furniture design.

I:Interiors
D:Andrew Byron
C:Andrew Byron
W:3D typeface
L:English
Y:2003

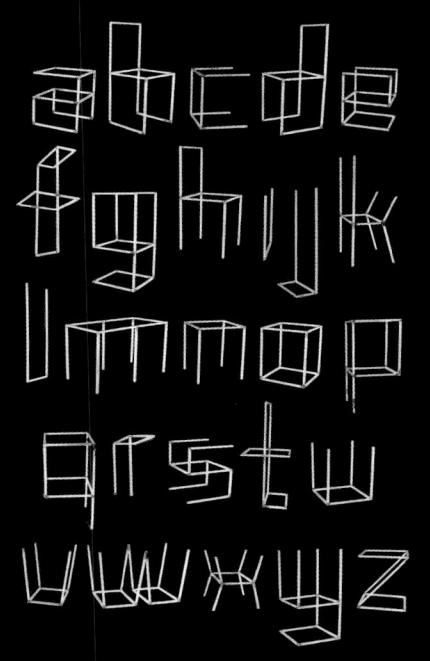

'Invention'

The typeface that stemme from the designer original poster 'Meaning is Made.' Geometry has always fascinated the designer, in school it was the only math subject he could make sense from, it seems natural to make a typeface using the simplest geometric

T:Re-Invent the Alphabet D:Widmest C:Widmest

W:Print L:Engli

Y:2007

4

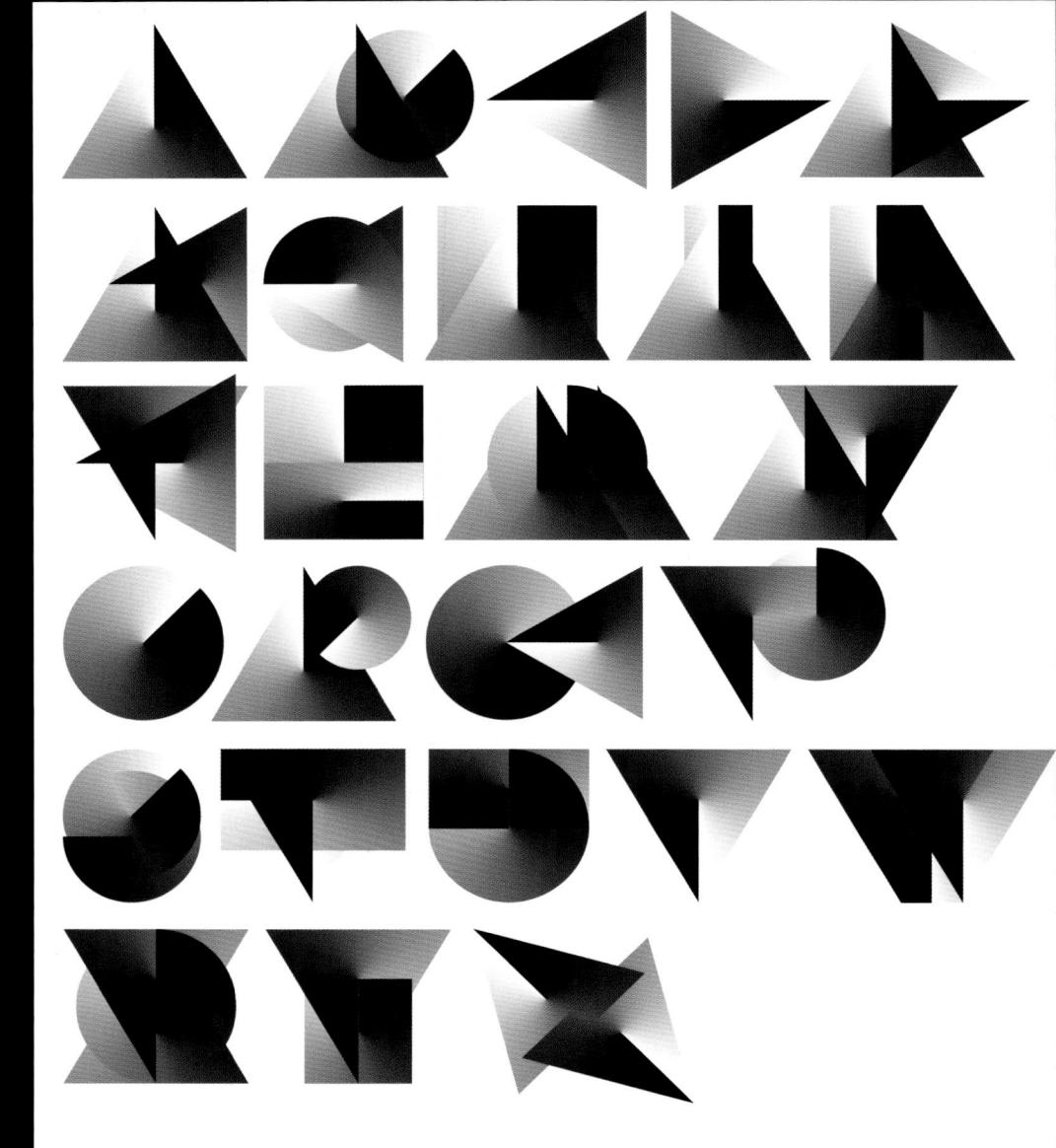

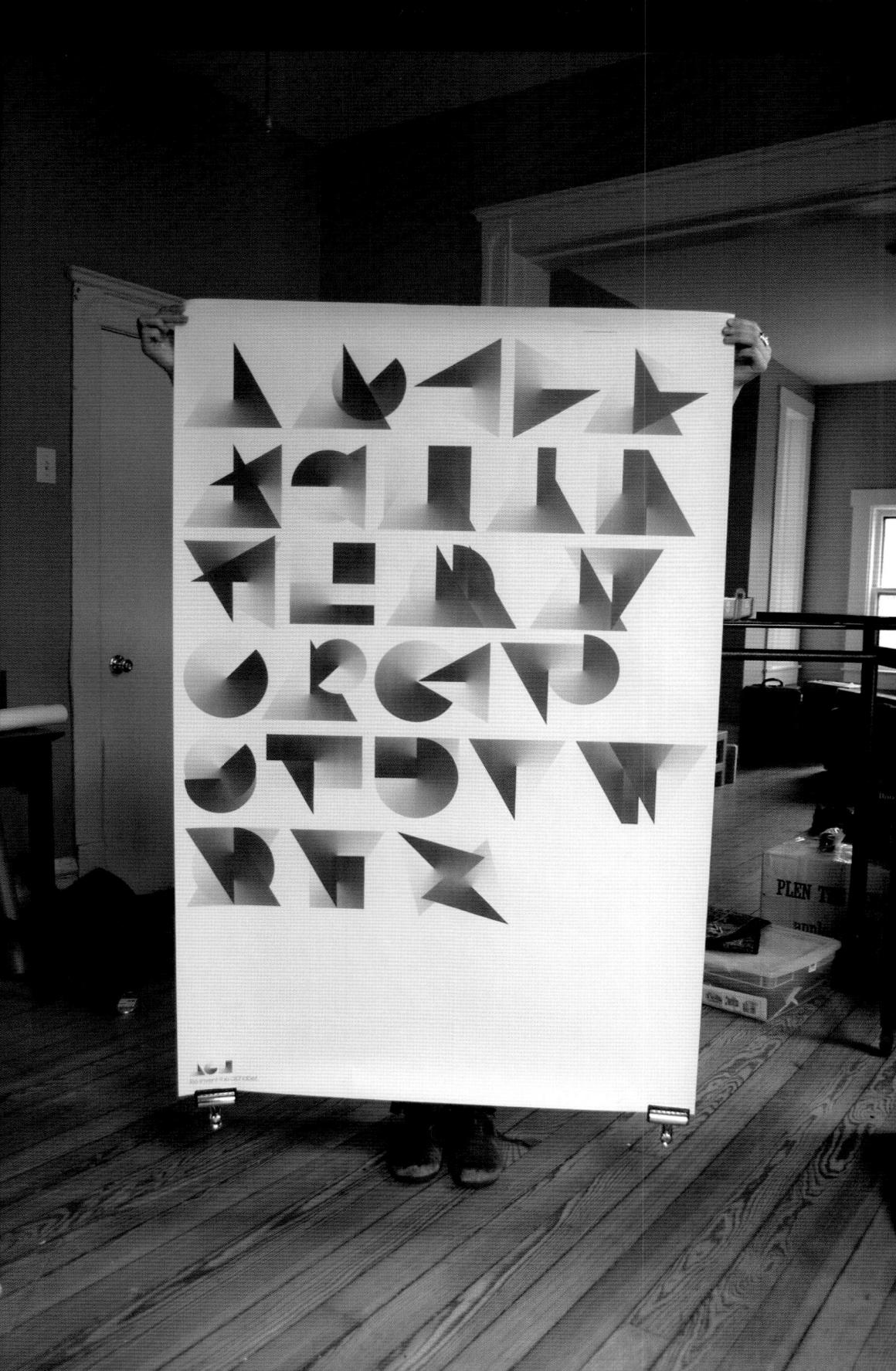

a wallpaper/pattern that would completely created in 3 isometric views and then glued up one letter at the put up randomly, but in-between you will words spelled out, like Debbie Does Dallas, Kaffi and all of the T:Wallpaper D: Iceland Academy of the Arts, graphic design graduation class of 2006 C:Iceland Academy of the Arts

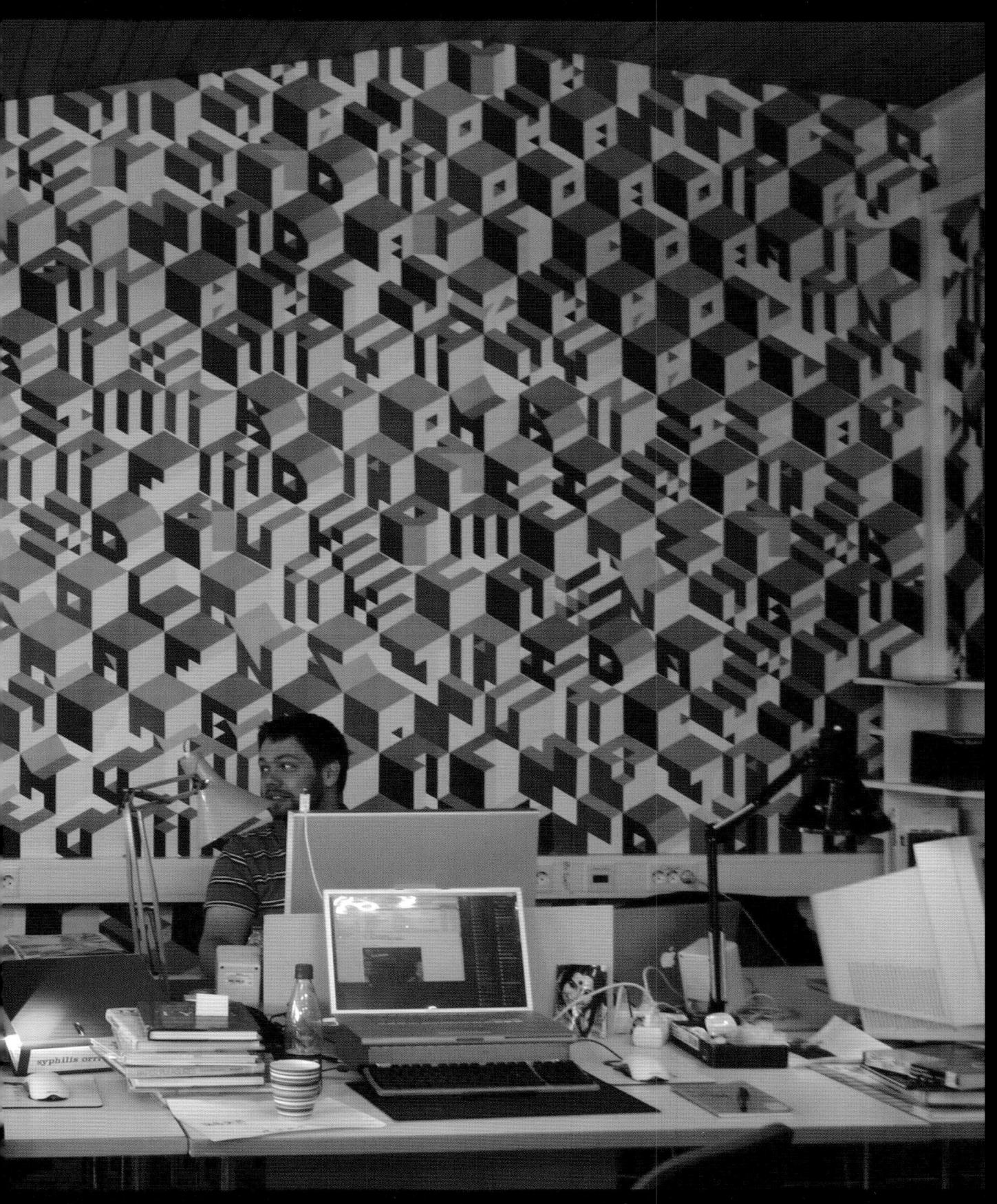

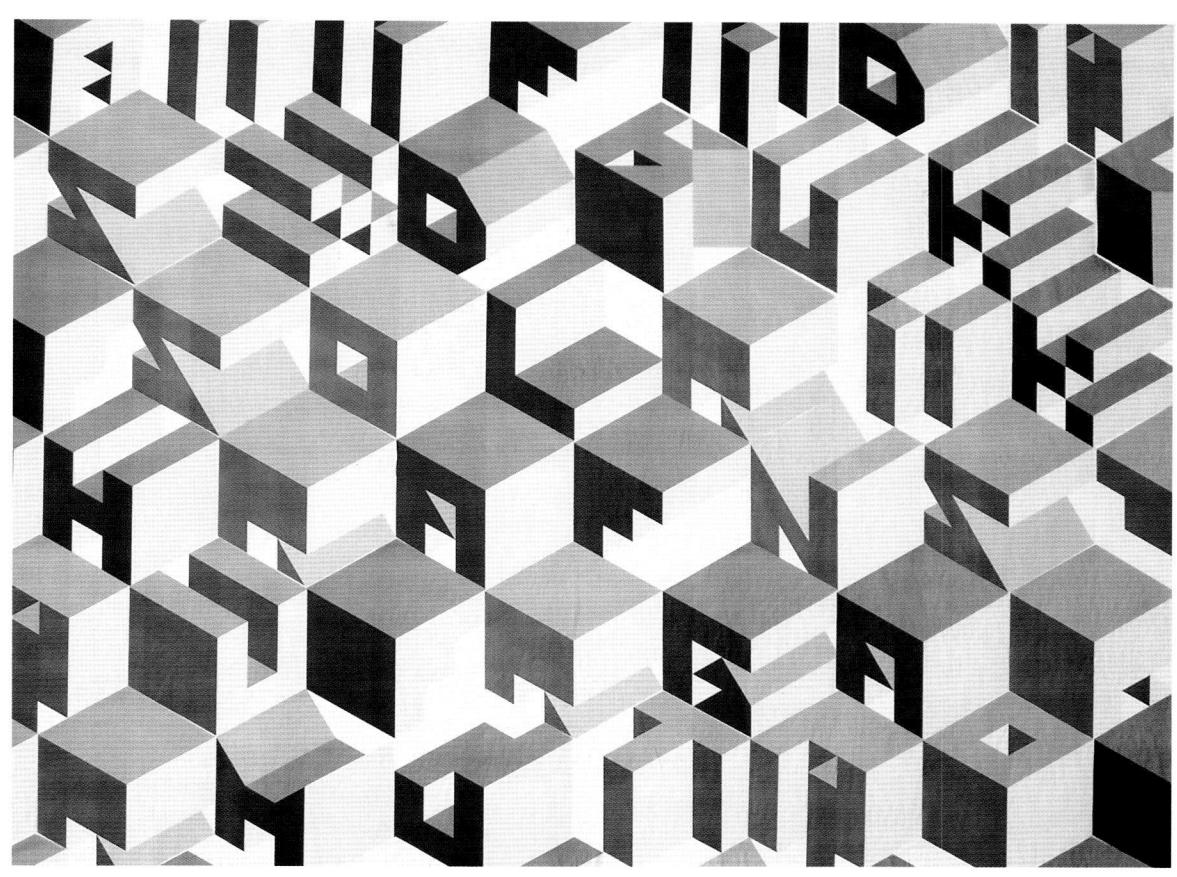

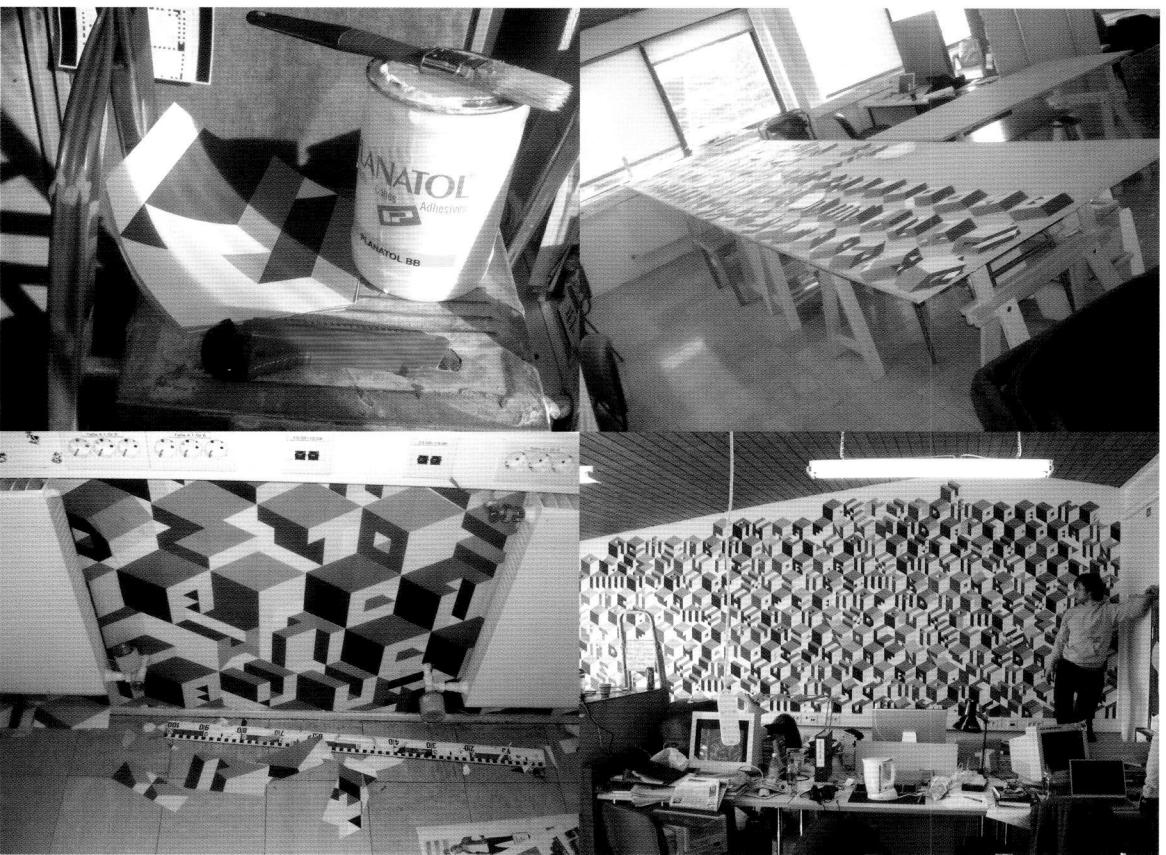

444 444

'Japanese'

1. The book is made for celebrating the 10th anniversary of the motion graphic studio called WOW Inc. Digital video works of WOW from the past 10 years are translated and assembled in a 2-dimensional and printable form; a DVD is included too. 5 artists who WOW respects: Shigeki Hattori (Graf), Yoshio Kubo, Gwenael Nicolas (Curiosity), Masafumi Ishiwata, Koichiro Tanaka (projector) and Artless joined and developed the theme 'Next 10 years' for this book.

2.Graphics collaged with Japanese plants and trees are placed on numbers. The designer used numbers as a flower vase and expressed four seasons from 0 to 10. For that, even numbers are collaged with photography and uneven numbers are collaged with illustration.

T:1.WOW10
2.WOW10 numbers
D:artless Inc.
C:WOW Inc.
W:1.Art book
2.Typography, Collage
L:1.English, Japanese
2.Japanese
Y:2007

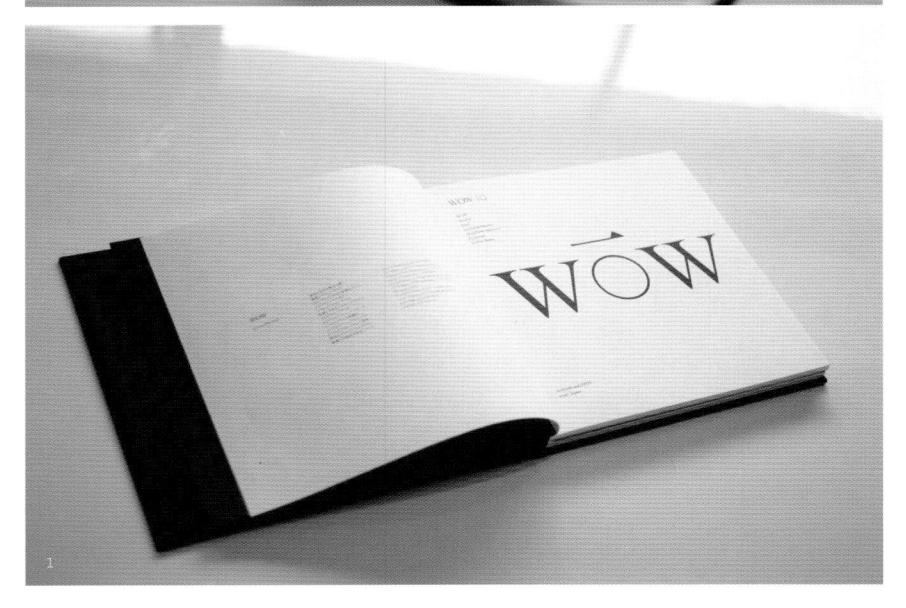

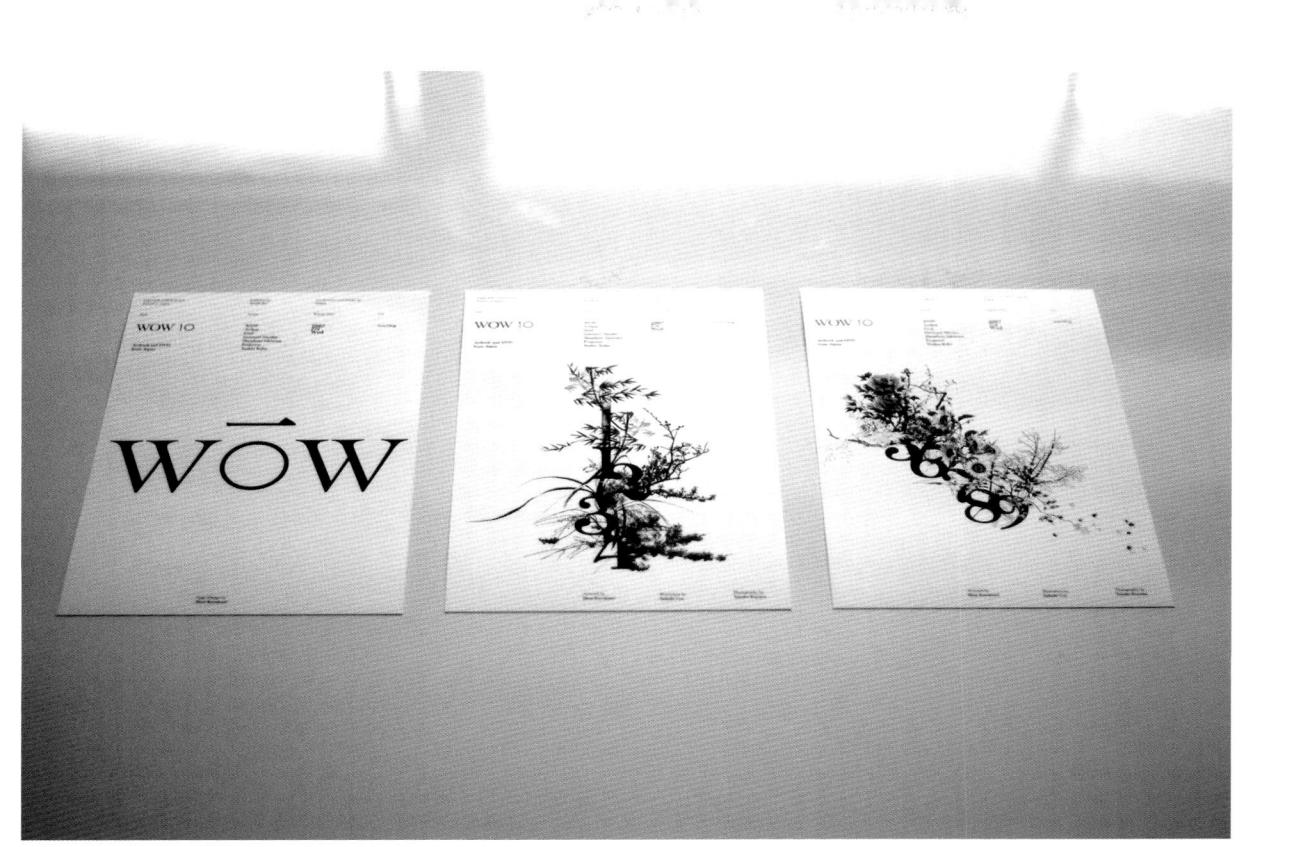

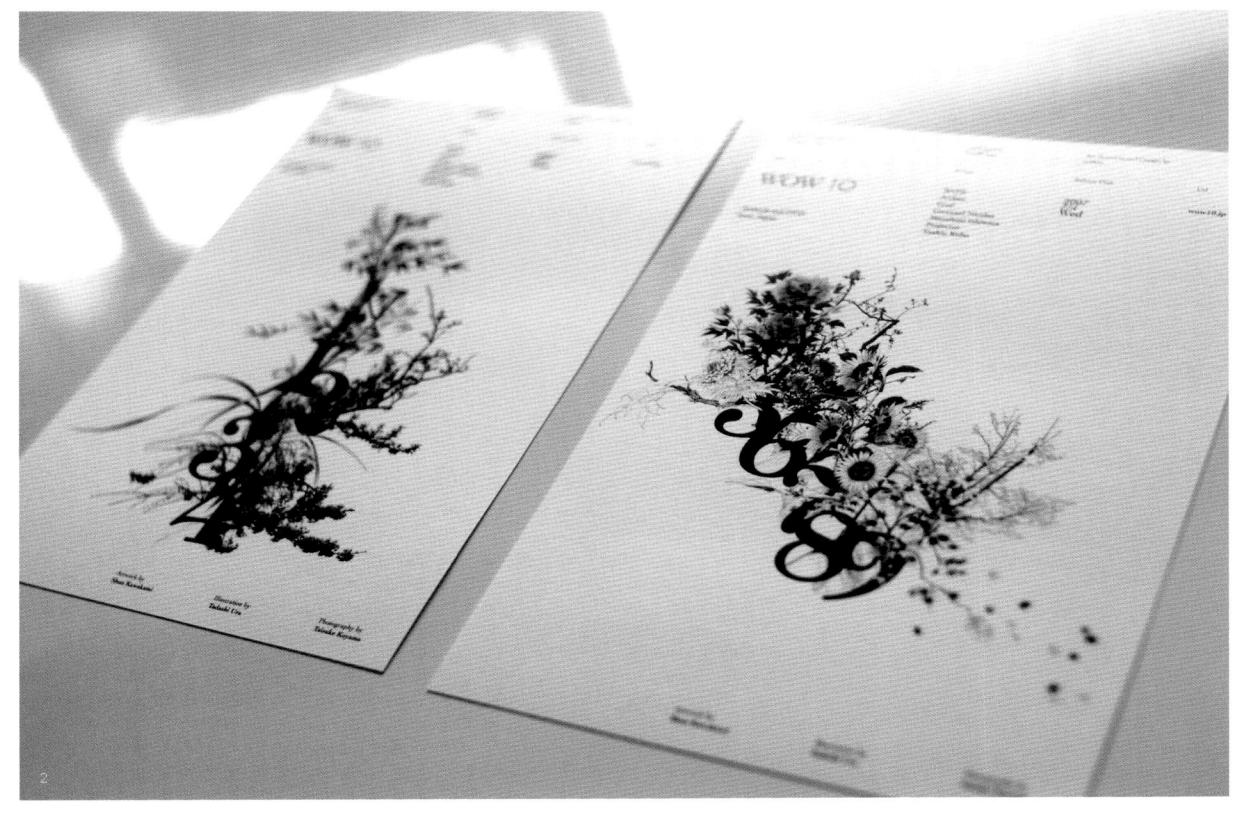

'Kerning'

The studio was approached by the International Society of Typographic Designers to create a piece of work to be exhibited in an exhibition entitled 'My City, My London' which was part of The London Design Festival 2006. The exhibition celebrated the place of graphic design in contemporary visual culture and its intention was to explore typography in the visual world of the capital.

The designers' solution was simple - a typographic map of London.

T:London's Kerning
D:NB: Studio
C:International Society
of Typographic
Designers
W:Poster
L:English
Y:2006

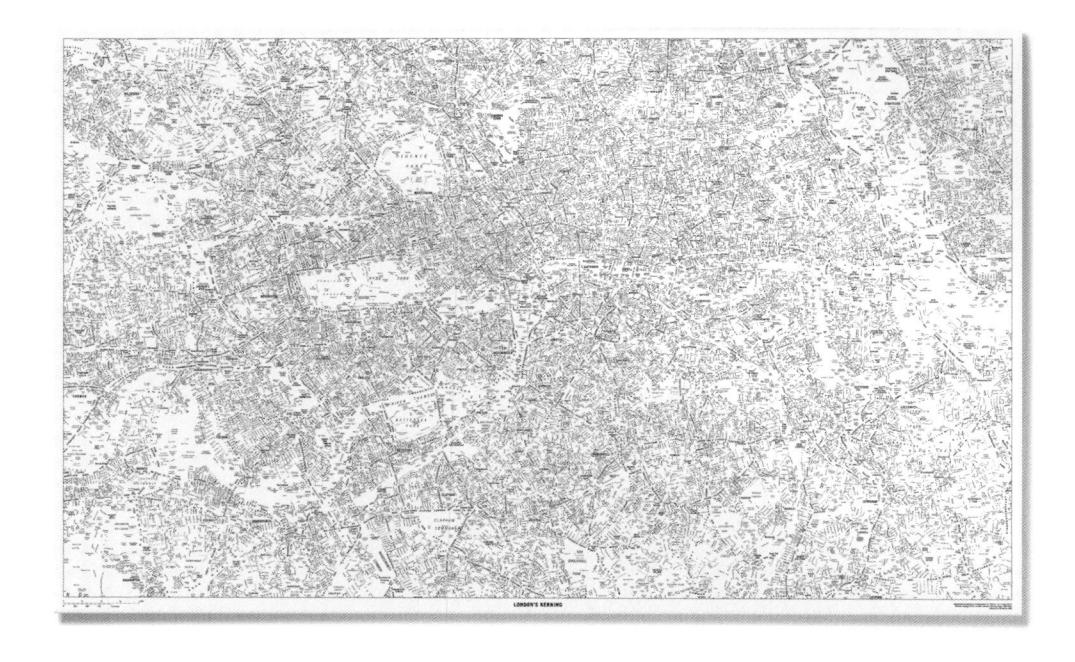

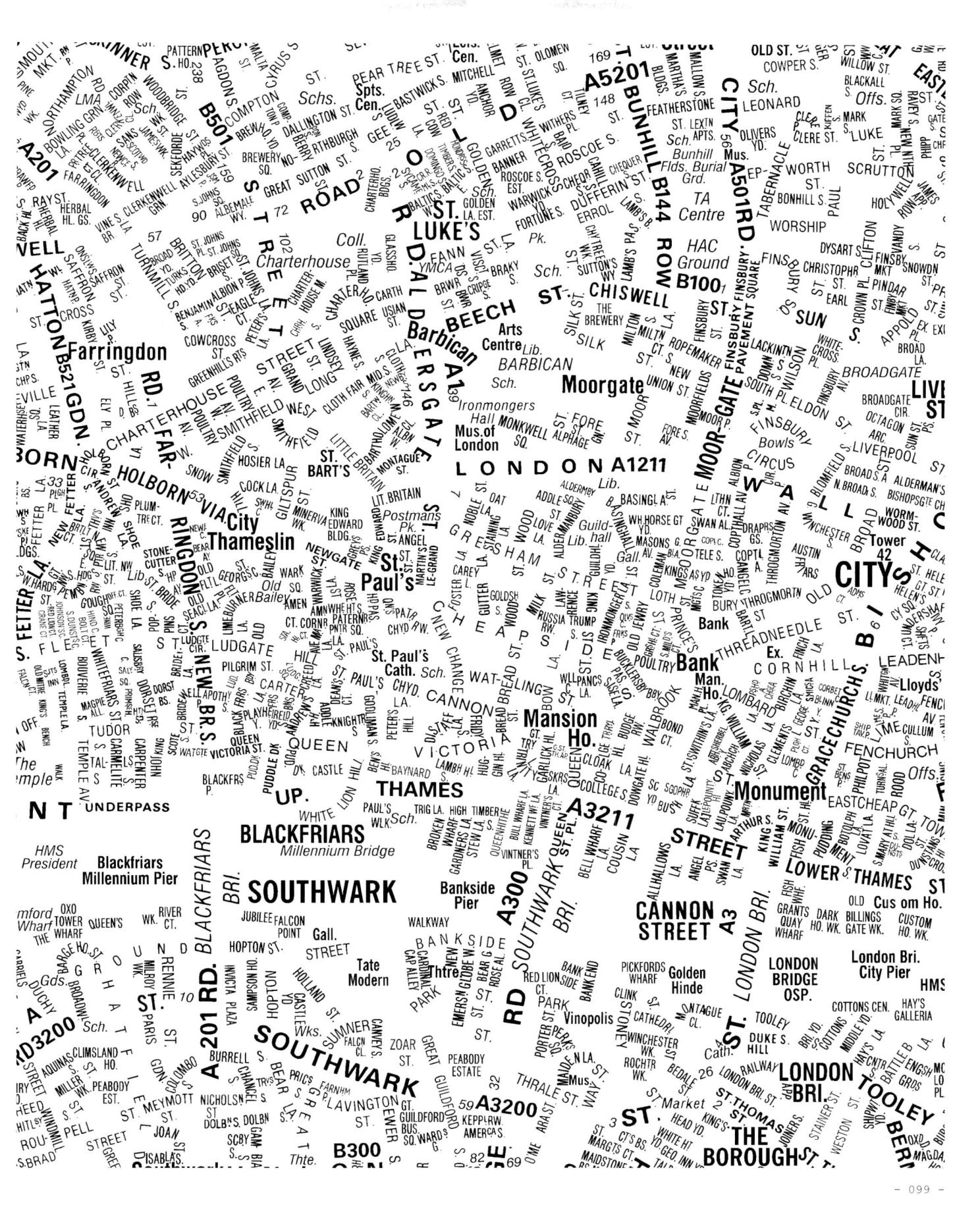

'Lace'

The Wish display face is inspired by contemporary lace. The custom font is engineered to hold all intricate details when laser cut.

T:Wish Type D:FromKtoJ/FromJtoK C:FromKtoJ/FromJtoK W:Display typeface L:English Y:2006

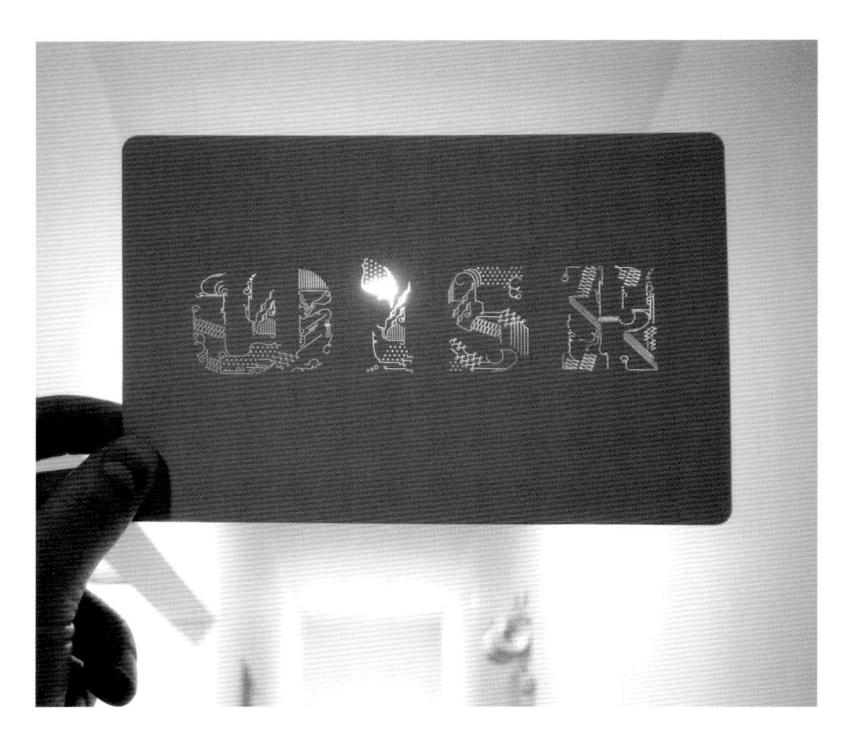

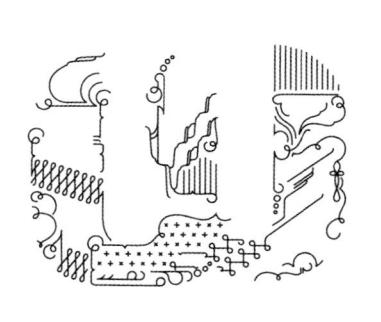

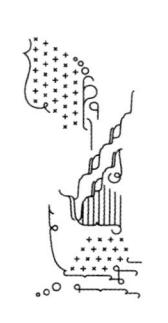

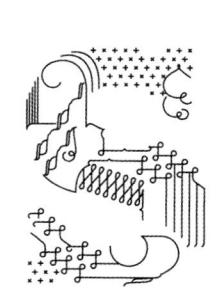

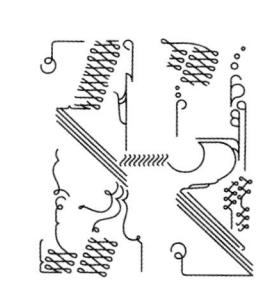

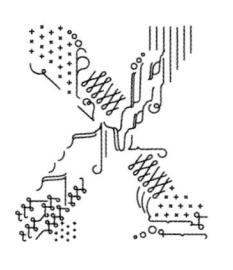

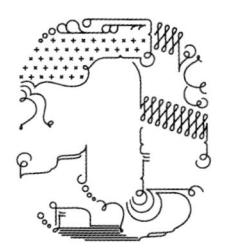

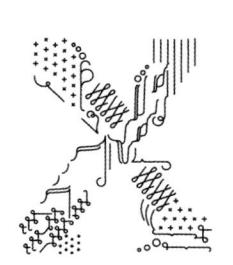

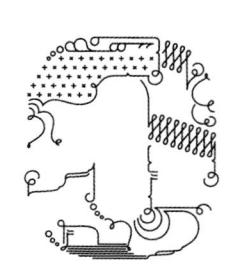

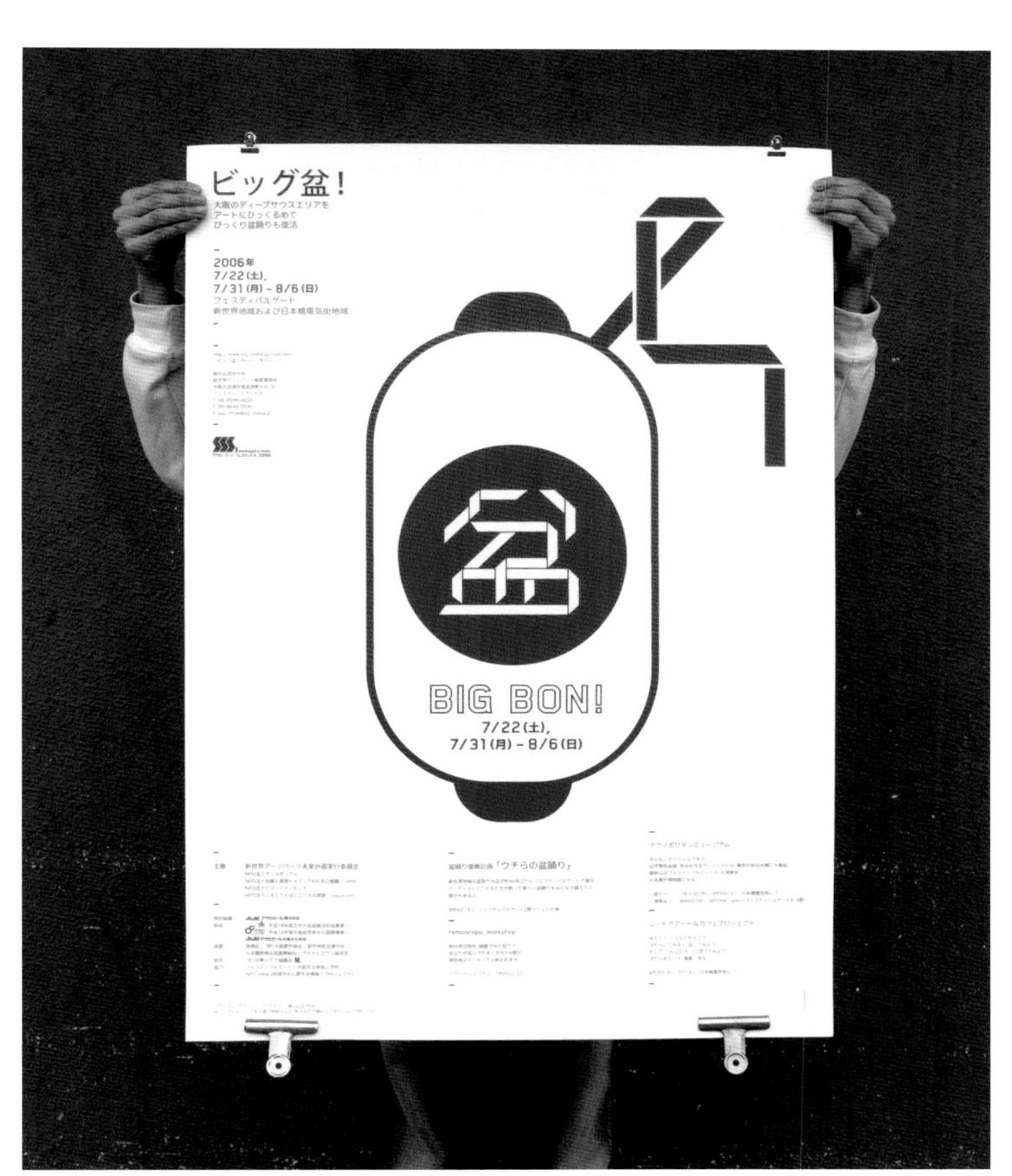

'Lantern'

Osaka Design Pack aimed at inviting young Asian designers to design specific posters for a local cultural event. The designer were asked to design for the 'Bon' festival, a traditional Japanese summer dance festival. The idea is to create a 'poster lantern' with the Japanese typography - 'bon' inspired from the Japanese 'Yakuta' belt. When posters are hanged together, it would appear as real lanterns with people dancing along the street.

T:Osaka Design Pack
- 'Big Bon!'
D:Milkxhake
C:Osaka Design Pack,
Japan
W:Poster
L:Japanese
Y:2006

'Lecturing'

Poster promoting a design lecture given by Post Typography at Susquehanna University. Being the middle of winter in the mountains of Pennsylvania, the designers grew impressive beards to help stave off the cold.

T:Beards Rule
D:Post Typography
C:Susquehanna University
W:Poster
L:English
Y:2005

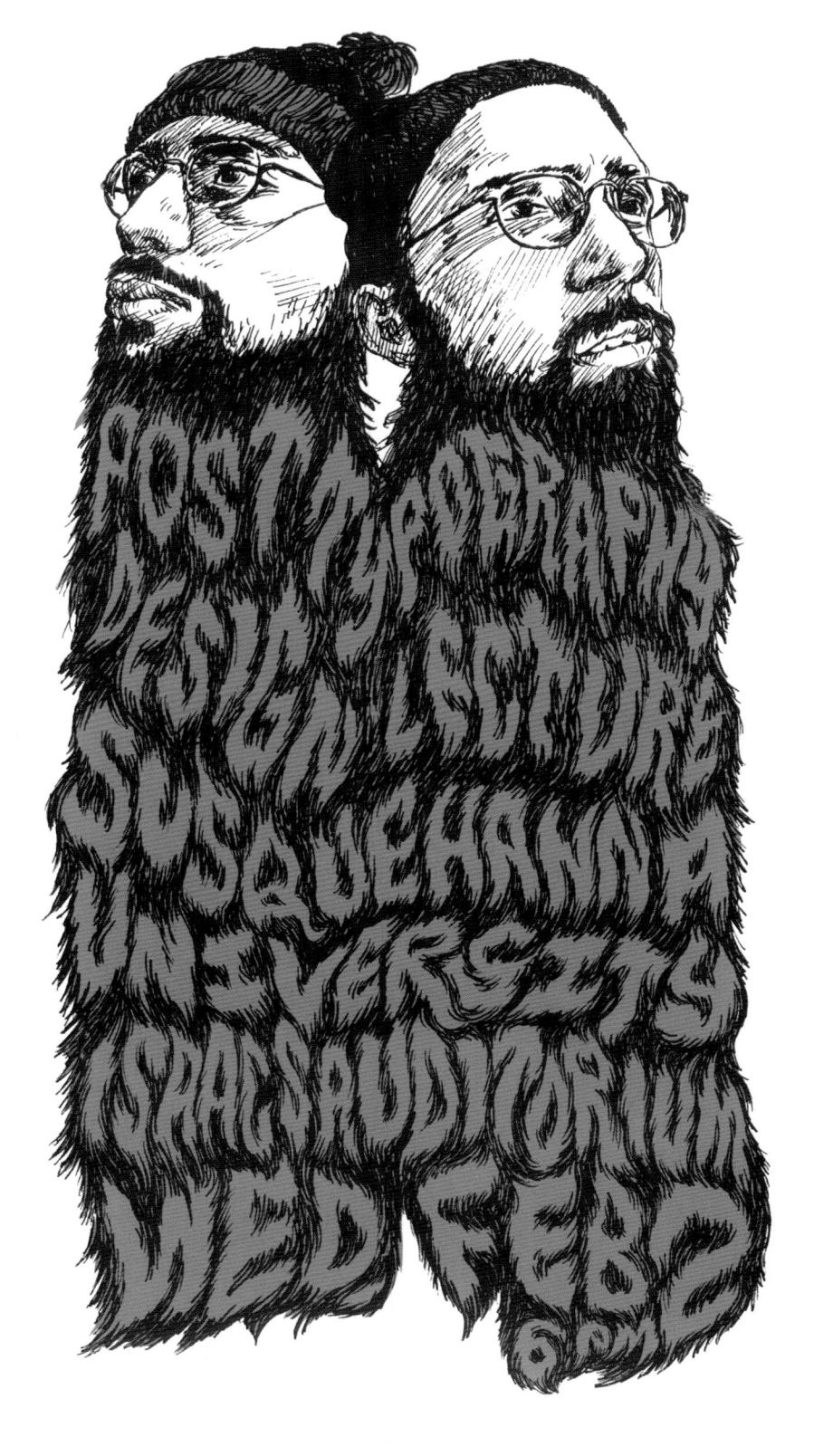

Life'

c can transform from the Kanji character to the English character, the other way round th the same meaning the without excess and efficiencies of parts.

Life
Dainippon Type
Organization
Dainippon Type
Organization
3D typeface
Englisn, Japanese
2006

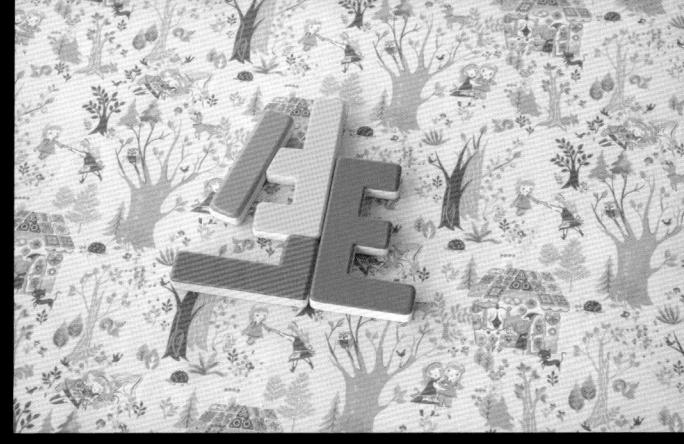

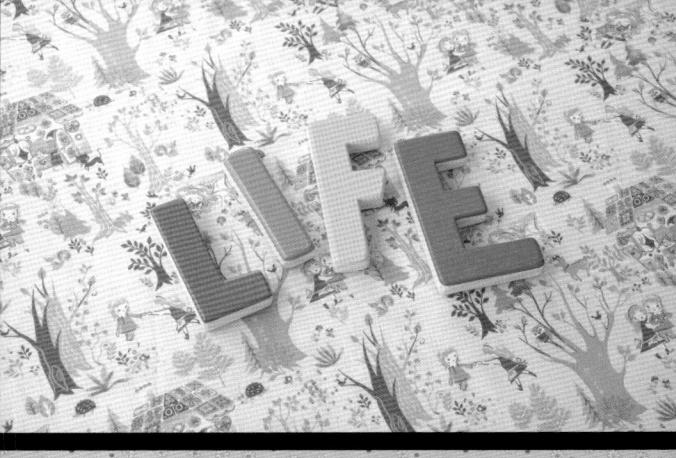

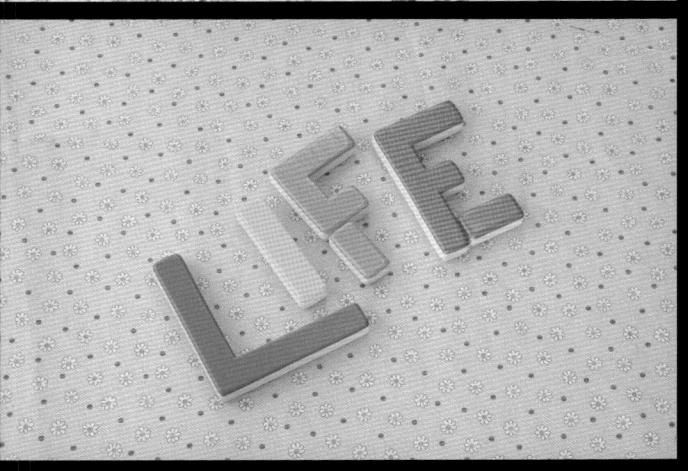

'Light'

NBLight™ is a computer programmed typeface which was derived from a light installation by Dutch designer Jarrik Muller and Stefan Gandl.

Diverse neon bulbs are used to form a simple matrix which is used to create the entire alphabet. NBLight^m contains 255 characters (upper case only).

v. 2006

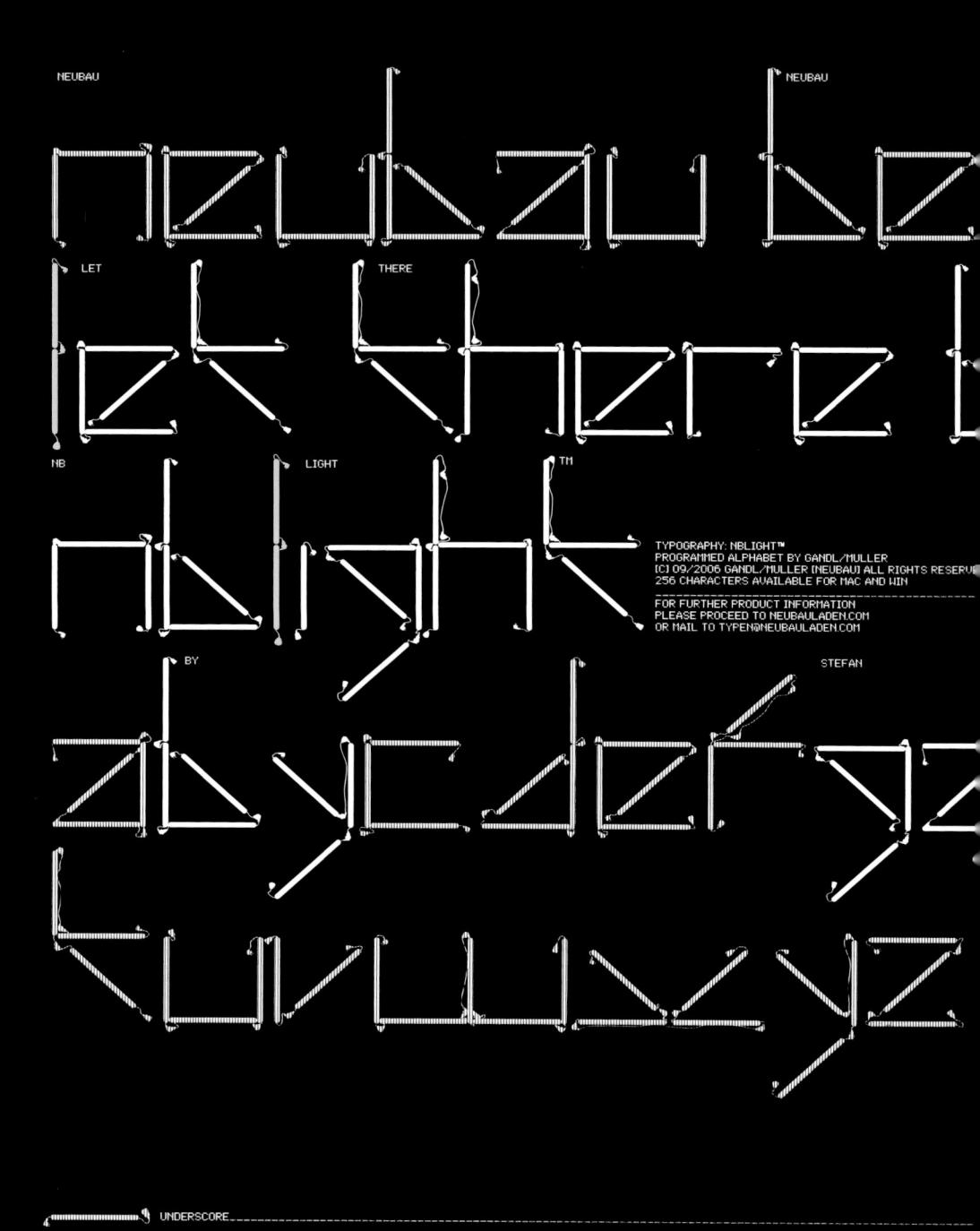

T: NBLight™

D: Neubau

⁽NeubauBerlin Com)

C. Noubaul adon com

W. Illustration

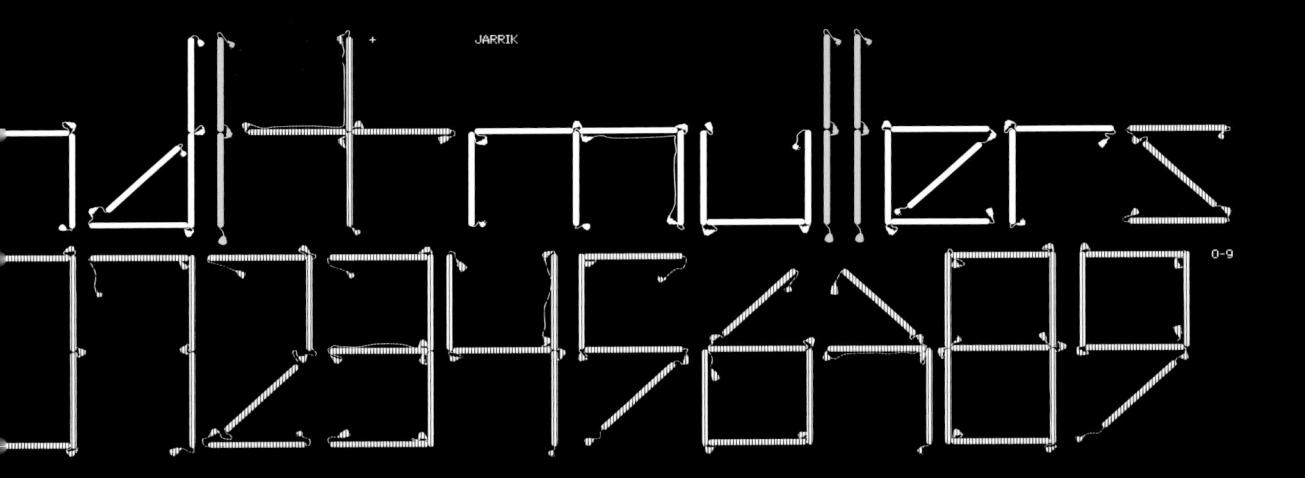

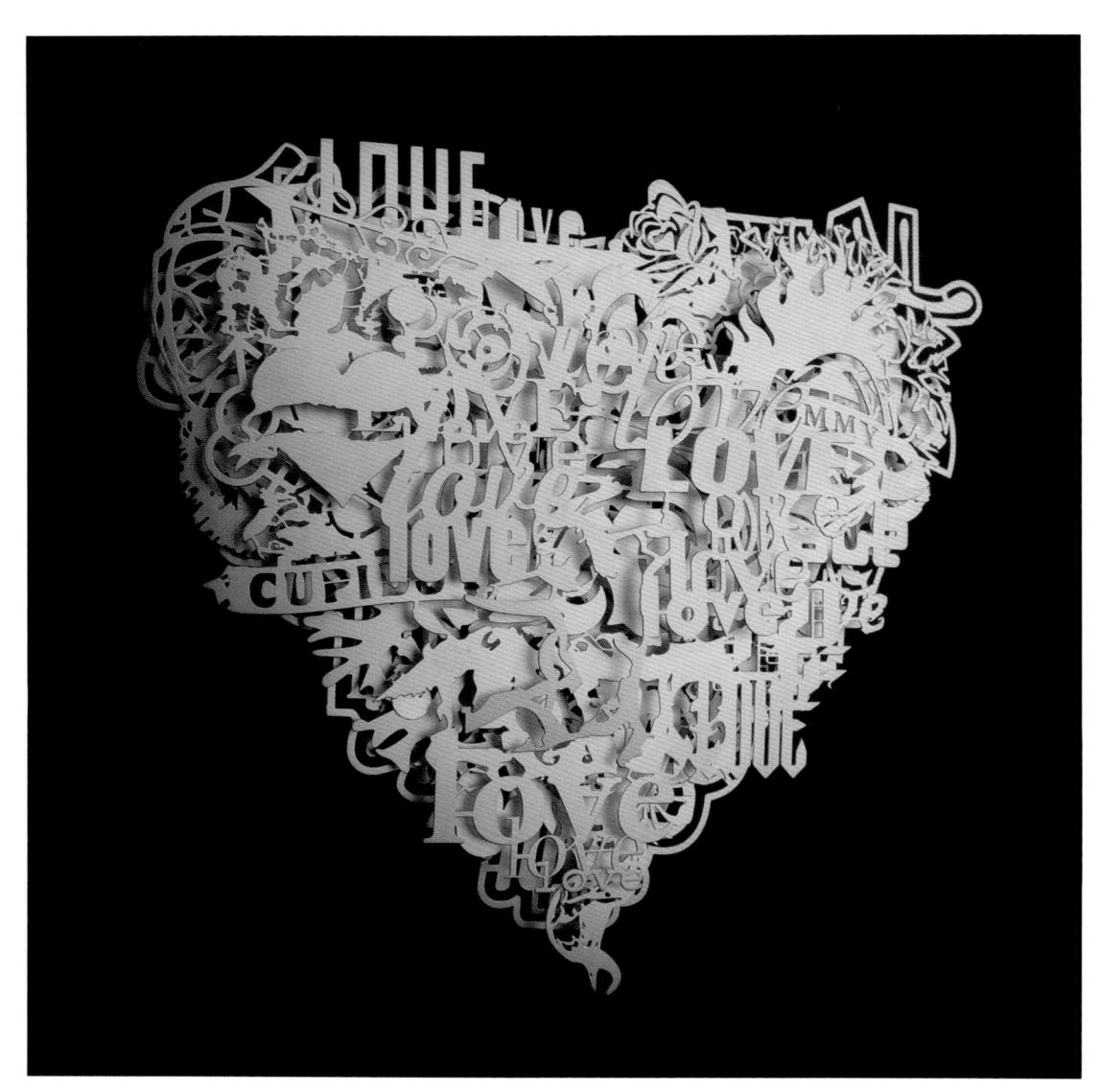

'Love'

The word 'love' is written in all the possible ways to express the idea of 'I love you' as the designer believes that true love never dies. The first prototype of this brooch was made in 2003. It has been revisited, improved and made wearable.

T:Love Heart D:Tjep. C: Tjep. W:3D brooch design L: English

M:12x12x1cm

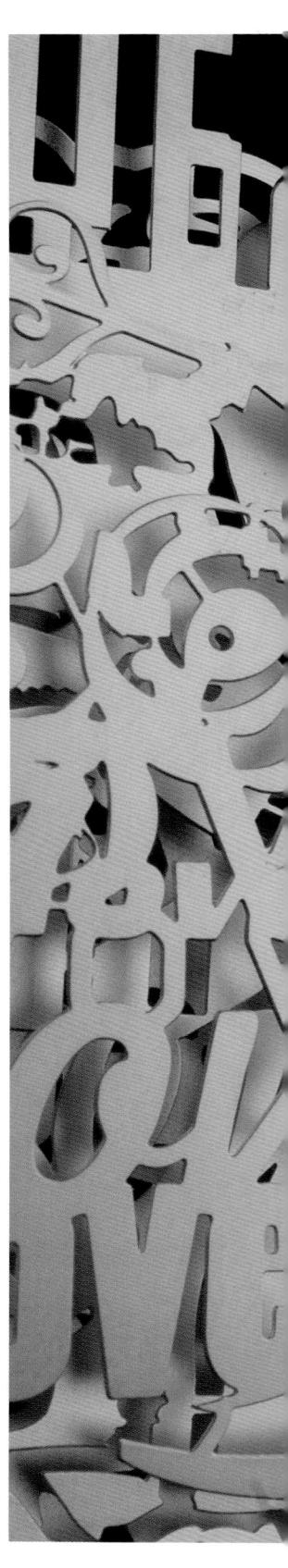

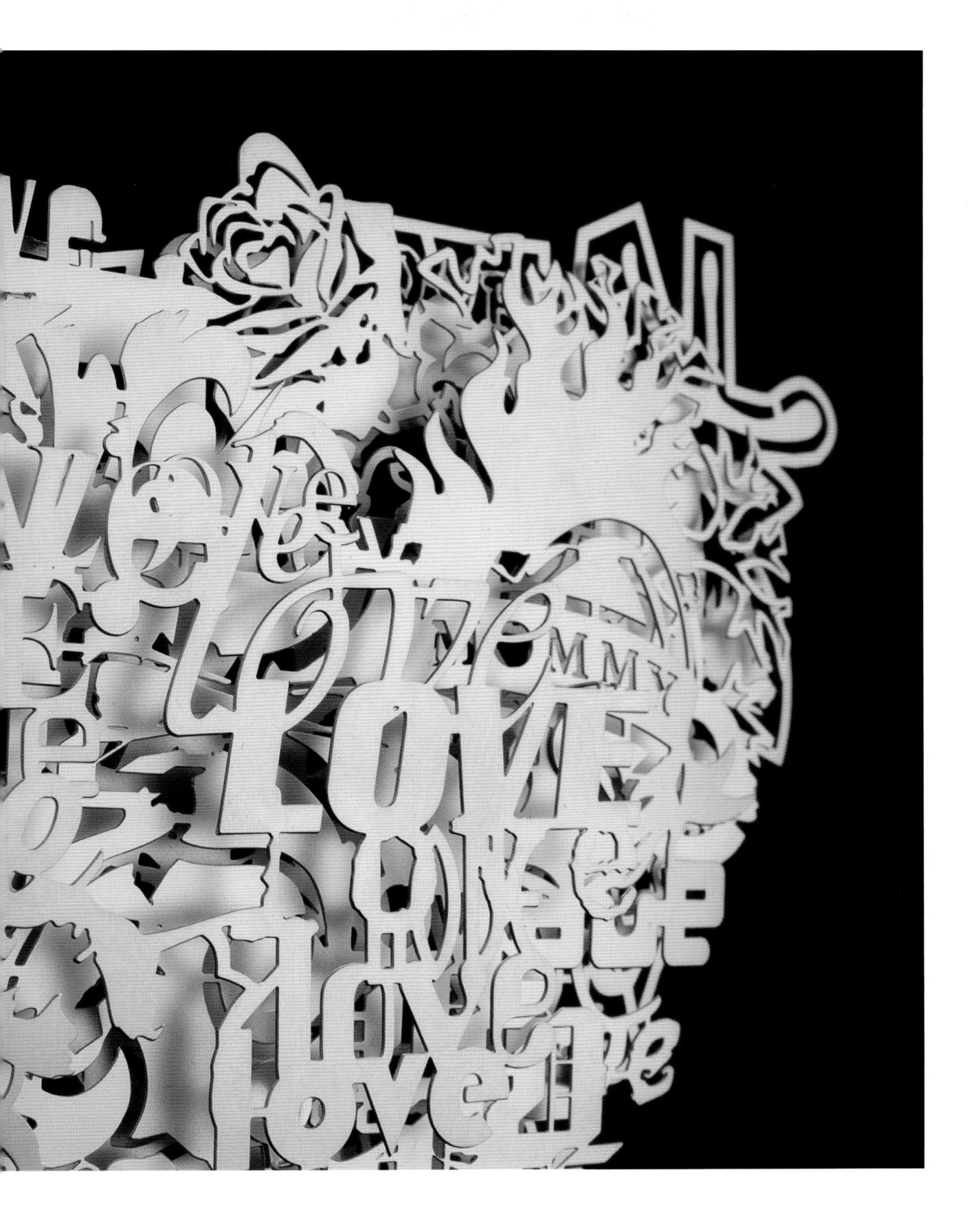

'Media'

Microwave is a new media-arts organization based in Hong Kong showcases classical and cuttingedge new media-arts from around the world. The designers created a totally new identity and designed all promotional items for the Festival in 2006 based on a new custommade typography with fluorescent orange and green. The new image emphasizes a dynamic identity with vision and sustainability.

T: Microwave International New Media Arts Festival 2006 D:Milkxhake C: Microwave W: Event identity L: English, Chinese Y:2006

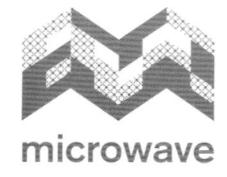

time: 2100 - late venue: 10 St. Francis address: 10 St. Francis Street, Wanchai \$40 at door

audio: Techno/Electric (soft + hard) to jam visual: Procedural Animation Projection

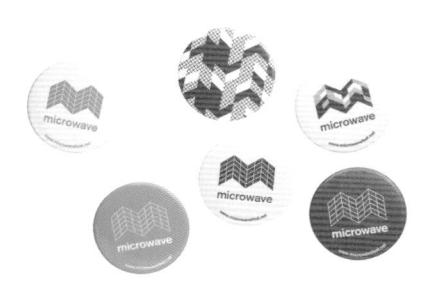

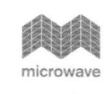

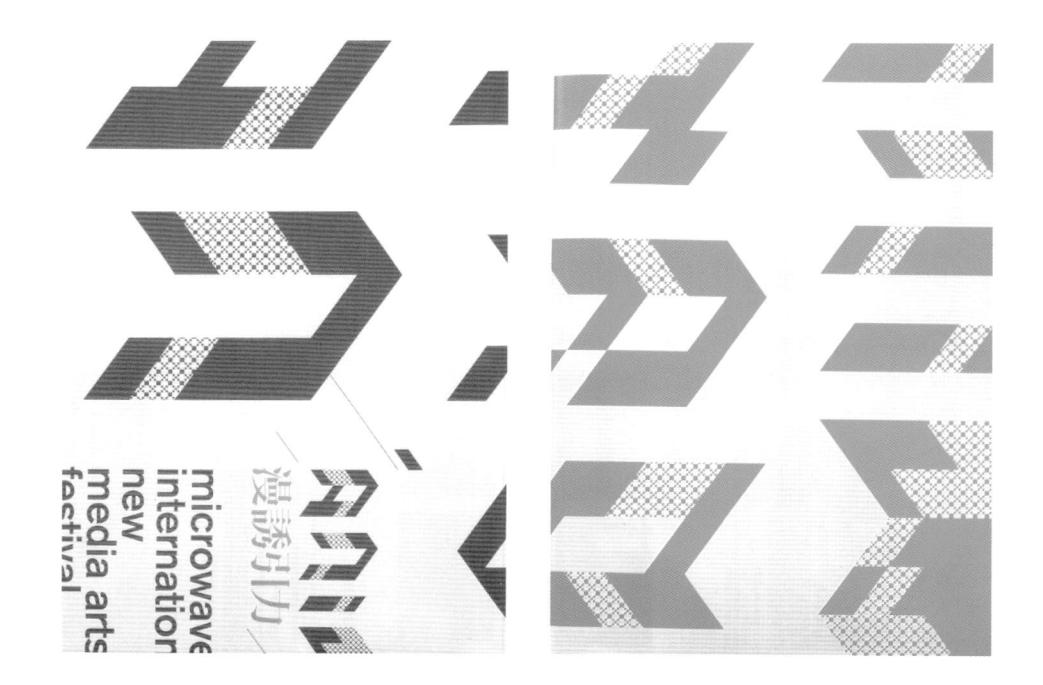
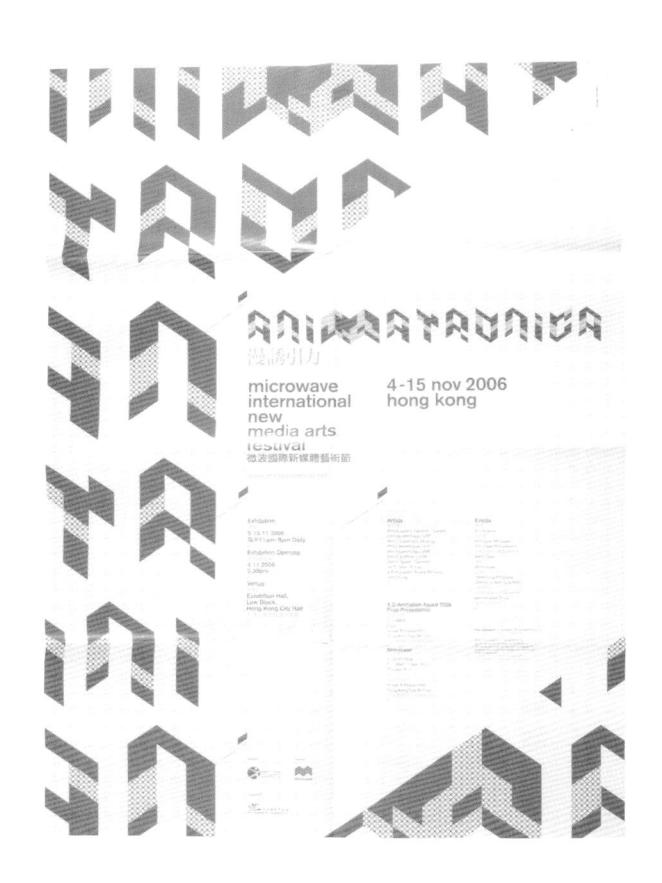

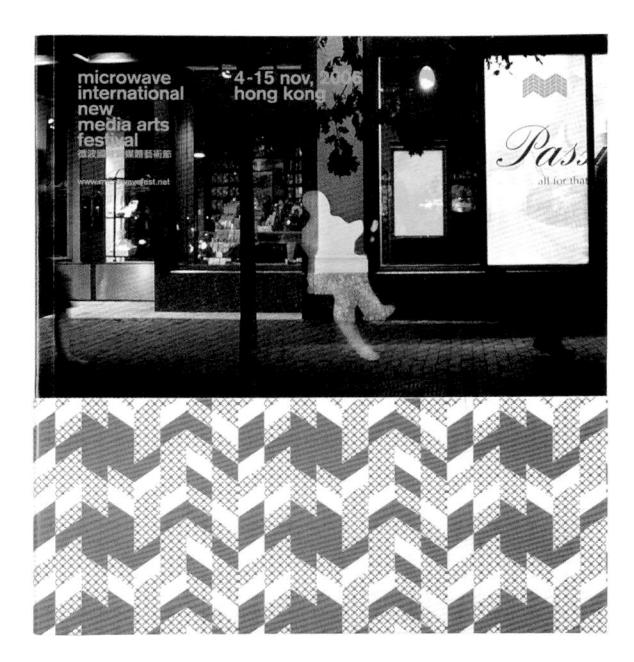

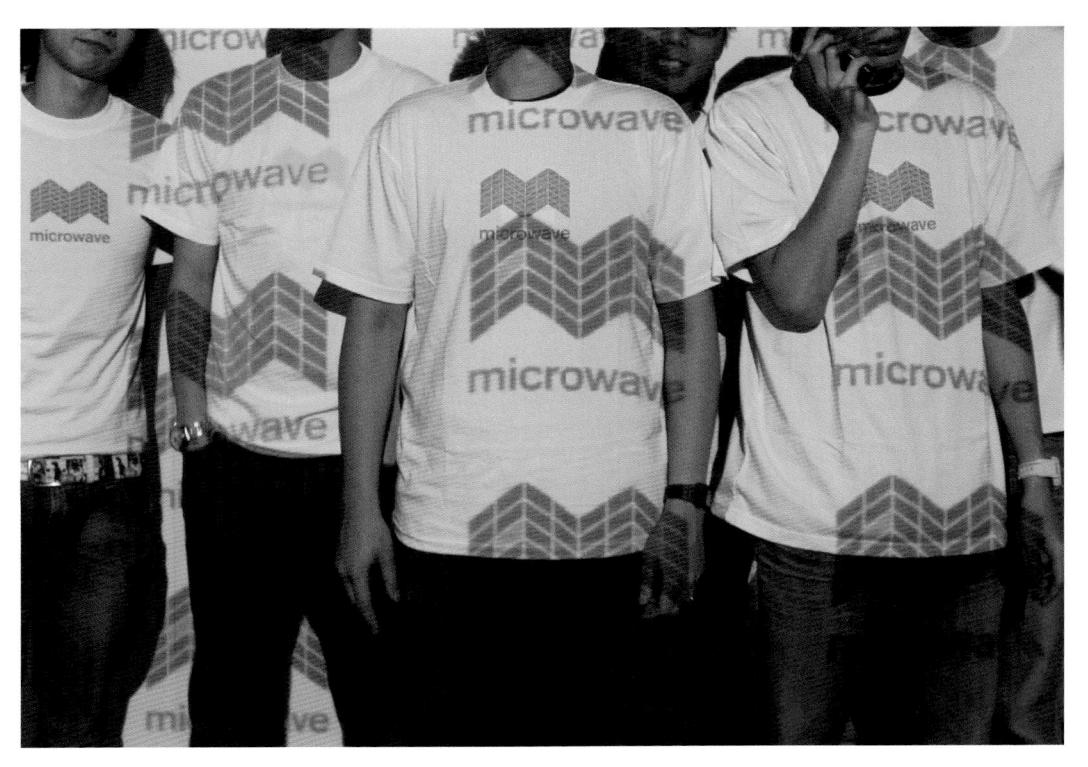

'Medieval'

The annual 'Random Cube' club profile was made strictly typographical. The typeface Midi Evil was created for this purpose, loosely based on medieval letters. The live music was a great mix of drones, noise rock impro to folk electronic music. A clash of everything, just like the typeface. Printed in gold and reflex blue.

T:Random Cube 2006 D:Grandpeople C:Random Cube Festival W:Visual profile Y:2006

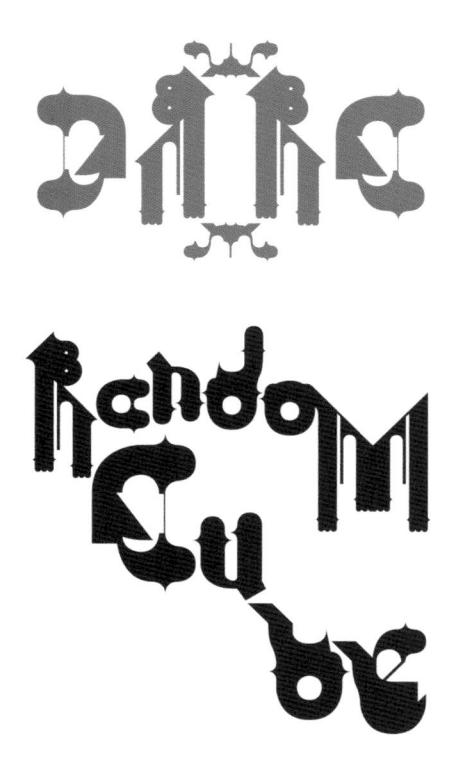

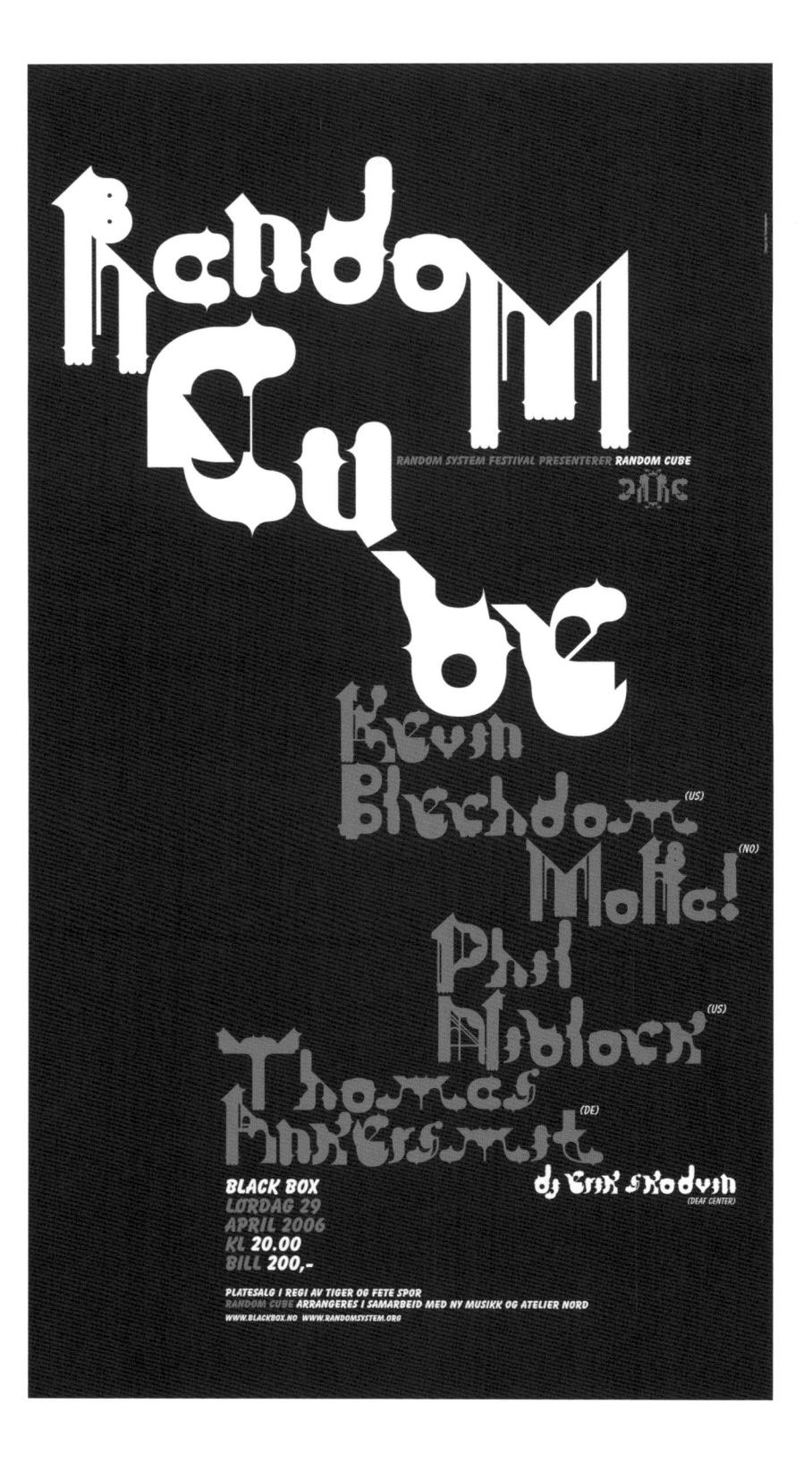

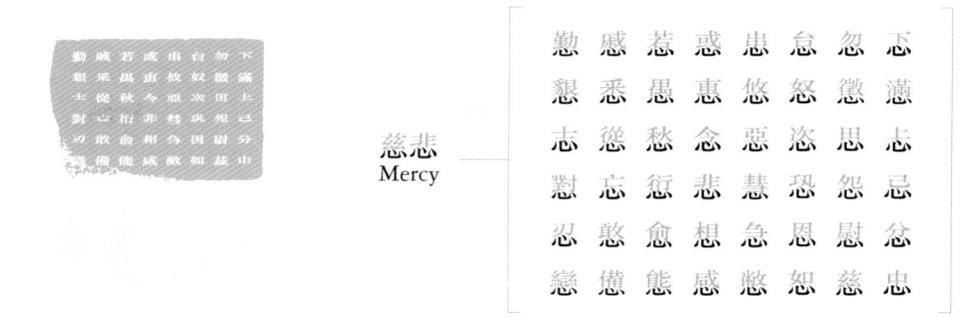

'Mercy'

The design illustrates the idea that oneself could take up any challenges in life and face to different emotional feelings with a mercy attitude.

T:Untitled
D:CoDesign Ltd
C:Peace of Mind Mercy
Foundation
W:Logotype, Stationery
L:Chinese
Y:2005

'Milky'

Image for the 'Talent Channel 4 Book,' which represents 'The 11 'Clock Show,' a famous Channel 4 comedy program. The client wanted to represent the name of the comedians who work in the program. The designers created a milky, cheesy and funny scene, where there is a bomb at 11:00 in a milky surface.

T:Milky Comedy Splash D:Serial Cut™ C:Channel 4 UK W:3D typeface L:English Y:2007

etro i saria e proprio de la companio de la companio

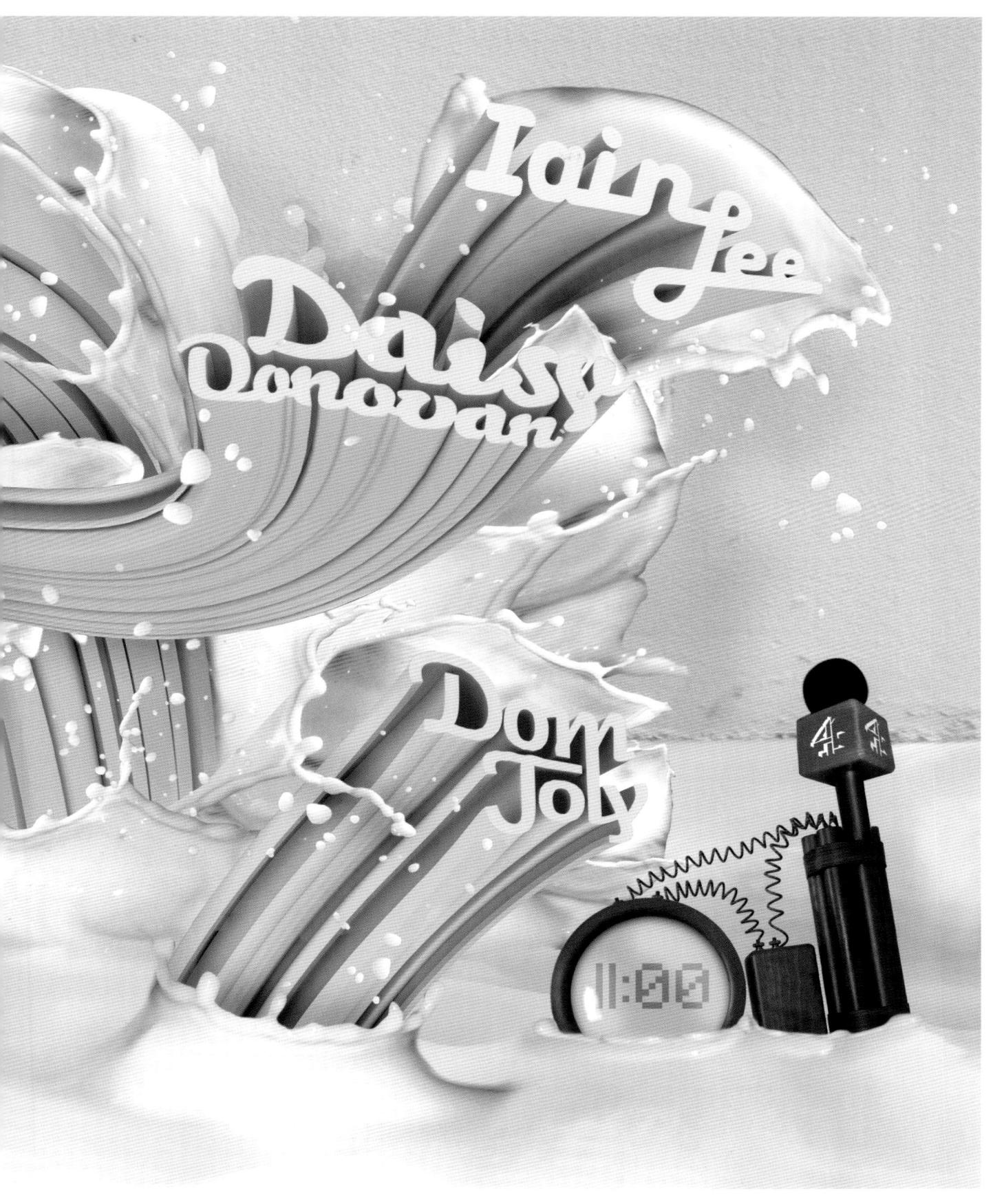

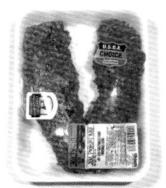

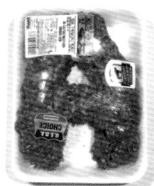

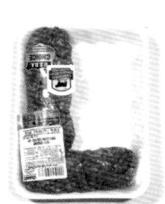

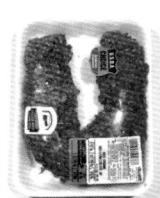

'Mince'

Alphabets completed while enrolled in the Communications Design Department at Pratt Institute. Each character was shaped, wrapped, and photographed individually.

T:Value Pack D:Robert J. Bolesta C:Robert J. Bolesta W:Typeface Y:2005

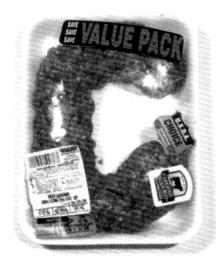

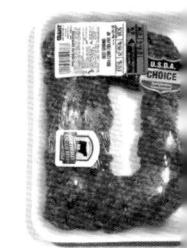

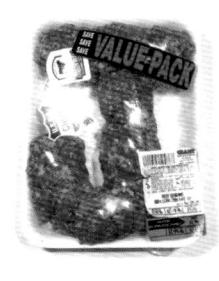

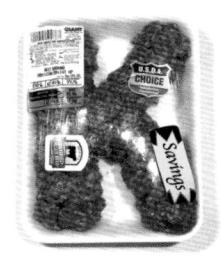

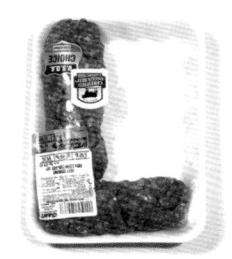

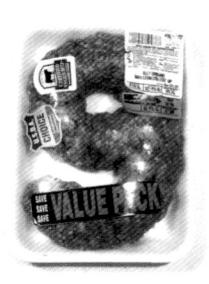

'Misprint'

- 1.Splash page for misprintedtype.com
- 2.Artwork created for an art show.
- 3.A personal work of the designer.

T:1.MisprintedType 2.Everything Will Be Just Fine

3.Greed D:Misprinted Type

C:Misprinted Type

W:1,2.Drawing
3.Drawing, Collage

L: English

Y:1.2002

2.2006

3.2007

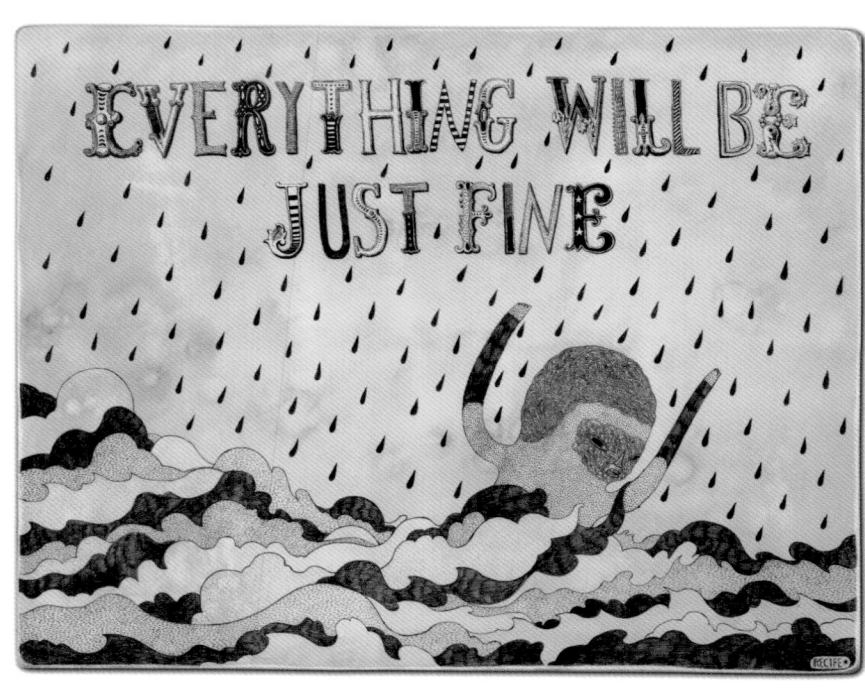

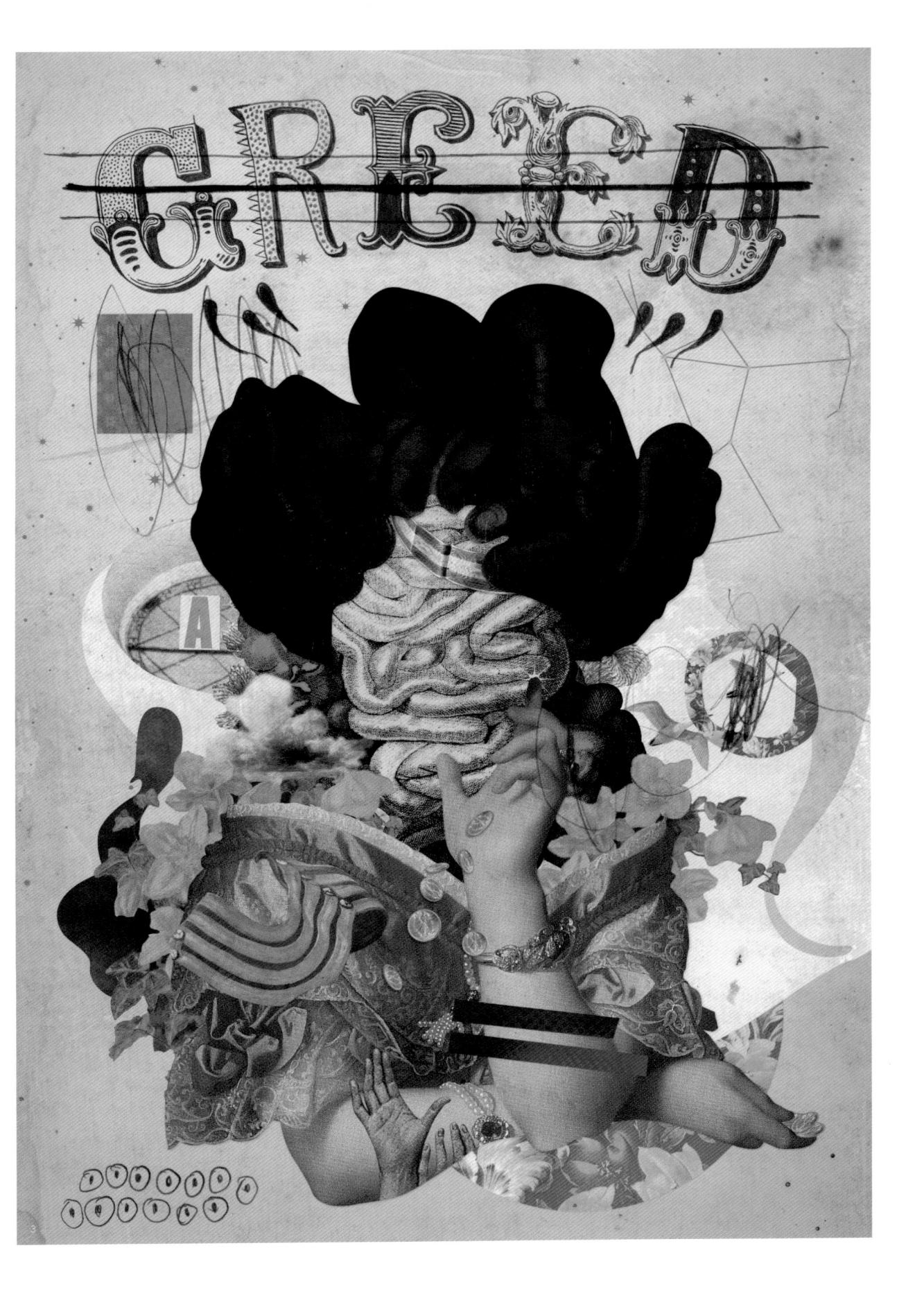

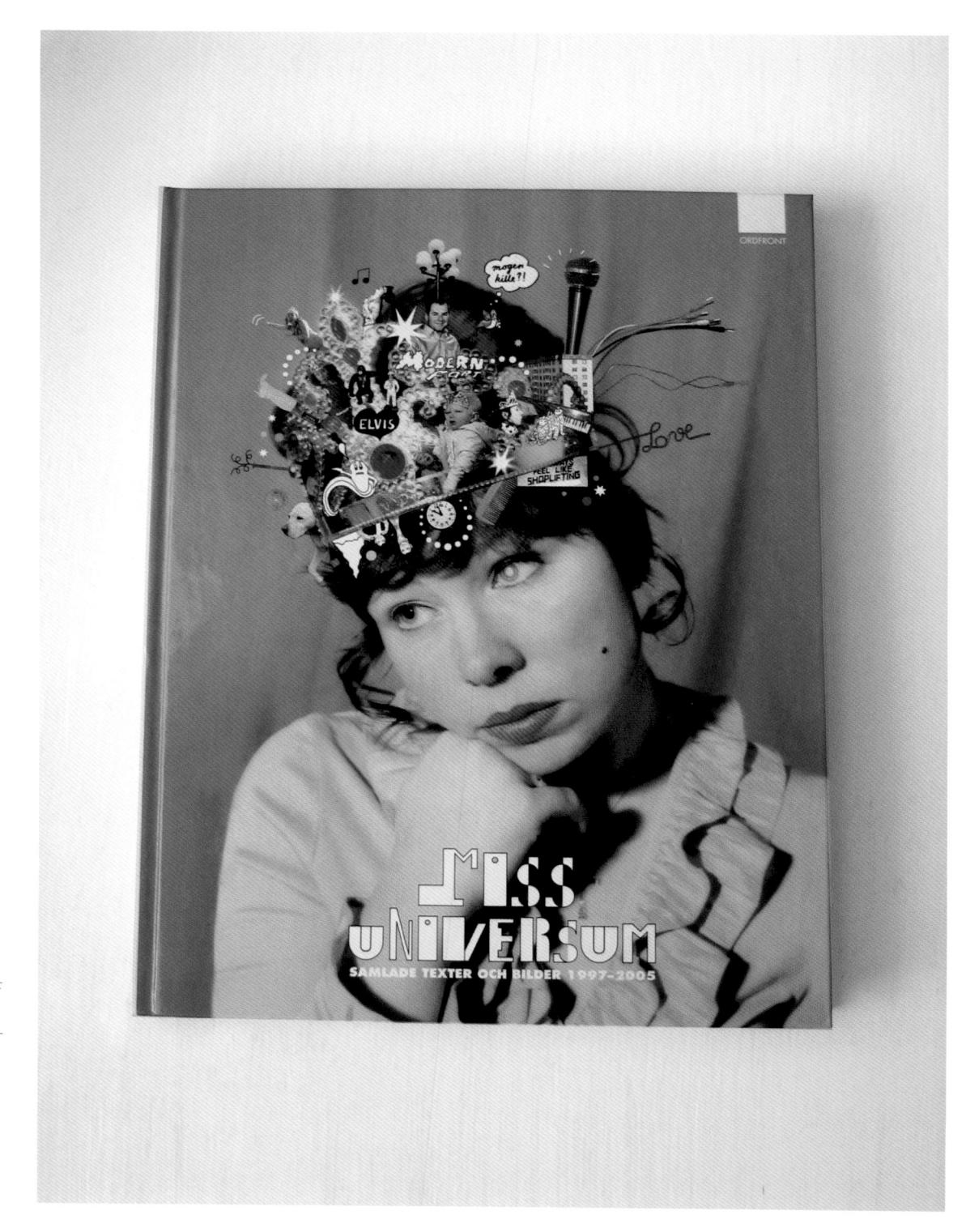

'Miss'

A book with the collected work of performance artist Catti Brandelius alter ego Miss Universum.

T:Miss Universum D:Hjärta Smärta C:Ordfront Publishing House

W: Book L:Swedish Y:2005

profession to the contract of the contract of

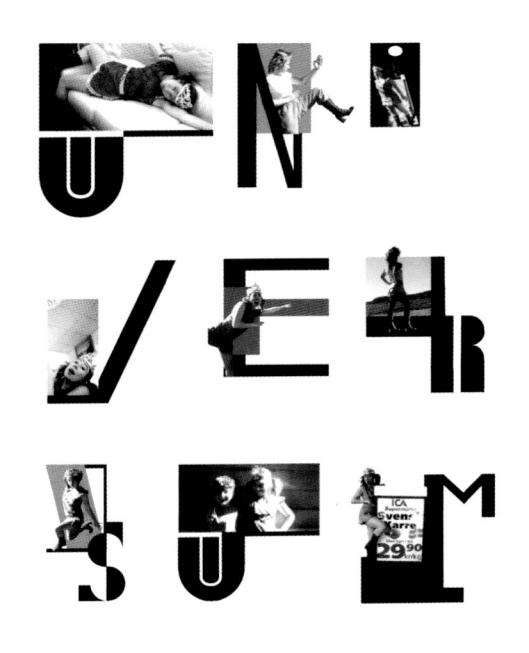

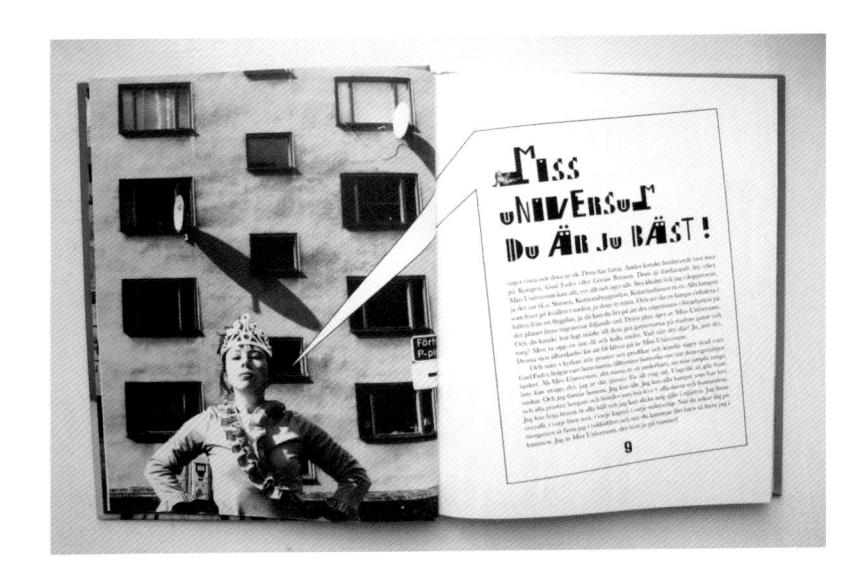

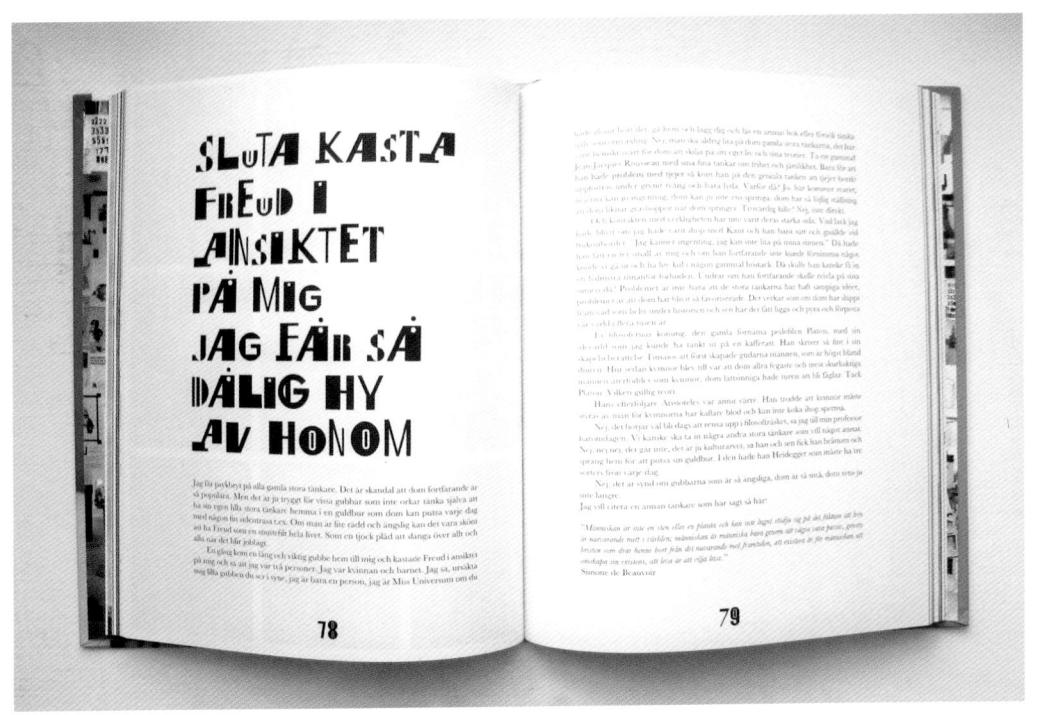

'Mug'

Build was initially commissioned to produce the identity for a new online shop called 'TYPE' which based in Hong Kong. The idea of the shop was to sell beautifully made products with a typographic leaning by different designers. After completing the branding, Build was asked to design the launch range of products for the store based on its range, boldly around different typefaces.

T:TYPE products
D:Build
C:TYPE, Hong Kong
W:Branding, Product
design
L:English
Y:2006

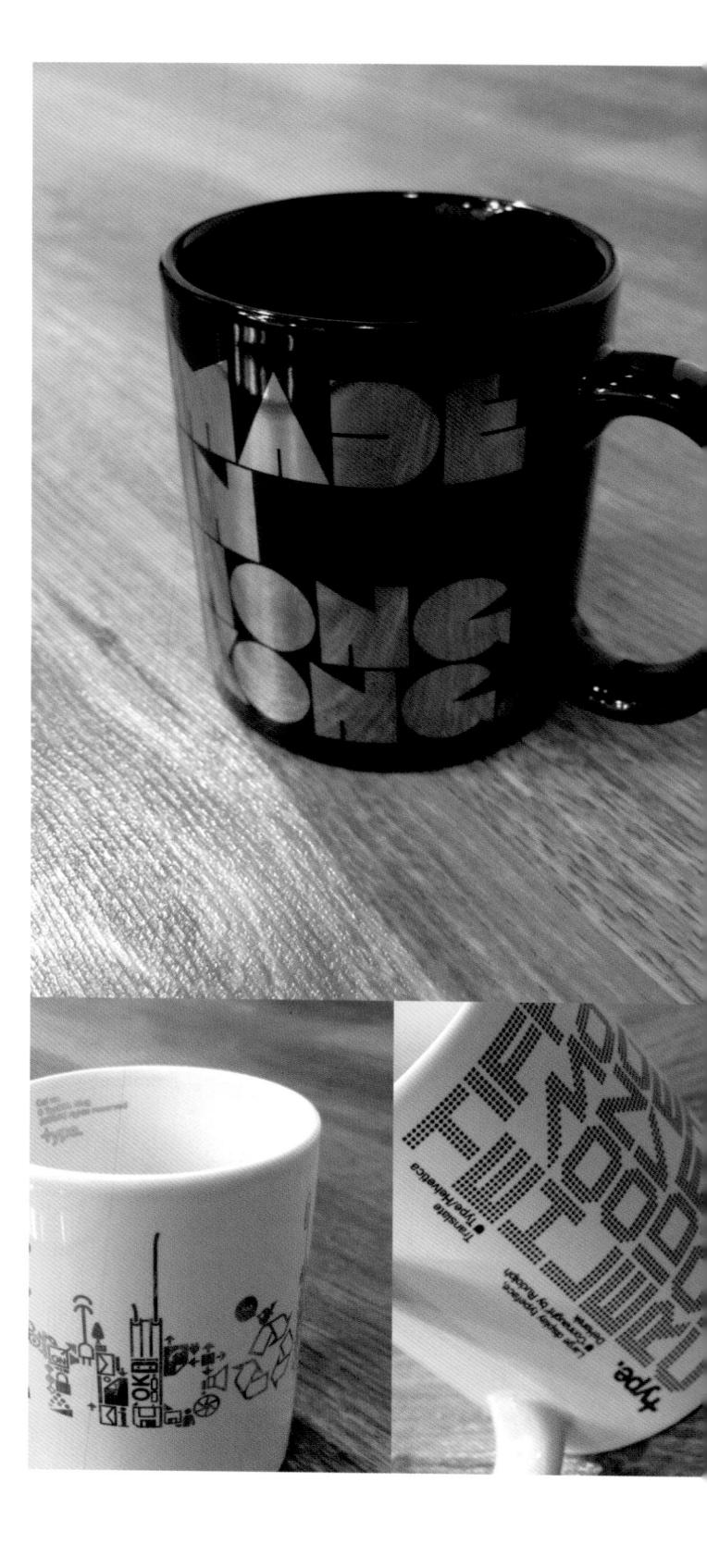

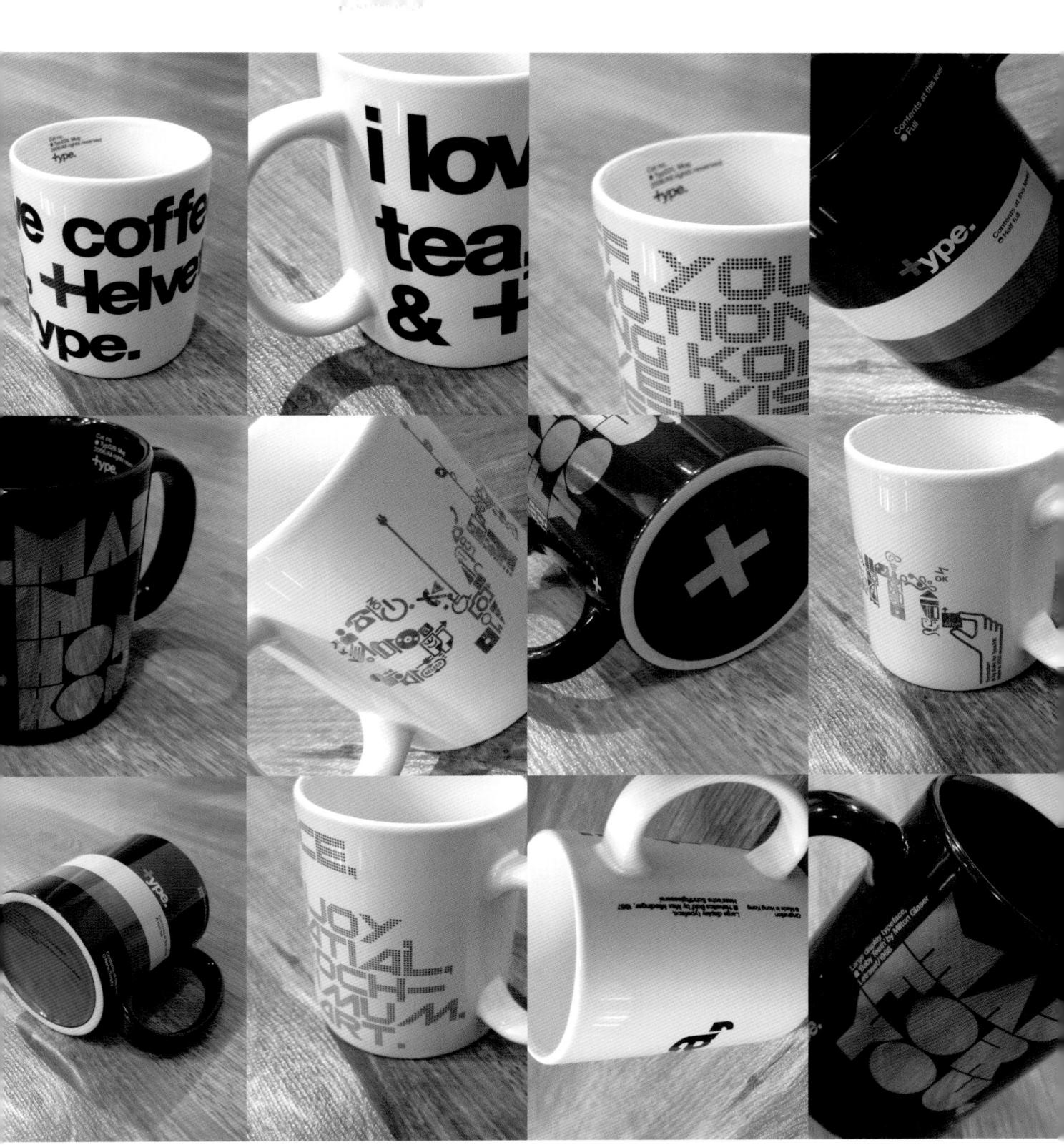

'Music'

This is a contemporary music concert organized by a French musician, who is now living and teaching in Tokyo. As the theme of the concert is about poems written by a Greek poet, Sappho, and a Greek composer, Xenakis, the designer made use of the poems with Greek alphabets and also some Japanese translation of the poems as the main elements of the design. He made changes to the size of the text and placed them on the harpsichord and the stage floor to make the design looked like coming out from the harpsichord and flowing around the space. At the same time, the design was made to combine with other objects in the shadow of the objects and other musical instruments.

T:Clavecin+Percussion III

D: Tsang Kin-wah

W:Stage design

w:Stag

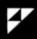

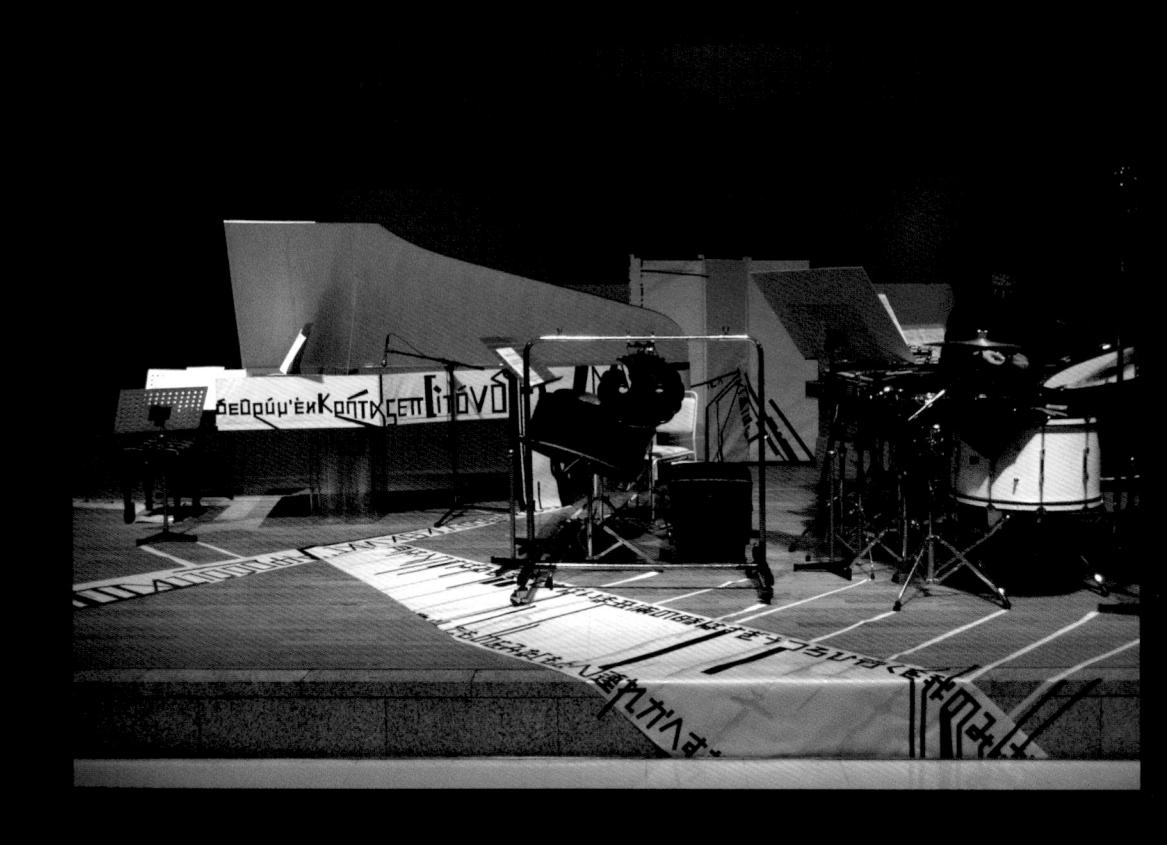

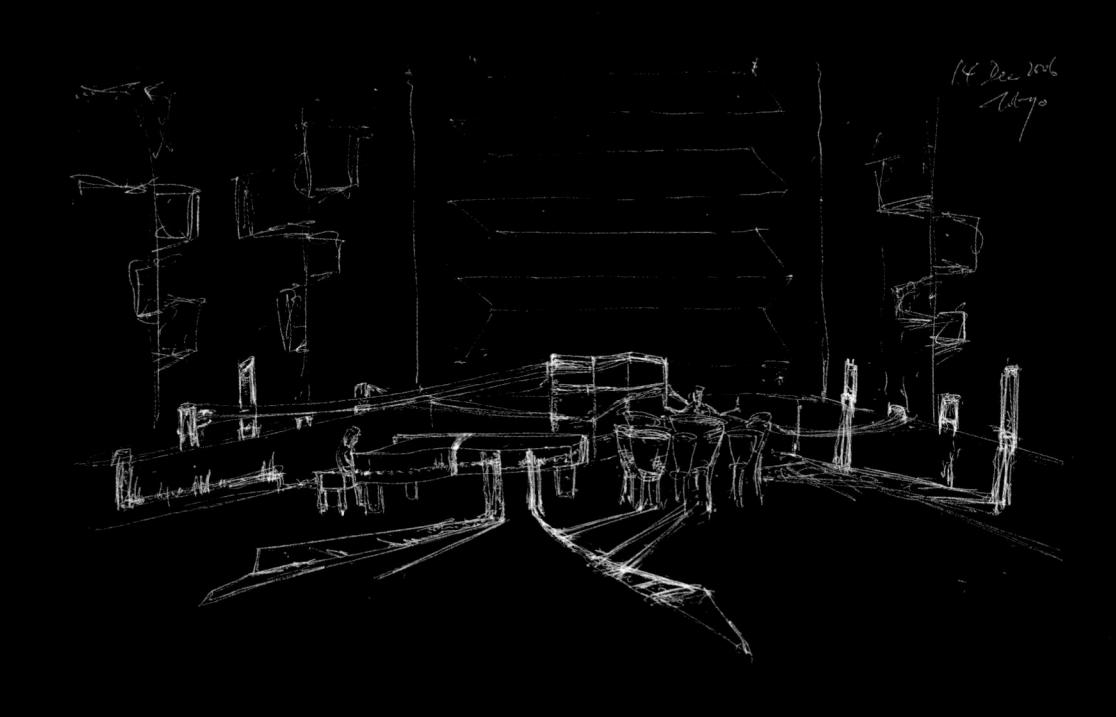

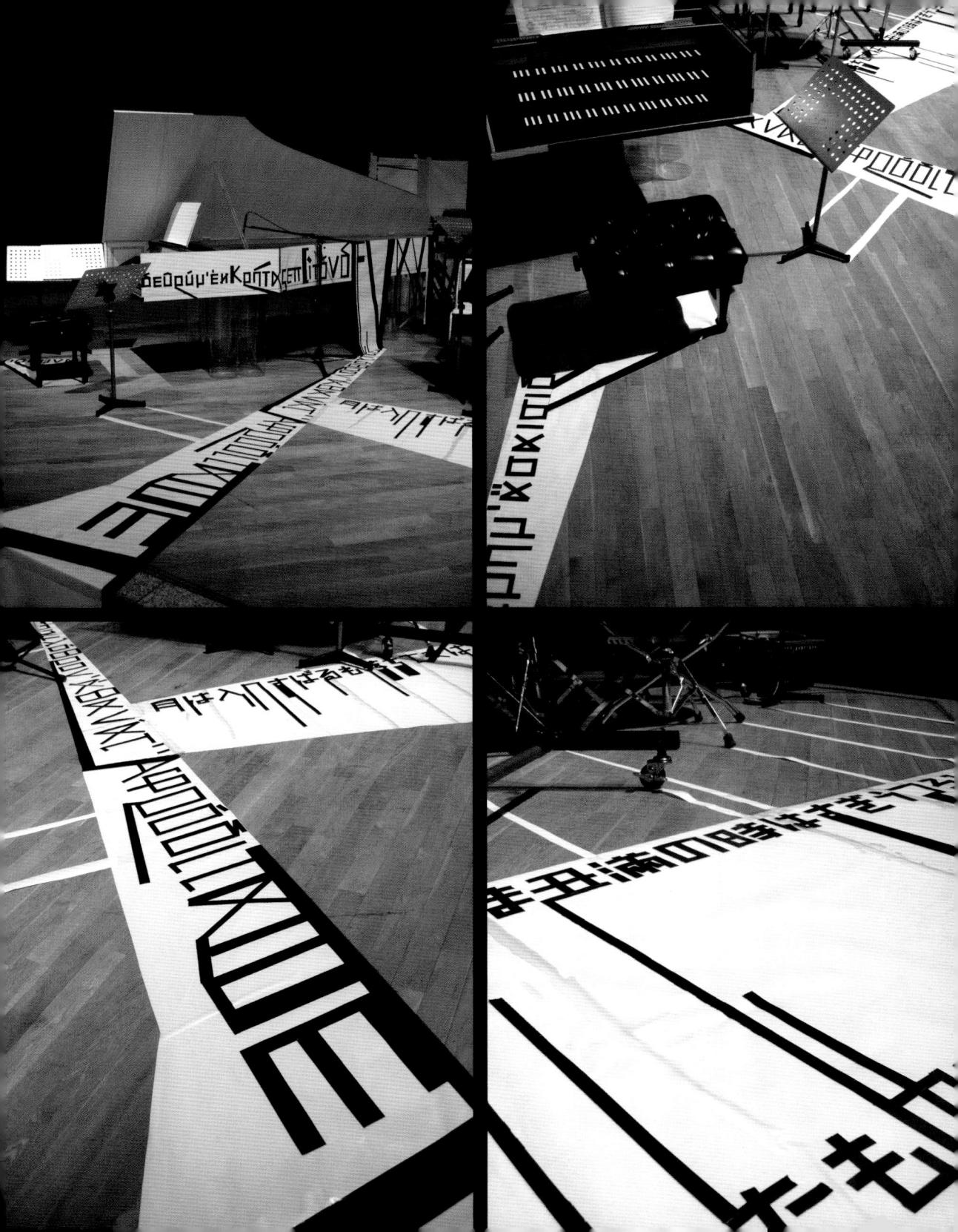

'Neon'

'Interiors Light' was inspired by Marcel Breuer's 'Wassily Chair' and was originally to be constructed from rounded chrome tubular steel. As Byron progressed he realized that by thinking on a smaller scale it could be constructed in neon. The limitations of working in neon is tough on the original design so he needed to rework the design several times, embracing the constraints of this beautiful and delicate material.

T:Interiors Light D:Andrew Byrom C:Andrew Byrom W:3D typeface L:English

L: Engl:

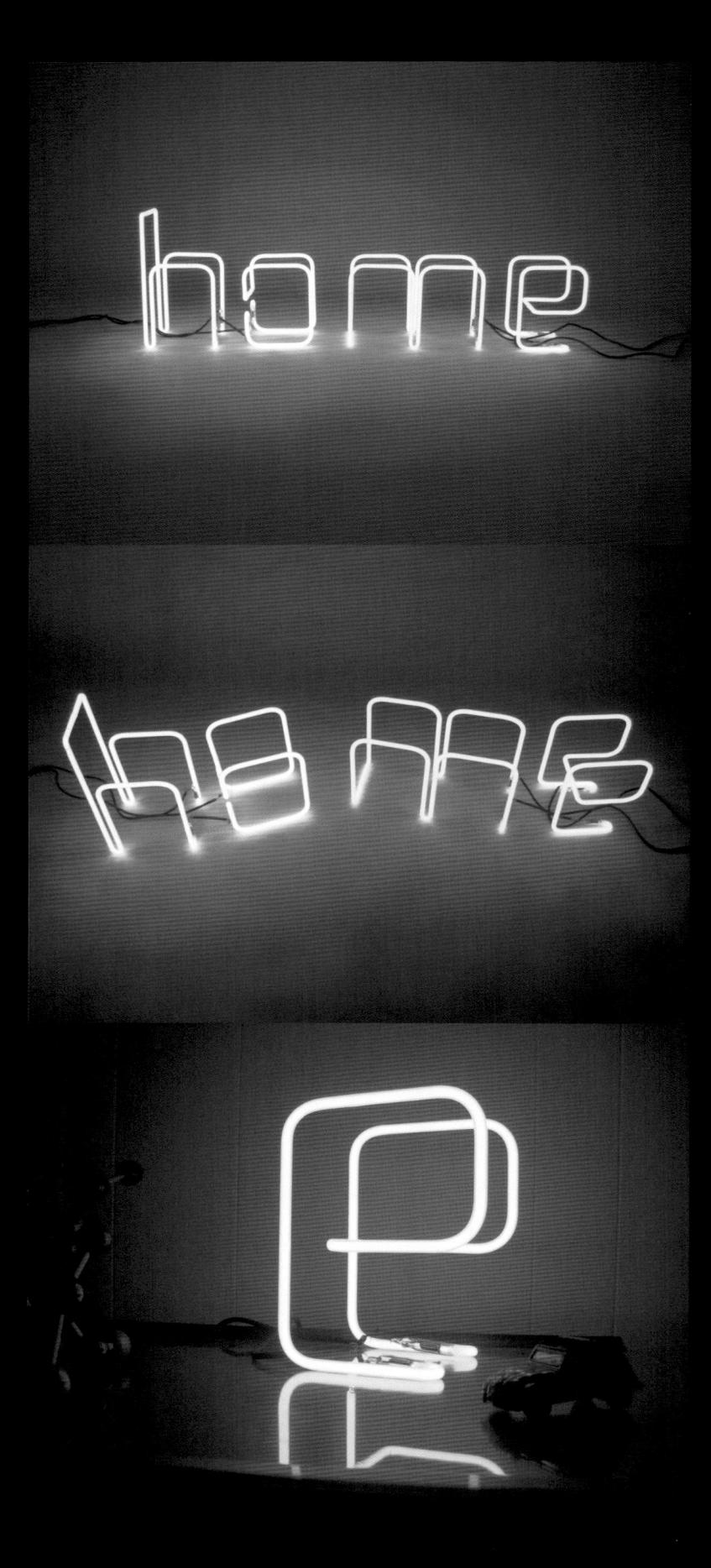

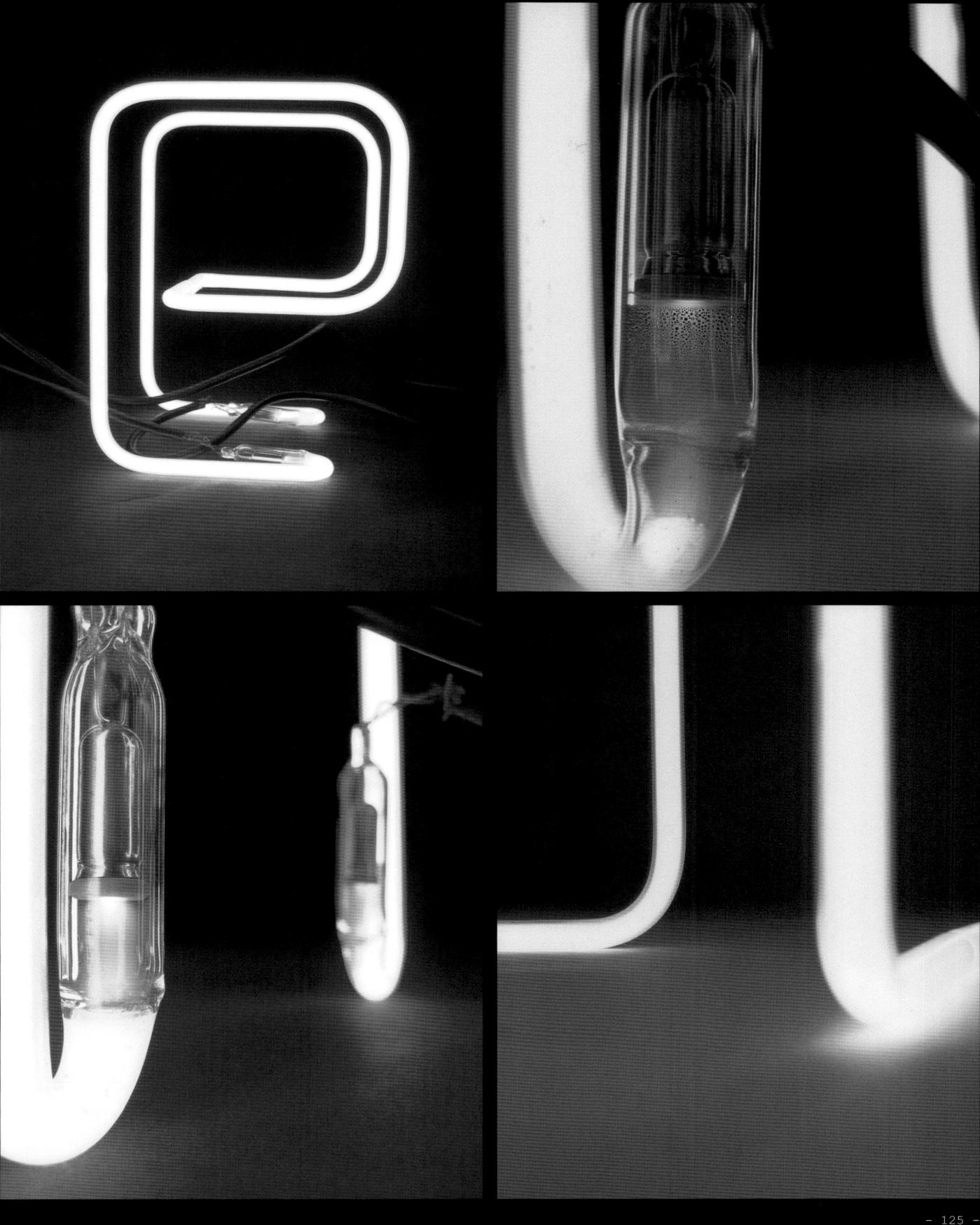

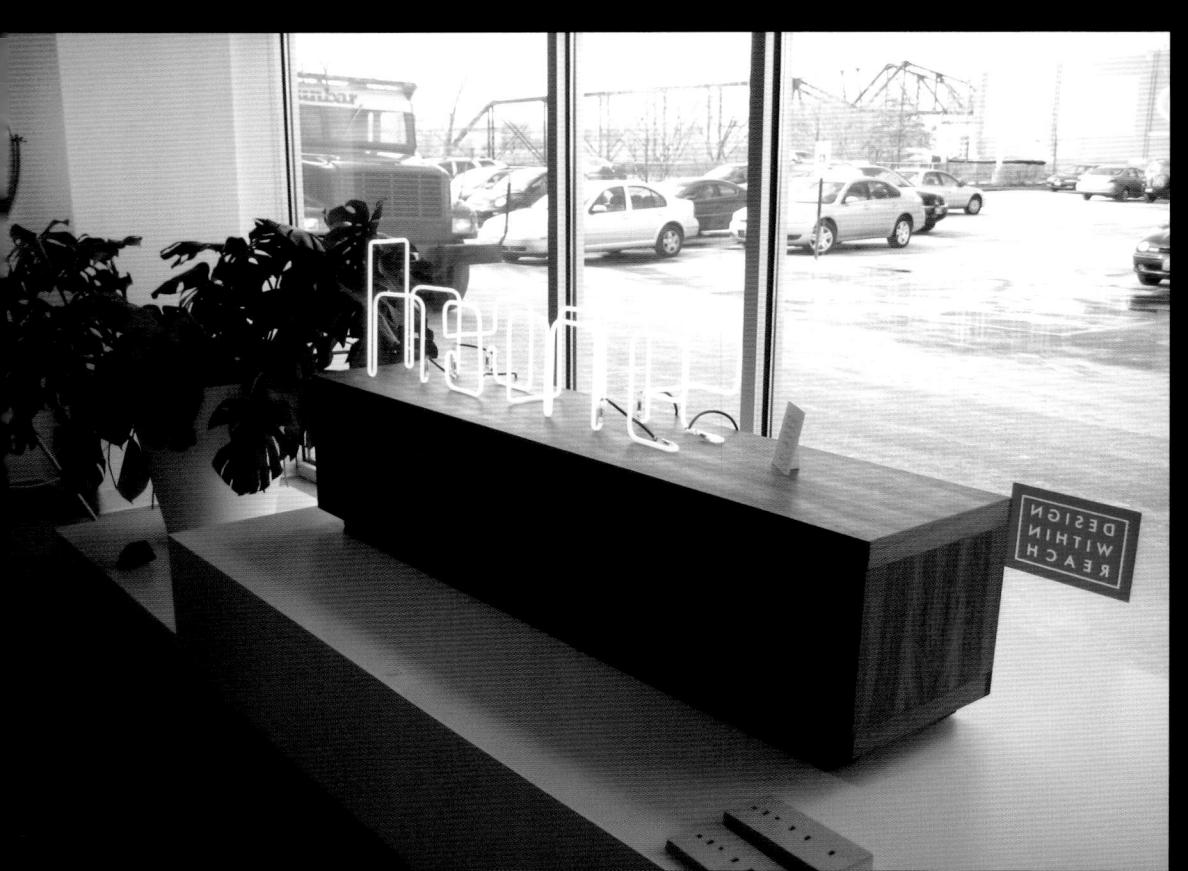

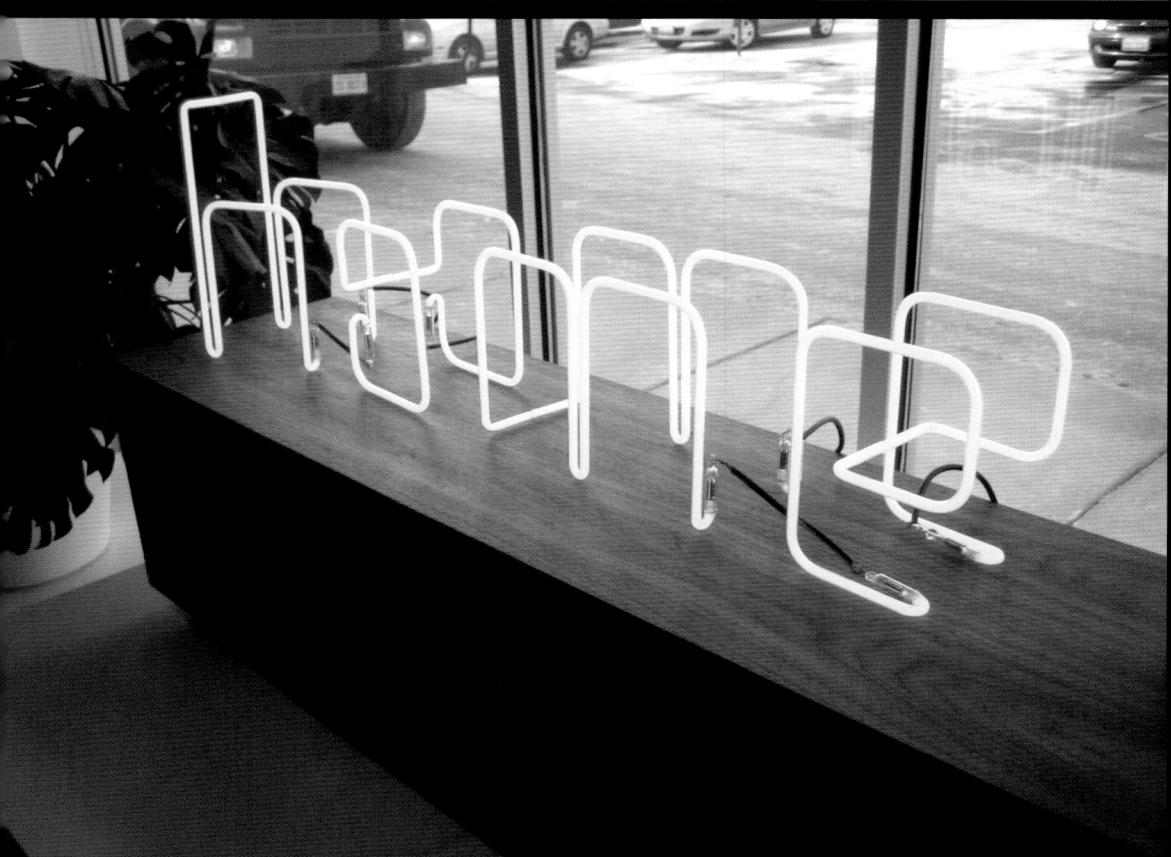

'New'

Phonetic play for Command+N charrette. A group of collaborating designers were asked to contribute work around the theme 'new.'

T: NEW!
D: Apirat Infahsaeng
C: Command+N
W: Poster
L: English
Y: 2007

'Night'

Guy designed a series of posters inviting designers to a fictional event - Designer's Night in Tel Aviv. The invitational posters are built from photographs of fluorescent and home lights rearranged into letters. The designer loves the fact that when you look closely at the posters you can see things like home floor and power plugs.

T: Designer's Night in Tel Aviv D: Guy Haviv C: Guy Haviv W: Poster L: Hebrew Y: 2007

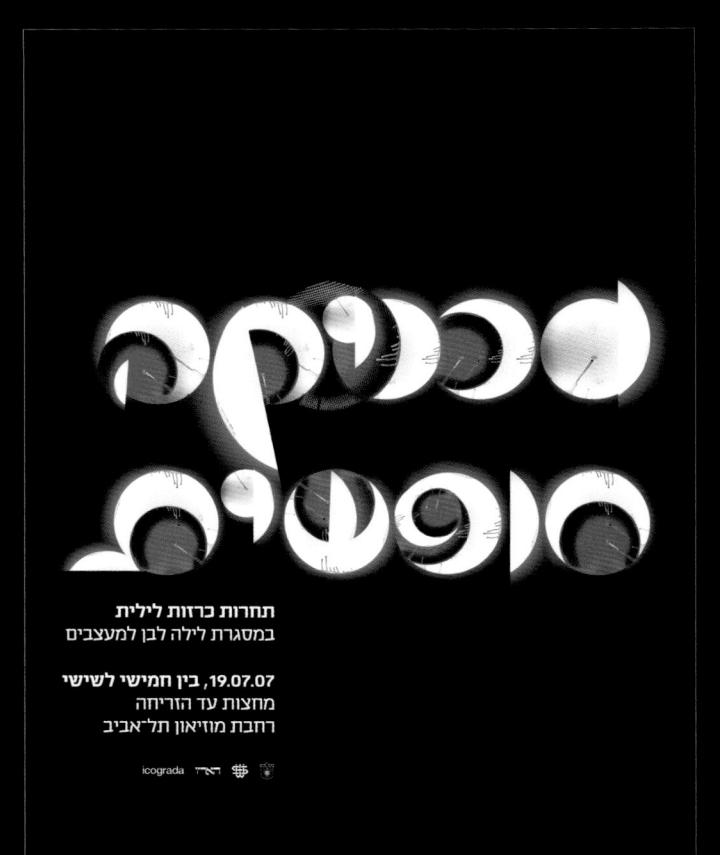

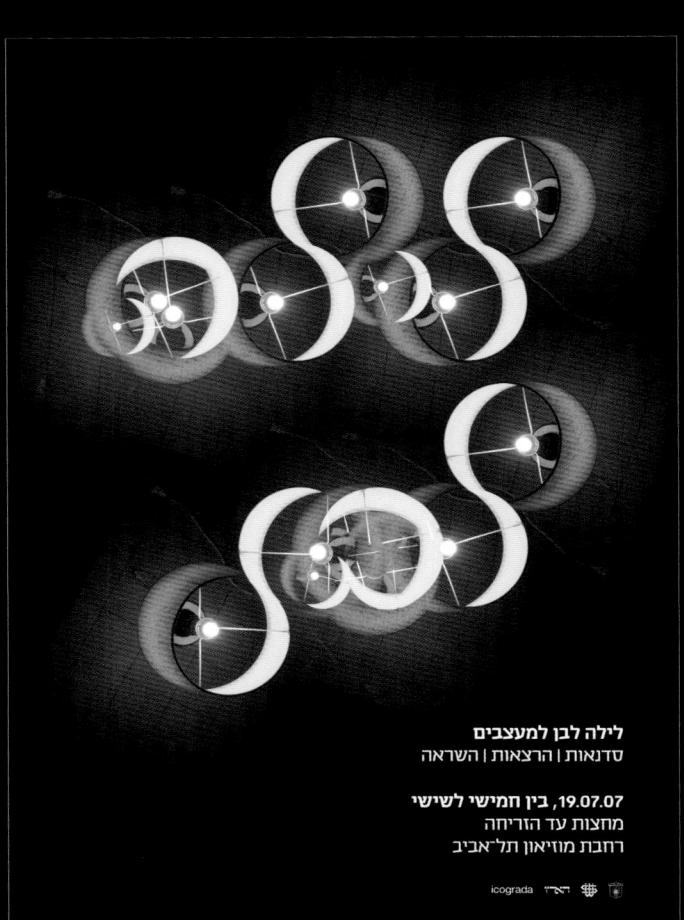

תחרות כרזות לילית במסגרת לילה לבן למעצבים

19.07.07, בין חמישי לשישי מחצות עד הזריחה רחבת מוזיאון תל־אביב

icograda 🐃 🕸

'Nordic'

Combining the simplest elements with organic forms to produce a new Chinese typeface to echo with Scandinavian design.

T:Nordic Alive Typeface D:Hamlet Au-Yeung C:Hamlet Au-Yeung W:Typeface L:Chinese Y:2005

私今日考新案發 明品一語四十五 抱燈文書內限定 本導丁恃學友愛 母兄妹大間我國 小賢句口永氾他

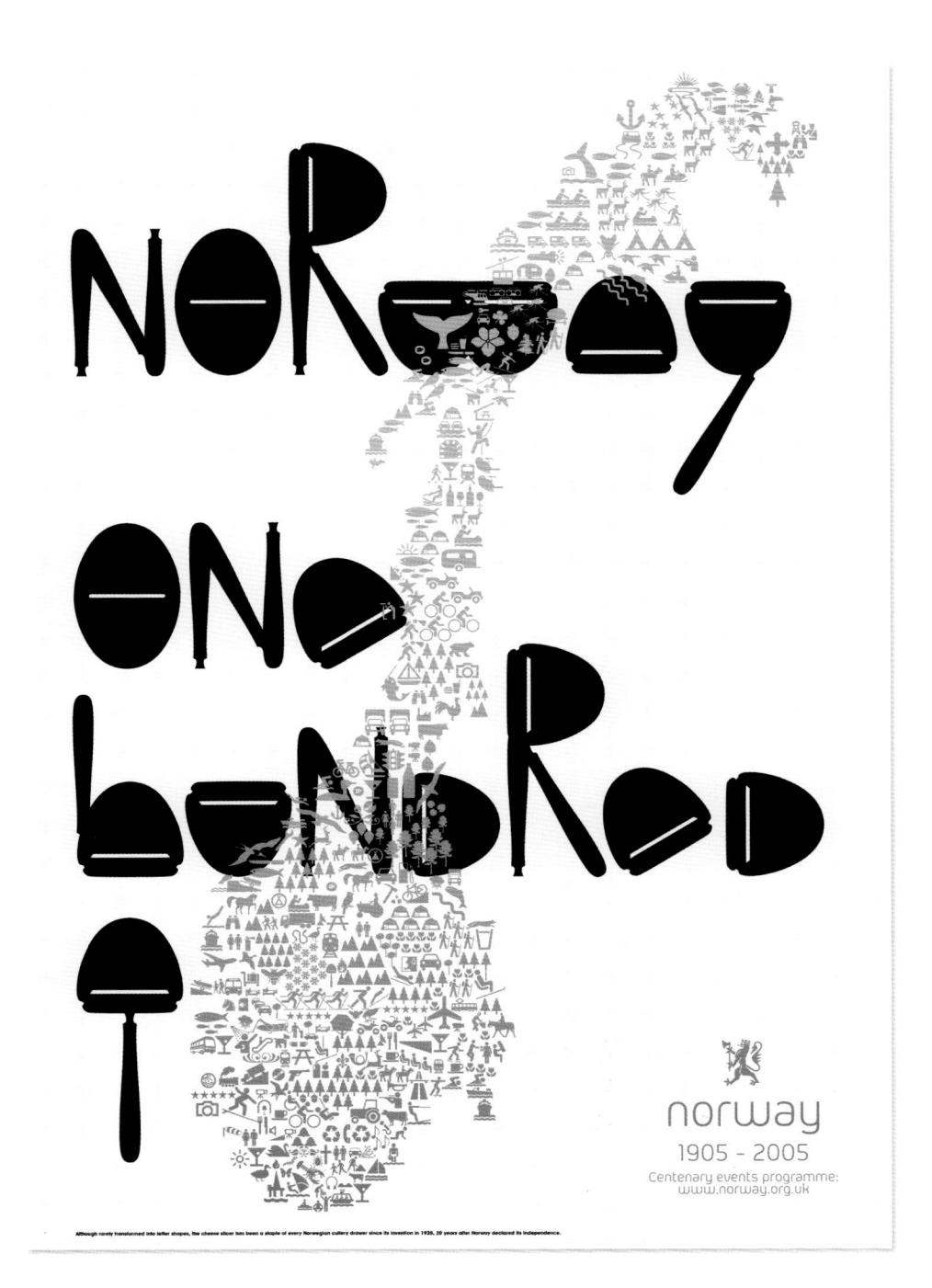

'Norway'

The poster is made to celebrate the Norway's centenary. It is printed with black and gold ink.

T:Norway 100 D:Non-Format C:The Royal Norwegian Embassy, London W:Poster L:English Y:2006

'Number'

Poster design for the brand 'Fayte.'

T: Life and Number. Number and Life D: Sixstation C: Fayte W: Poster L: Chinese Y: 2007

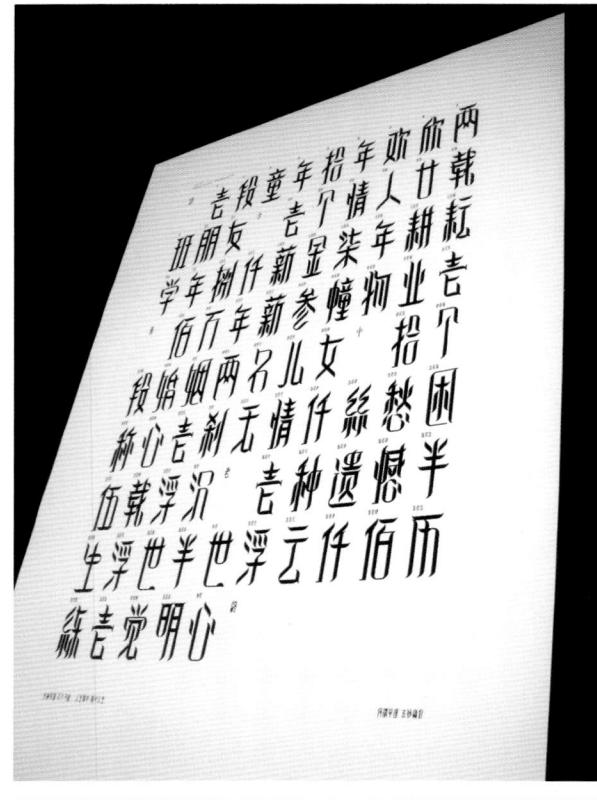

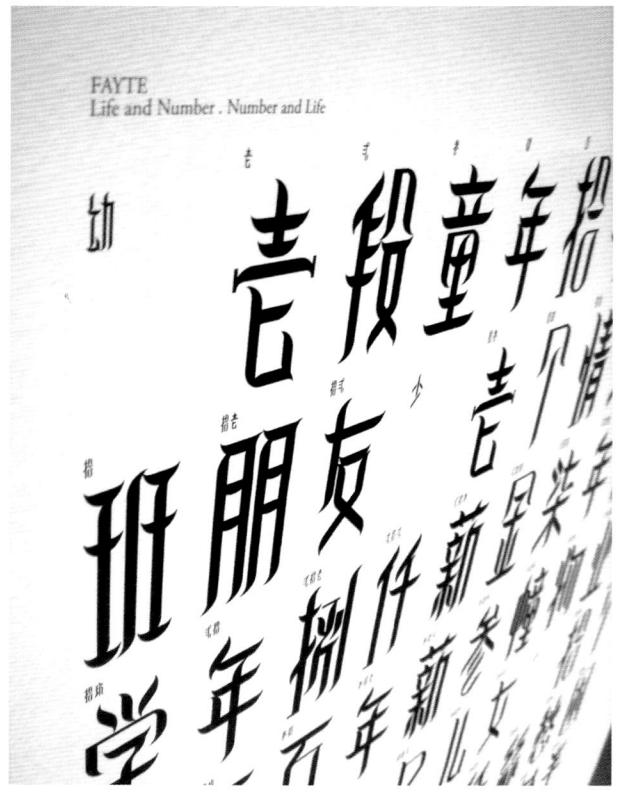

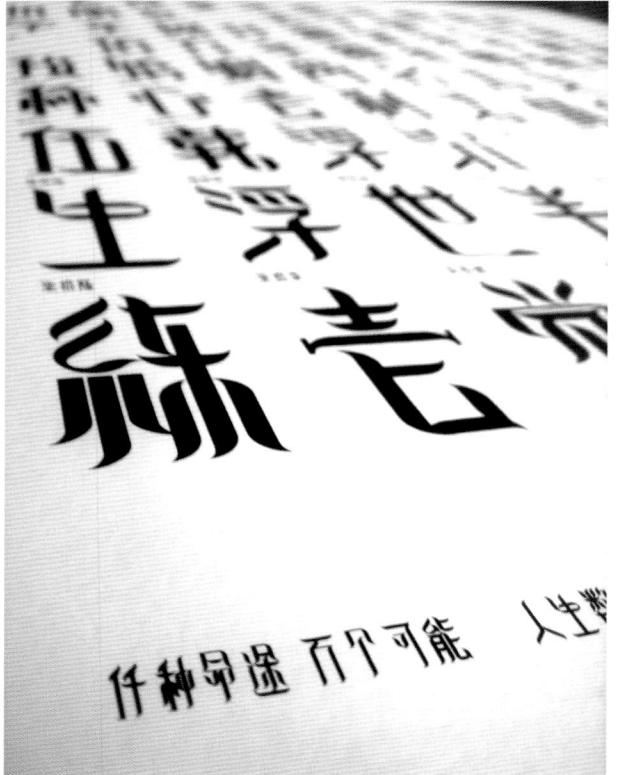

FAYTE Life and Number Number and Life

年指年斯 加 河河

作种早盛 百个可能 人生物宁 物宁人生

'Objects'

Making a poster with any kinds of objects in 2 hours.

T:AinsiFont
D:Atelier télescopique
C:AinsiFont. Digitale
Type Foundry
W:Poster
L:English, French
Y:2007

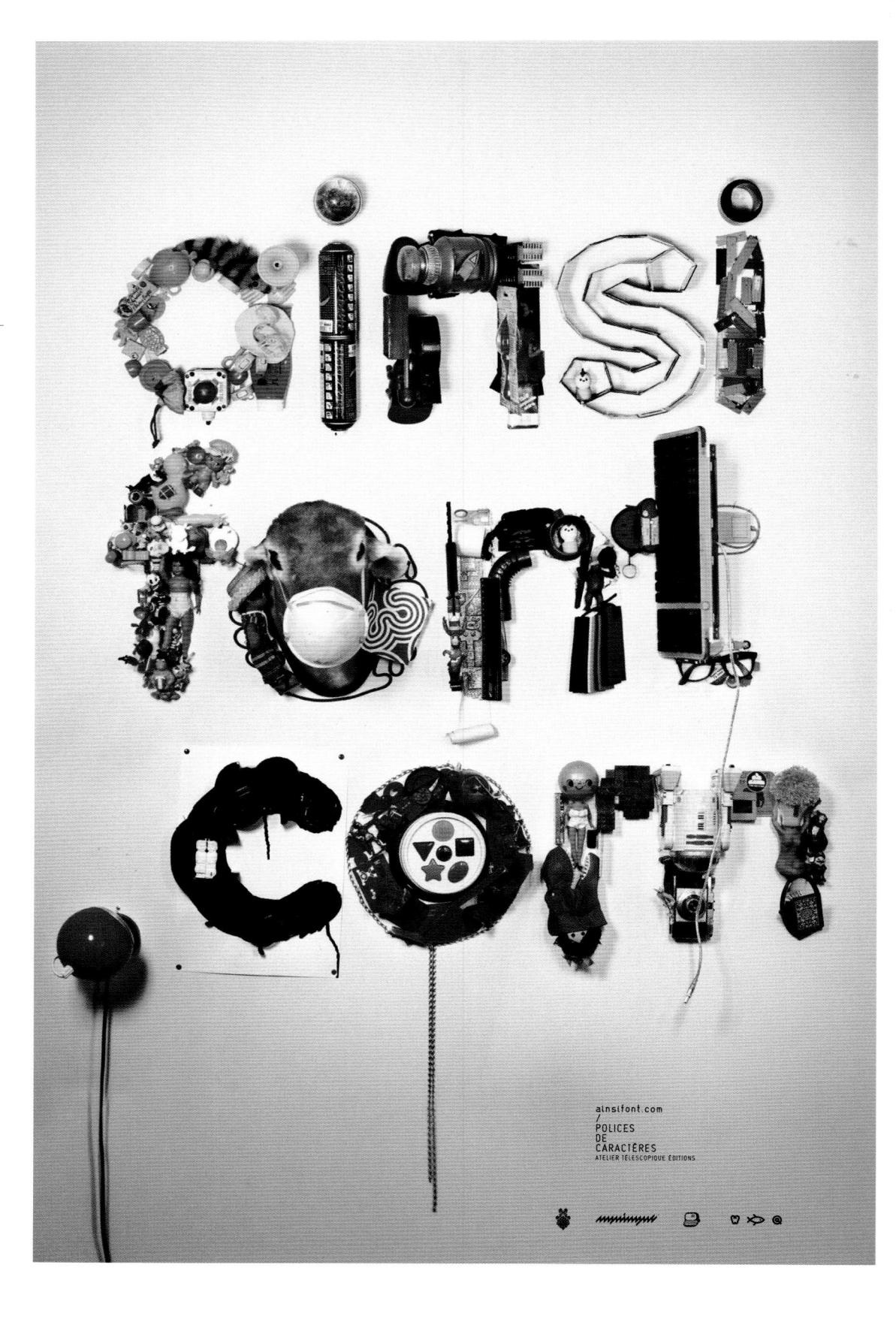

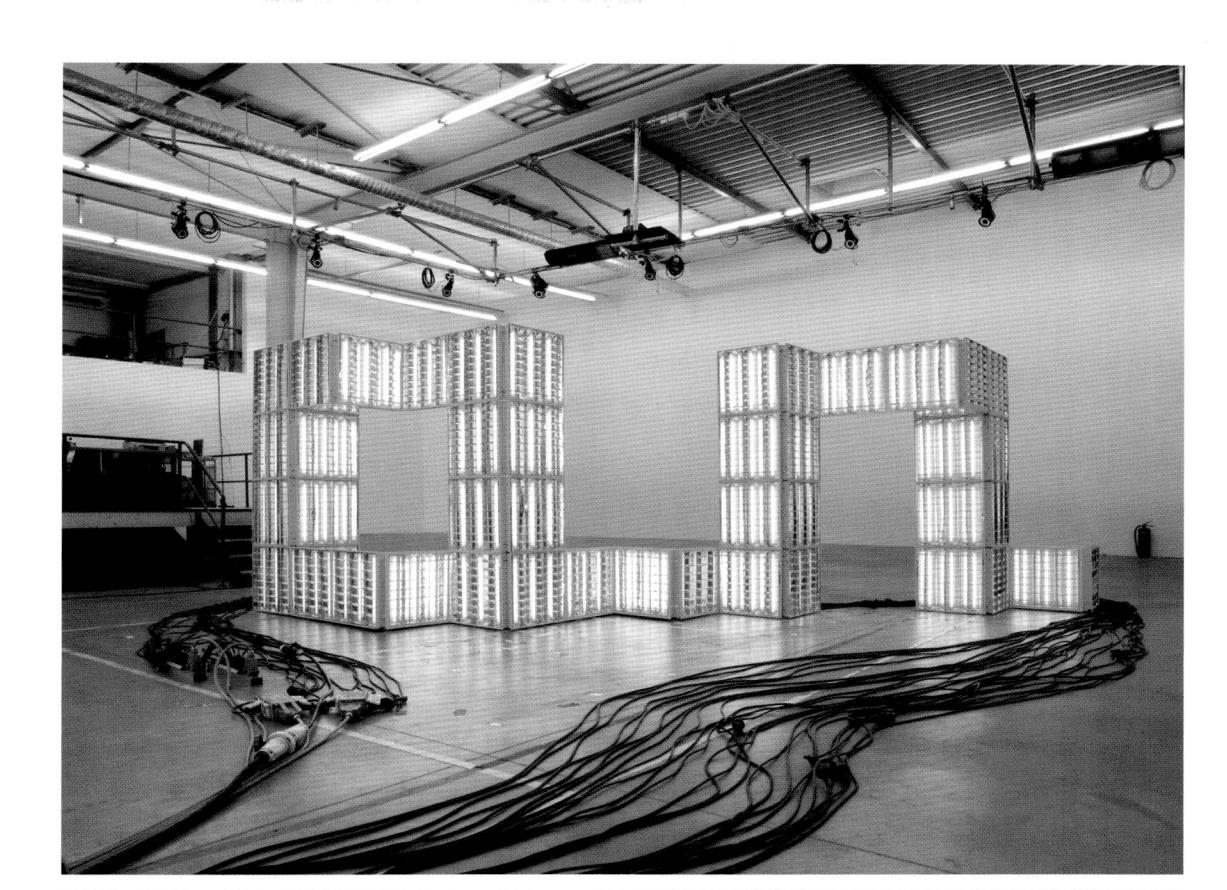

'On'

Fifty ceiling lights form an illuminated 'ON.' A lighting installation designed as the key visual for the launch of the desres design group. It is used on posters, flyers and the start screen of the website.

T:desres is on D:desres design group C:desres design group W:Installation L:English Y:2006

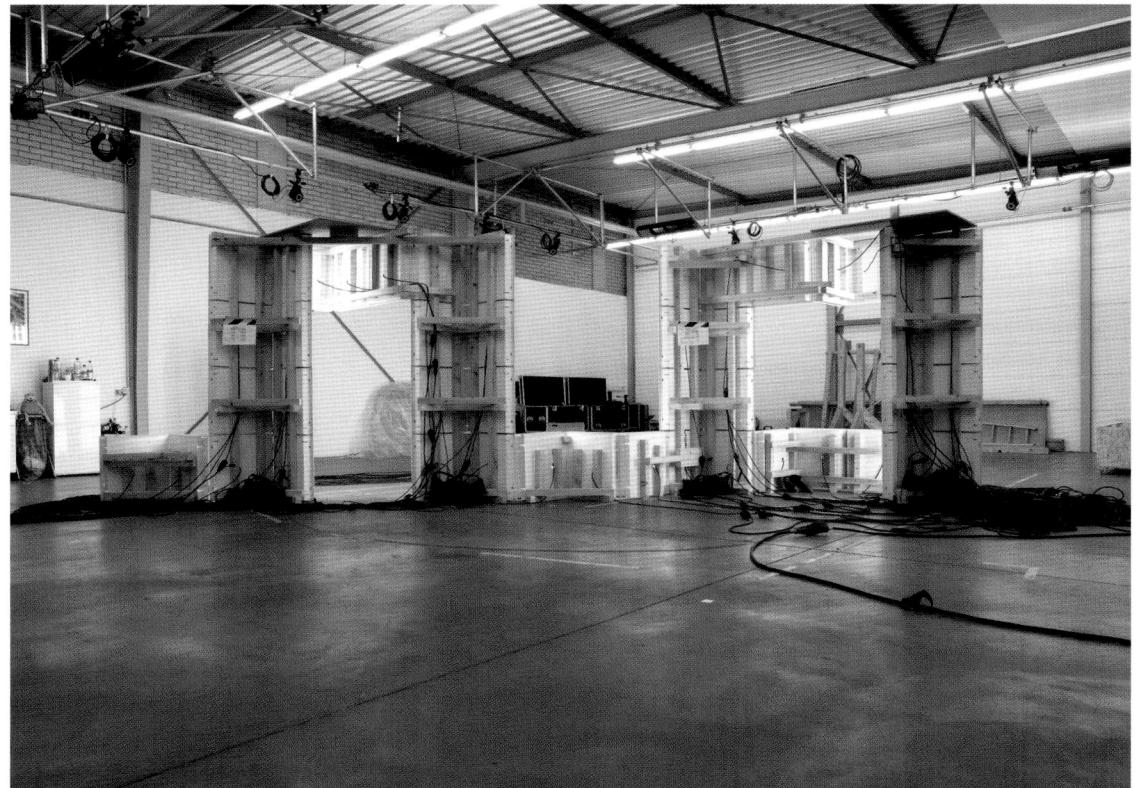

'October'

PDF Calendar design for design portal and ezine `Lounge72.' The designer was invited to create one of the 12 months - October.

T: 玖別 (September is gone)
D: Sixstation
C: Lounge72
W: Poster
L: Chinese
Y: 2005

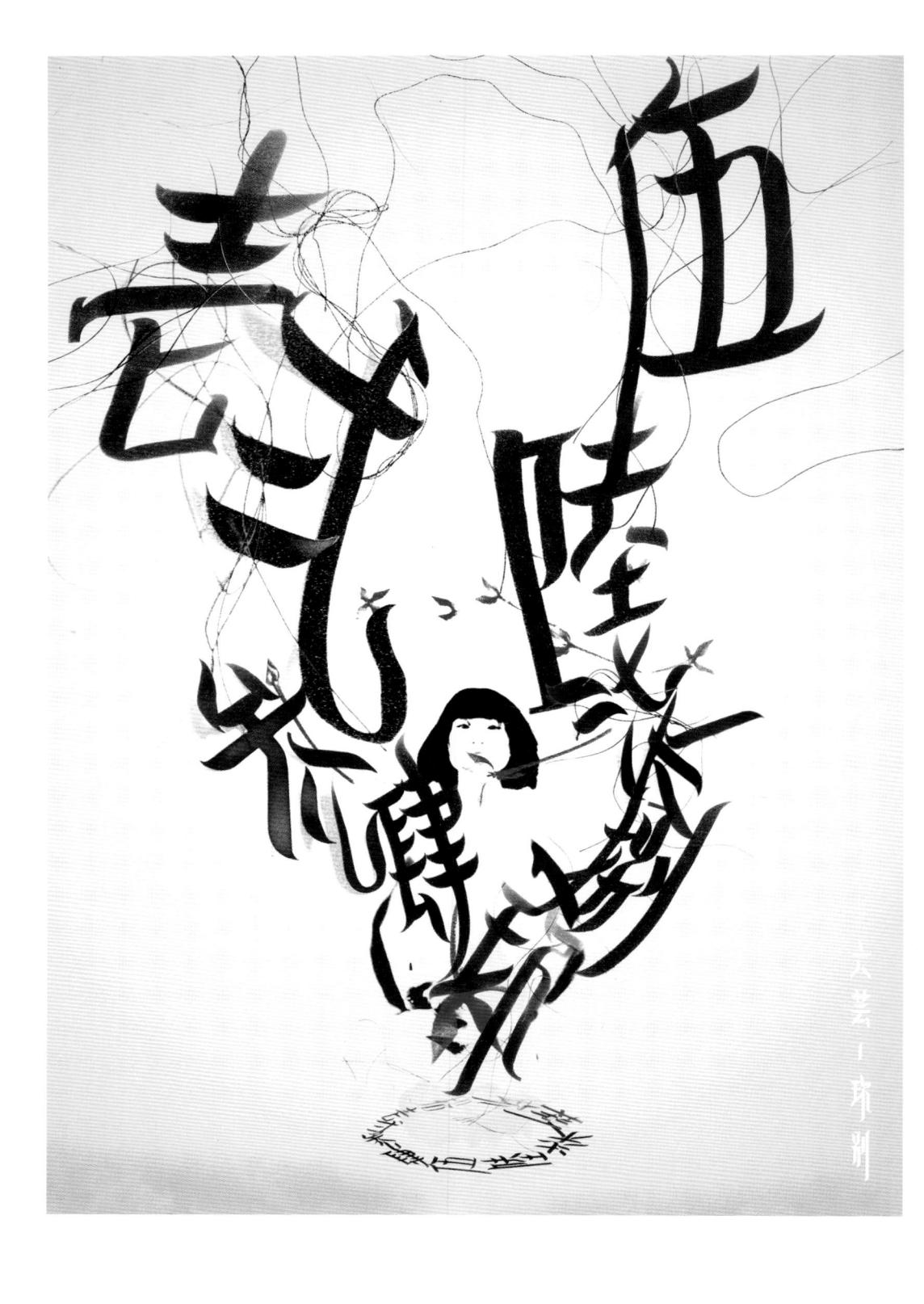

'Online'

Online logo created for Accept & Proceed design studio as part of the Accept & Proceed logo ongoing project.

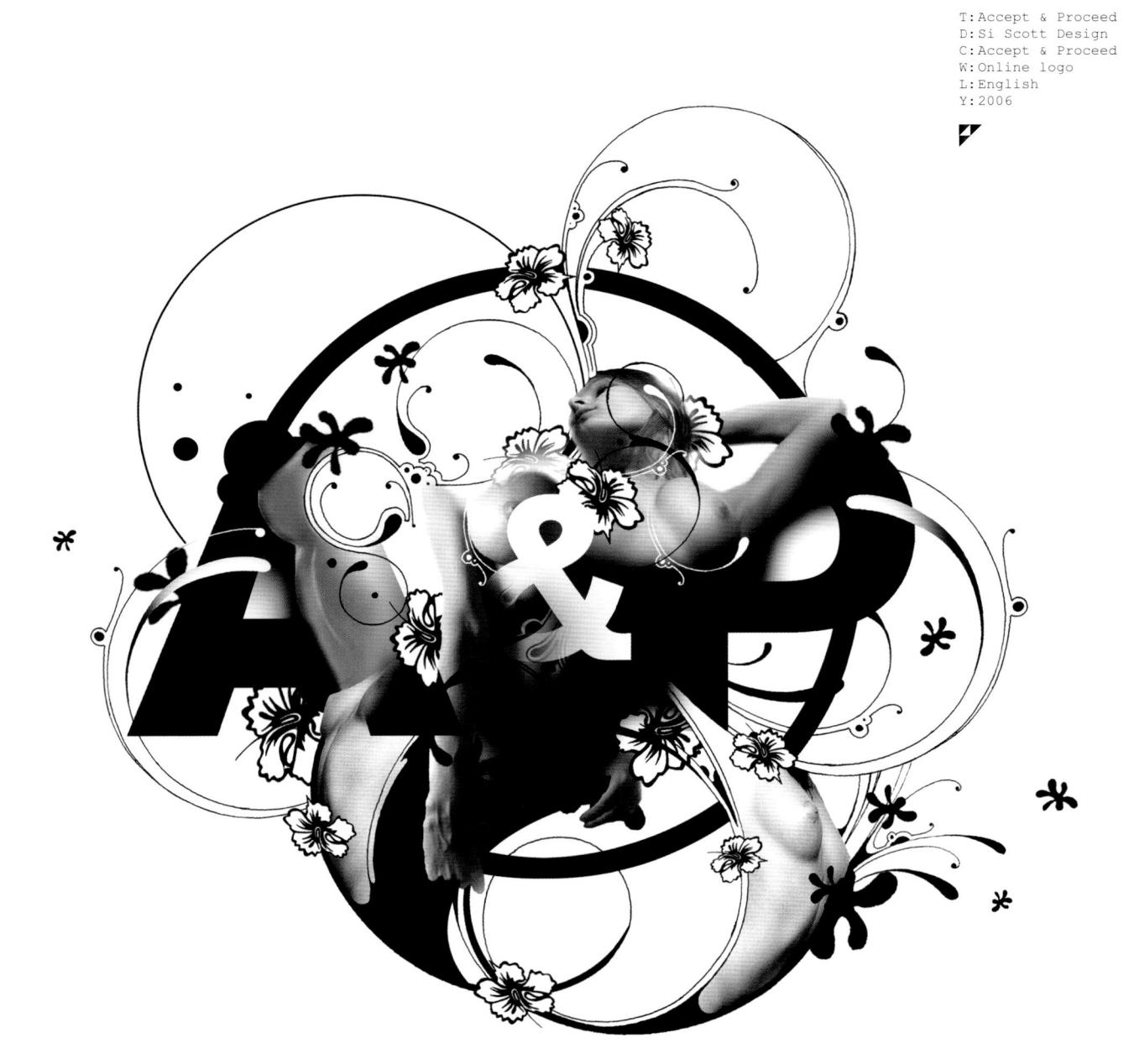

'Organic'

seemingly organic forms using digital technology. Using only a scanner, some tape and most importantly a notecard each letter was created. Using the tape, a grid was marked out on the scanner glass. As the scanner belt moved, the designer moved the notecard folding it, bending it and rolling it but always sticking to the grid. The images were then bitmapped so they could be applied to fontographer and be used. It is not a practical typeface and only exists as an upper case, however, the project was more about the process than the final result.

T:Scan Note
D:David Lane
C:David Lane
W:Typeface
L:English
Y:2006

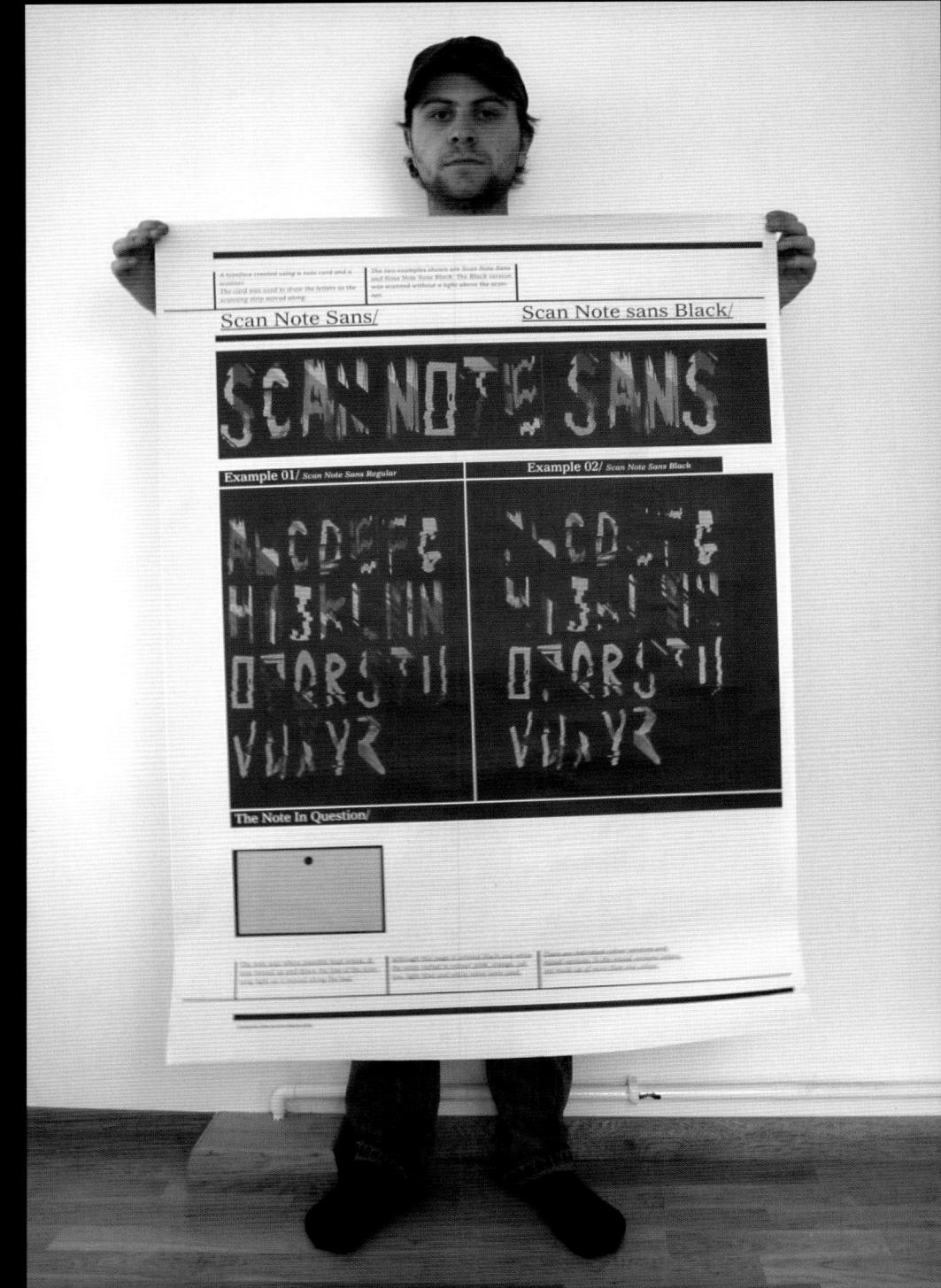

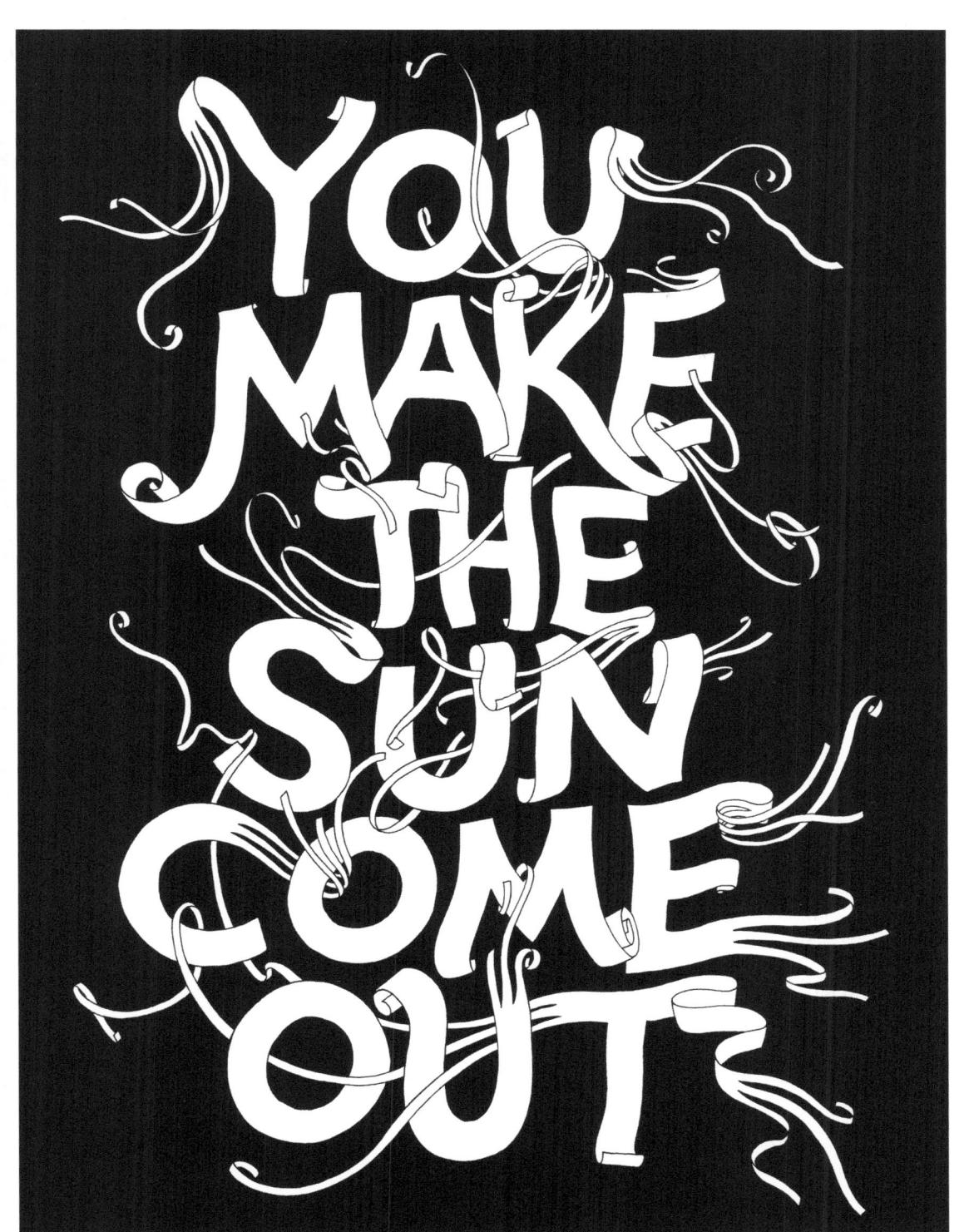

'Out'

This is a poster taken from a current series of personal works which are produced in very small numbers and given as gifts to friends.

T: You Make the Sun

Come Out

D:Adam Hayes

C:Adam Hayes

W: Hand-lettered poster

L: English Y: 2007

'Party'

A series of 3 flyers designed to promote the designer's birthday party. Sort of a funny realization of the concept 'life before and after August 17.' Combining retro found images together with doodle sort of typography.

T: AUG 17 party flyers D: Corp.Unit C: Corp.Unit W: Flyer L: English Y: 2002

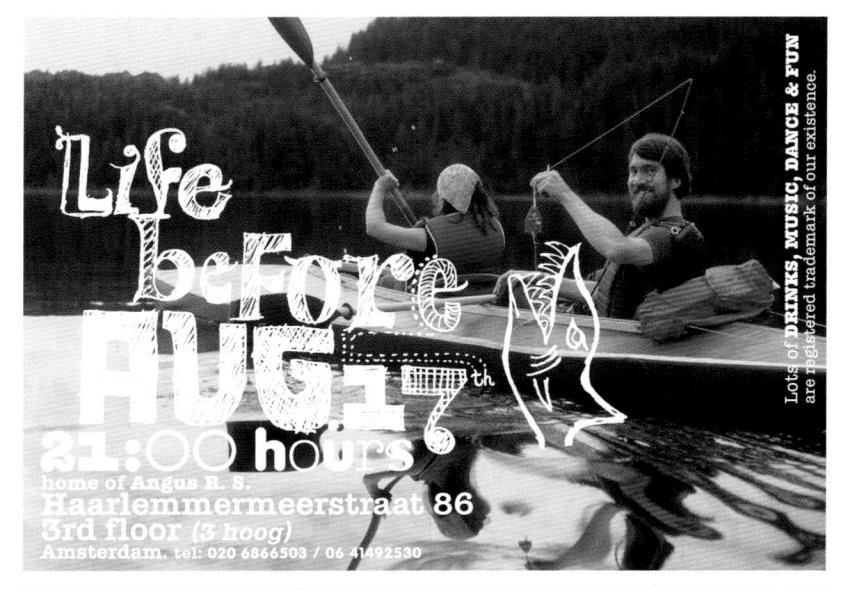

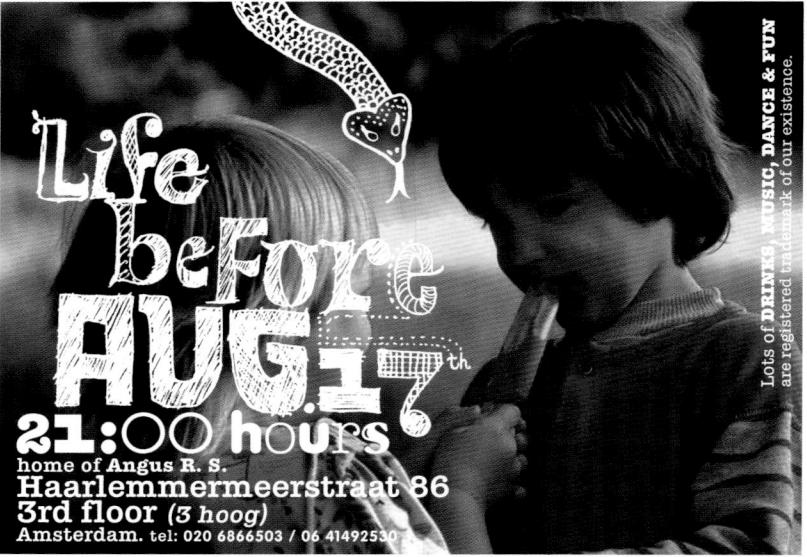

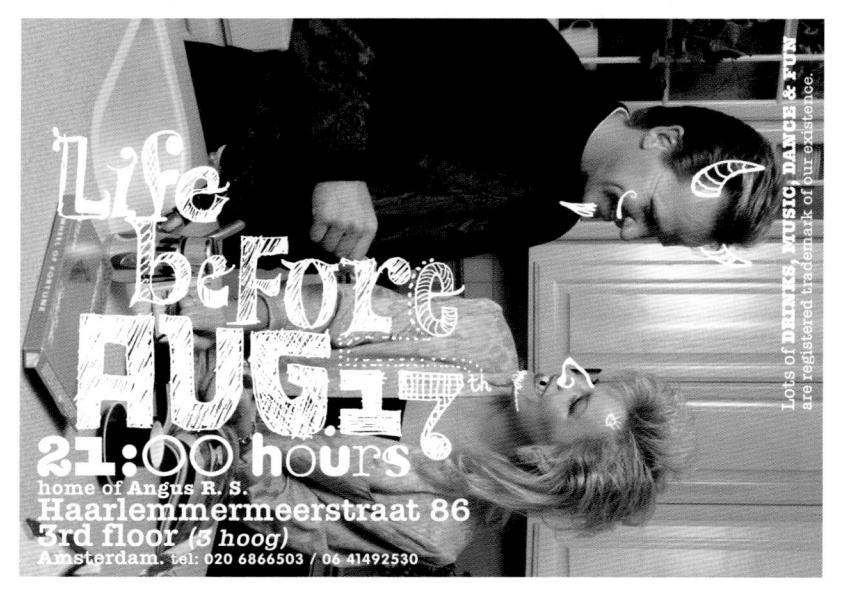

of poster exhibition project initiated by Art4Soul from Malaysia. The poster is based on the same theme for the exhibition. Pray&Pay' illustrates the relationship between religion superstition and Chinese people. The design is purely inspired from the traditional paper money for ancestor 'Yuen Bo.' People 'pay' as in 'pray' to God.

D:Milkxhake C:Art4Soul, Malaysia W:Poster L:English Y:2006

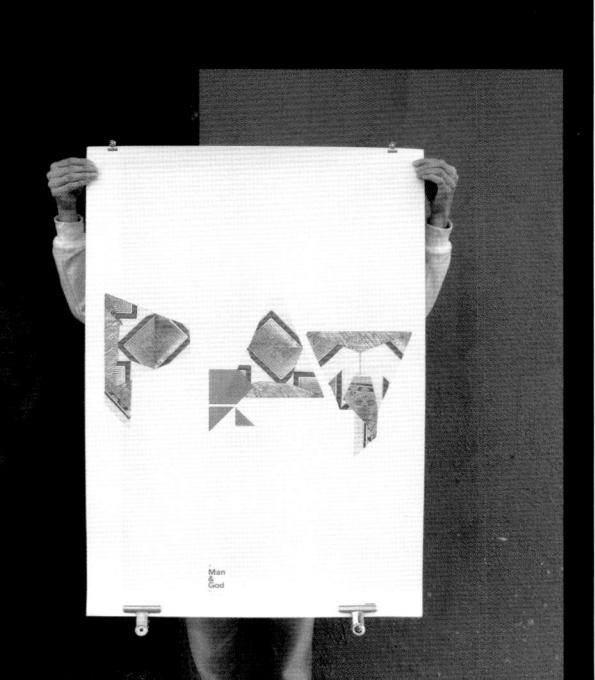

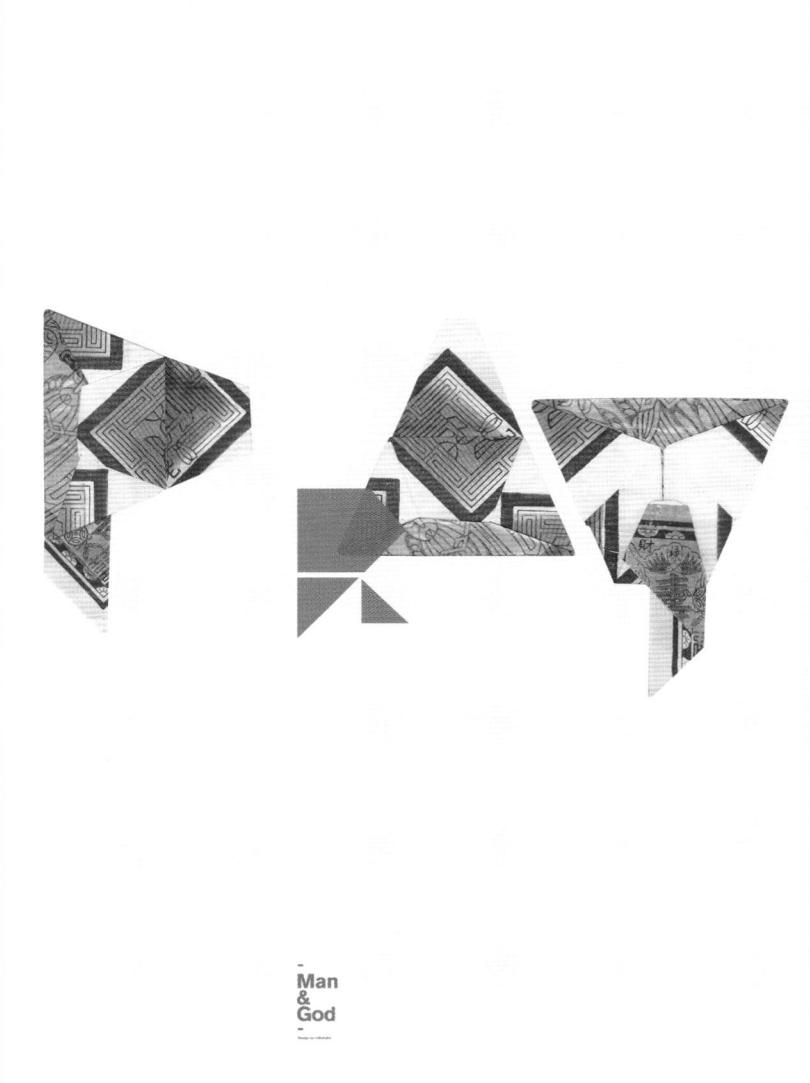

'Peace'

peace and environment by original alphabet composed by dots.

Poster approached

D:Taste In C:Taste In W:Poster L:English

These his 21st century for towar, the ethichic which pushful from one terrains, the centurities of the extrement, the centurities of the extrement, the centurities represent pollster are the most numerical than the initial principal production are successful extrementation of the extra the fitting extrating of the extra transfer of ordering the fitting extra the fitting

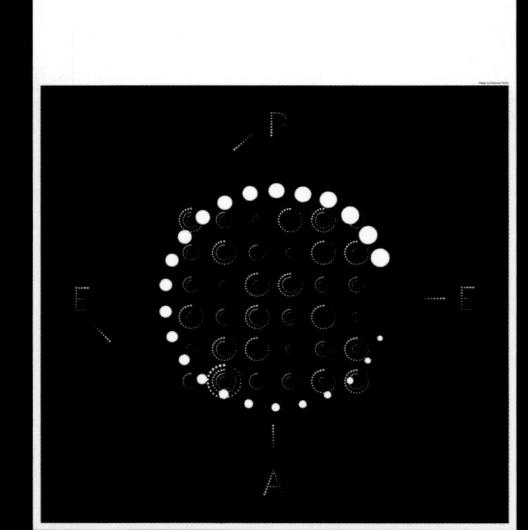

Though the 21st century has begun, the situation which mankind's war and terrorism, the destruction of the environment, the atomic energy pollution and the mass murder don't end in is an important problem. Mankind's consciousness decides the future destiny of the earth. As for understanding a difference in the religion, it is the first step to wipe away racial discrimination. It is the important point for manking to access in this earth environment, it becomes the start of manking's new history.

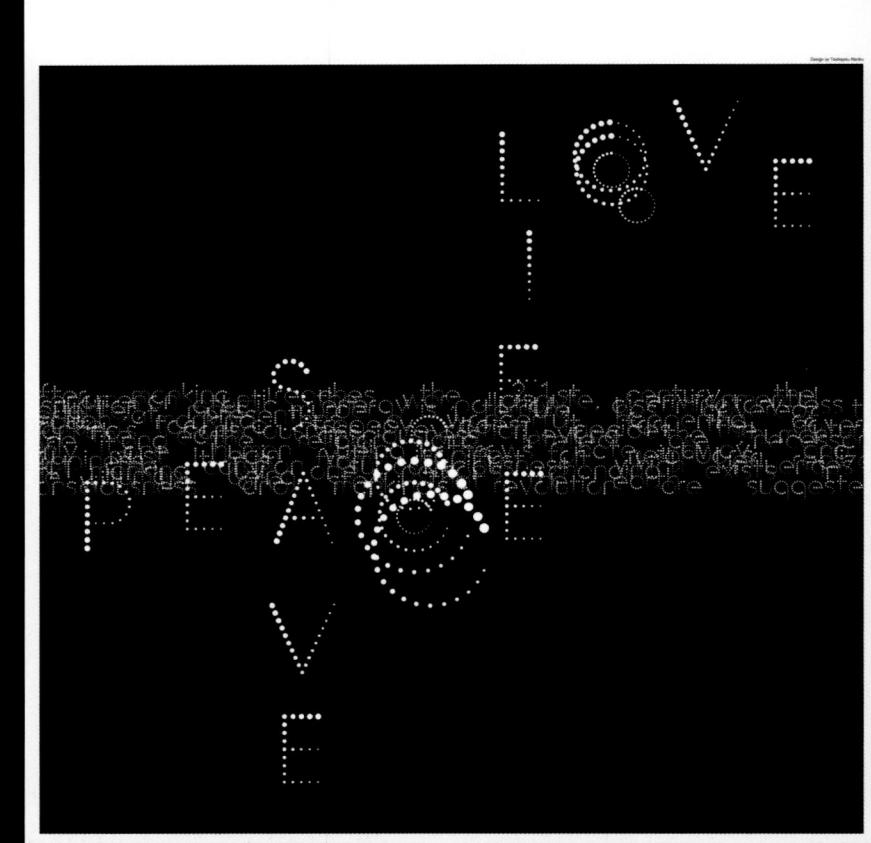
'Performance'

Poster announcing Piebald's performance.

T:Piebald
D:Apirat Infahsaeng
C:Manic Productions
for Piebald
W:Poster
L:English
Y:2007

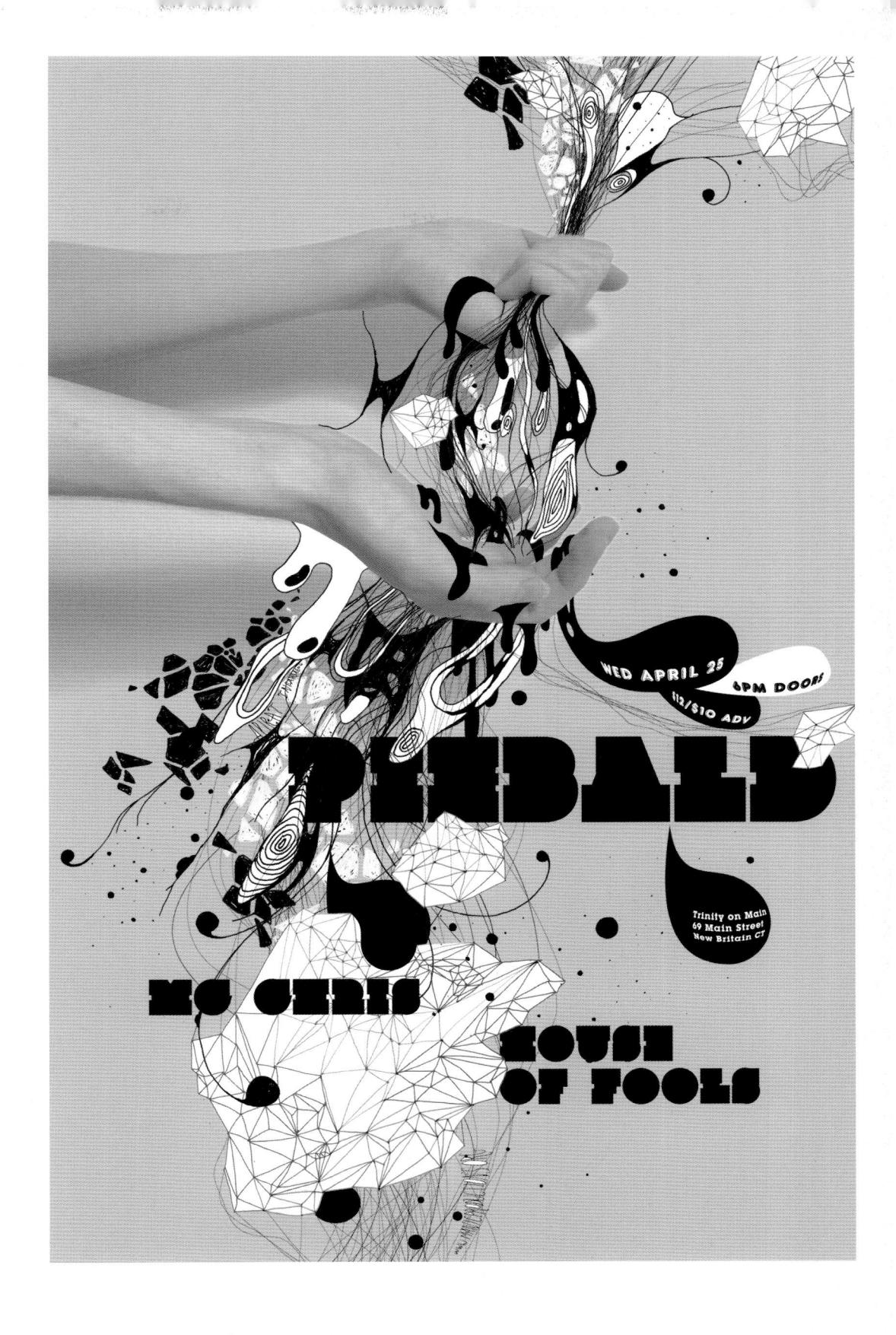

'Plastic'

This font was made for a plastic surgery clinic. Each letter is an illustration of a word, for example B for Botox, S for Silicone or N for Nip/Tuck.

T:Beautiful
D:Florence Tétier (Whaa)
C:Ecal (University of
Arts of Lausanne)
W:Typeface
L:English
Y:2007

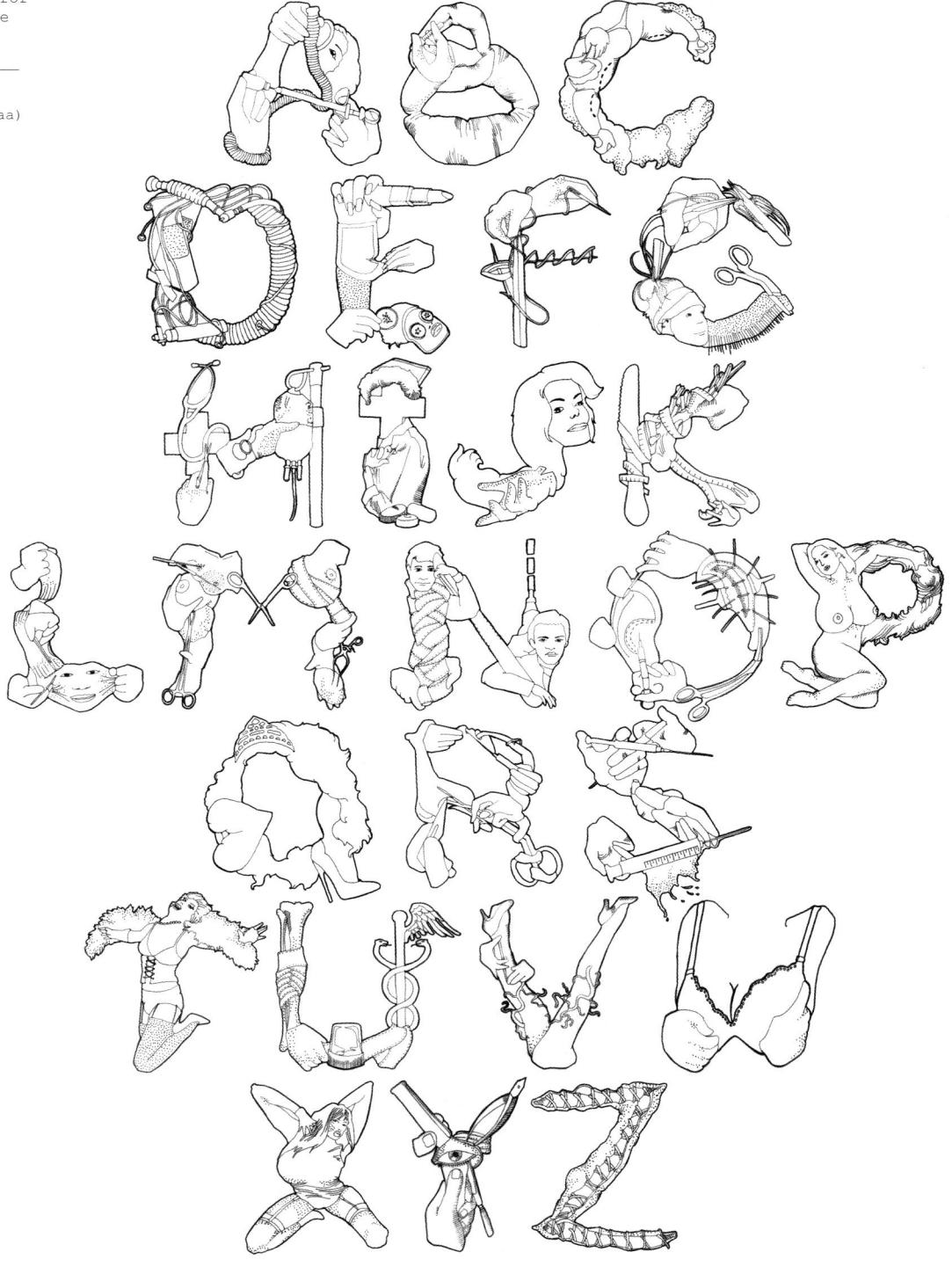

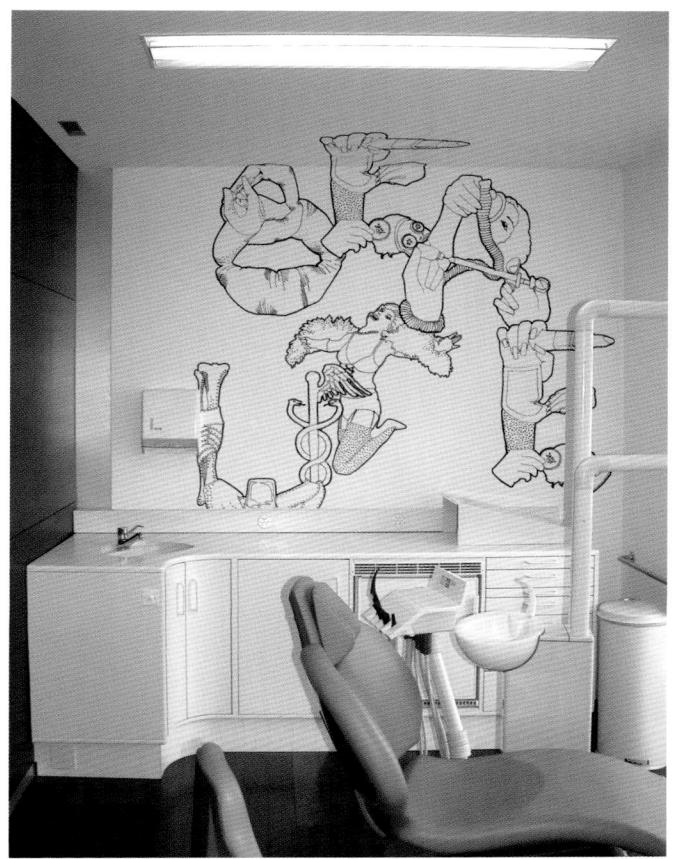

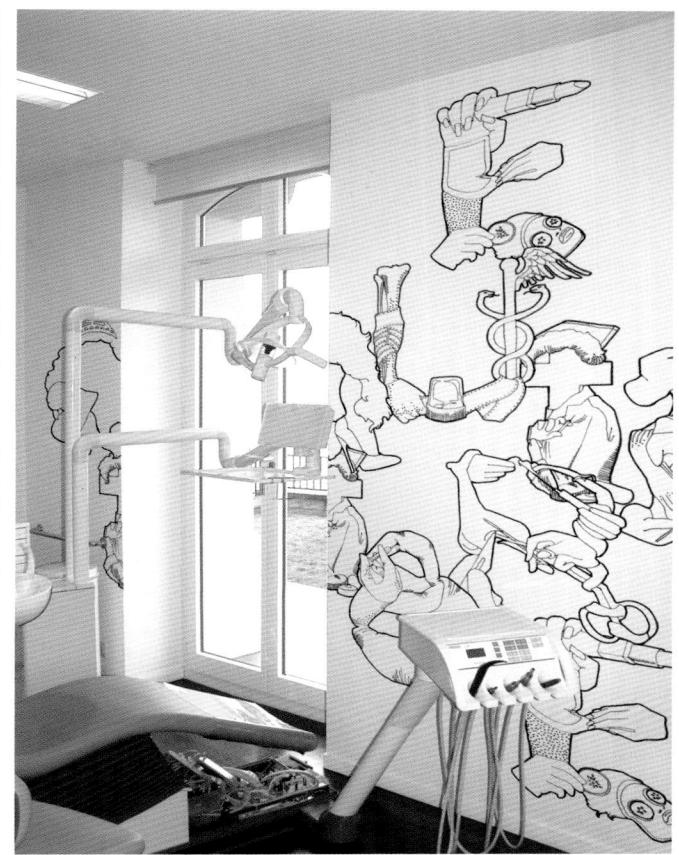

'Plyke'

A series of posters created by hand and then printed on black plyke board in phosphorescent ink.

T:100% Design Tokyo Exhibition

D:Si Scott Design C:100% design week

Tokyo/designers block

W: Exhibition L: English Y: 2006

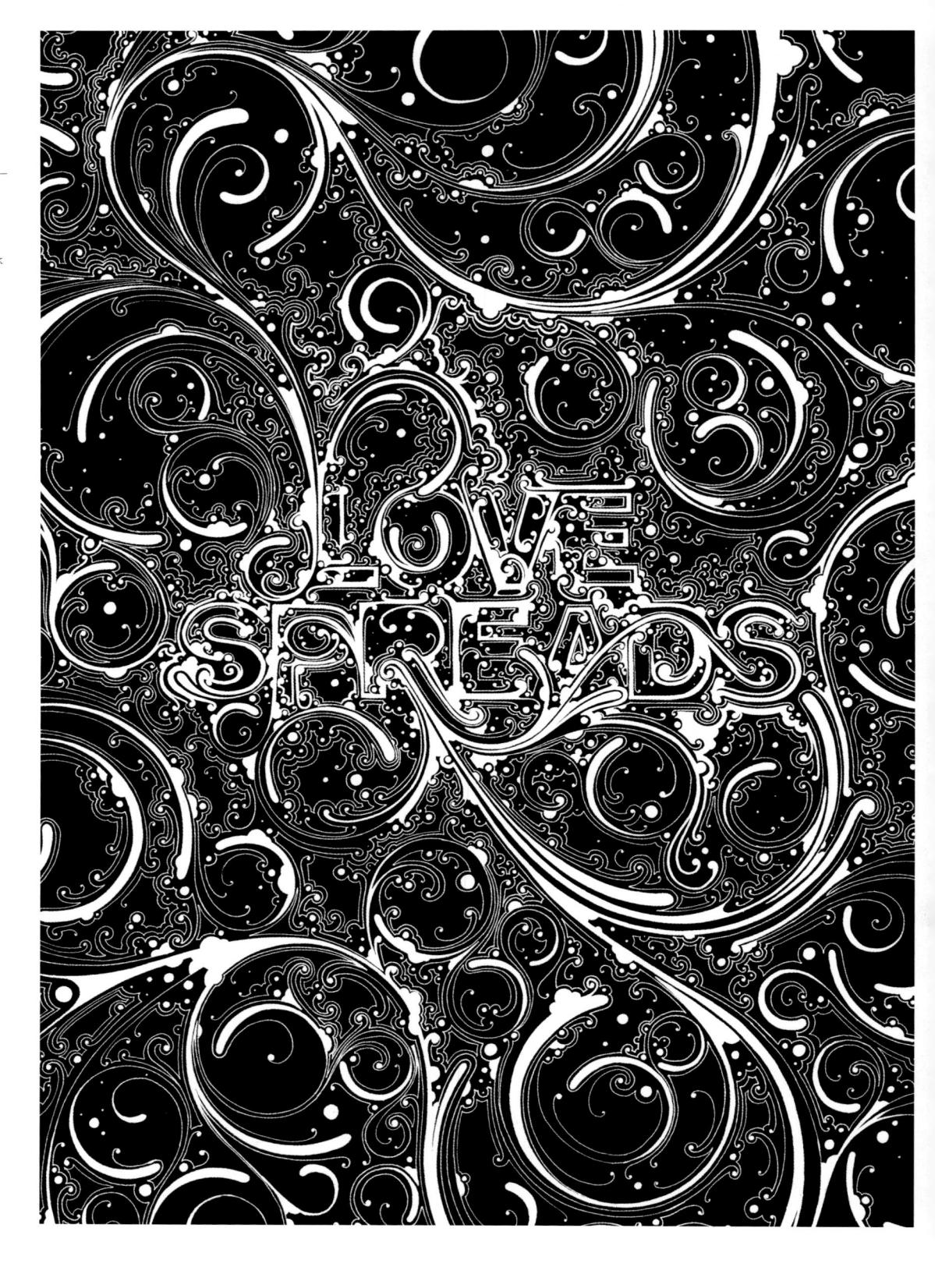

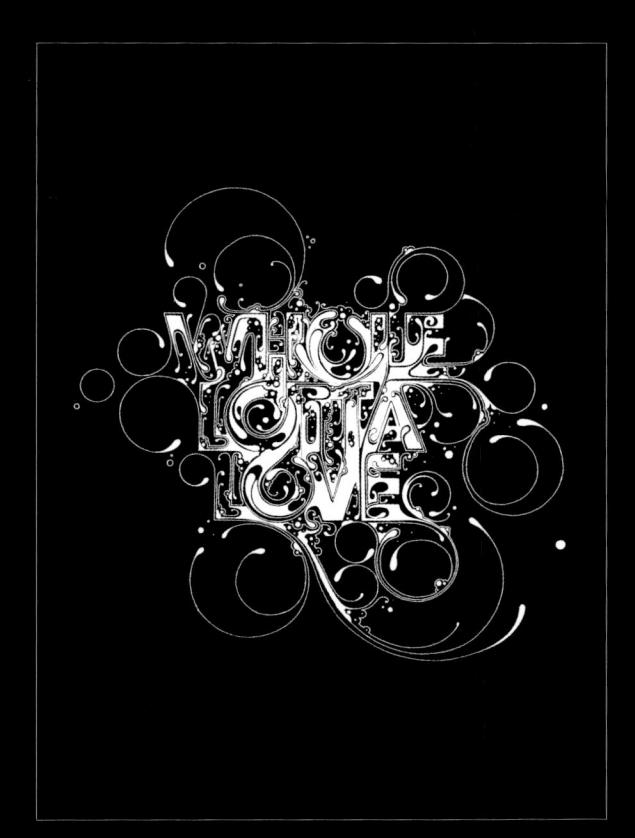

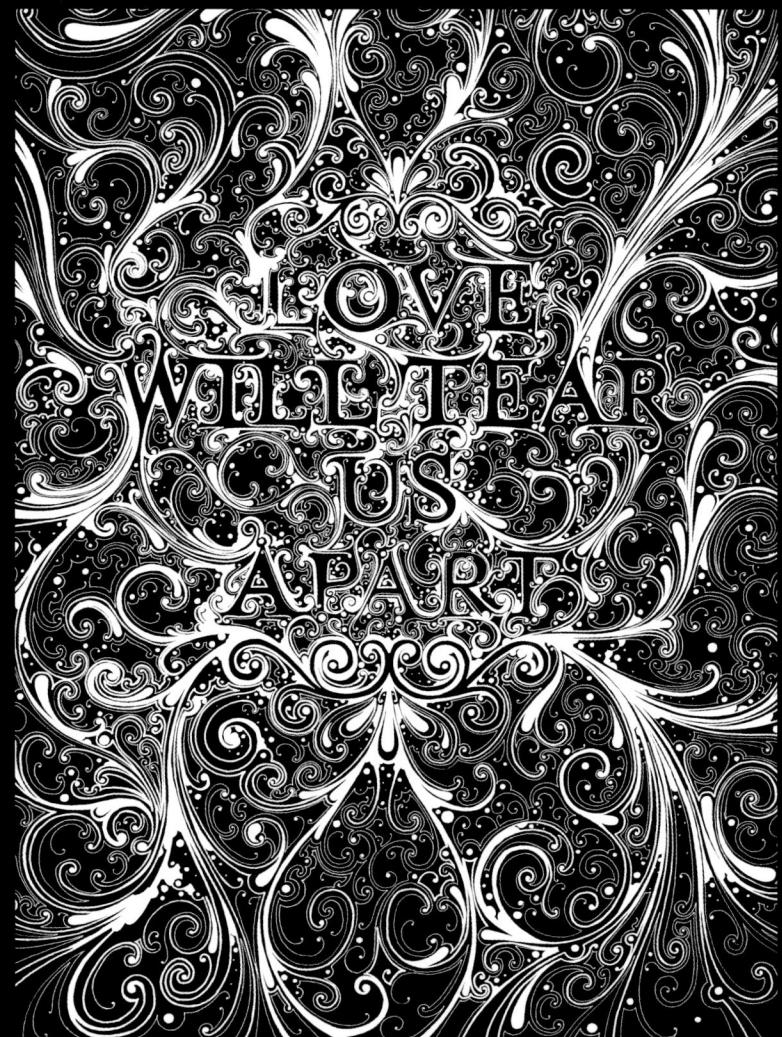

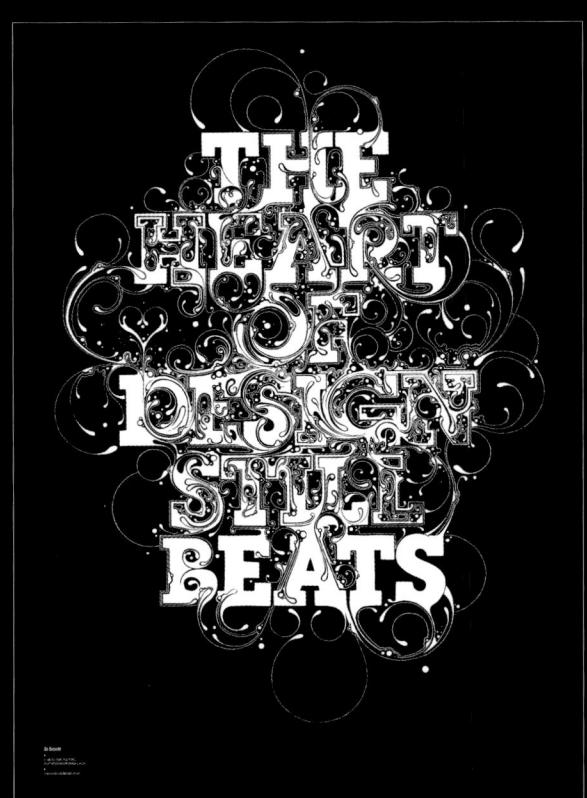

'Poem'

Experimental typography work mixed with Chinese poem in modern typography.

T:滿江紅 (Manjianghong)

D: Sixstation

C:Sixstatio

W: Poster

L: Chines

Y:2007

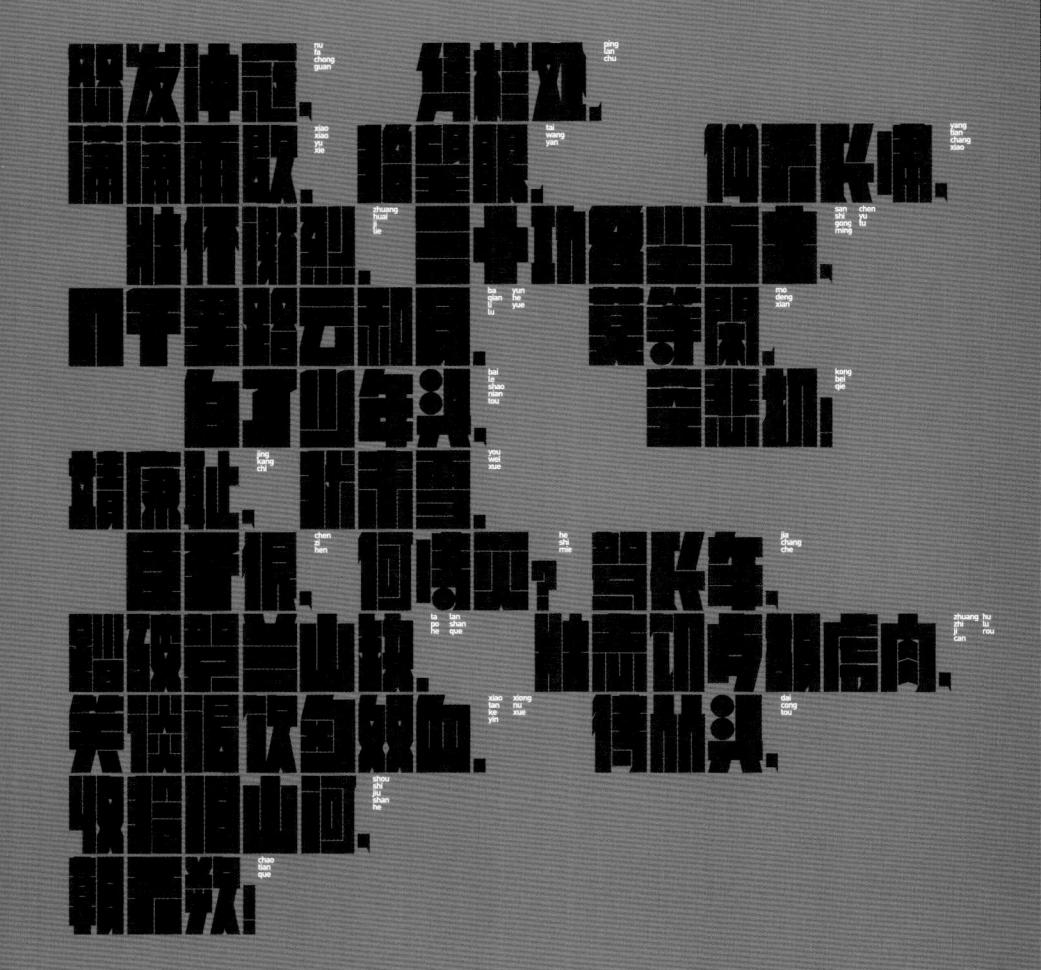

HIII ET

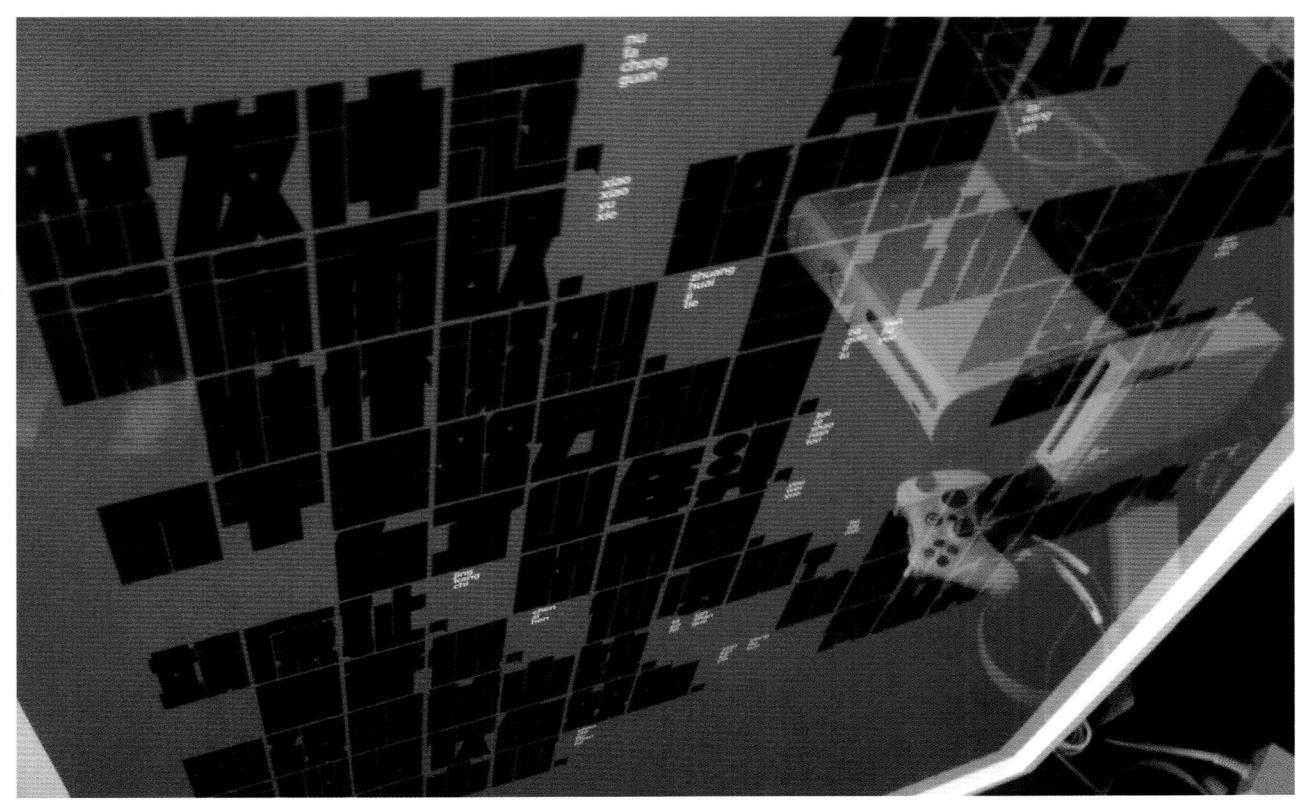

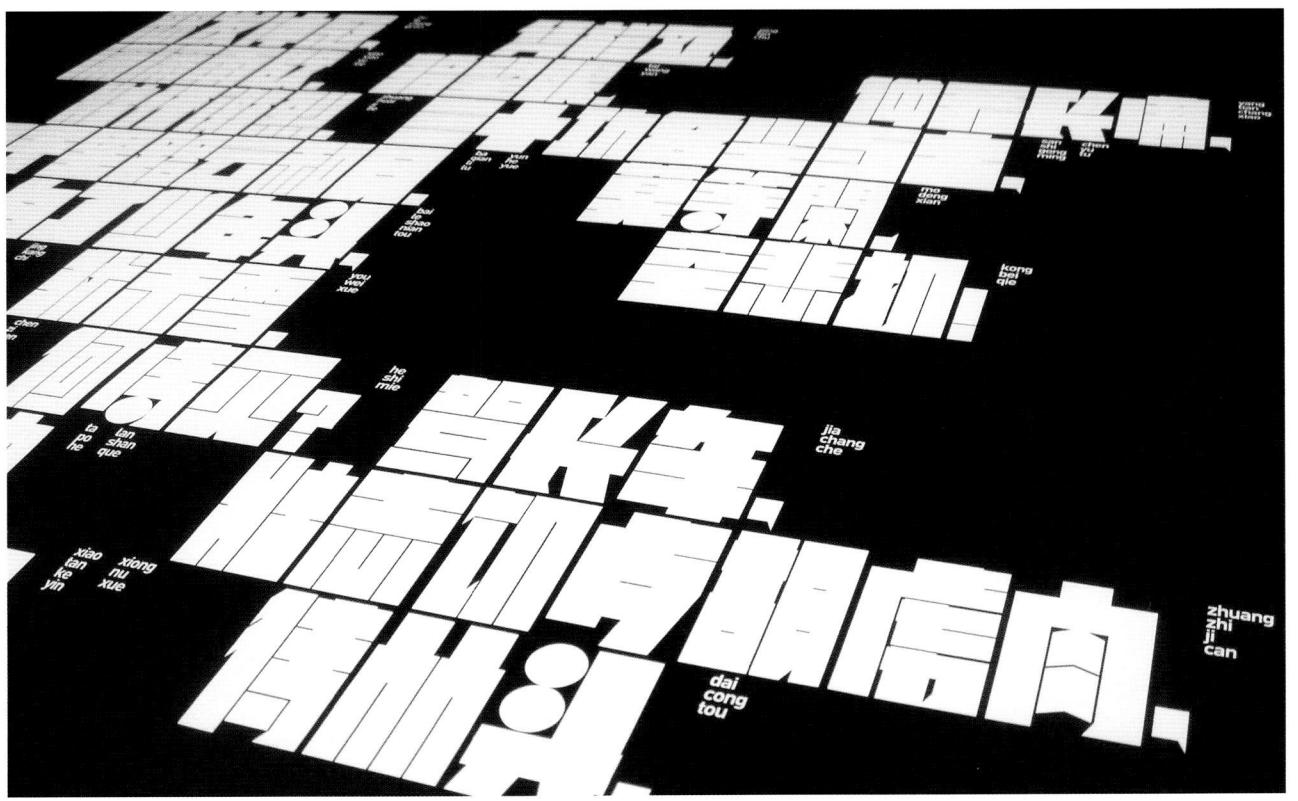

'Poet'

Poster exhibition by 24 designers who make poetry by poet motif. Posters in B0 size were put in the underground of a shopping center and the extension of it formed into environmental design.

T:Dog's name often
'Character designer
of/Kanayo Ueda and 24
poets'
D:Taste Inc.
C:Kanayo Ueda
W:Poster
L:Japanese
Y:2004

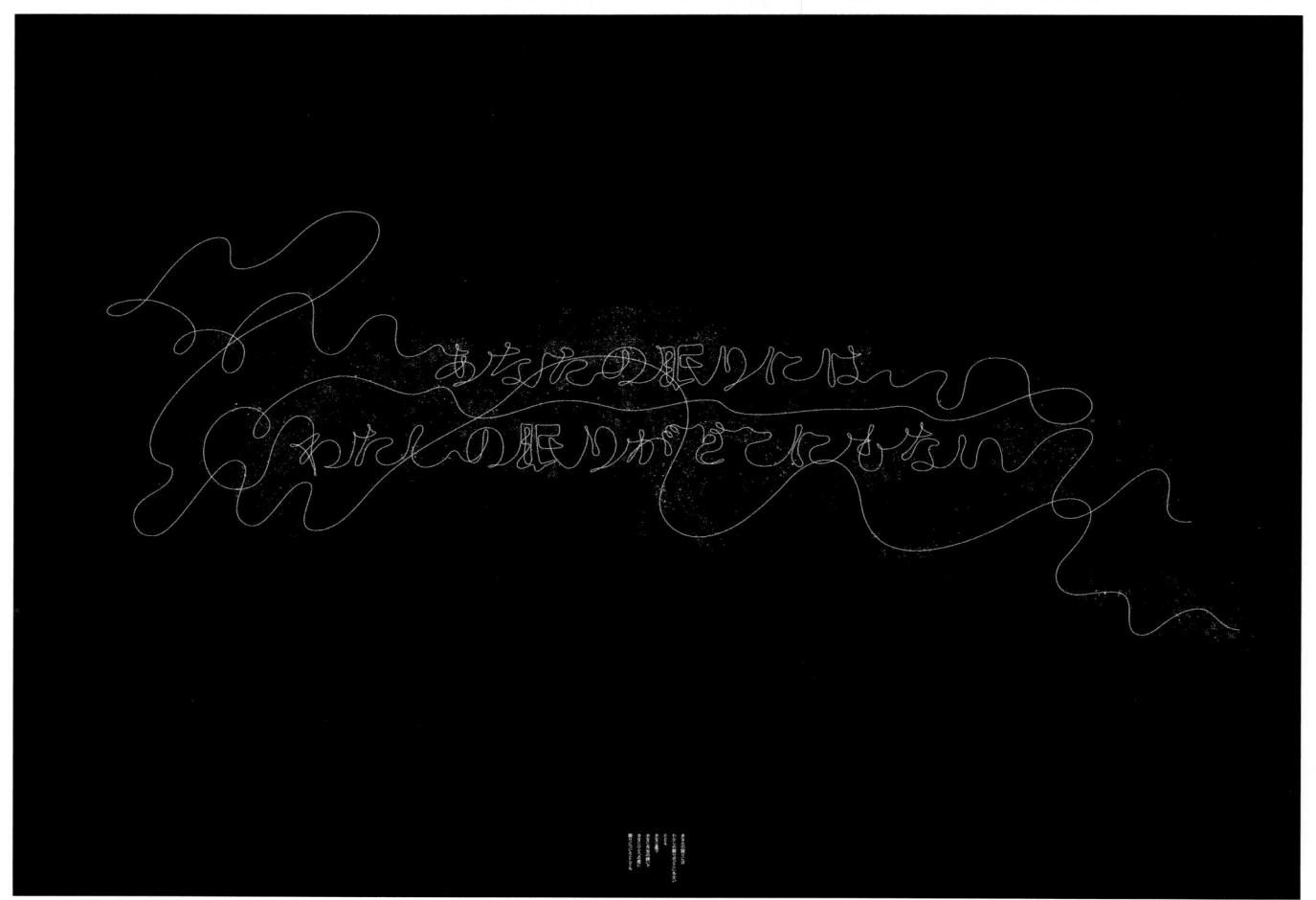

以1950年的1960年(1950年) - 中国的基础的1960年

'Pompei'

Poster and catalogue for the 37th International Theatre Festival.

T: Pompei D: Non-Format C: VENICE BIENNALE W:Poster, Catalogue L: English, Italian Y: 2005

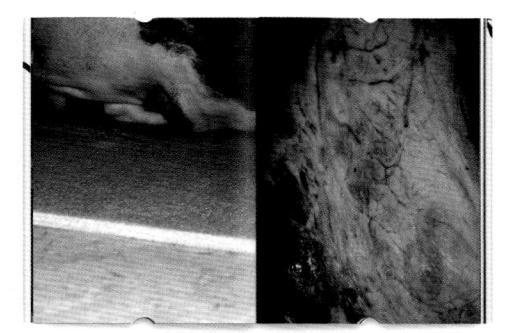

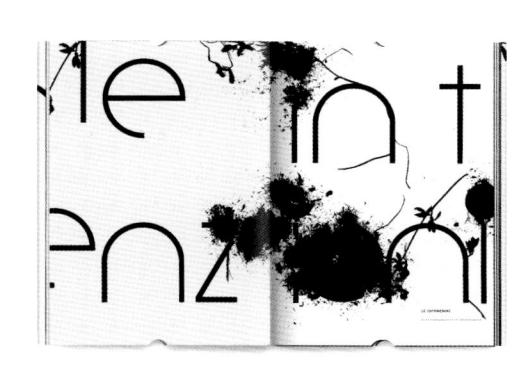

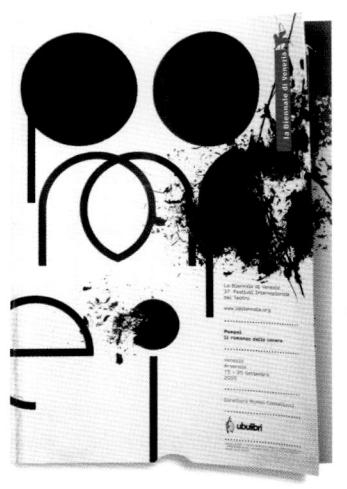

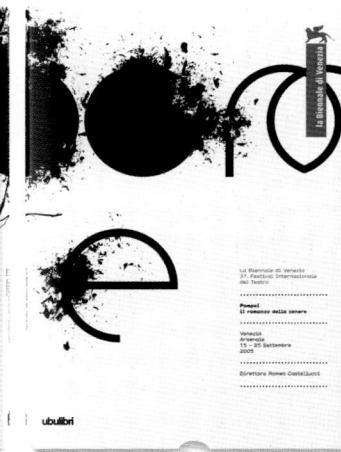

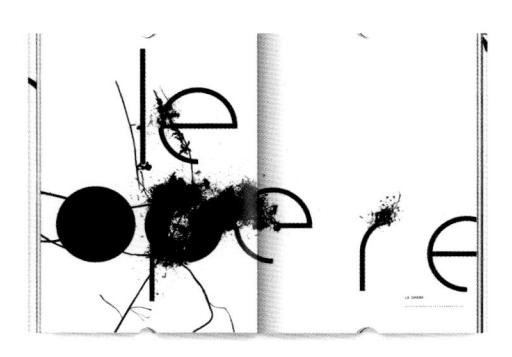

'Pop-up'

Byrom TSS is a 'pop-up' temporary signage system. Each letter is fabricated from waterproof nylon wrapped around a fiberglass pole frame (similar to the construction of a modern dome tent). An elastic cord running inside the hollow poles allows the design to collapse into a small bag for storage. The design is intended for use in shops, galleries, festivals, conferences etc.

T: Byrom TSS D: Andrew Byrom C: Andrew Byrom W: Temporary signage system, 3D typeface L: English Y: 2007

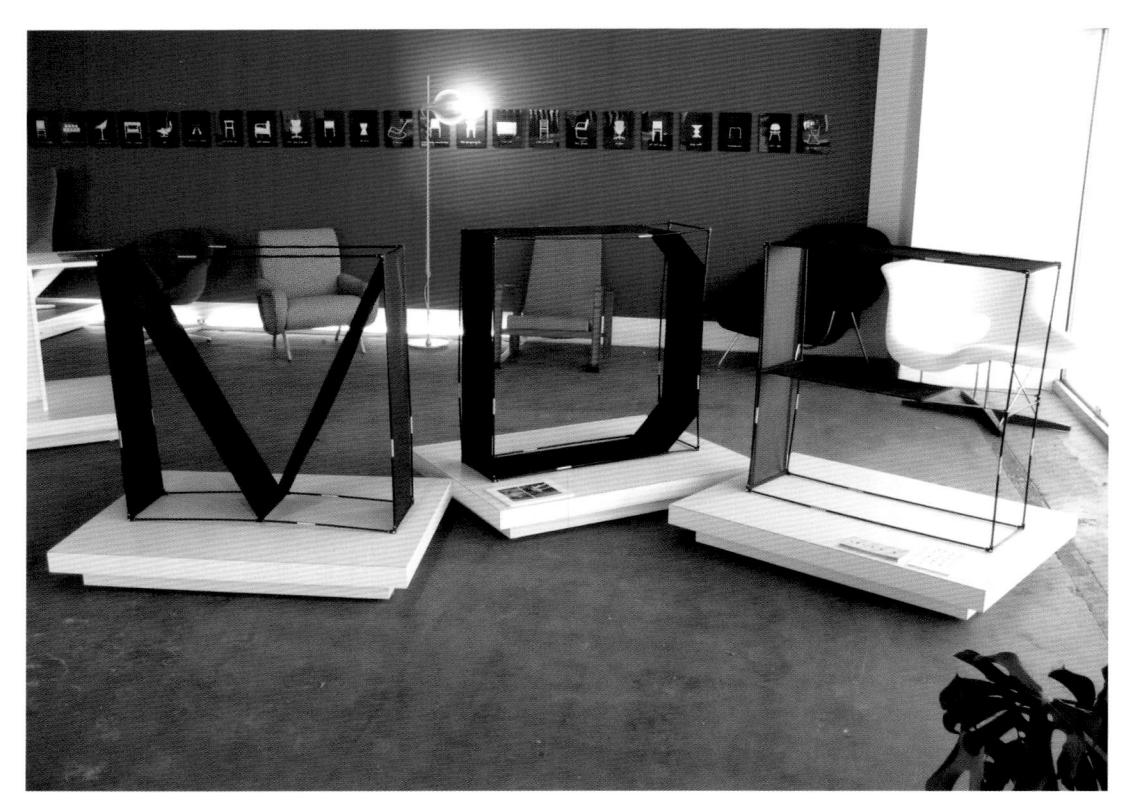

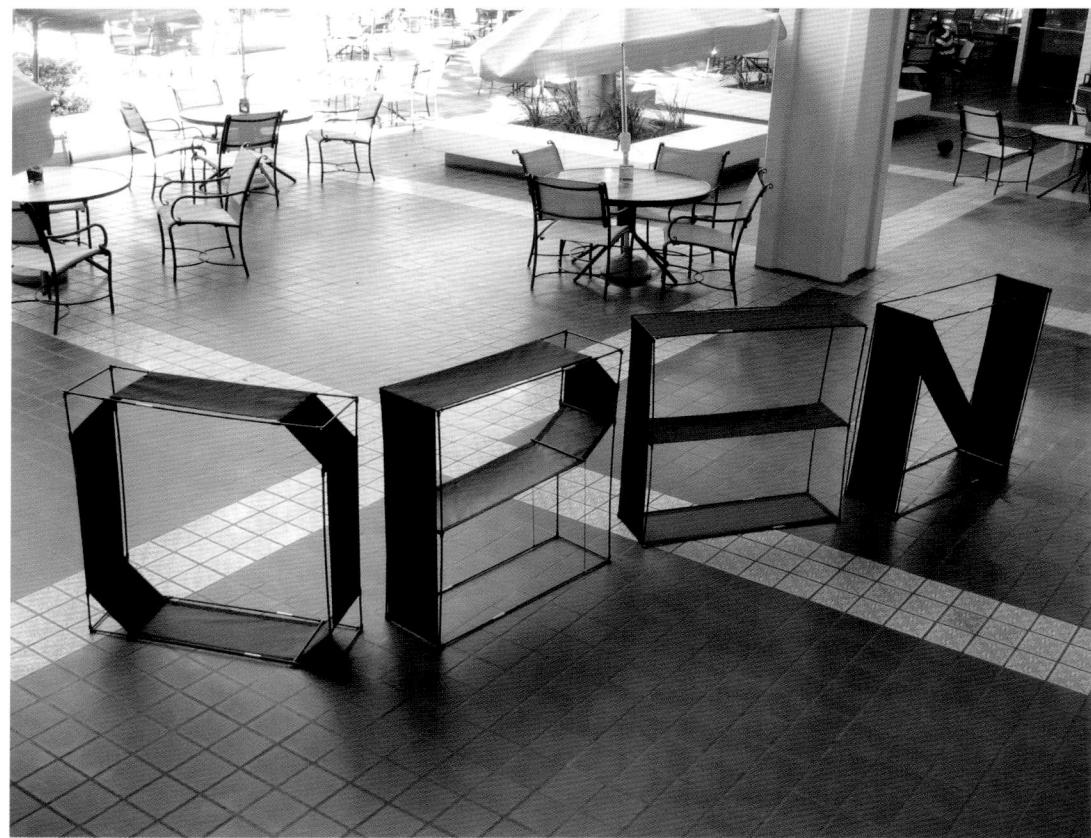

ABCOFFEDU BUNDDEGEUU UNXYV

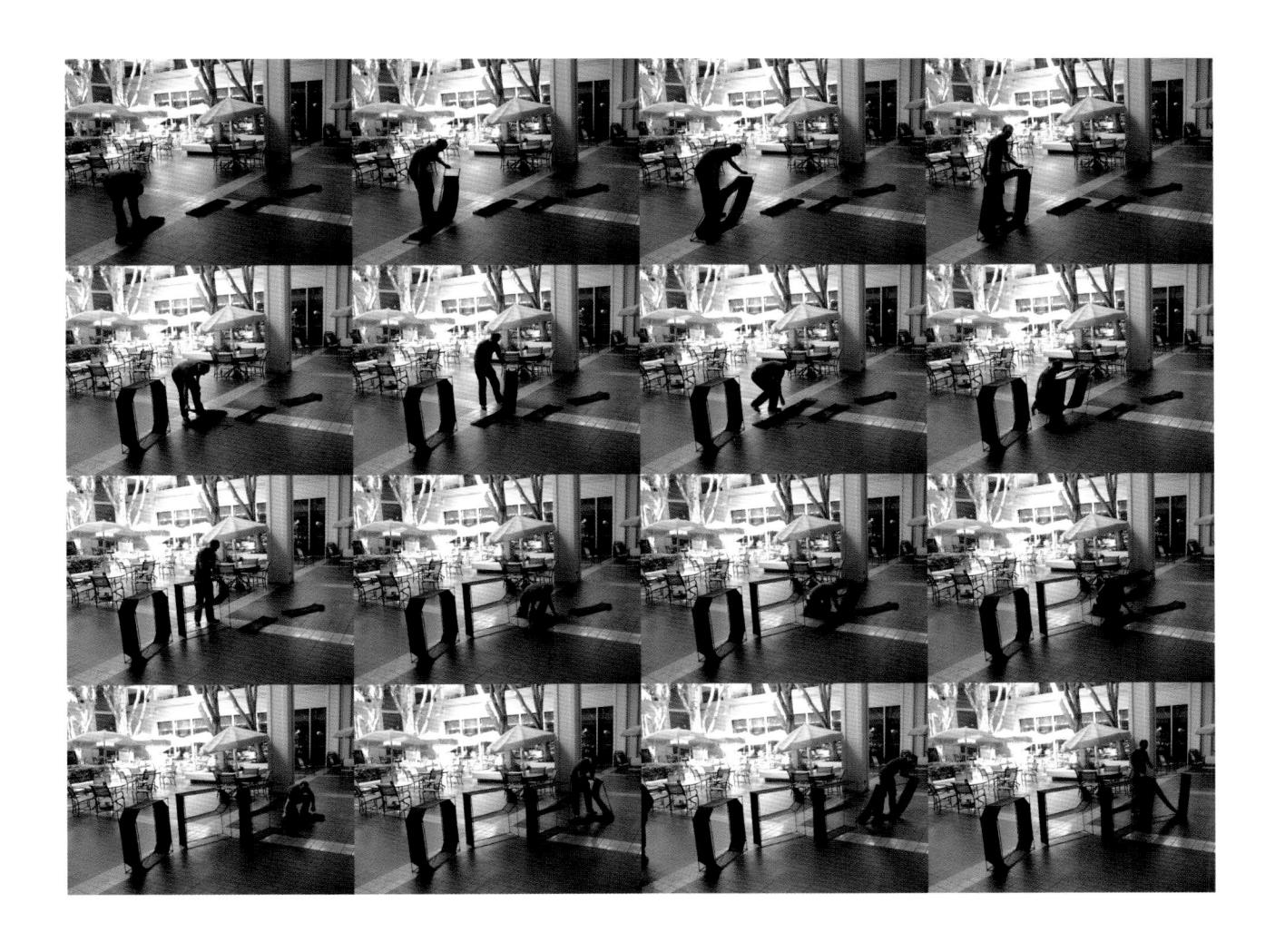

'Prize'

D&AD commissioned the designers to devise a new campaign for promoting and boosting membership over their 5 different categories. The challenge was to devise a concept that would appeal to the design community, from art directors to students. The concept had to have a distinct look and feel that would translate well over various forms of print, as well as online. The message had to be clear and concise, as some of the target audience may not have heard of D&AD and its membership. The designers' solution was to highlight the benefits of being a member by literally showing people what they could get for their money. The concept loosely based on a parody of popular family game shows, referencing the stack of prizes (but minus the

beautiful assistant). The designers wanted people to be reminded of the D&AD membership, so they decided to have the leaflets double up as posters that people could display, as opposed to just receiving a leaflet which would inevitably be tucked away in a corner.

T:D&AD Membership Campaign D:NB: Studio C:D&AD W:Poster, Postcard, Online Y:2006

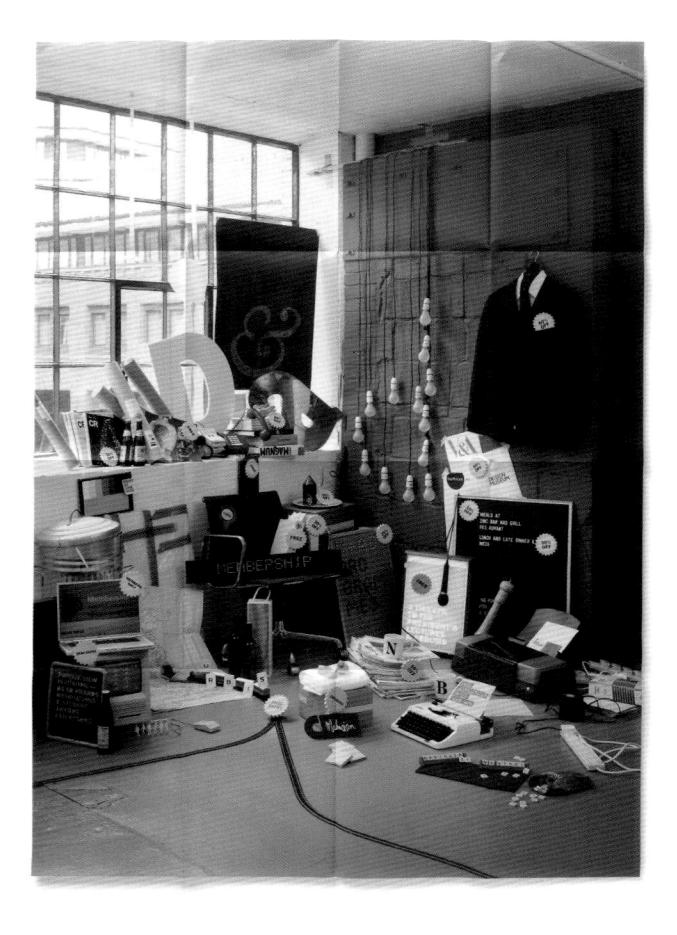

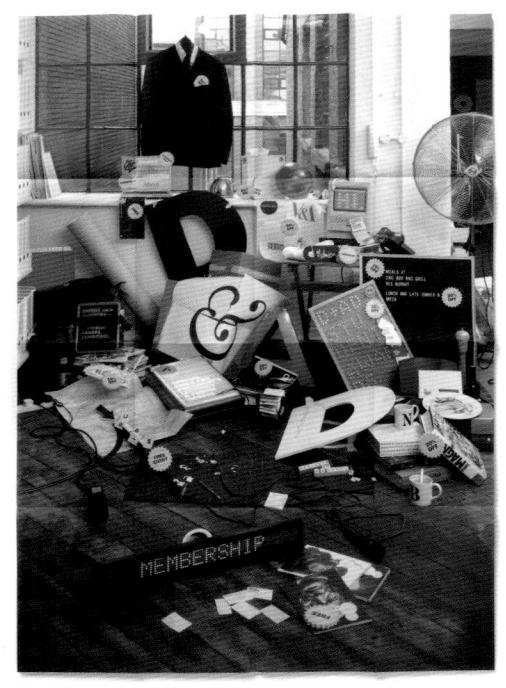

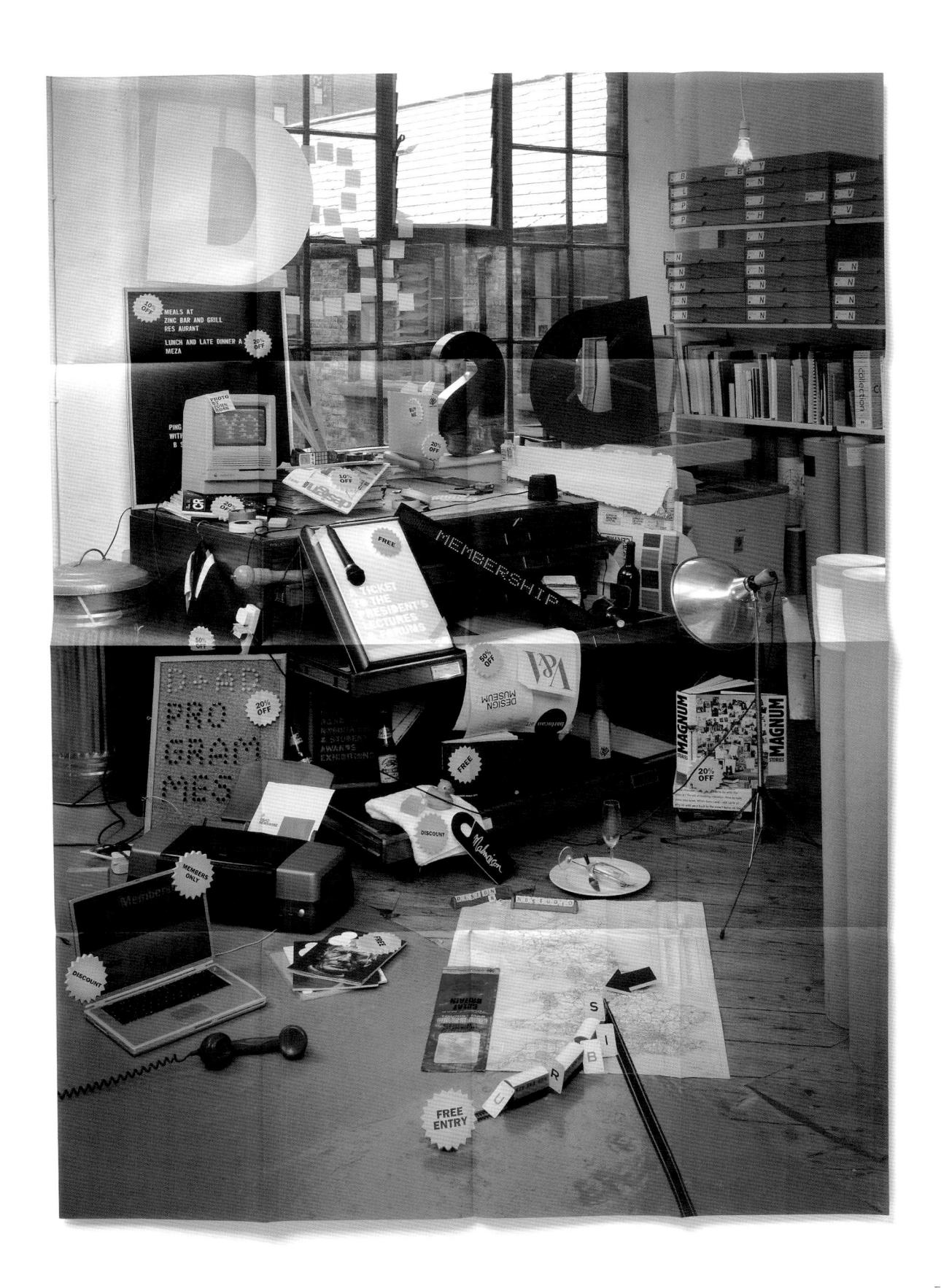

'Punch'

Because 'classic' and 'antis' are not sold in pairs, the wholesale buying process will result in waste. The 'Waste Collation' system typeface that would is employed to re-design reflect the intensely garments a subsequent collection beginning with the waste garment components. Material By Product believes in intelligent design, not fashion whimsy. The essence of its design sensibilities is steeped within the traditions of bespoke tailoring and the essential realities and reconsidered design

potentials of a 'piece of cloth.' 3 Deep Design was asked to document the collection and create an original crafted approach of the company and the collection.

T: Material By Product, Punch Out D: 3 Deep Design C: Material By Product W: Publication Y:2006

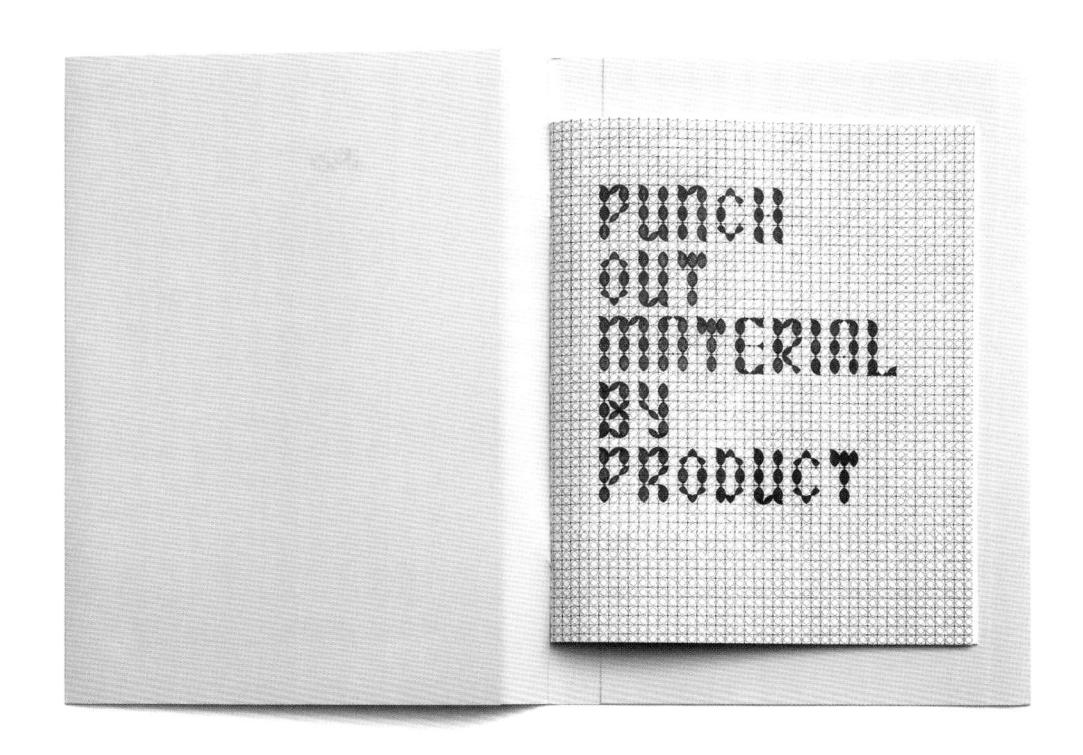

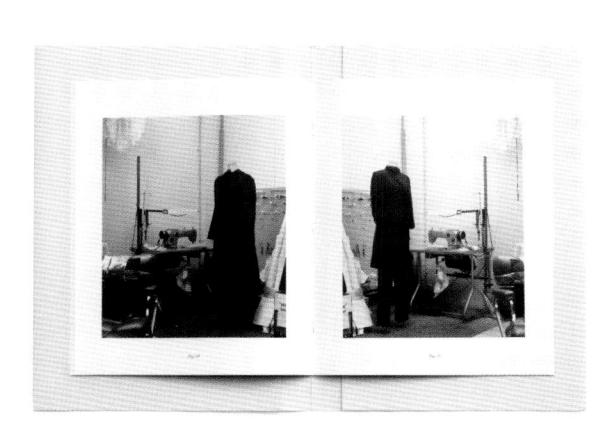

'Puti'

This work is a typographic interpretation of 2 poems quoted from the original Zen classic, The Platform Sutra of the 6th Patriarch, that dates back almost 1500 years ago. This is a Chinese philosophyfrom Buddism. The general idea is to believe everything is the same in the world and nothing really has a shape or appearance, so where could dust come from if there is actually purely nothing in the world?

T: The Puti Tree
D: Khaki Creative &
Design, Inc.
C: Khaki Creative &
Design, Inc.
W: Typeface
L: Chinese
Y: 2006

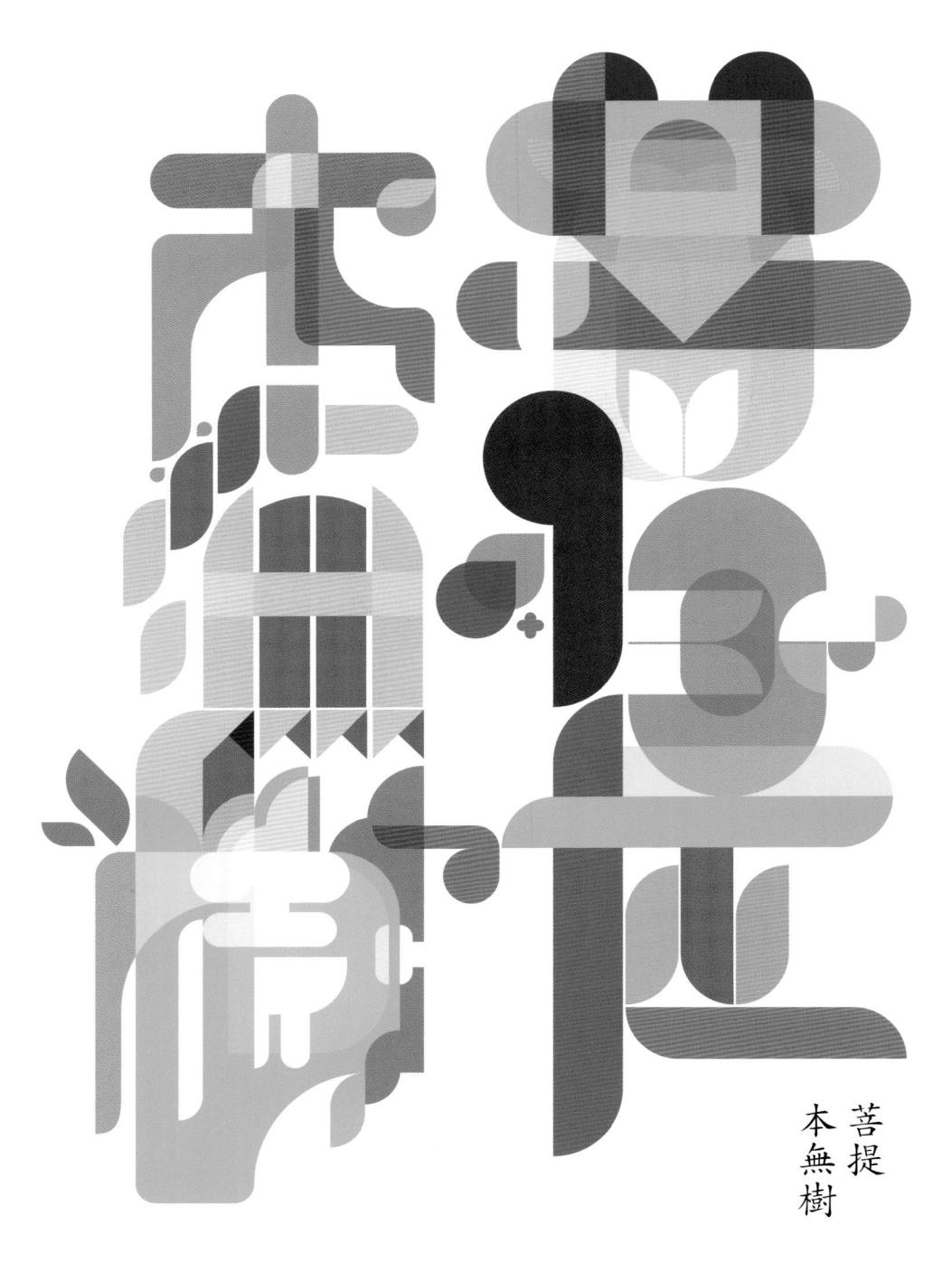

"Actually, the Puti tree does not exist..."

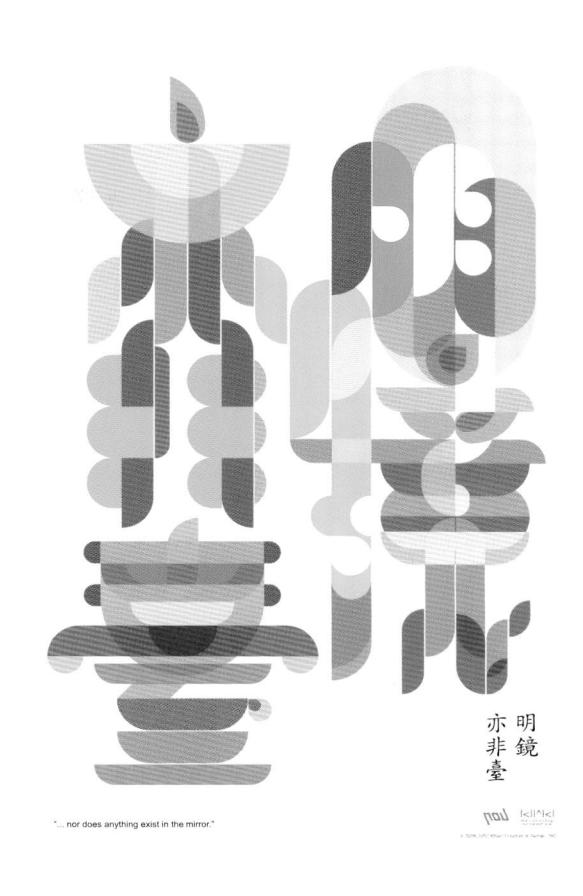

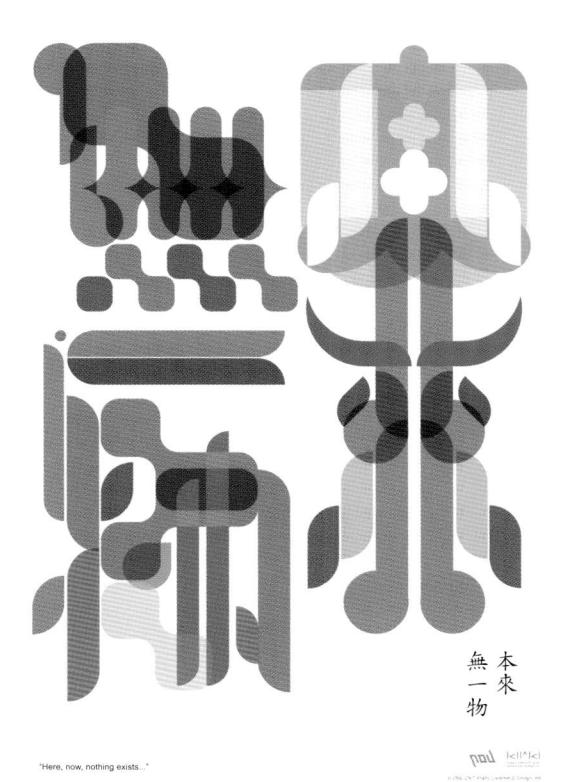

"... so how might there be dust?"

100 NOT 100 NO

'Quarter'

Poster Magazine was a quarterly magazine at the vanguard of Australian fashion, art, architecture and design. Having evolved dramatically since its inception in 2001, Poster Magazine was a printed forum for the discussion, presentation and critique of Australian culture. 3 Deep Design demonstrated the sheer diversity of the editorial approach and the ethos and energy behind the design of the magazine. 3 Deep Design no longer art directs this magazine.

T:Poster Magazine D:3 Deep Design C:Poster Magazine W:Editorial Y:2006

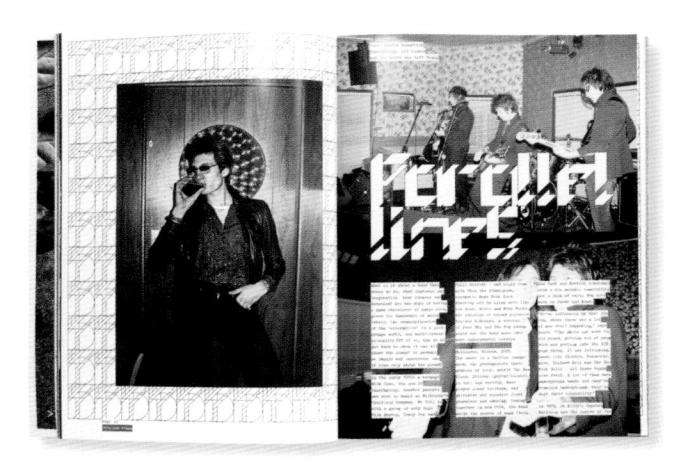

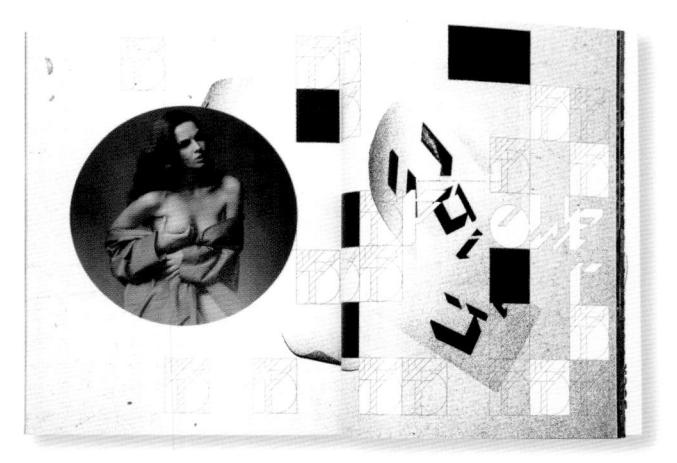

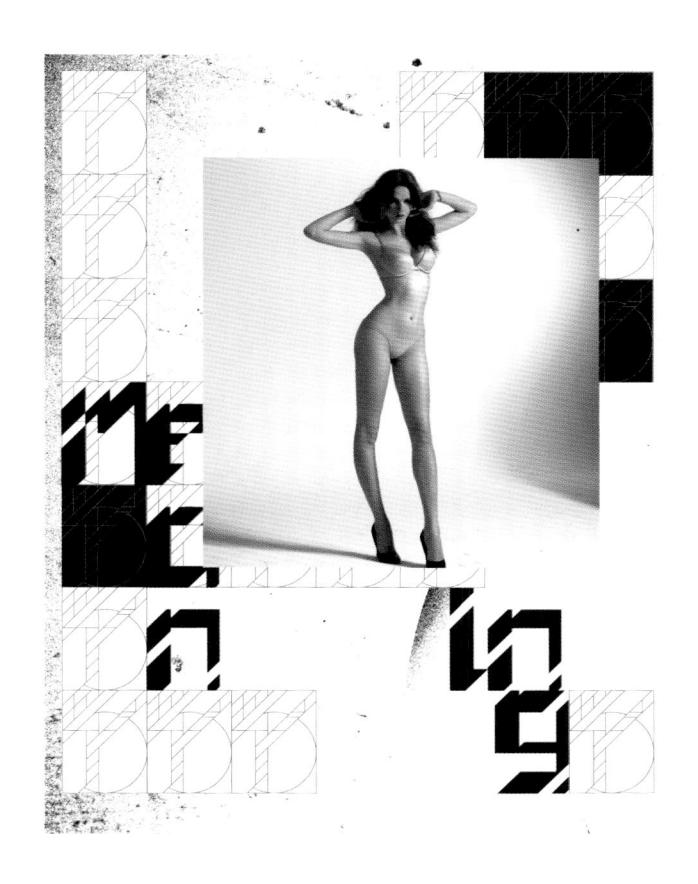

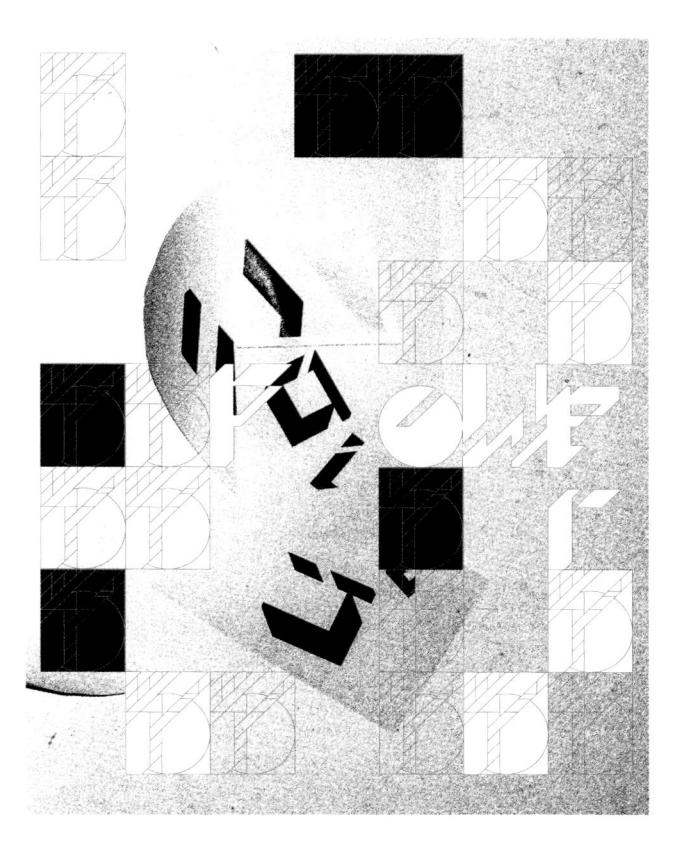

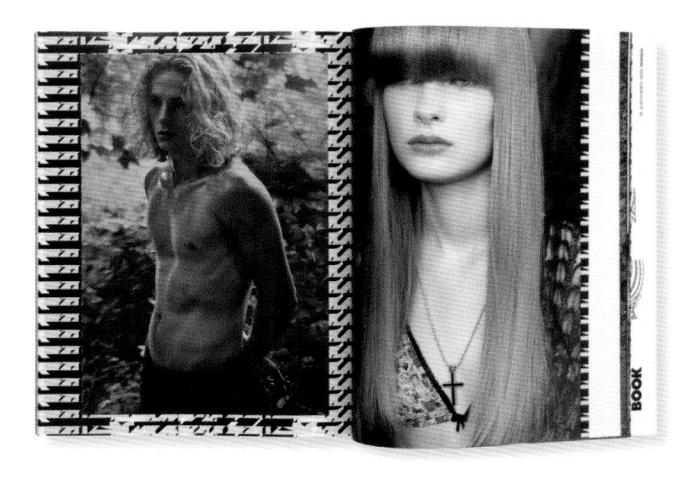

MAMORINA

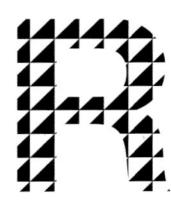

'Radio'

Artroom always try their best not to only use the existing types in their designs if time is sufficient, the designers believe astonishing typographic approach can make design shines on stage. Here the designers randomly picked different typographic designs throughout the years among the plentiful inspiring projects.

T:Chinese logotypes
D:Artroom - Commercial
Radio Productions Ltd.
C:Commercial Radio
Productions Ltd.
W:Logotype
L:Chinese, English
Y:2002-7

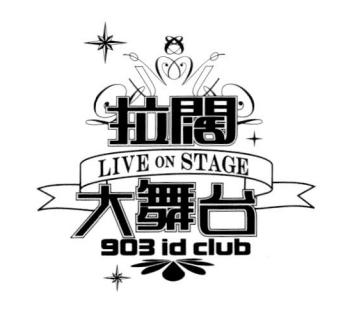

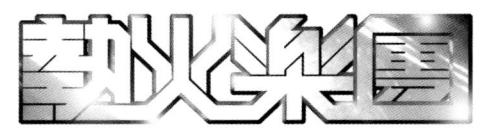

北美川橋駅劇圏中大火船撃事件

口2年度 叶啶染增流行榜油类典禮 03年-月-8-0氣 越梁場上的最後勝利

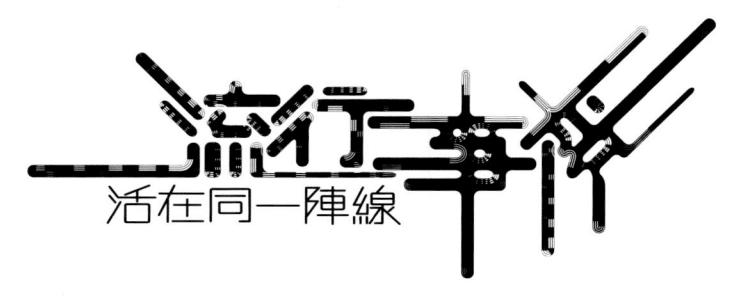

'Real'

To promote Beeffeater's drink in every WET issue, the designer is asked to develop an idea based on a particular theme. For the 1st issue, Serial Cut^m was given a theme about 'Night' to work with. All photographed elements were real, so the final result was a photographic collage, with elements that had been scanned, printed and cut (falcon, deer), and Helvetica typography made from plastic and real

elements (pink strips, straws, ice cubes, glasses, diskette..). This collage could have easily been done with Photoshop, but was actually done in a photography studio, and was barely retouched digitally. It is something like 'photographed graphic design,' in a sophisticated blue and magenta atmosphere. A 20-page promo magazine is produced for the first non-dry gin in the world: WET by Beefeater.

The publication was created by DressLab, designed by Albert Folch, and distributed in the coolest fashion stores and clubs.

T:WET
D:Serial Cut™
C:Beeffeater
W:Promo Magazine
L:English
y:2006

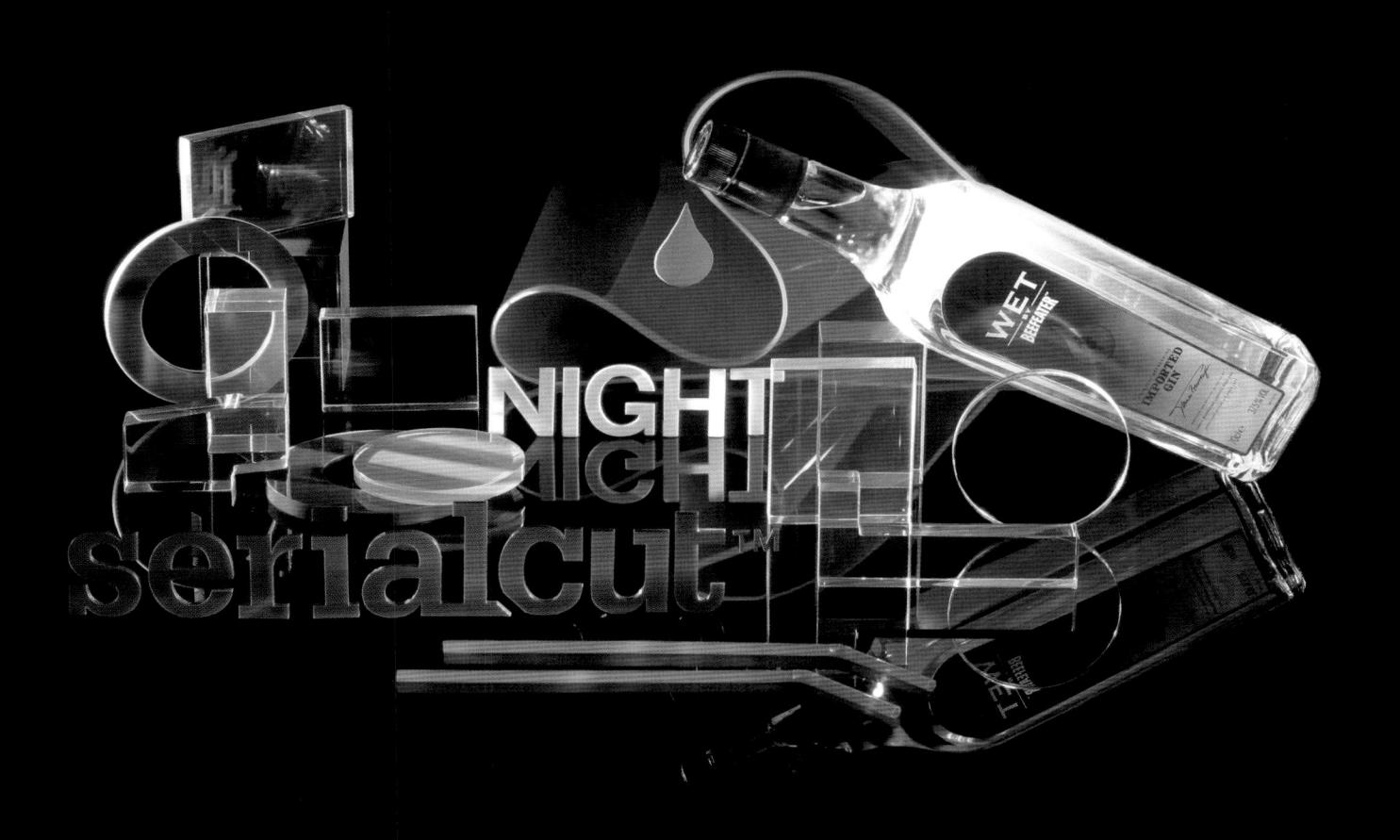

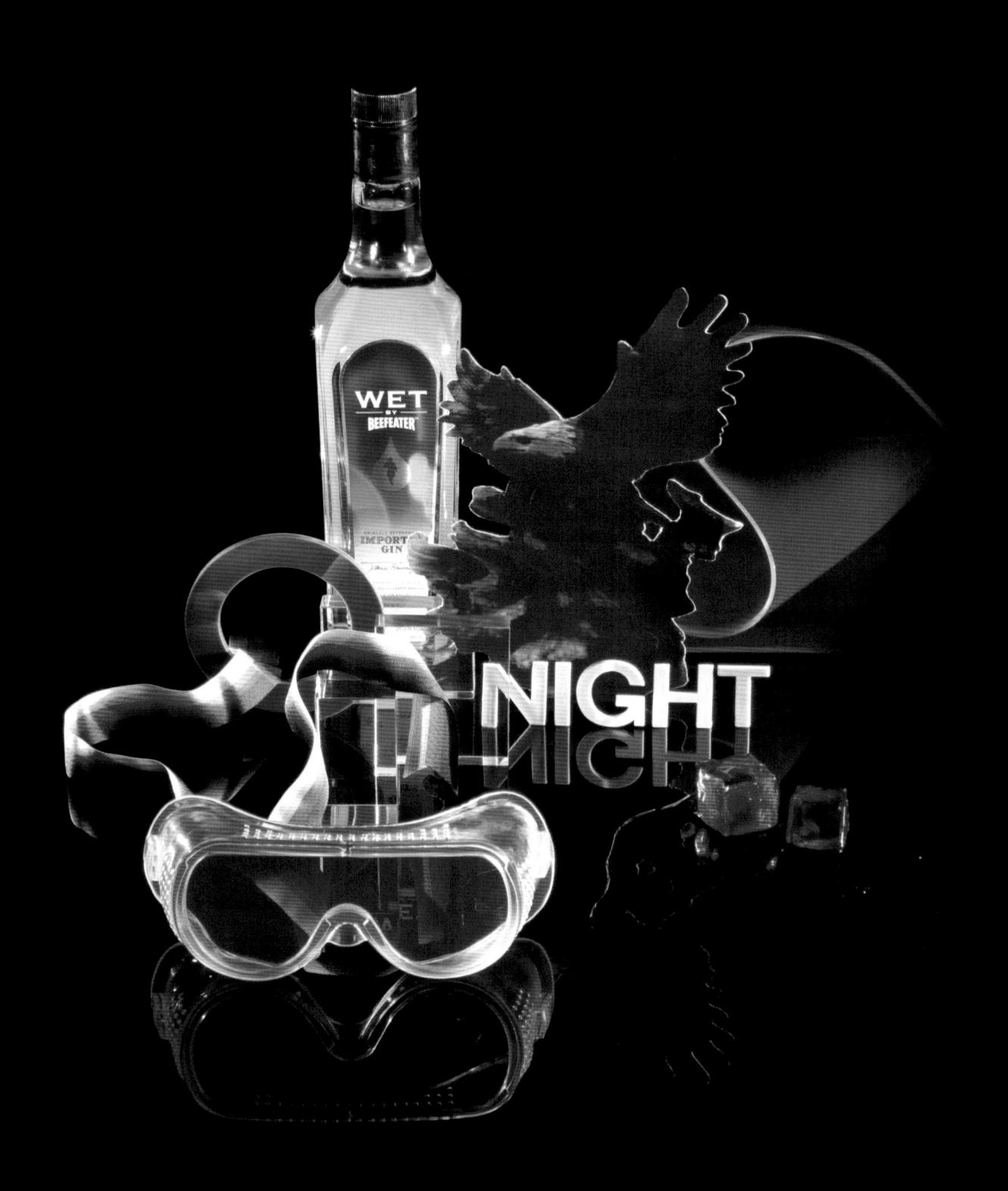

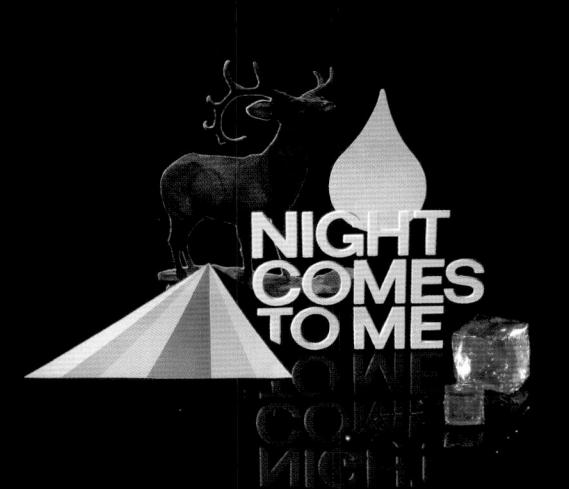

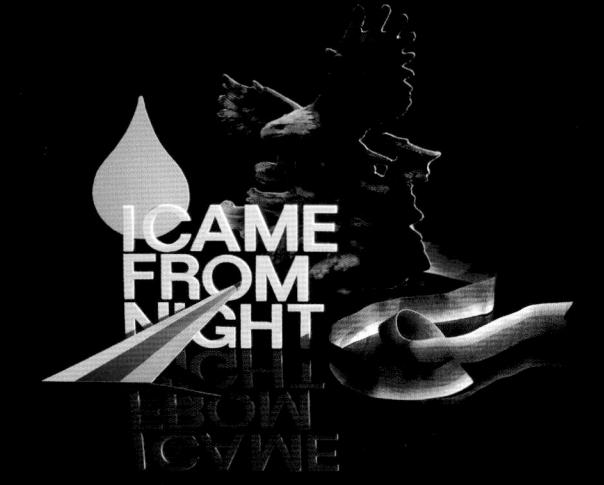

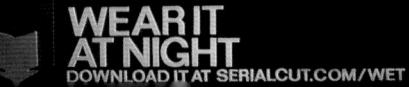

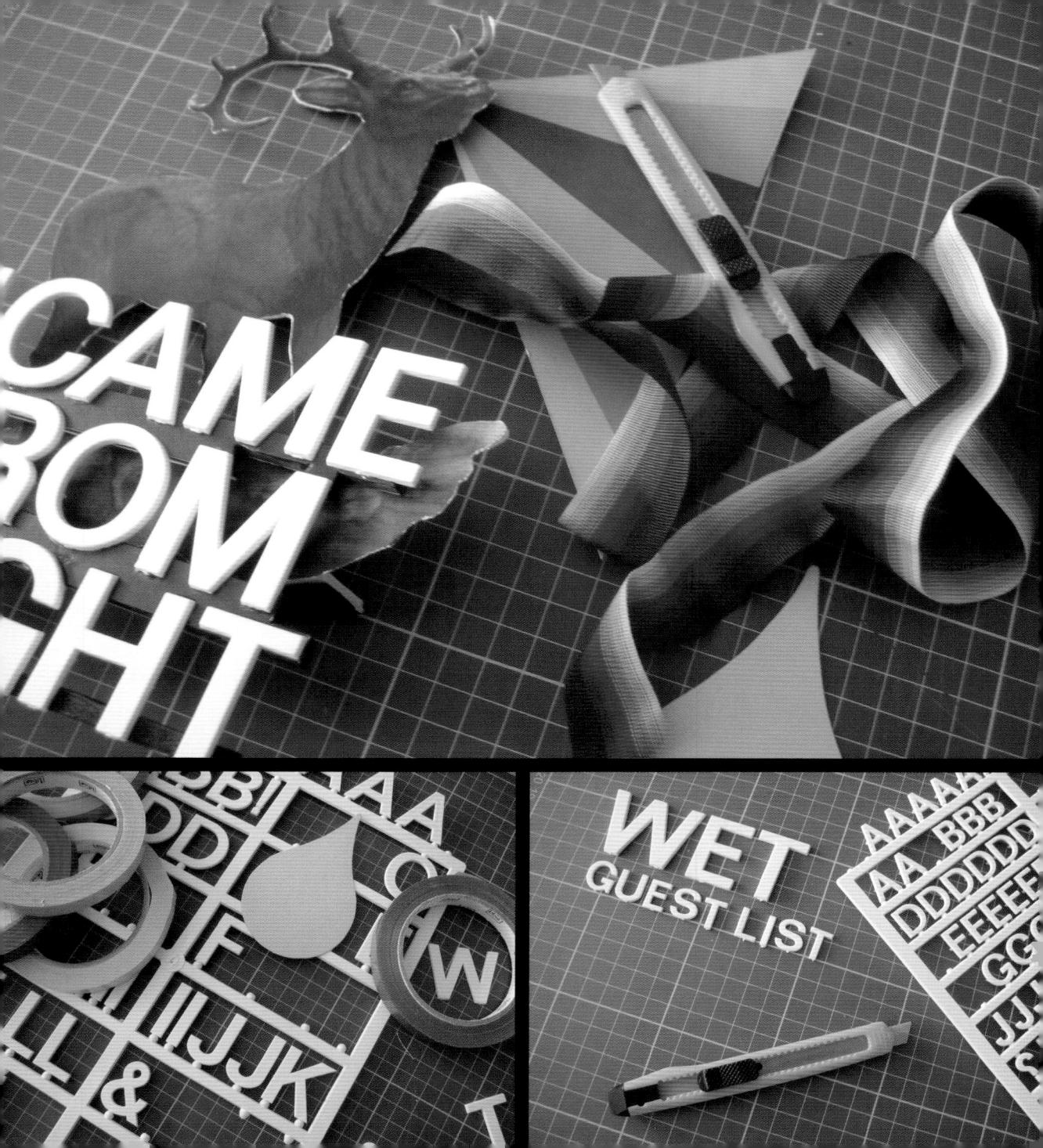

'Revolutionize'

Announcing Brian Collins' travelling lecture 'Design Changes Everything' at various design schools around the nation. The piece is a visualization and documentation of the process of creation, exploration, struggle, self-doubt, and the final crystallization of inspiration into form.

T: Design Changes
Everything,
Everywhere, Always,
Sometimes, Never
D: Apirat Infahsaeng
C: Brian Collins,
Executive Creative
Director, BIG
W: Poster
L: English
Y: 2007

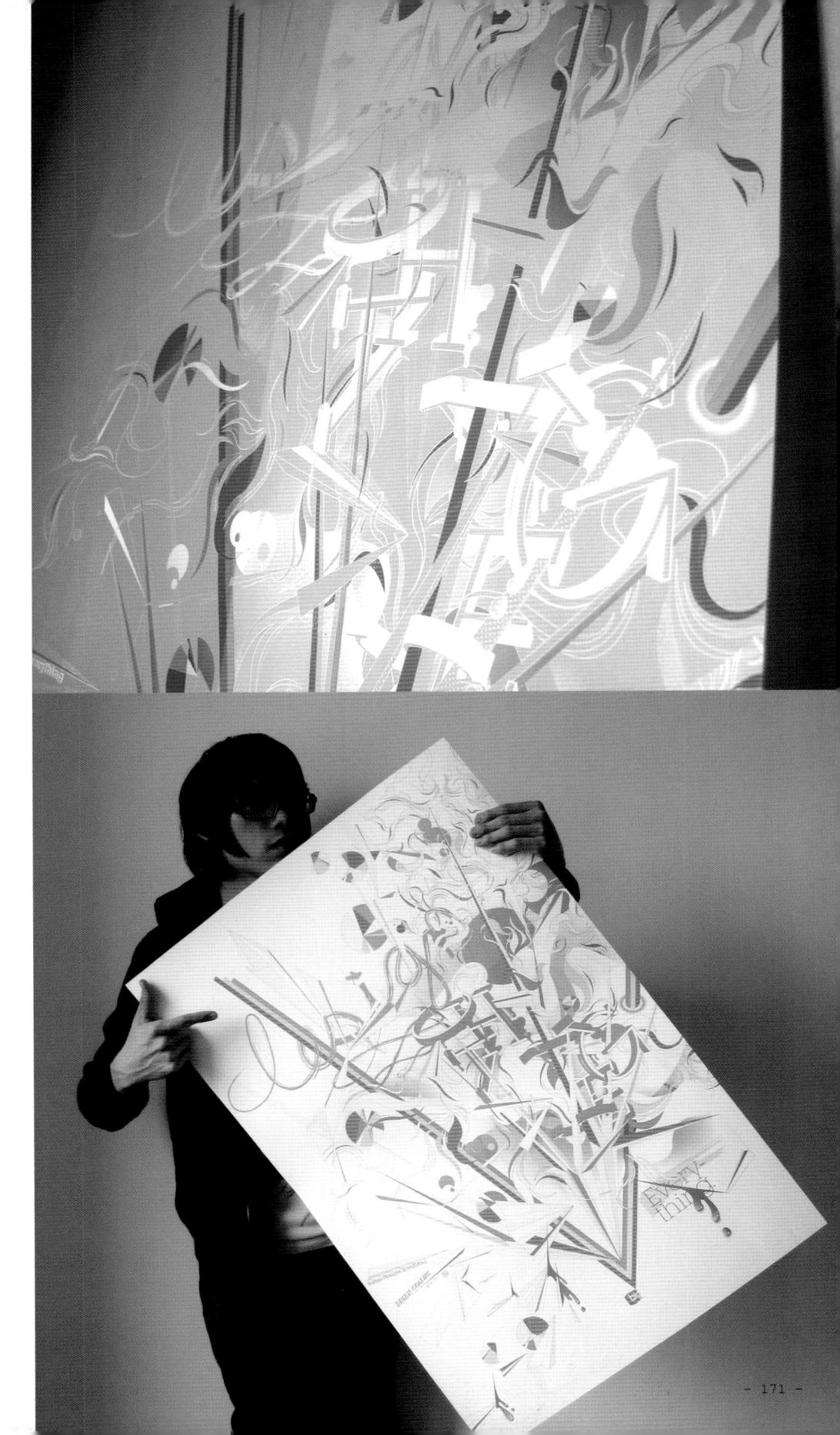

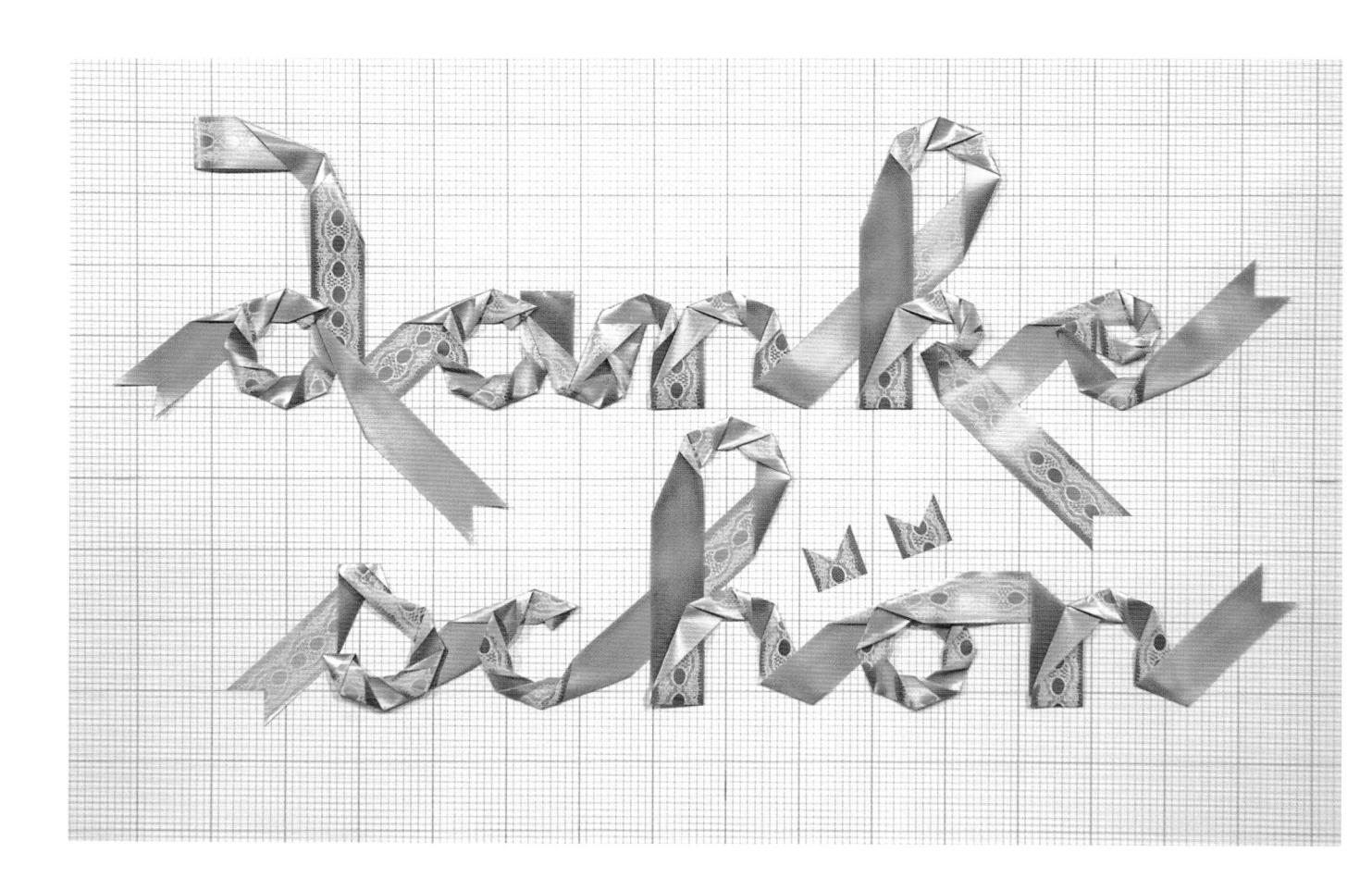

'Ribbon'

Paulette is a script ribbon typeface with corresponding folding templates.

T:Paulette (folded)
D:FromKtoJ/FromJtoK
C:FromKtoJ/FromJtoK
W:Typeface, Folding
templates, Poster
L:English
Y:2006

, ,

abadafg hijklmmm opqrstm numyg

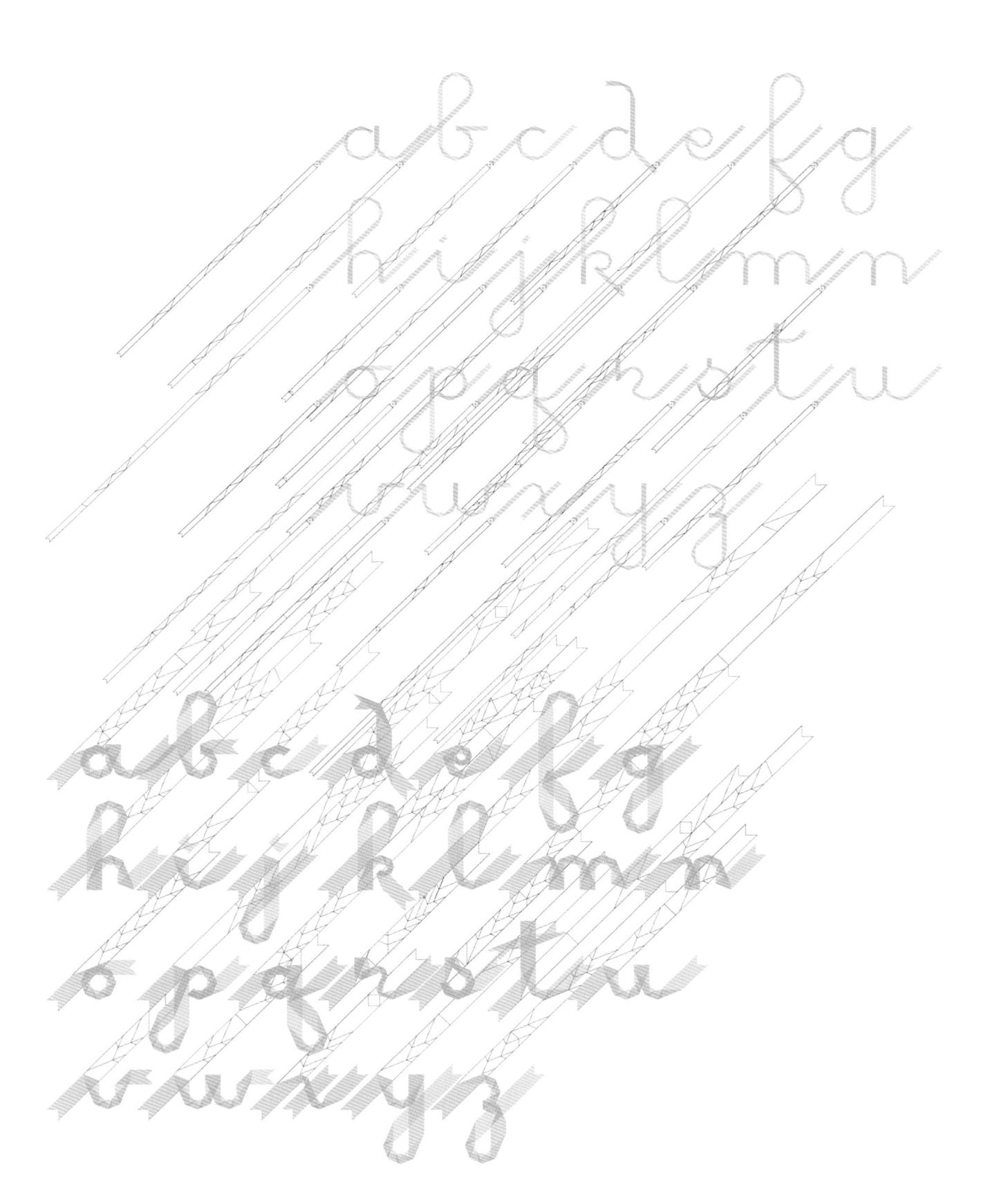

'Scotch'

The designer created the logo of Tropic Blues Band, printed in a natural size (6x2.5m) on 120 A4 sheets. They recalled the logo on floor, envisaged and redrawn the whole with Scotch Tape.

The band came one day and let the designers roll them up with Scotch Tape. The music of TETBB is a mixture of psychobilly-punky-blues, completely anchored in the Seventies. The designers found out that they like Whisky, so they used Scotch.

T: The Experimental
Tropic Blues Band/
Dynamite Boogie
D: pleaseletmedesign
C: The Experimental
Tropic Blues Band
W: 1.Album cover,
2.Inside booklet,
Poster
L: English
Y: 2006

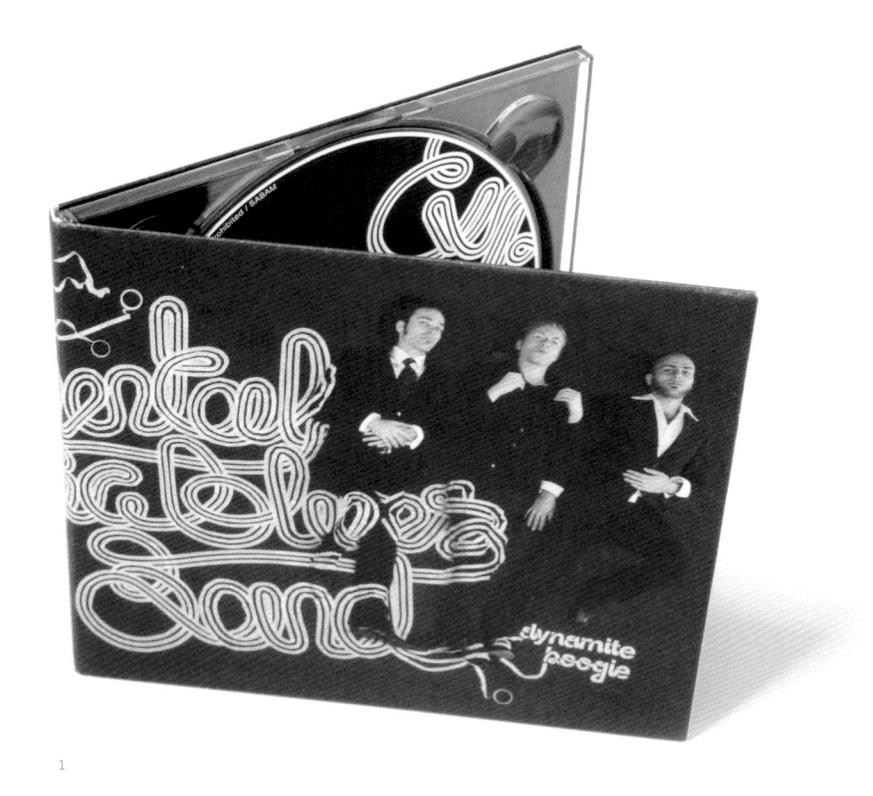

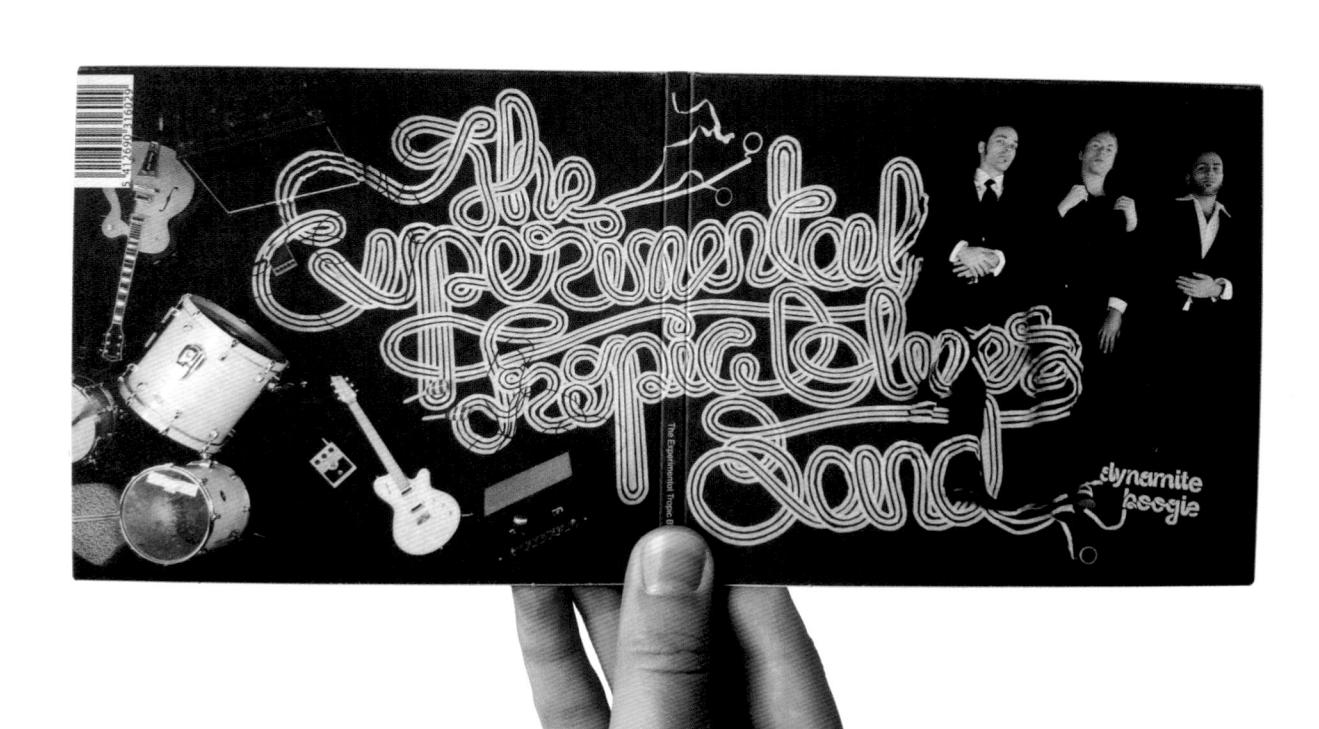

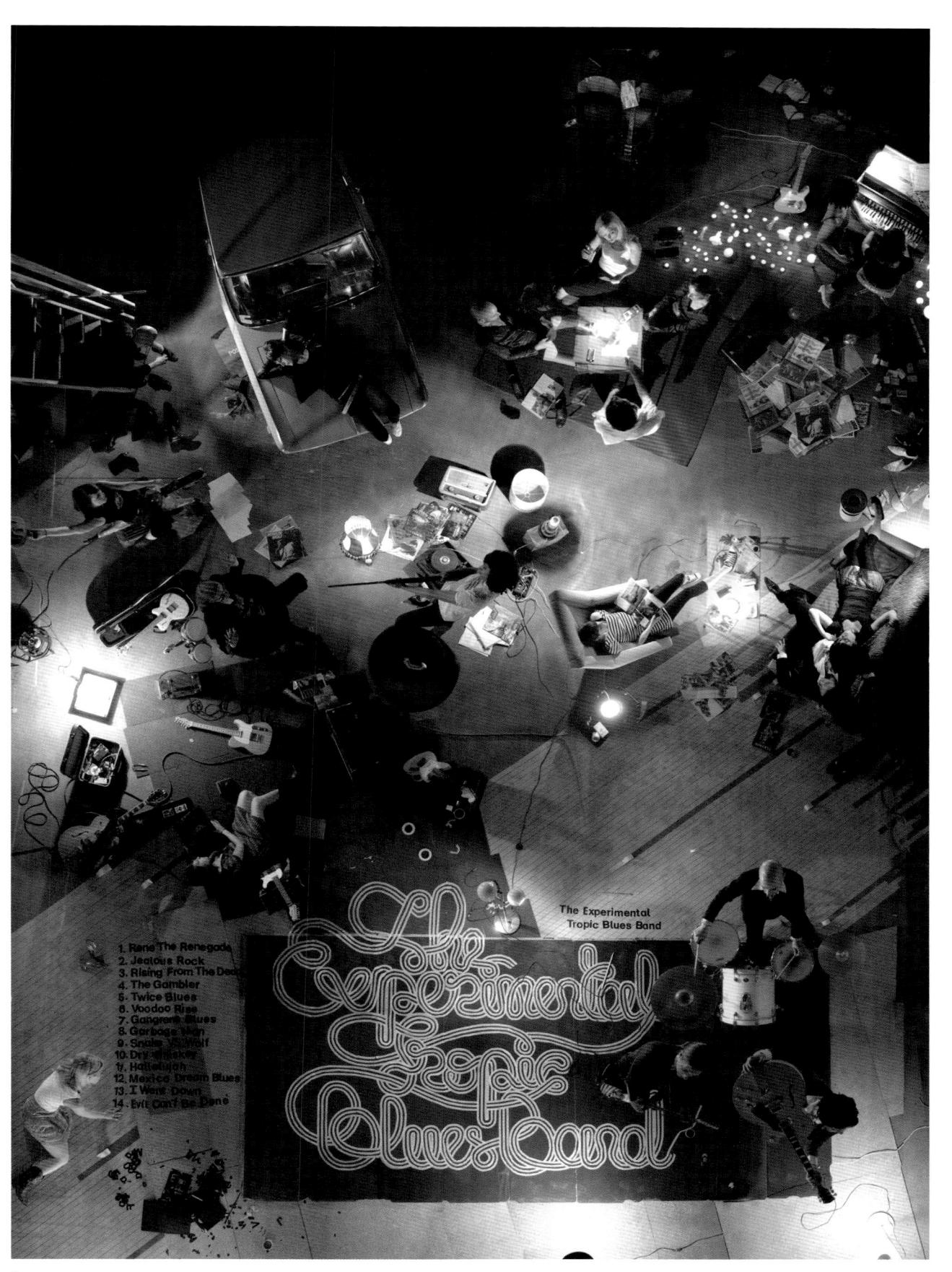

- 175 -

'Sculpture'

1.A 3-dimensional word, 'WAR' made of ash tree branches, commercial wood, paint and blue bullets for building (red, white and blue) . This piece is the 4th in a series, one each year since March 2003, in protest of the American war in Iraq.

2.A 3-dimensional word, 'ART' made of various fruit woods doweled. Collected by Charles Breyer in San Francisco, California, it is created for a Judge in the US Federal District Court in San Francisco, California.

3.A 3-dimensional symbol for the word, 'AND' made of apple prunings from a fruit grower in Northern California. It is painted with inks and constructed with screws.

4.A 3-dimensional letter of the alphabet made of manzanita branches and bullets for building (screws).

5.A 3-dimensional ampersand symbol made of apple tree pruning, paint and copper roofing nails.

6.An ampersand, a 3dimensional symbol for the word, 'AND' made of ash branches and screws.

T:1.Globalization IV:

Collateral Damage

2.Art Rules

3.Estuary 4.Big Ouestion

5. Past Tense

6.GO and ...

D: Gyöngy Laky

C: Gyöngy Laky

W: Sculpture

L: English M:1.32x97x4inches

2.8x14x4.5inches

3.35x34x3.5inches

4.68x78x5inches

5.22.5x22.5x3inches 6.40x46x4inches

Y:1.2006

2.2001

3,4,6.2007

5.2004

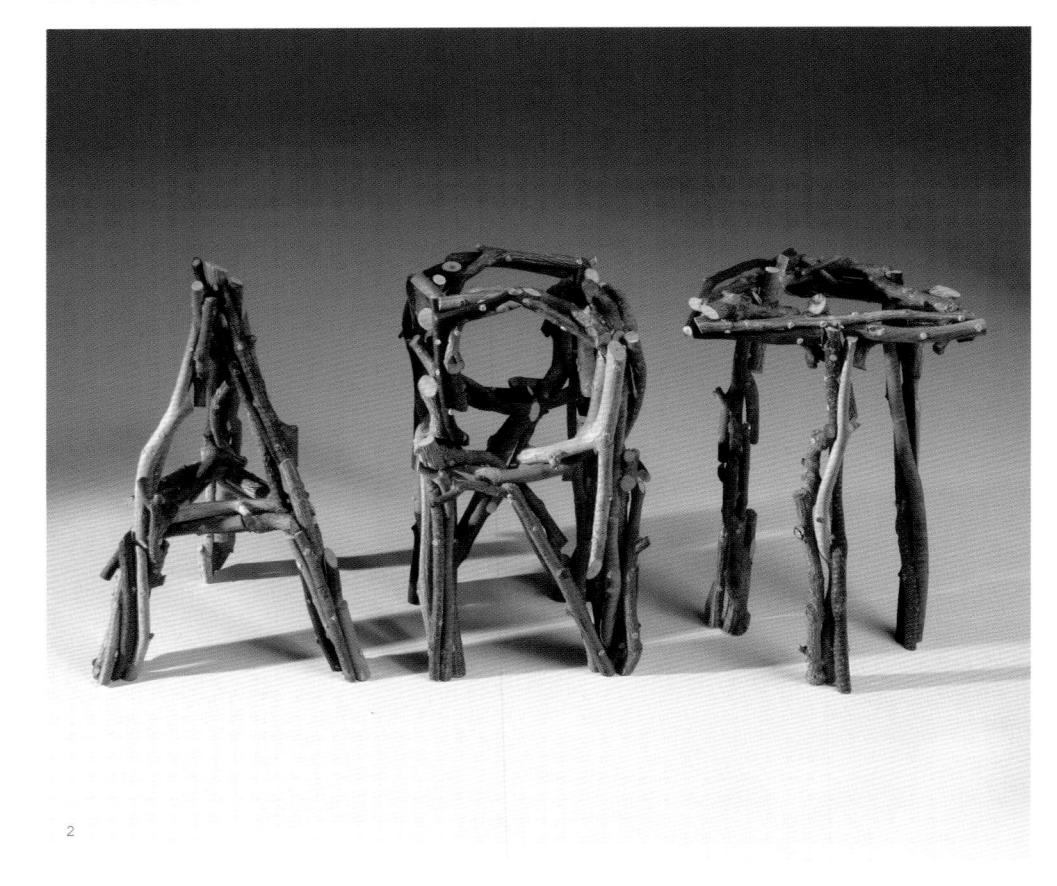

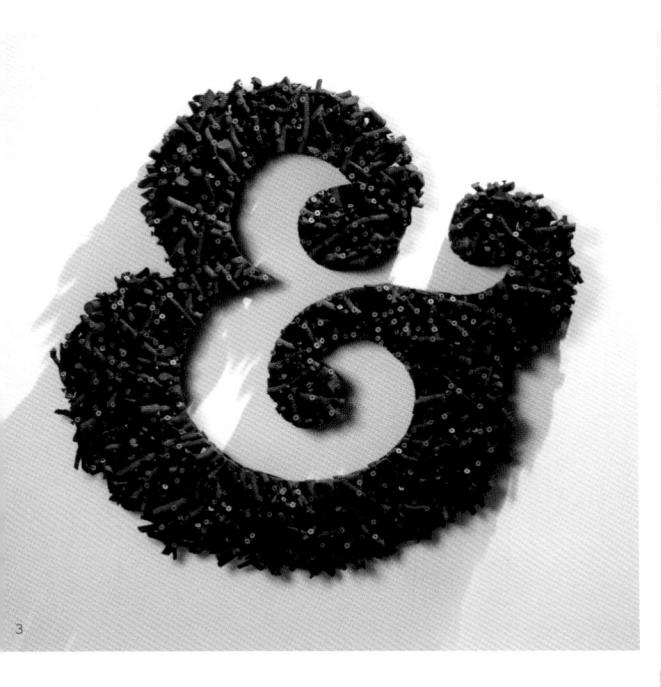

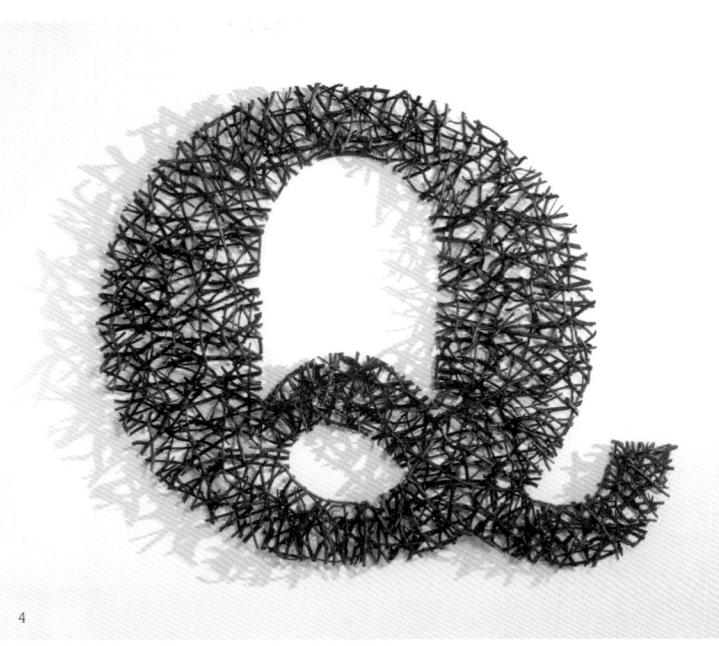

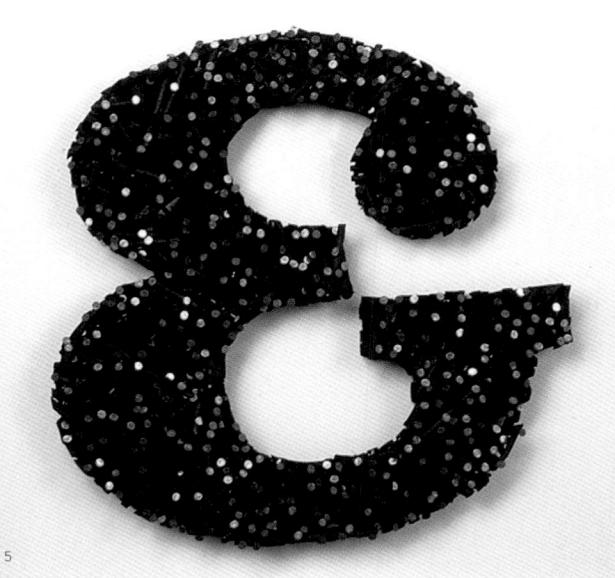

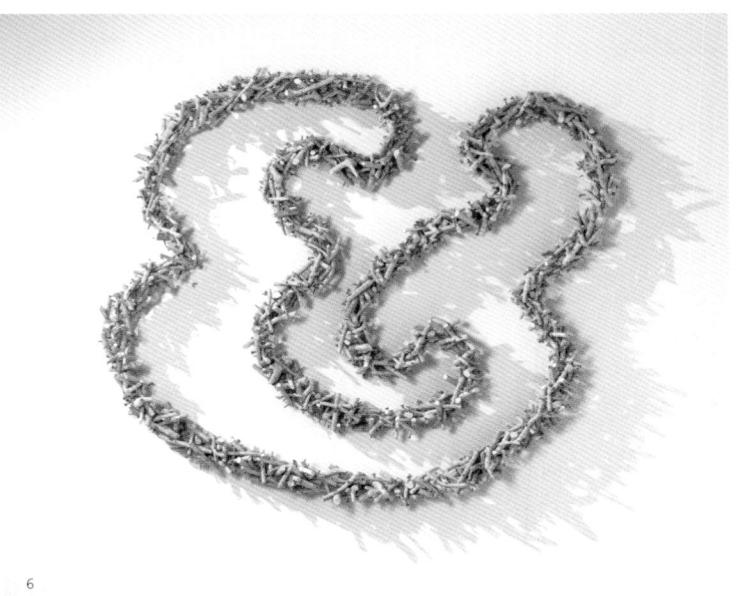

'Signage'

Visual identity and signage system of the New Highschool Guy Debeyre building.

T:Guy Debeyre Highschool D:Atelier télescopique C:Communauté Urbaine de Dunkerque, Luc Delemazure Architectes W:Graphic language L:French Y:2006-7

'Shaolin'

T-shirt design series for GMTEE. The theme is about 60's HK film's fighting scene.

T: Shaolin

D: Sixstation C: Atomicsushi

W:T-shirt graphic Y:2005

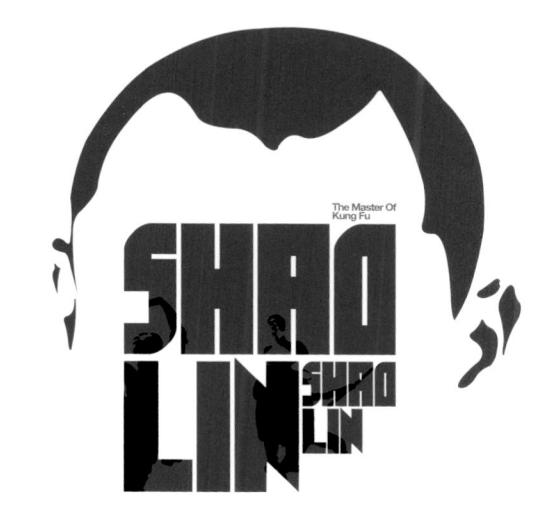

'Silence'

The starting point is the installation series 'Sounds of Silence' that turns various forms of silence into a sensory experience. The documentation of this project should provide an original interpretation of the subject that transcends the descriptive approach.

This book extends the concept of the installation series in a formal sense. The 4 installations of the series, each of them autonomous, are represented by 4 associative booklets - accompanied by texts of various authors, photographs of the project and a cinematic documentation on DVD. A multiply wrapped cover combines these diverse aspects into a comprehensive book whose diversity in terms of contents and design creates its very own approach to the subject of silence.

T:Sounds of Silence D:desres design group C:Petra Eichler, Susanne Kessler W:Artist exhibition catalog L:German Y:2007

'Sleeve'

Detroit Underground, generic sleeve concept, design and typography by Gandl, 2004. A graphical pattern system derived from world maps was used to define a release index which also matches perfectly with a map of Detroit masked by Gandl's typeface NBForm™, a typeface he originally designed for the Typography issue (196) of the European Design Magazine 'form.' The customer receives a free copy of the typeface with the purchase of the record.

T:Detroit Underground Generic Sleeve D:Neubau (NeubauBerlin.com) C:Detroit Underground W:Record sleeve L:English Y:2004

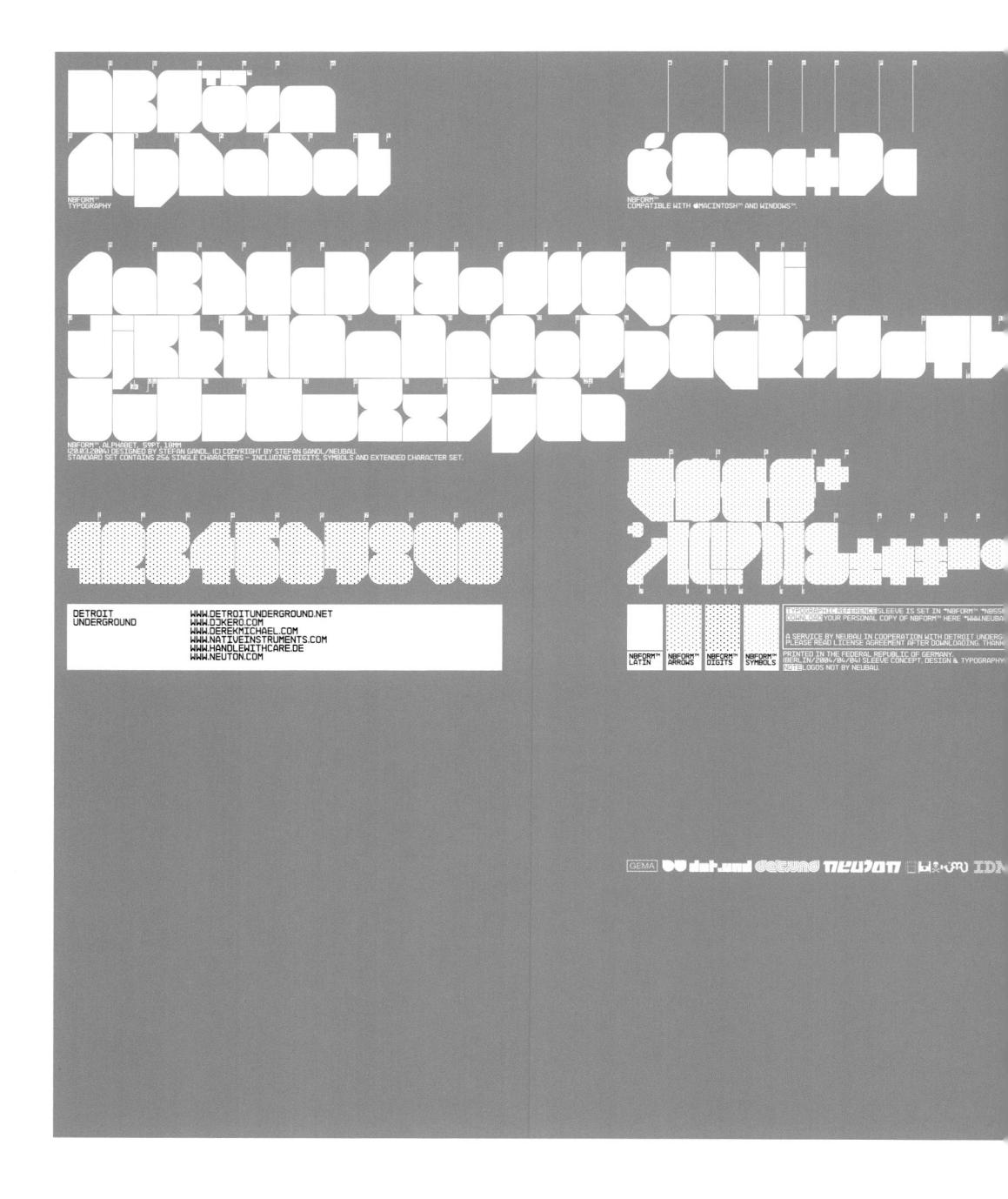

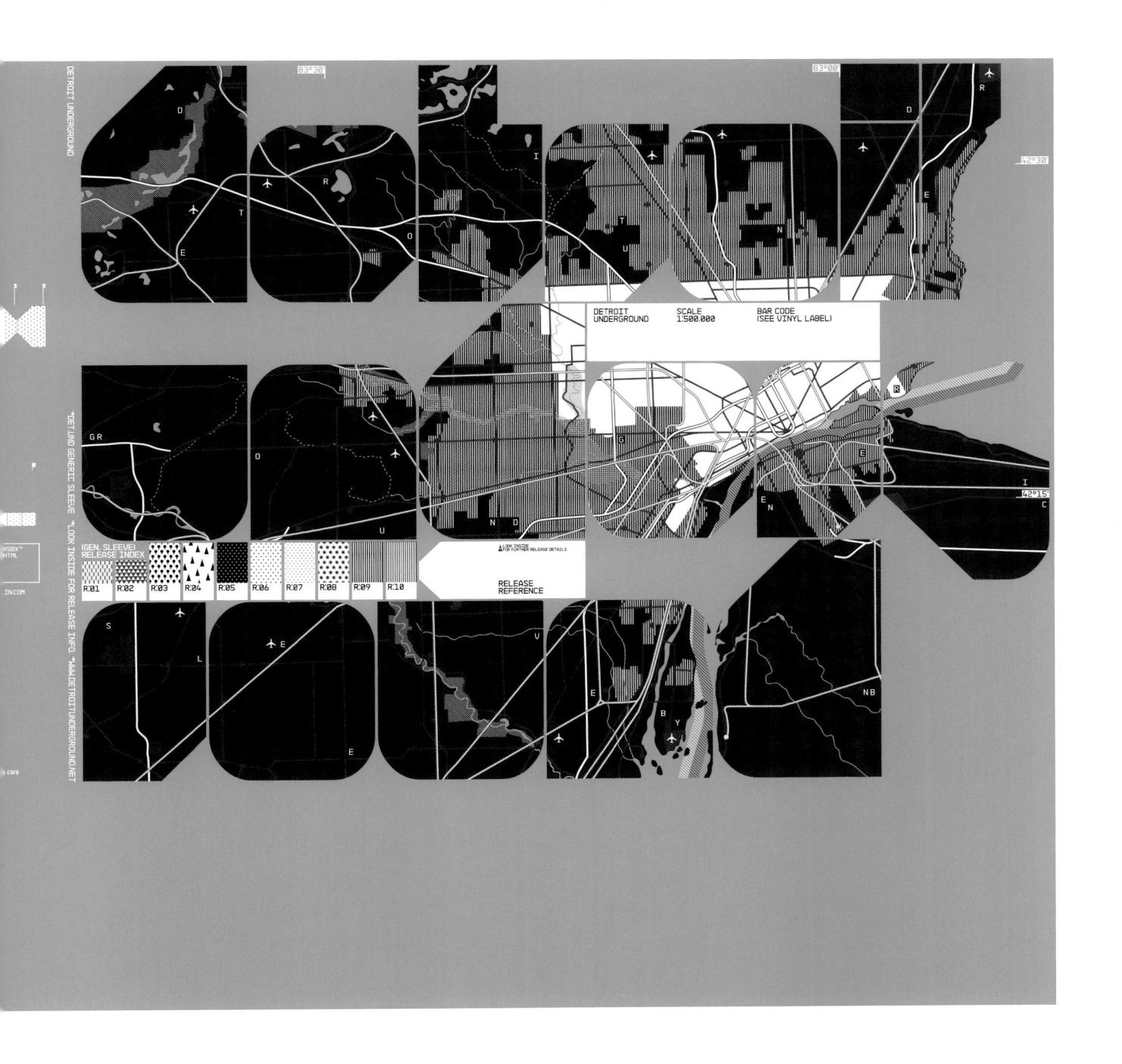

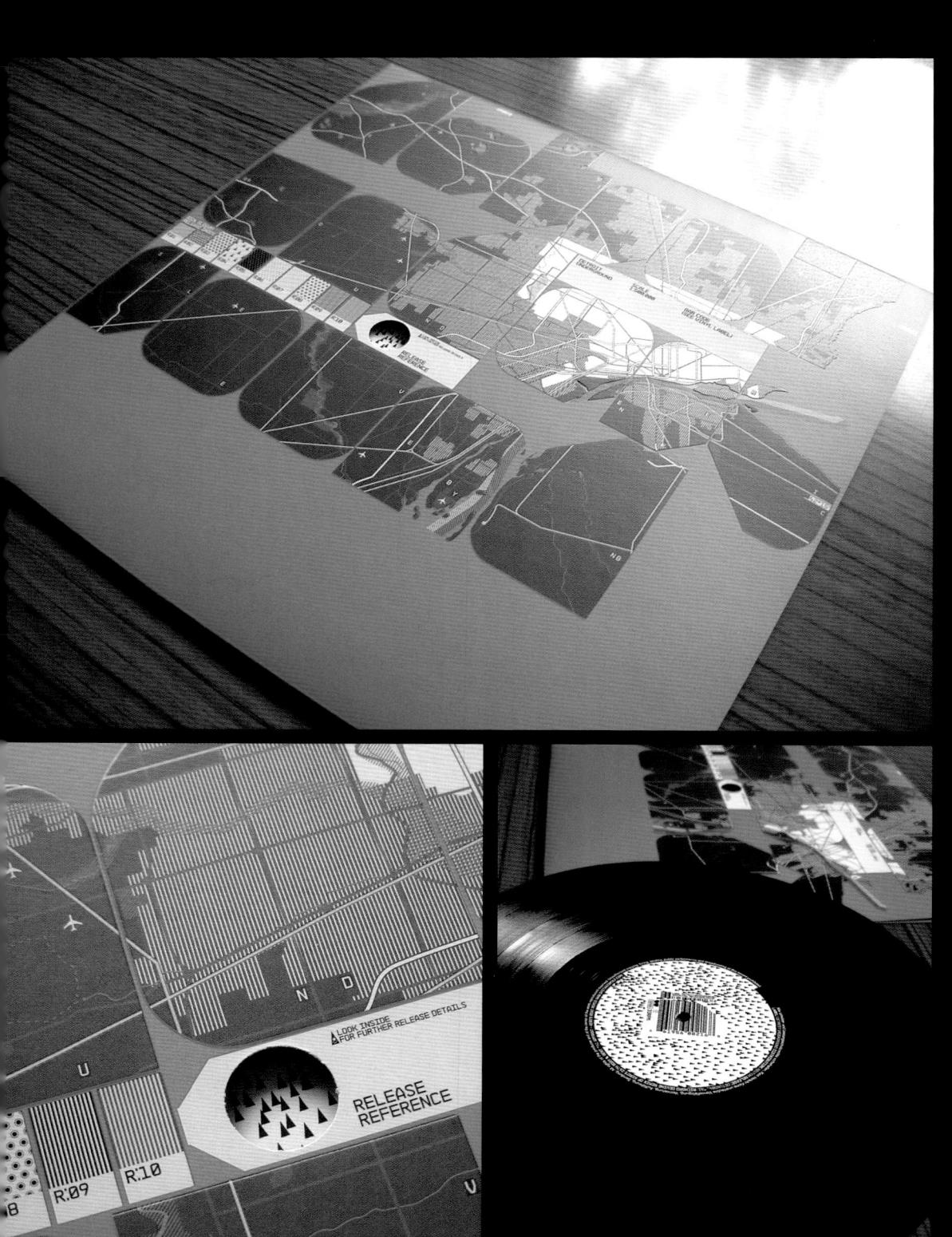

'Space'

'Re' means reproduce like recycling or regeneration. The typography on the wall surfaces means that a green life is reproduced on the surface of concrete walls when it is viewed from a regular place. The typography is designed on the wall surface so as to materialize 2-dimensional typography in 3-dimensional space.

T:Re D:KOKOKUMARU,Co Ltd. C:Osaka University of Art W:Environment/space L:English Y:2003

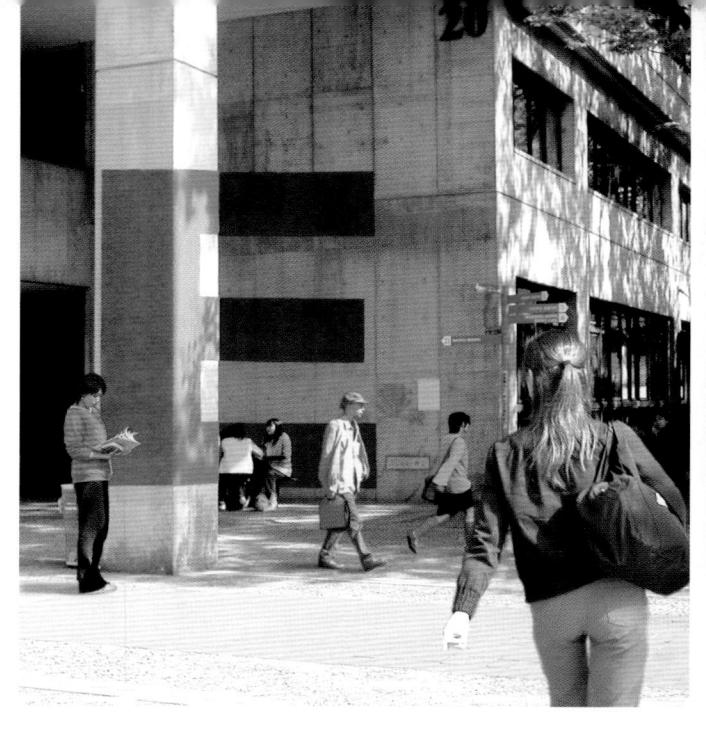

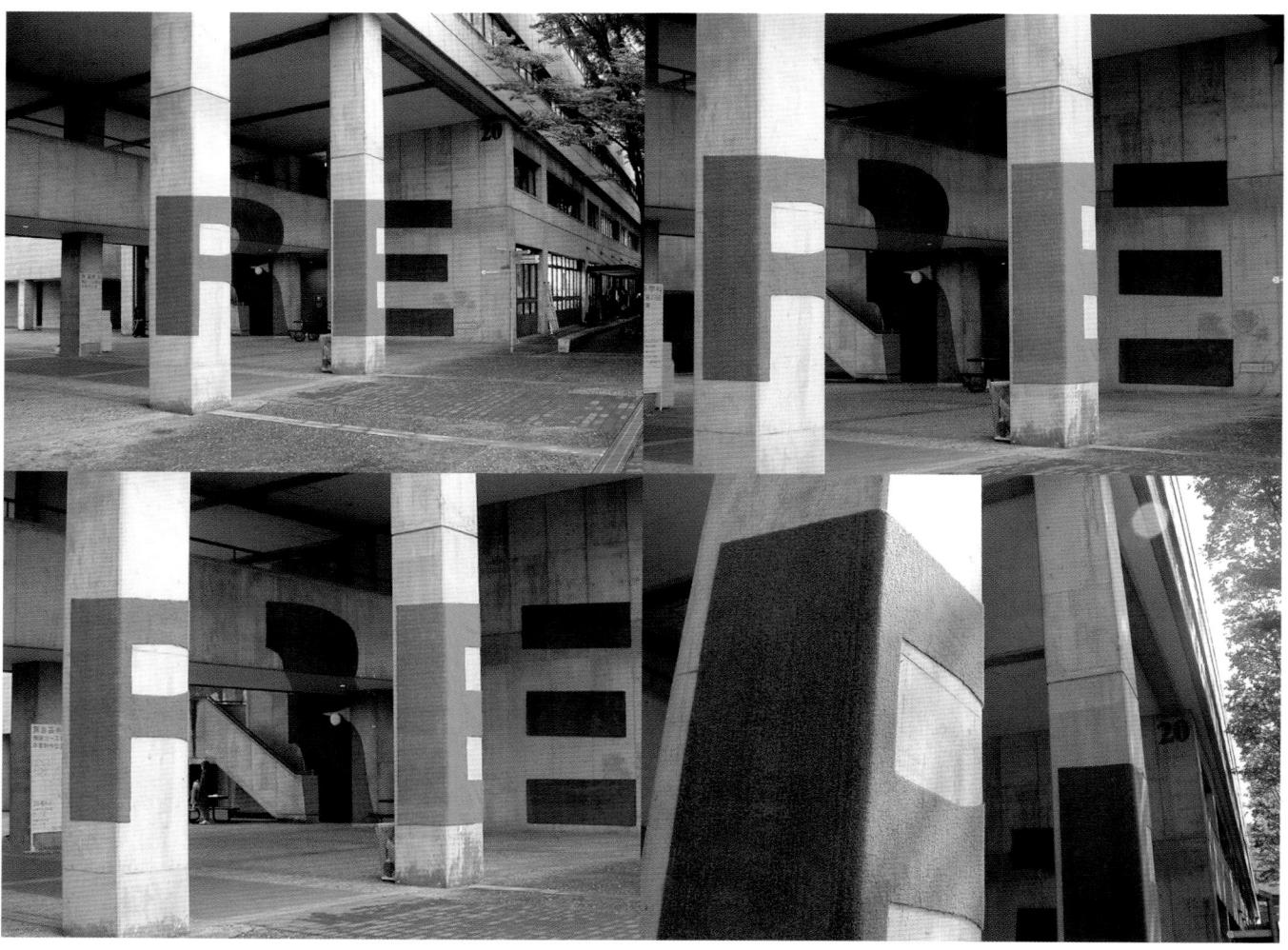

'Square'

Type treatment for a band. square-extension is an audio-visual band based in Poland. It is a multidisciplinary project that expresses its beliefs and ideas via the medium of music, video, graphics and text.

T:square-extension D:mylifesupport™ C:square-extension W:Commercial L:English Y:2007

'Sports'

Typographic designs for shop display units. The designs are printed in gold on white leather.

T:Revolution/Destiny D:Non-format C:Nike W:Shop display L:English Y:2005

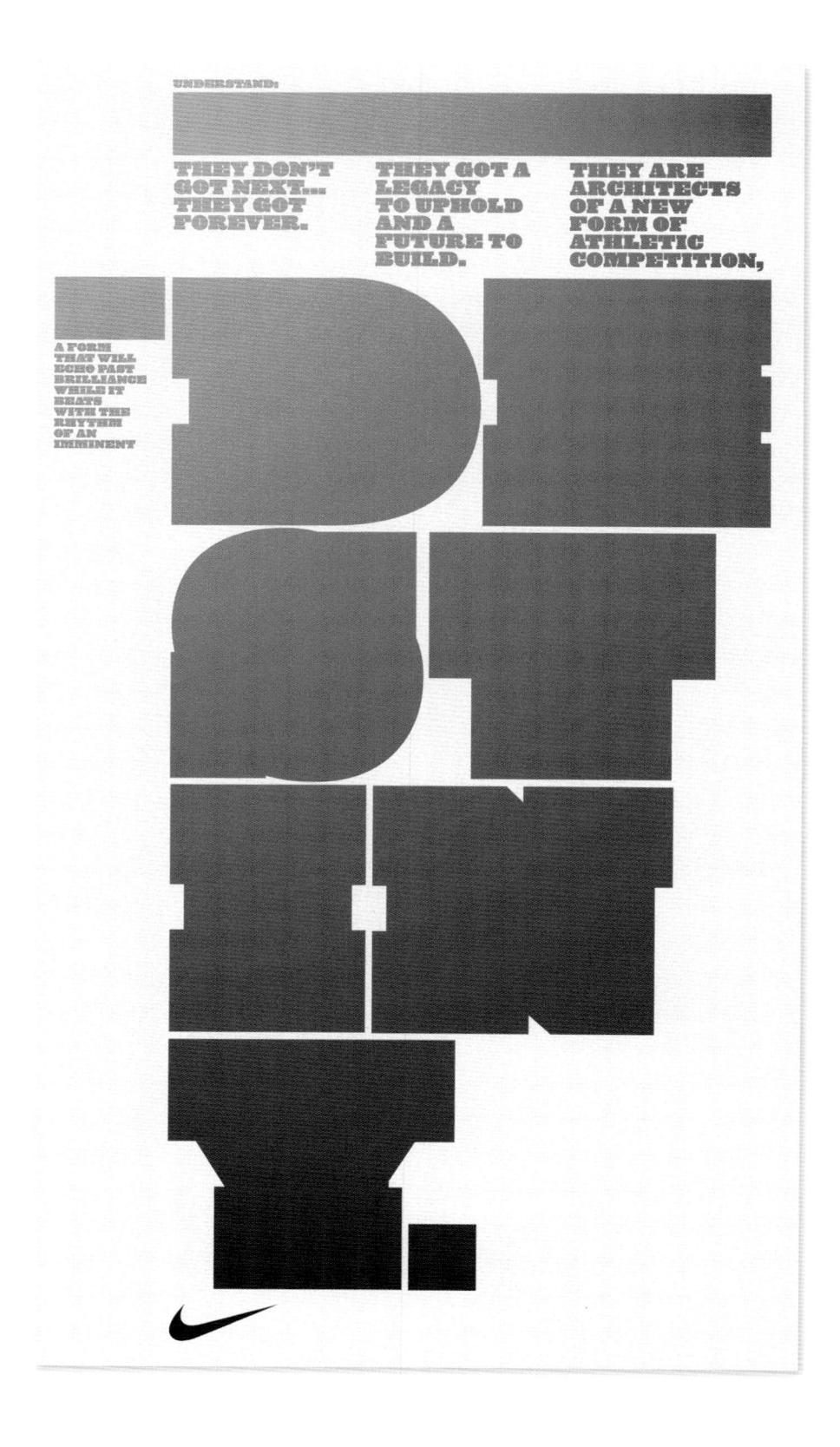

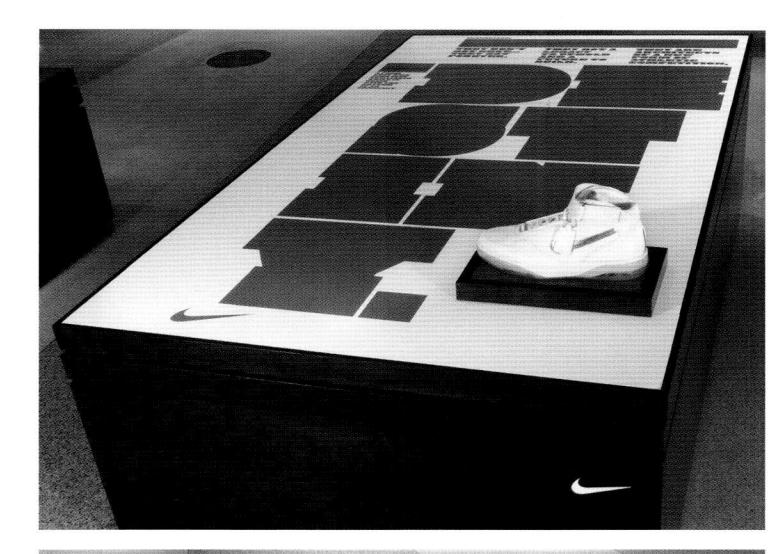

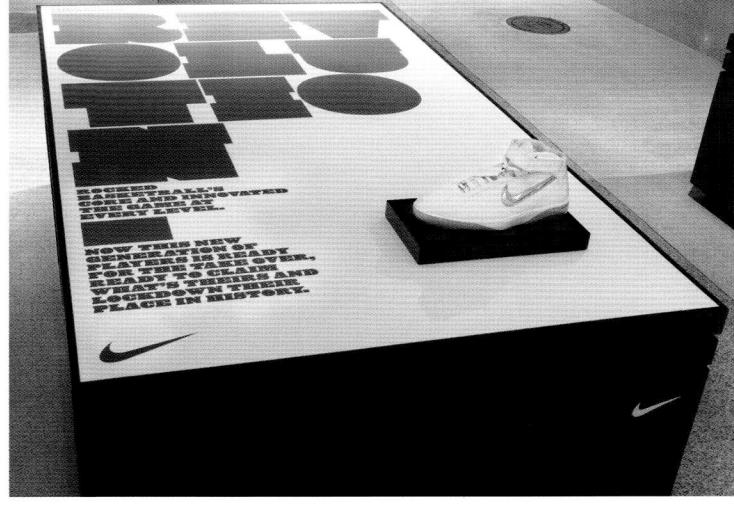

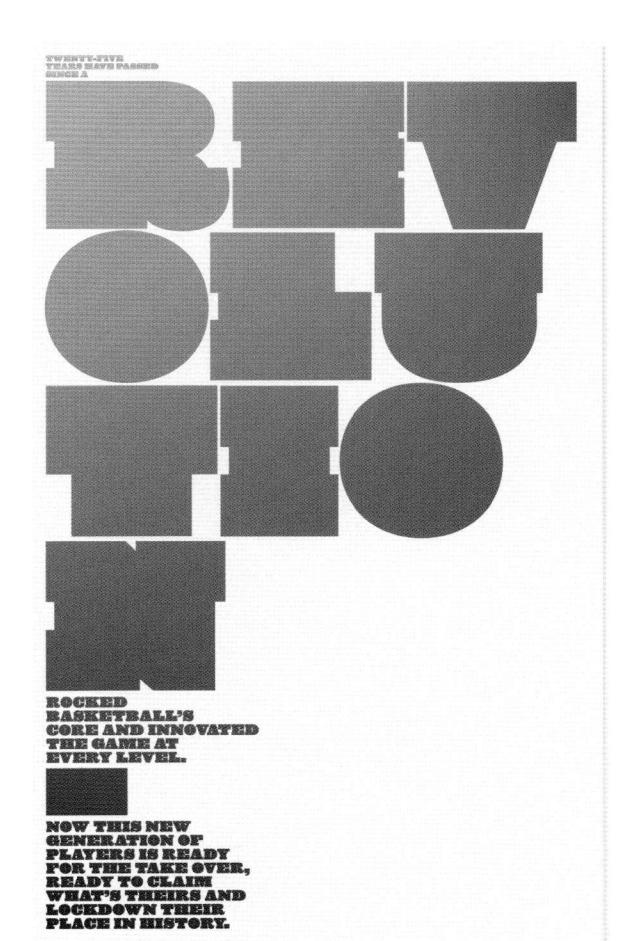

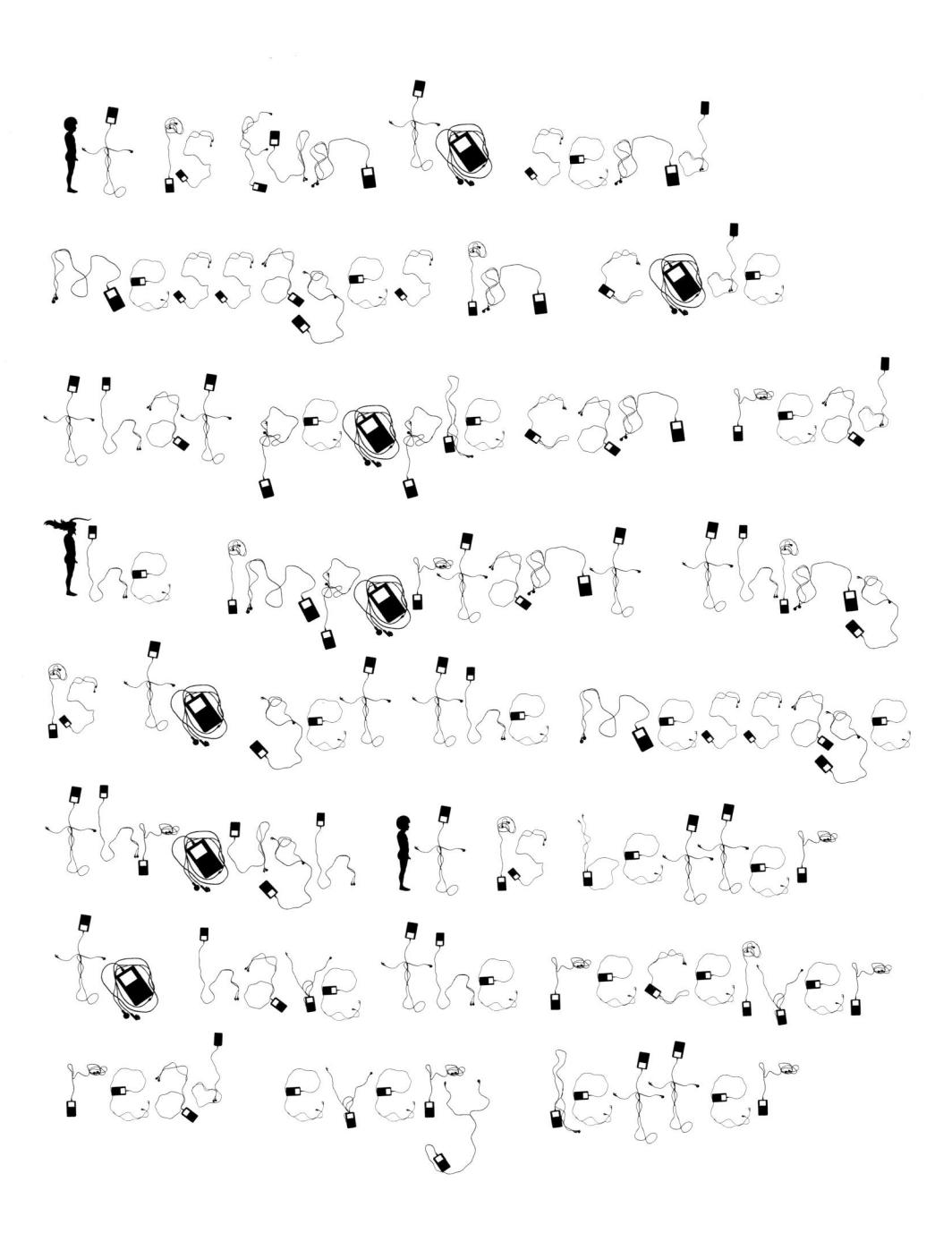

'Stereotype'

iType is a 'stereotype' that was designed from a desire to embed metaphor, mythology, popular culture, and innuendo into a typeface. The alphabet was made on the occasion of Post Typography's call for experimental typography, and it is now part of 'Alphabet: An Exhibition of Hand-Drawn Lettering and Experimental Typography,' travelling throughout the United States and abroad.

T:iType
D:Topos Graphics
C:Topos Graphics
W:Typeface
L:English
Y:2005

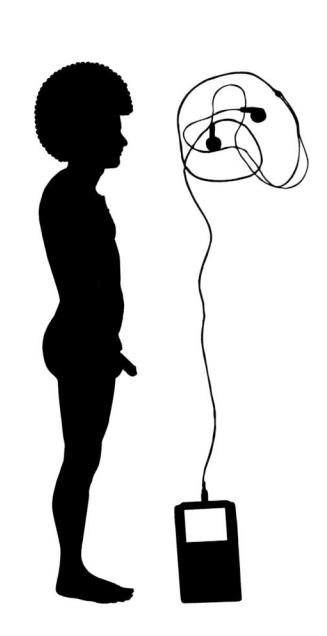

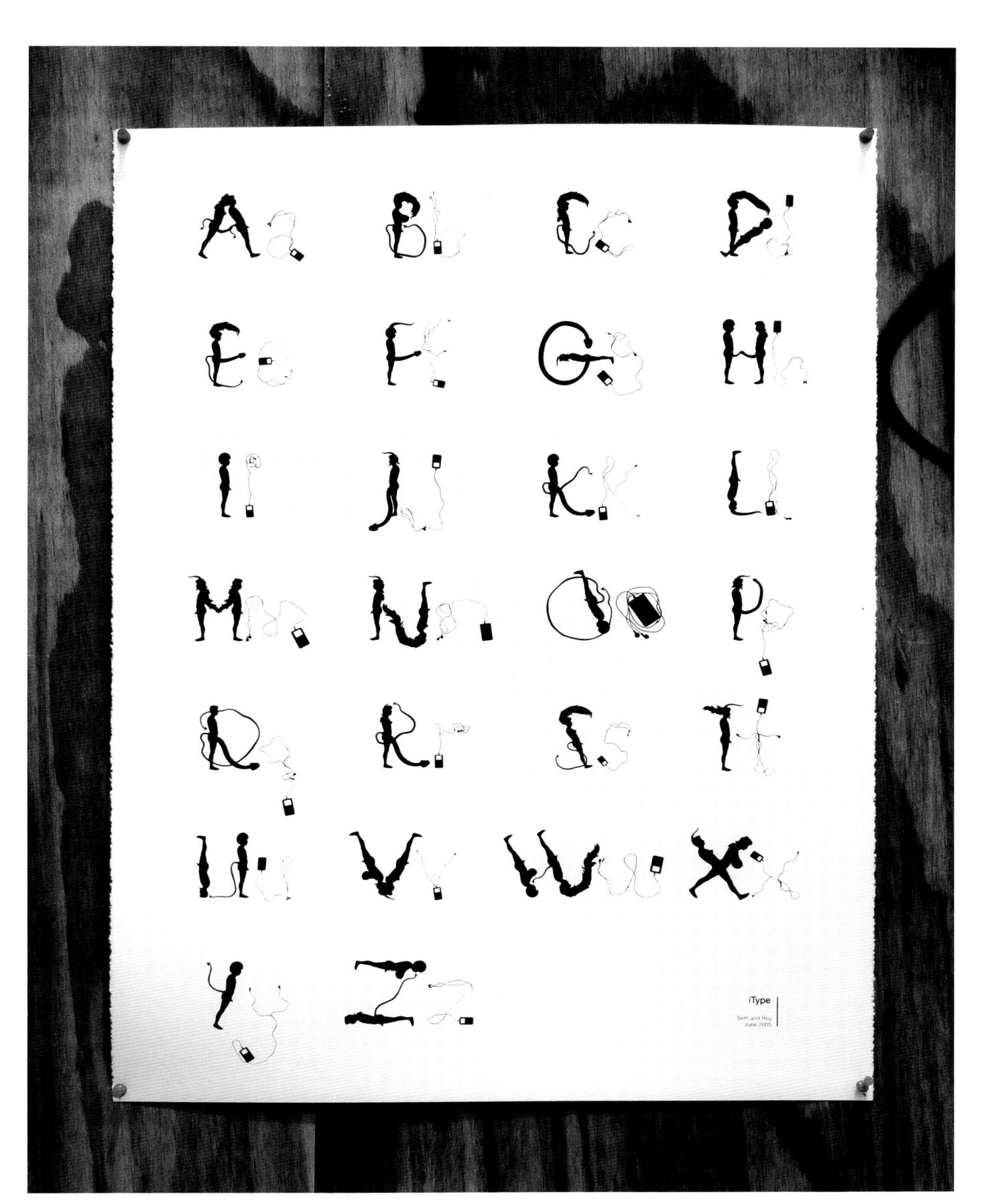

'Stick'

NBStick™ is a typeface that was exclusively produced for the German design and fashion magazine called Jpeople. NBStick™ is inspired by the work of Markus Dressen.

T: NBStick™
D: Neubau
(NeubauBerlin.Com)
C: Jpeople Magazine
Germany
W: Illustration
L: English

Y:2004

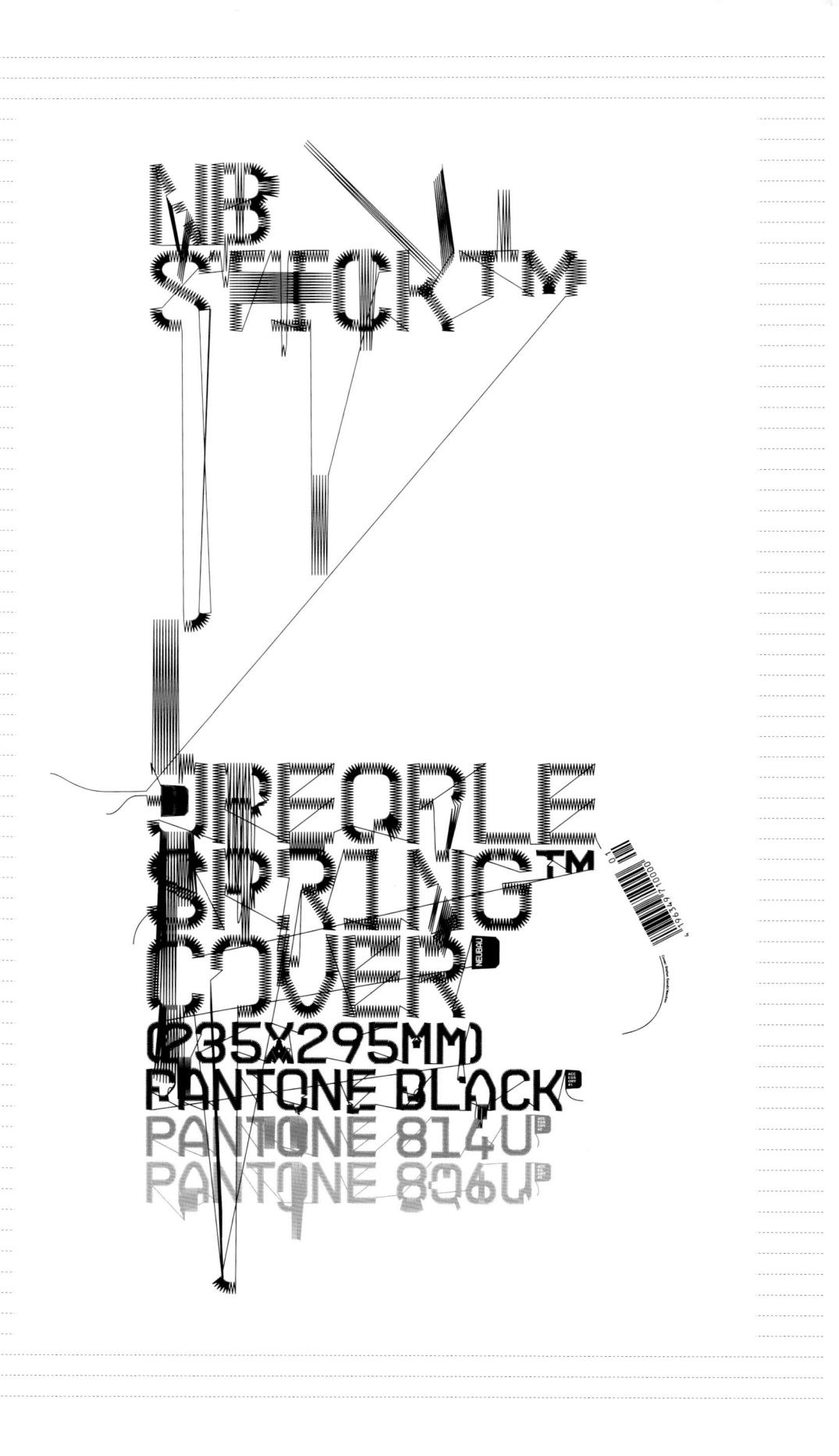

'Still-life'

It is made for New Year's Eve as Serial Cut™ wanted to wish everyone a happy new year. Together with the release of the newsletter titled 'Colour&Illusion for 2007,' the poster is made with huge real 3-dimensional words (props) in different colours. It was real still-life photography with a guy moving the scenes.

T: Fan Poster D: Serial Cut™ C: Serial Cut™ W: Promotion L: English Y: 2006

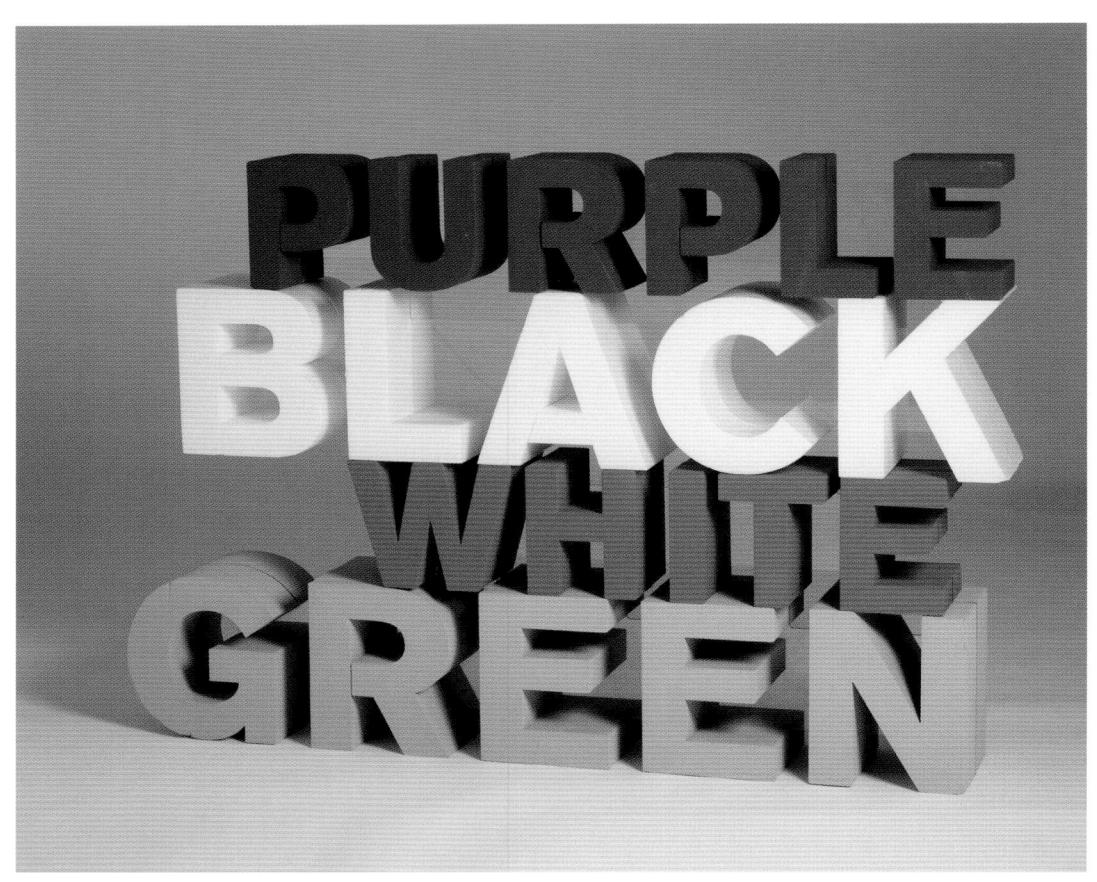

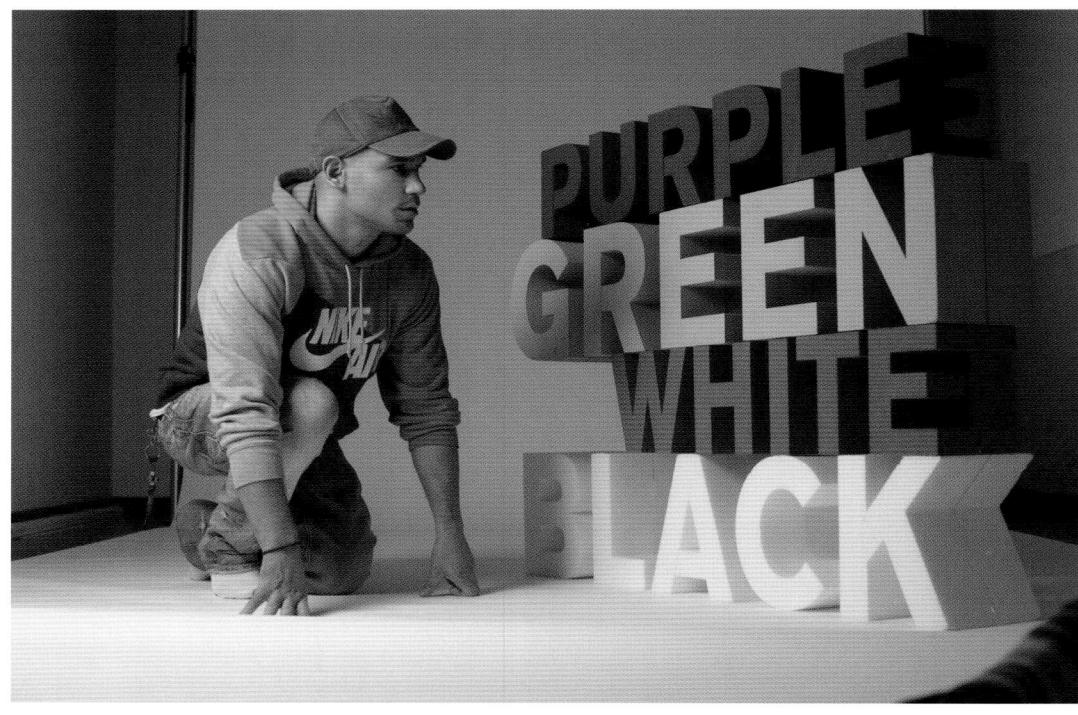

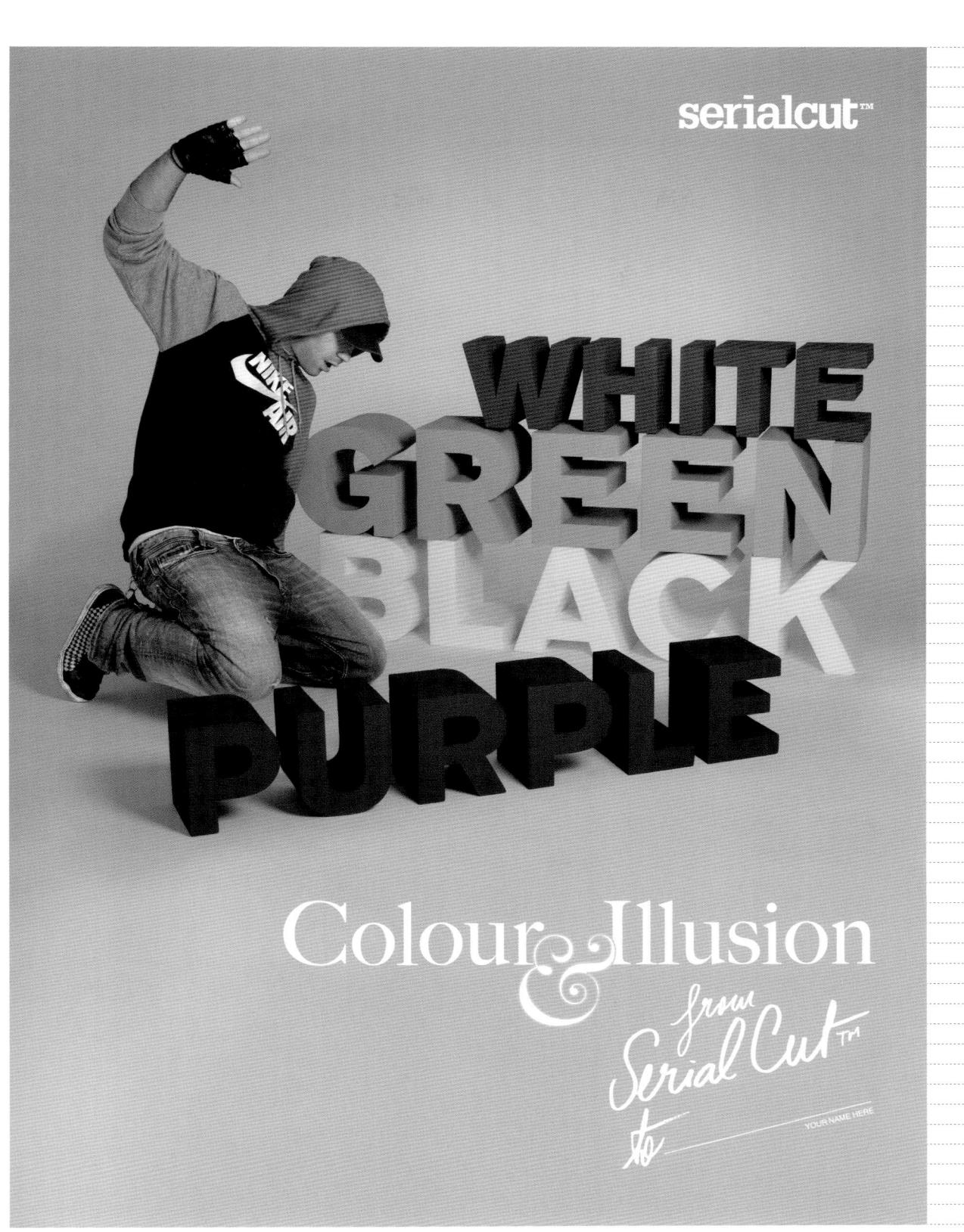

'Structure'

To place artwork in the windows of a shop, Jo intented to create some new typographic illustration. As the space was quite deep on one side it seemed it would be more interesting to create a 3-dimensional interpretation of the designer's typographic work. With the help of set builder Tony Hornecker who built the structures in wood from Jo's drawings, the project worked out really well.

T:B-Store Letters D:Jo Ratcliffe C:B-Store, UK W:3D installation L:English Y:2006

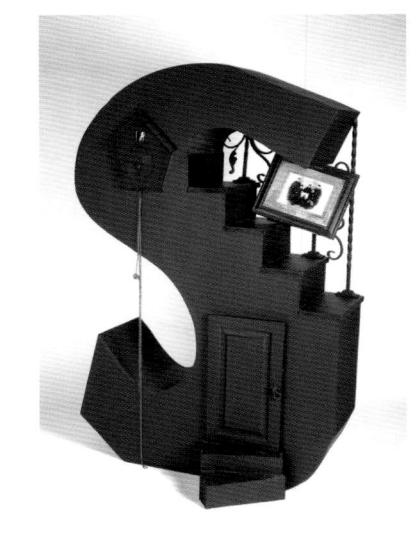

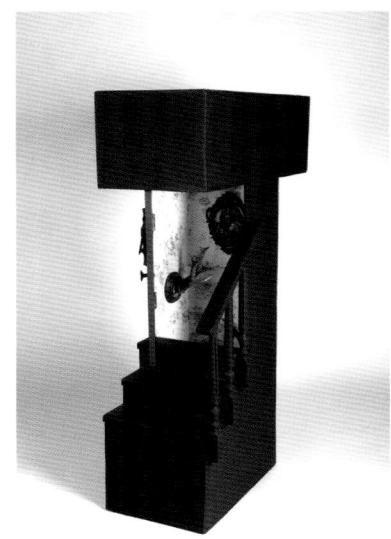

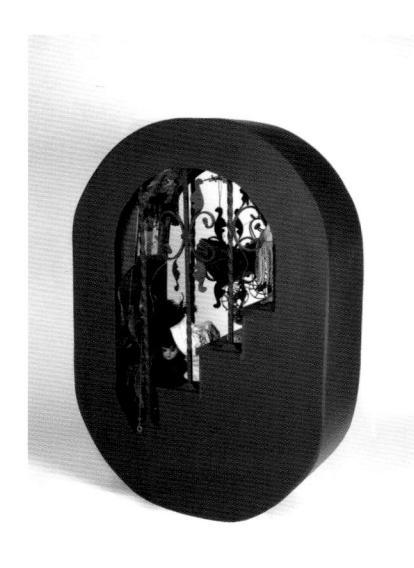

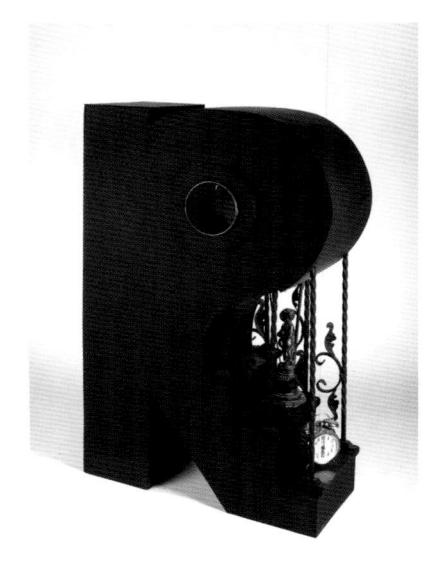

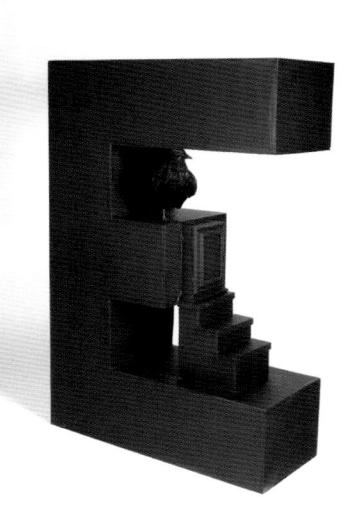

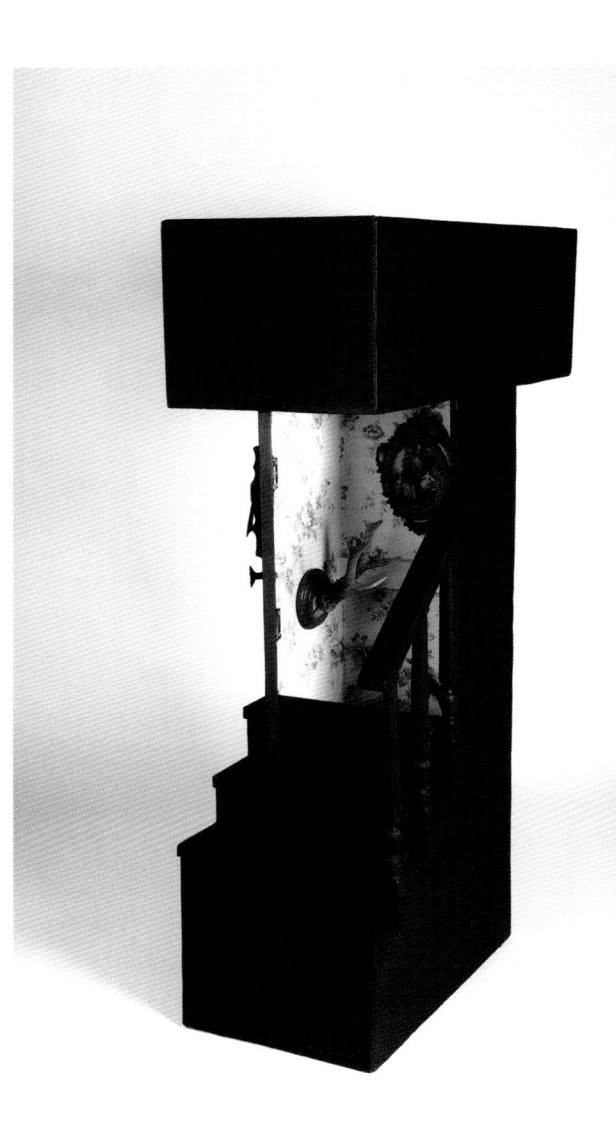

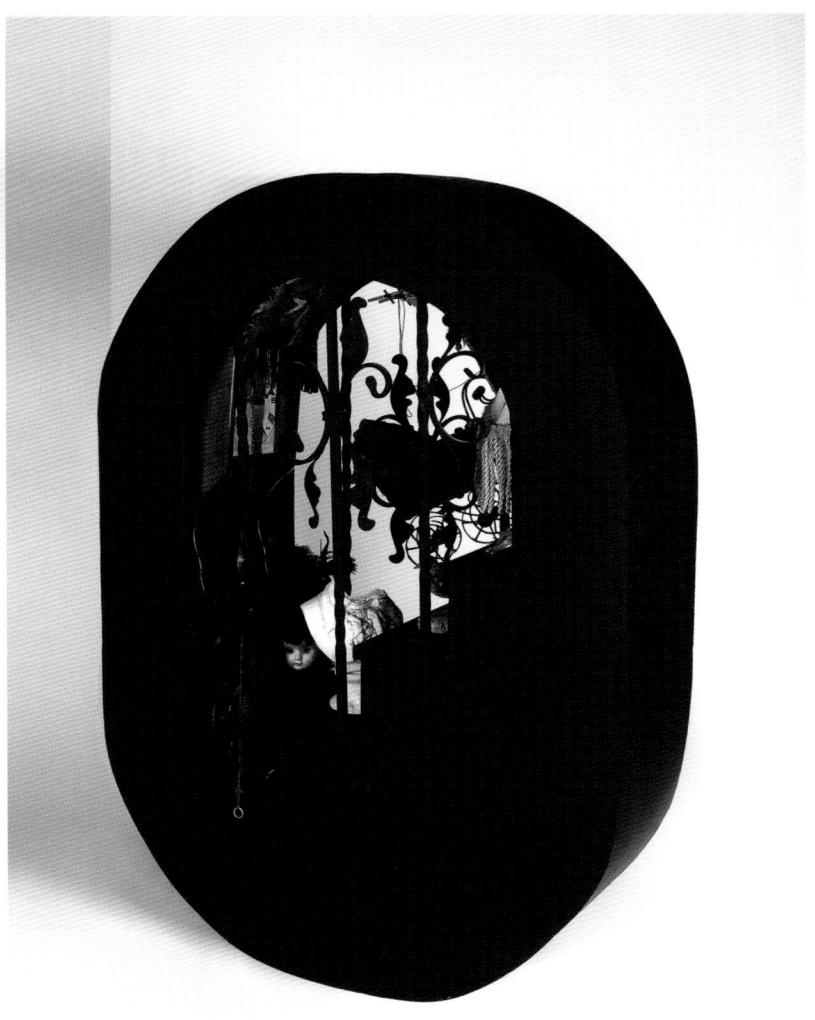

'Toy'

They look like simple English characters blocks at first. By combining the parts, they will transform into Kanji or English characters with the same meaning. You can also freely make unique shapes or discover new combinations.

T: TOYPOGRAPHY
D: Dainippon Type
Organization
W: Toy
C: KOKUYO
L: English, Japanese
Y: 2007

TOYPOGRAPHY LTJC LTJC

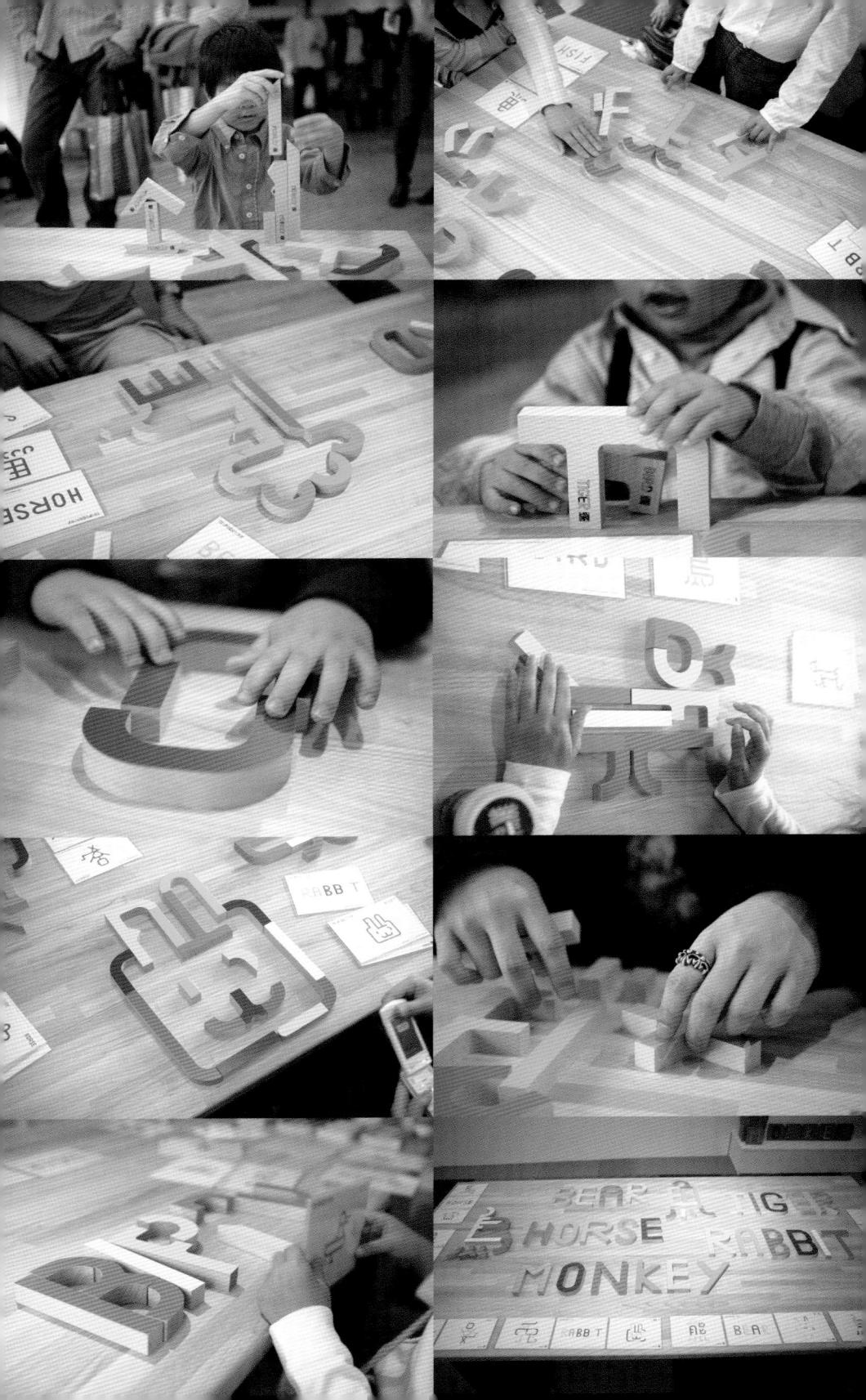

MONKEY RABBIT HORSE

FISH BIRD BEAR

'Tubular'

5 posters using Lorem Ipsum Dolor Sit Amet, fake text. The idea behind is just to make a visual exercise around type, content and concept was not a priority in this project. Designers consume just shapes and images but not content, here designers use only a fake text to express 5 different tubular letters.

T:Lorem Ipsum Series D:Alex Trochut C:Alex Trochut W:Poster Y:2007

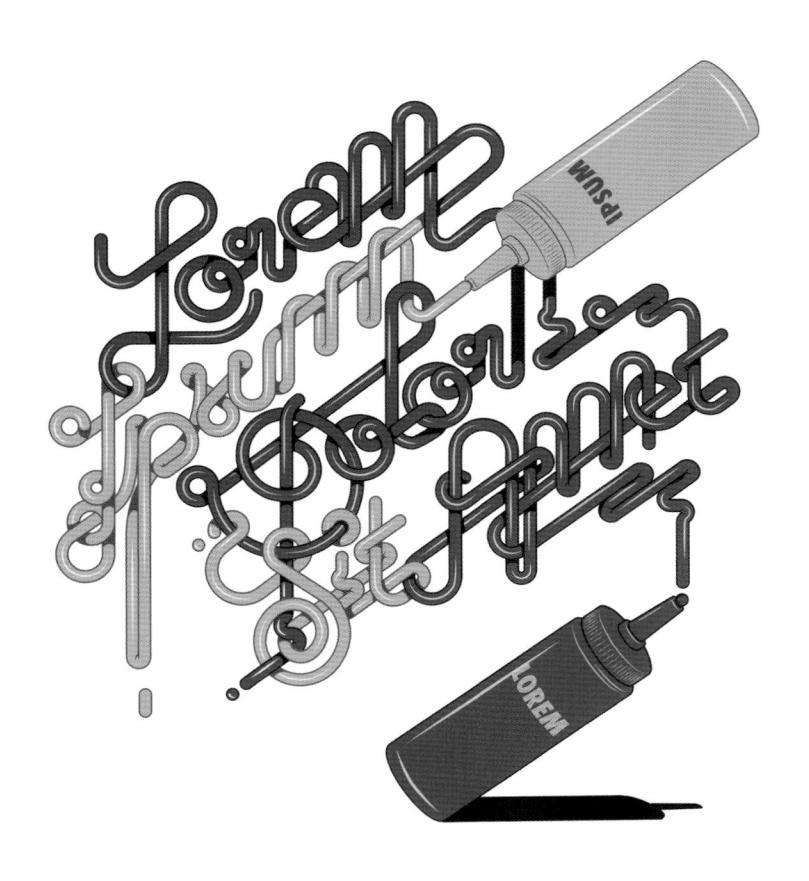

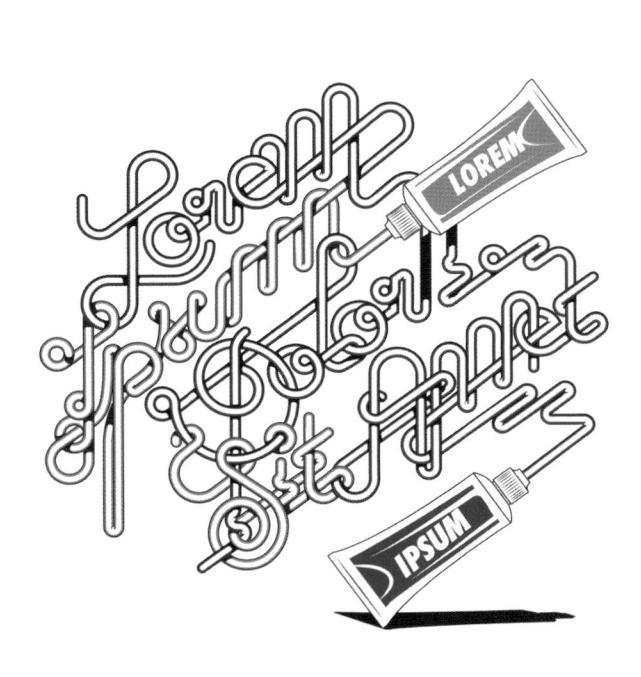

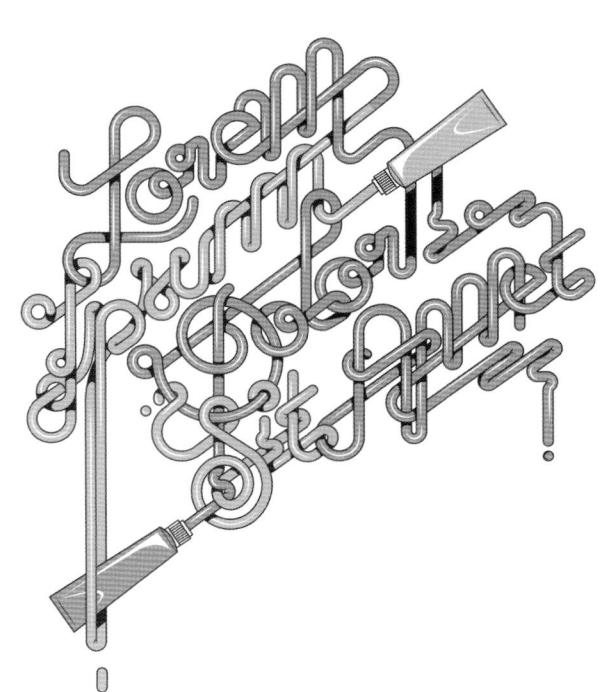

'Univers'

NBUnivers™ is a computer-programmed typeface that was designed for the NBUnivers project. NBUnivers™ contains 255 characters (upper case only).

T:NBUnivers™ D:Neubau

(NeubauBerlin.Com)

C: NeubauLaden.com

W:Illustration

Y:2004

'Vågen våkner!'

Poster and identity made for the music and art festival 'Vågen våkner!.' The festival took place at Vågsallmenningen in Bergen in the early summer. None of the designers had ever been to the place before, but to them it sounded like a vicious animal. The poster was made with green leaves that had just sprung out on trees in order to keep the feel of summer, it seemed like a good idea to try out leaves and vegetables for the heading. The leek was particularly good. The leaves were highlighted with spot varnish.

T:Vågen våkner D:Yokoland C:Vågen våkner W:Poster, Identity L:Norwegian Y:2005

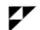

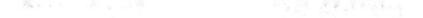

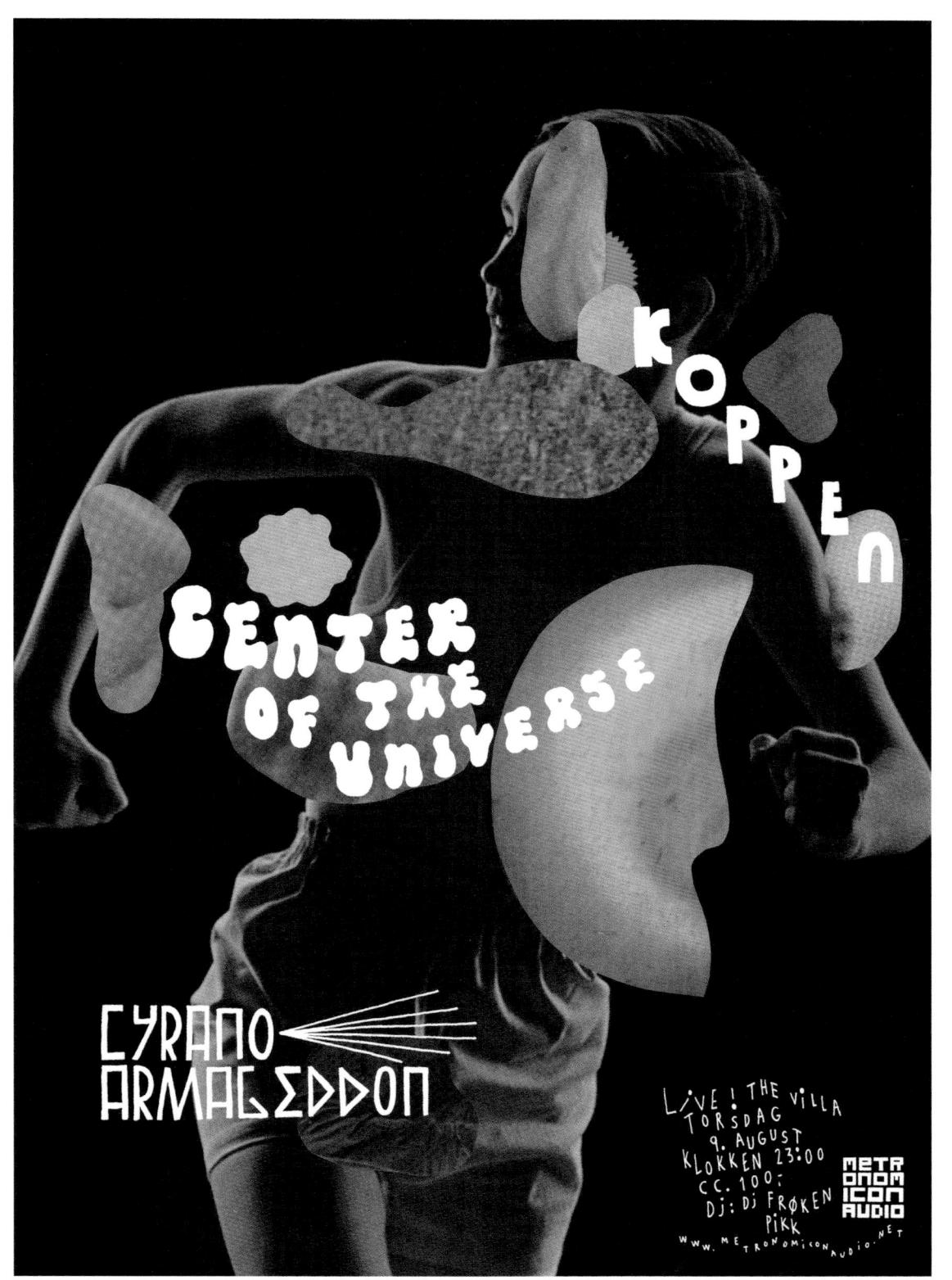

'Villa'

Poster for a live night held by Metronomicon Audio at The Villa in Oslo. The poster was made with collage, and combined several different types of handmade letters.

T:Metronomicon Audio at The Villa

The Villa D: Yokoland

C: Metronomicon Audio /

The Villa

W:Poster

L:Norwegian Y:2007

'Virtual'

Tybrid - Oded Ezer's typo hybrids is a new work created specially for an invitational poster exhibition themed 'My favorite Game' that was held in July 2007 in Ithaca, and in September in Athens, Greece. 'Tybrid' consists of 4 squares combined together, forming the Hebrew word 'Typography.'

Typography researcher Yehuda Hofshi commented, '... Influenced by Dadaist methods and contemporary virtual hybridizations of animals and human beings, Ezer treats this work as a suggestion for typographic/visual expression, something to look at and not necessarily to write with.'

T:Tybrid (Poster series)
D:Oded Ezer Typography
C:Oded Ezer Typography
P:Oded Ezer
W:Poster
L:Hebrew
M:50x50cm (each square)
Y:2007

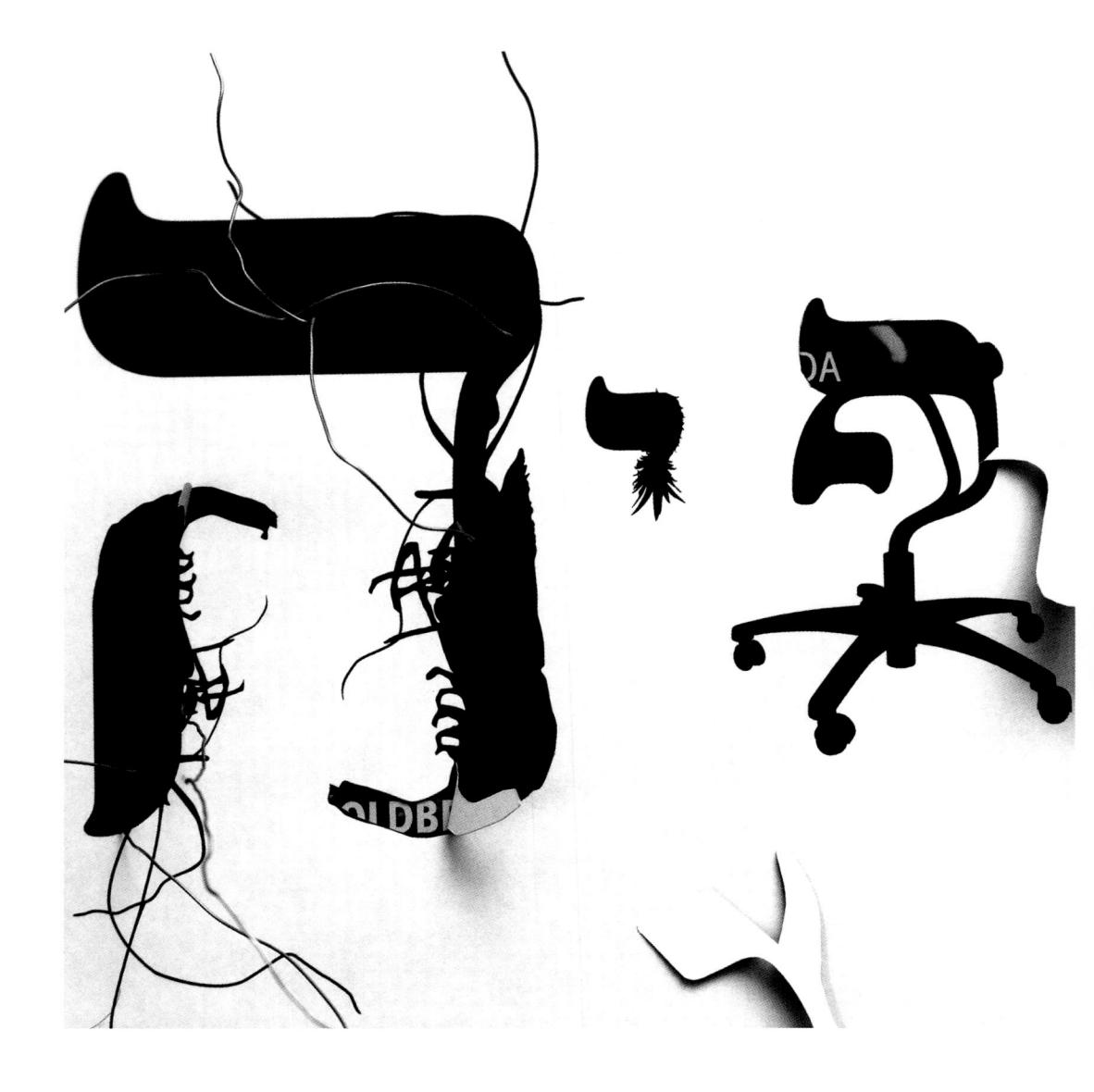

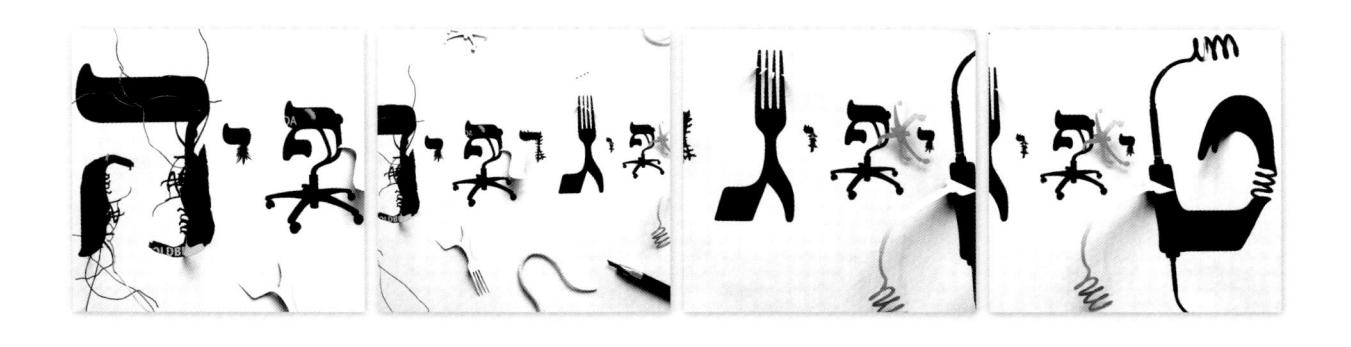

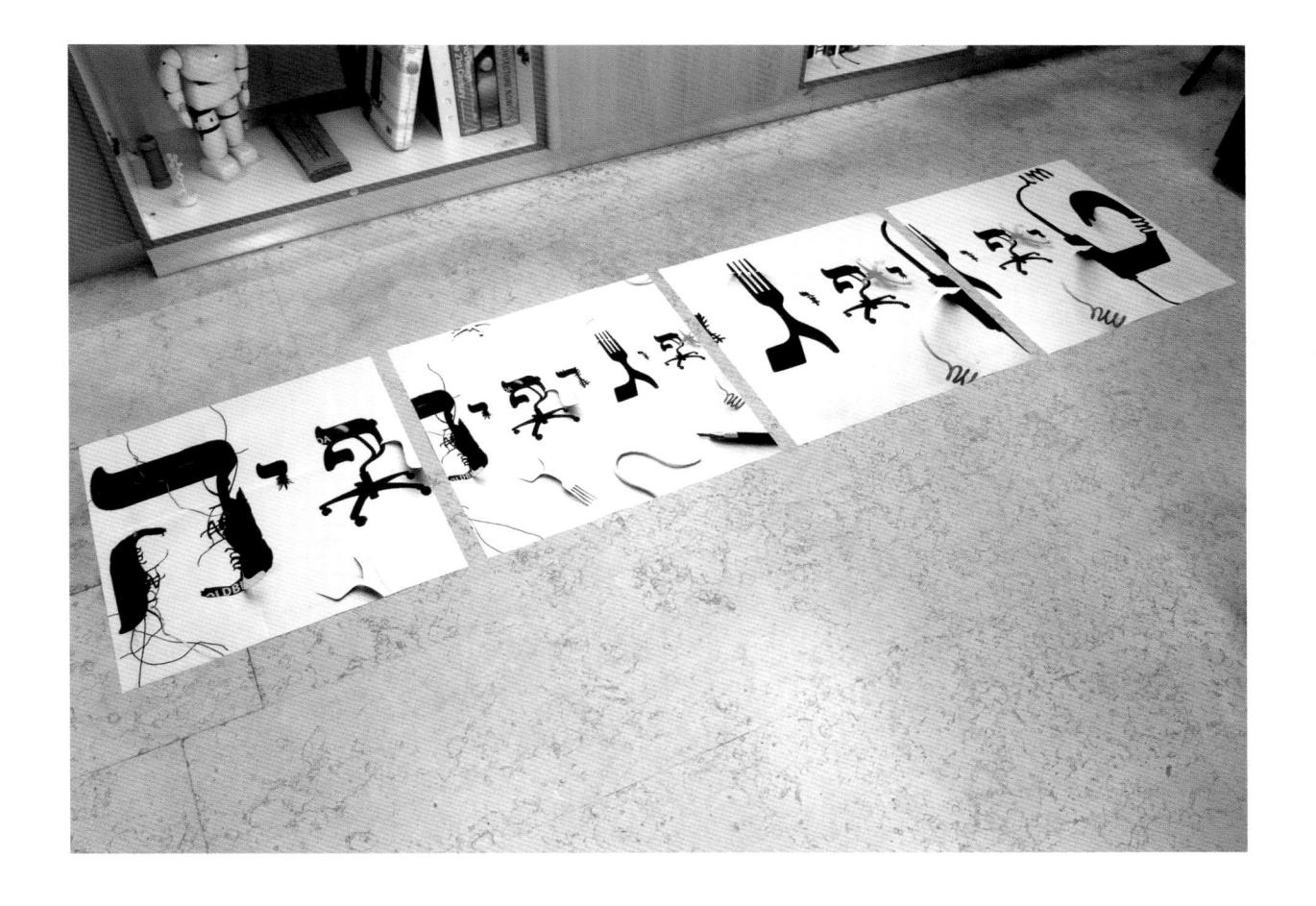

'Virus'

The brief was to create spreads with the theme '...is the public enemy.' The interpretation took inspiration by the rising public awareness of animal deceases and the danger in attacks with chemical weapons. The designers created a typeface based on hand drawn sketches of bacteria and viruses.

T:BD SPREADS
D:Made
P:Peter Dawson
C:Beautiful Decay
W:Fashion graphics
Y:2006

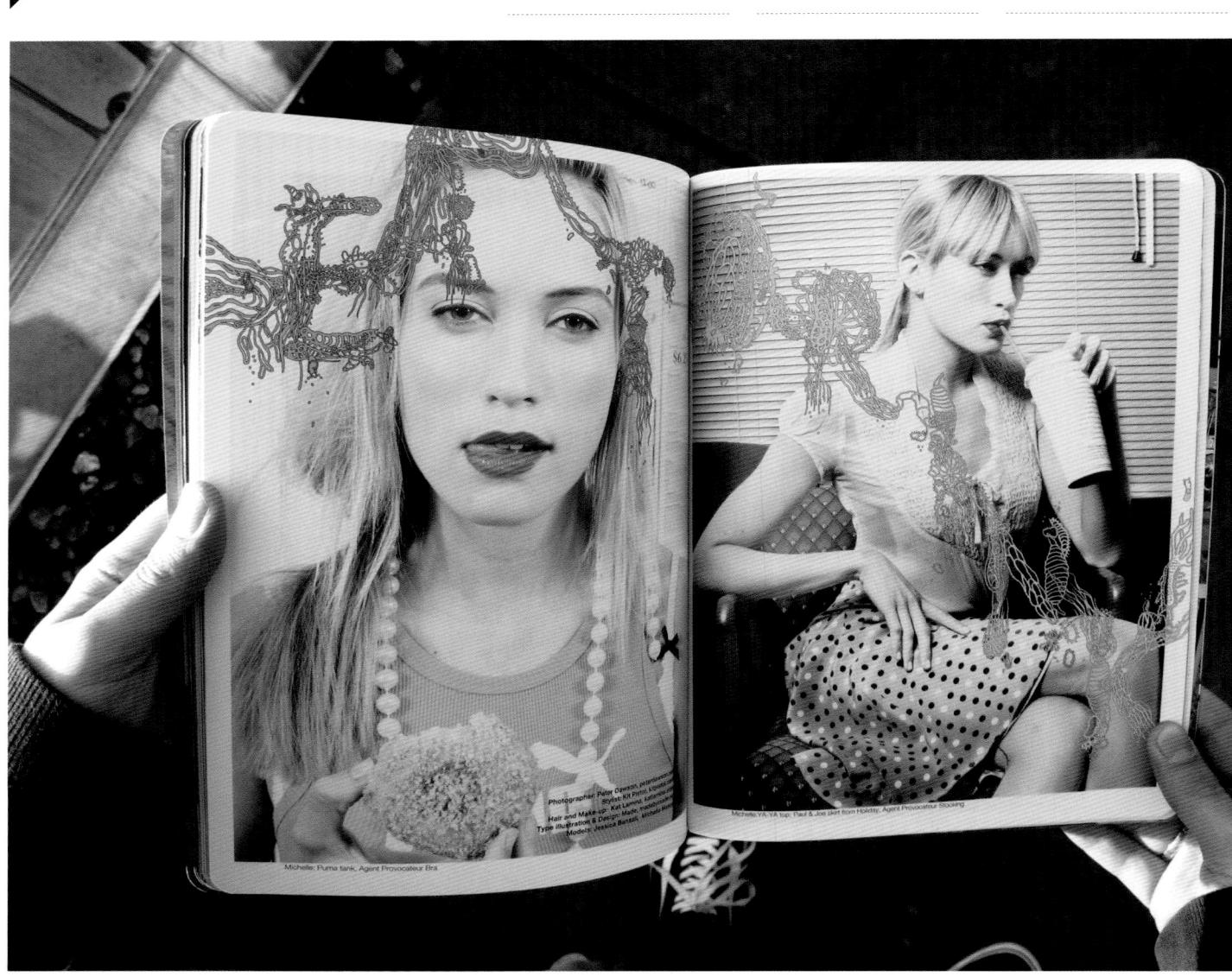

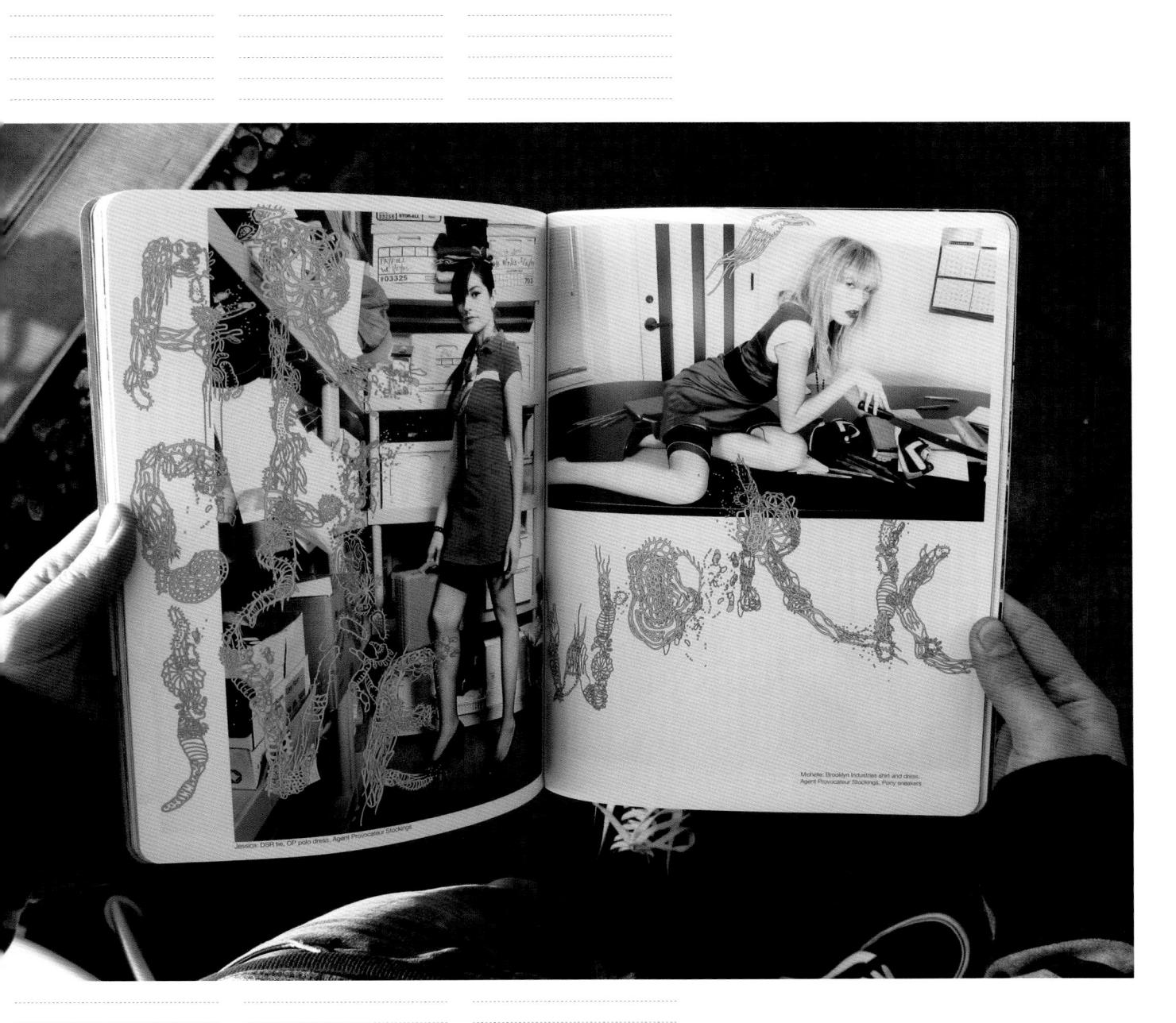

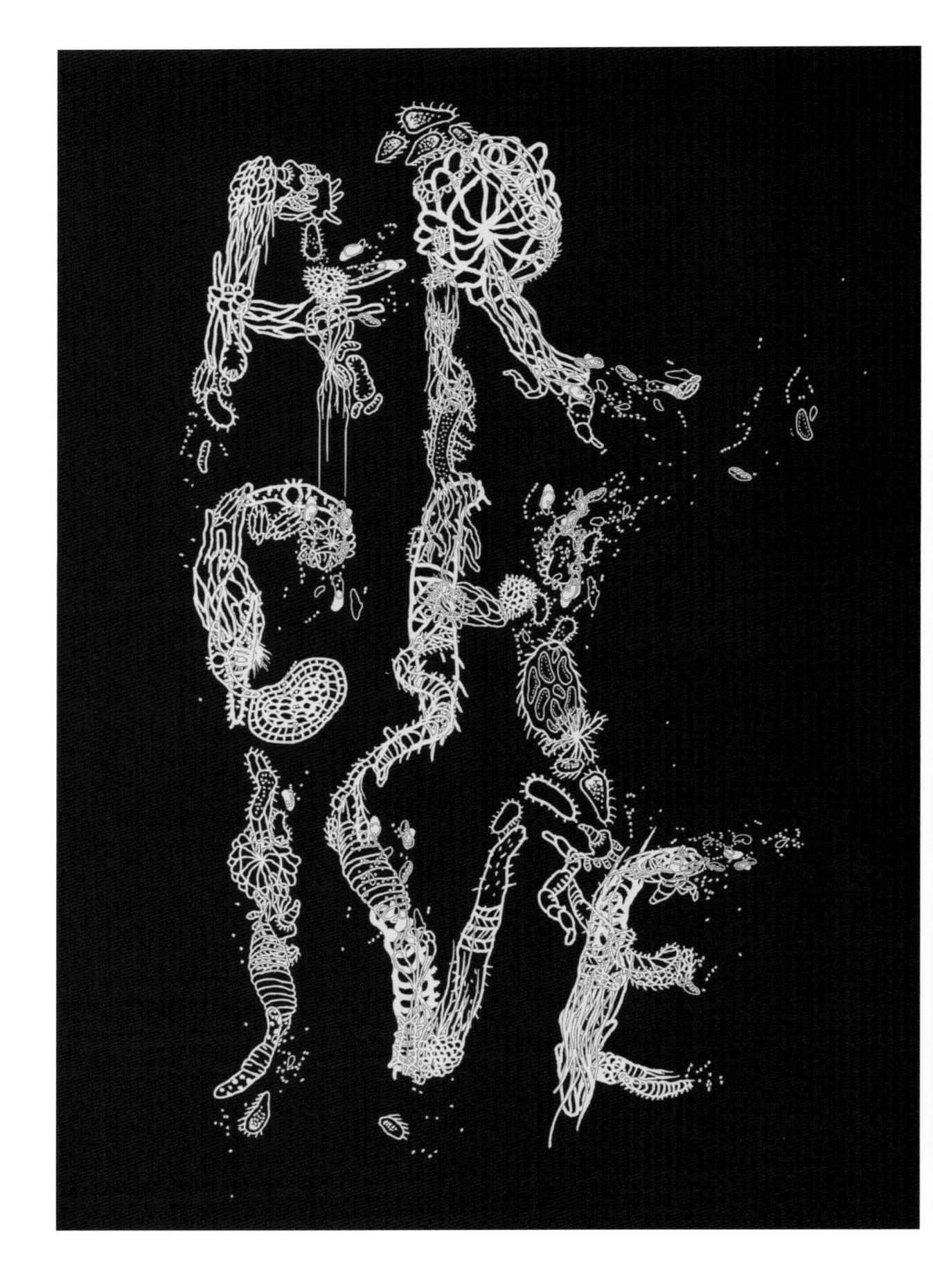

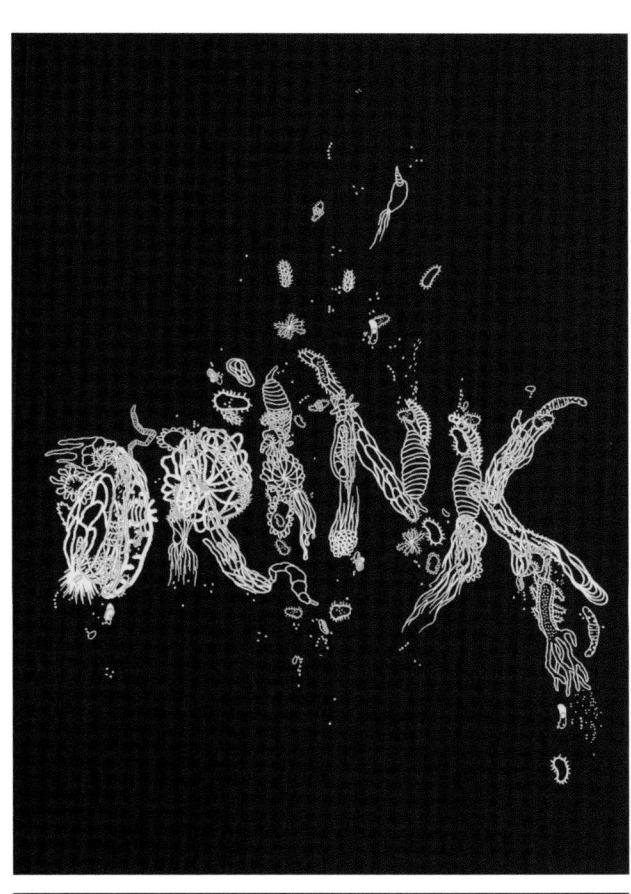

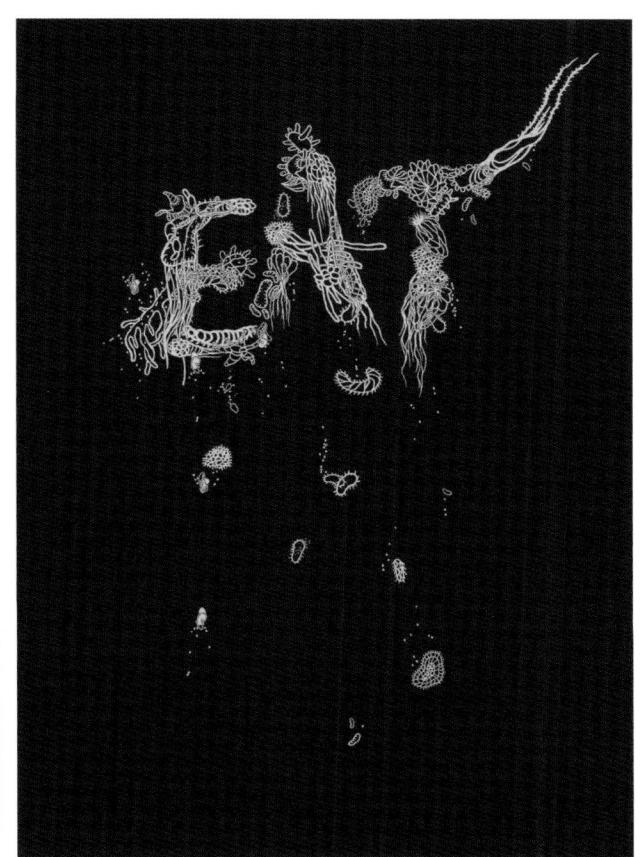

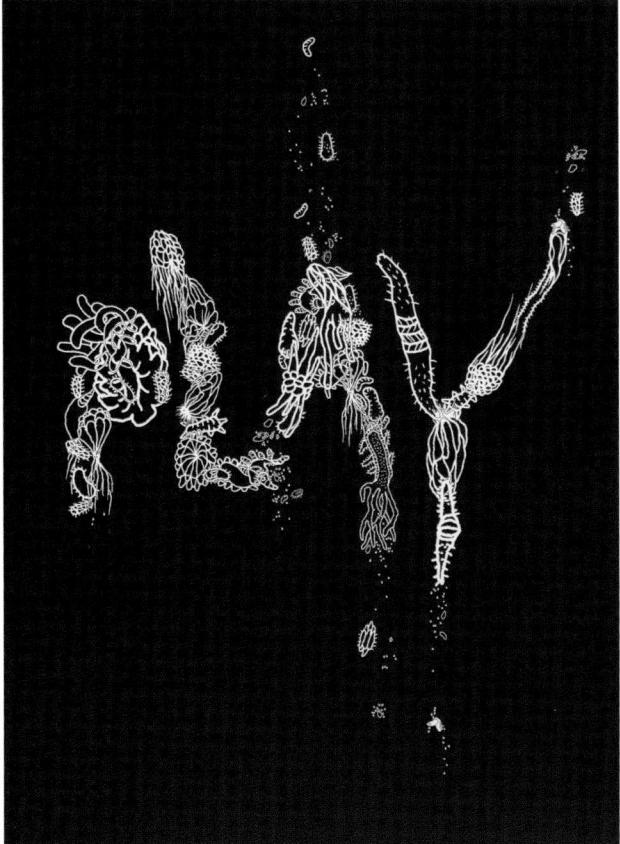

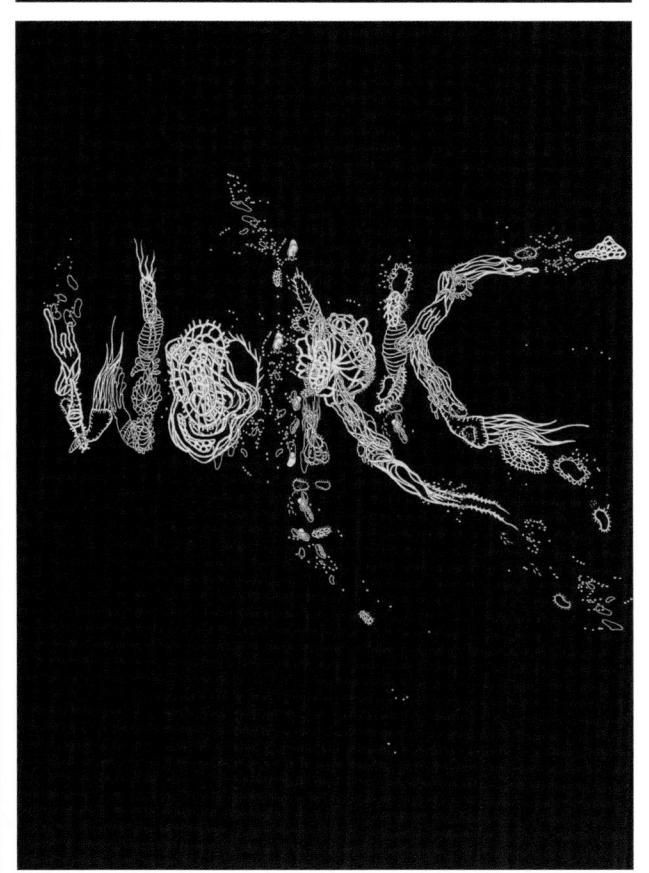

'Wabi-sabi'

Exhibition poster of a book cover that makes tea theme.

the tea of the chinese character is expressed with the deadwood and it is designed in the image that feels Wabi-

T:Book cover of Tea D:Taste Inc. C:Japan Typography Association W:Custom-made font L:Japanese Y:2006

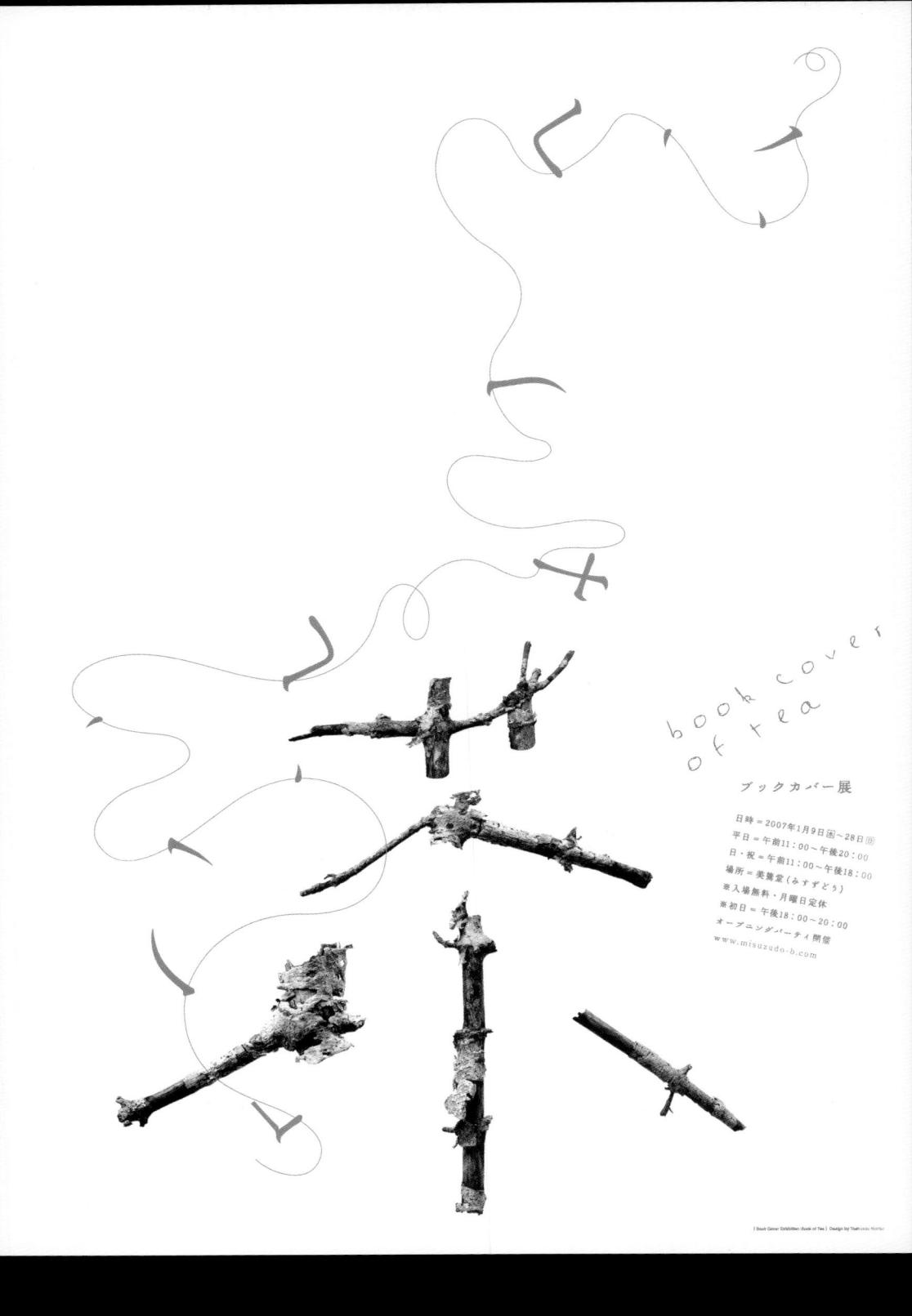

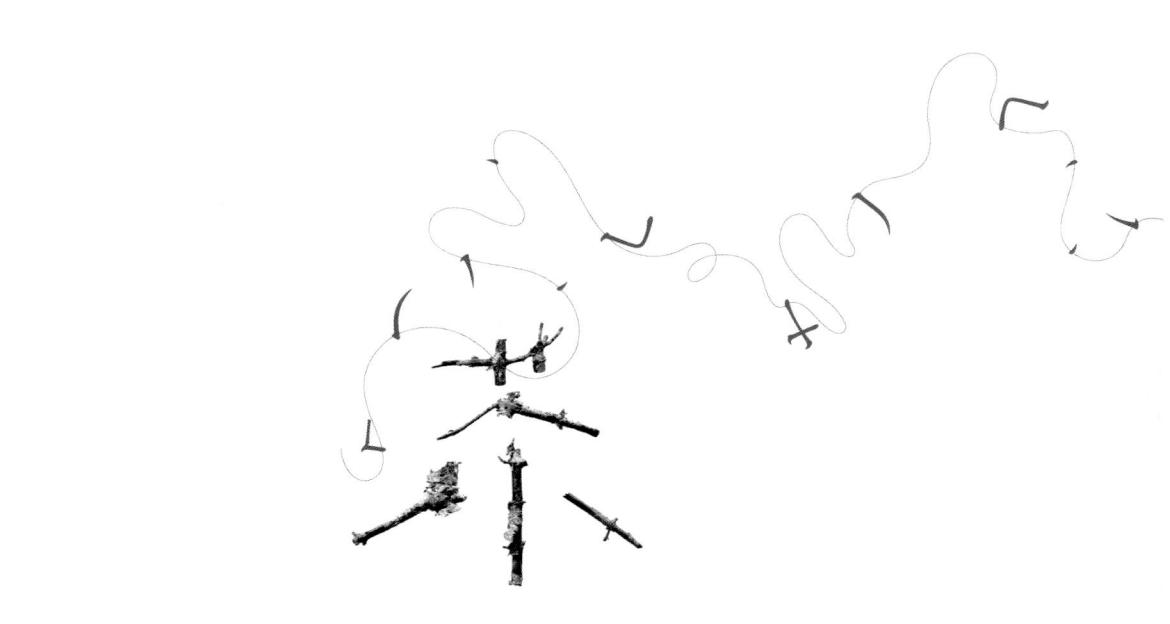

'War'

The pronunciation of a Chinese word '禍' is exactly the same as 'War' in English, thus the designer created a mixed effect of typeface based on that.

T:War D:Tommy Li design Workshop Limited C:NO WAR W:Poster L:Chinese Y:2003

'Welcome'

Instructions to your
own Welcome:

1.Choose an appropriate doorway or step for your Welcome stencil, and lay it in position.

2.Sprinkle chalk dust/
cocoa/dust removed from
your vacuum cleaner
liberally over the
surface.

3.Remove stencil carefully to avoid disturbing dust.

4.Observe as people pass over your Welcome, inadvertently destroying one artwork and creating another.

T:Welcome
D:Lizzie Ridout
C:Lizzie Ridout
W:Chalk dust
intervention
L:English
Y:2002-5

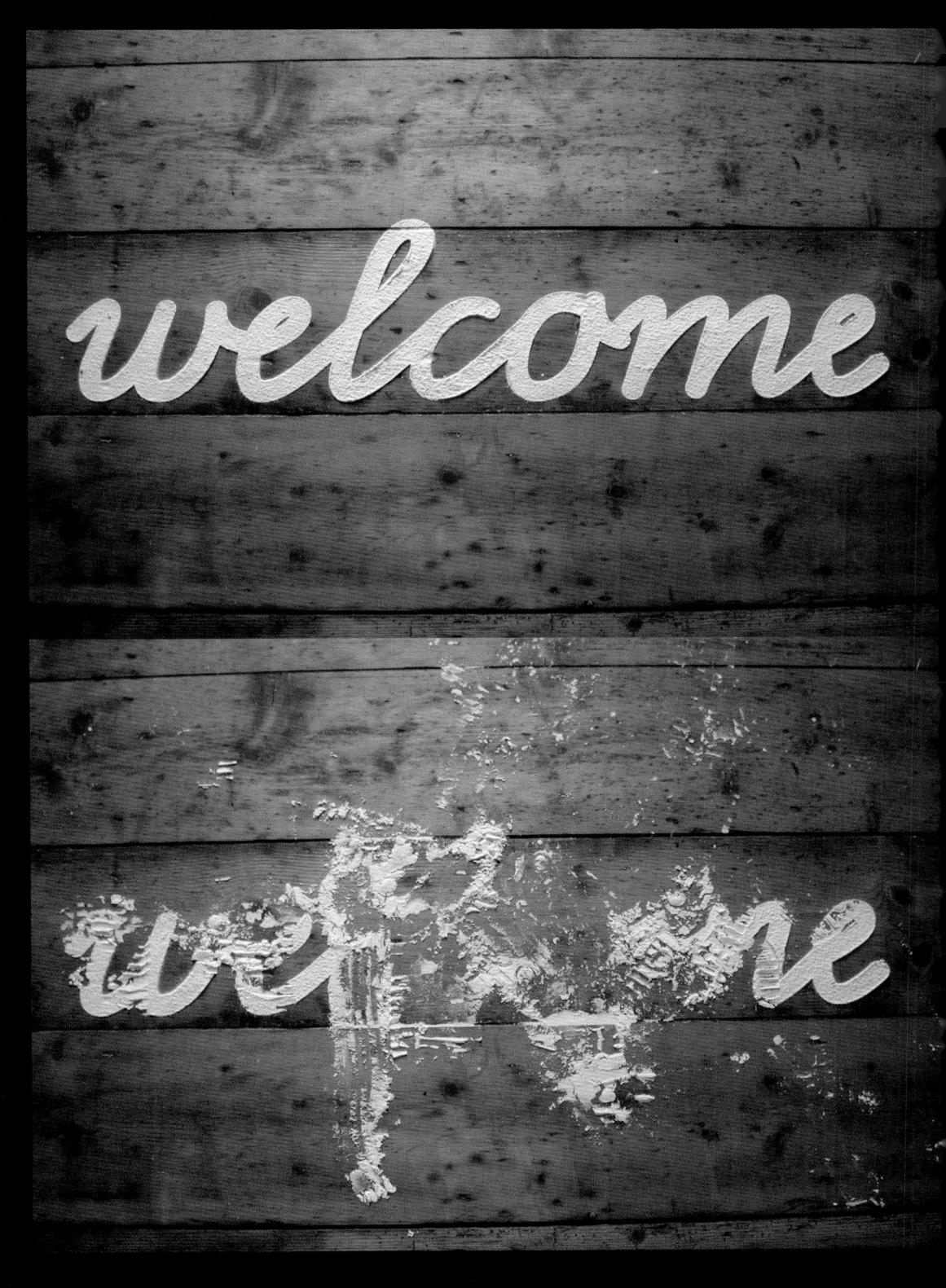

typeface shows the merge of both English

D:Tommy Li design Workshop Limited Exhibition @ ARTtube

47

足非黑白

"Black & White - Works by Tonnmy Li"

地點 - 地鐵中環站了出口 及近道戀接樓層 | 展覽日期: 08-07-2008 a : Exit J. Jackson Lobby, MTR Central Station, Dates : 08-180

ARTtube@mfr

the tally all the

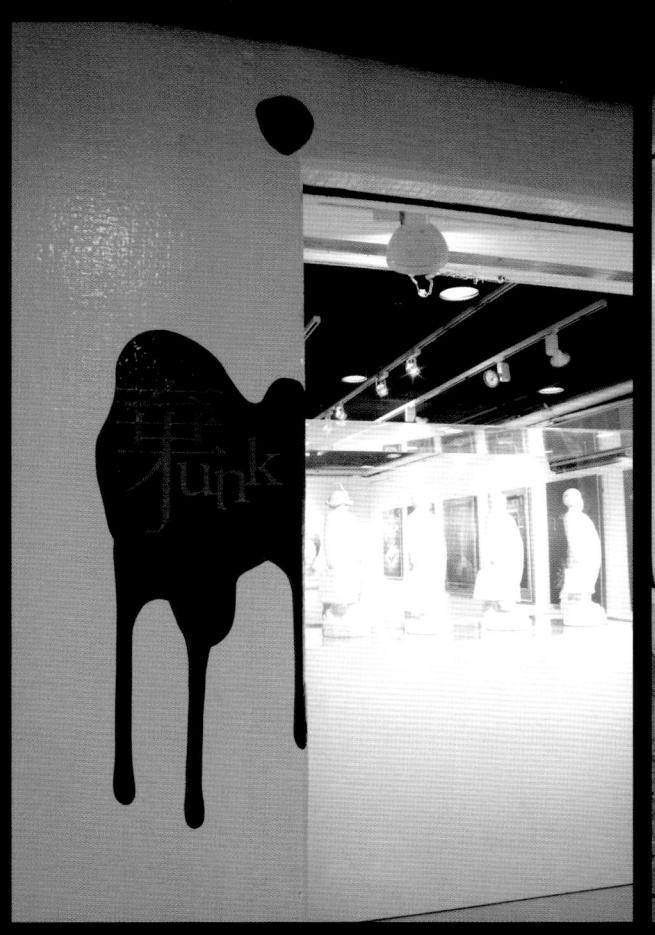

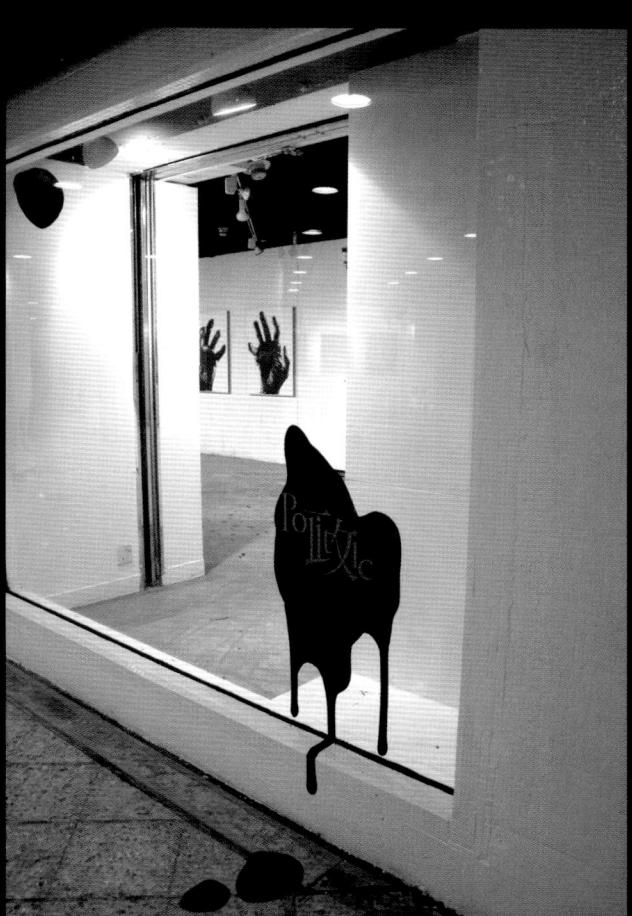

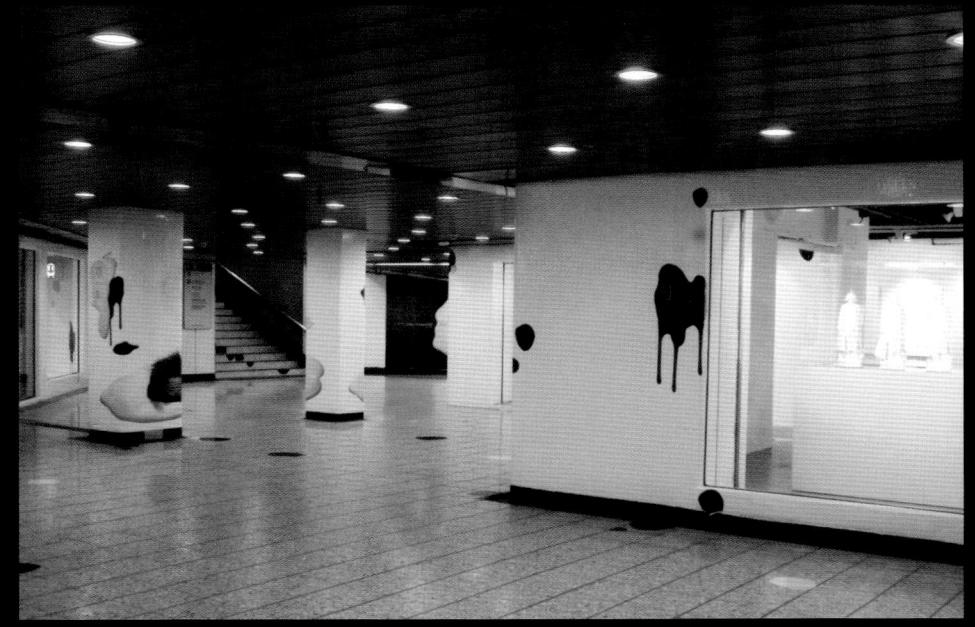

'Wildlife'

Vault49 has teamed up with H.Un.T to support a very worthwhile animal preservation cause. The Helping Understand Taxidermy society has enlisted Vault49's services to promote awareness of their sterling efforts in preserving wildlife, and to disseminate their charitable motto: 'If you can't save 'em, stuff 'em.'

T:H.Un.T D:Vault49 C:Vault49 W:Exhibition L:English Y:2007

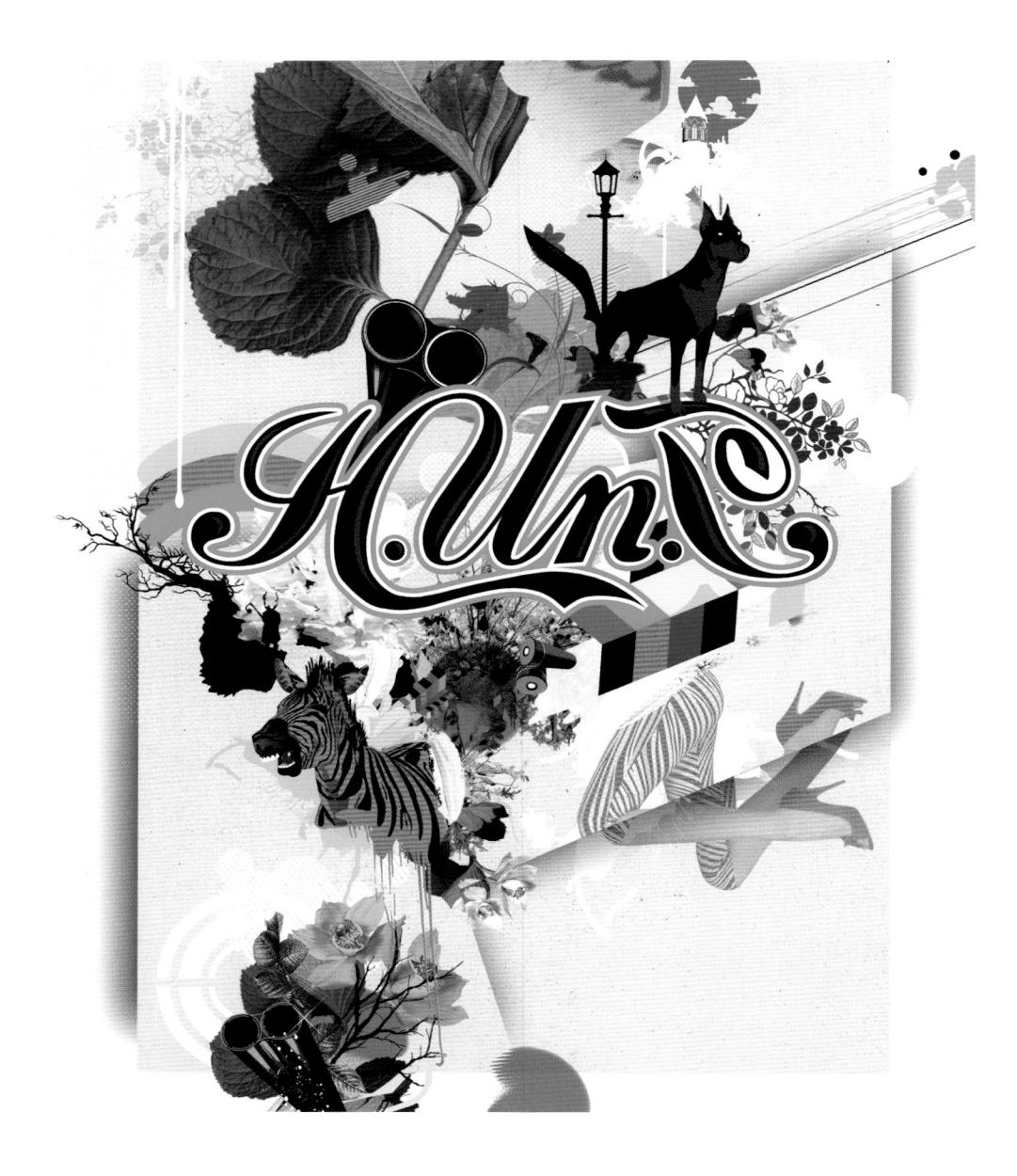

in Fra and fu Wooden for De DE sta fold o inform

T:Desi Fran D:HAWA C:Desi W:Exhi

balloc contir

'Wordless'

Wordless world, but you become conscious to words...

T:No future without ' '
D:Dainippon Type
Organization
C:neut 06
Y:2005

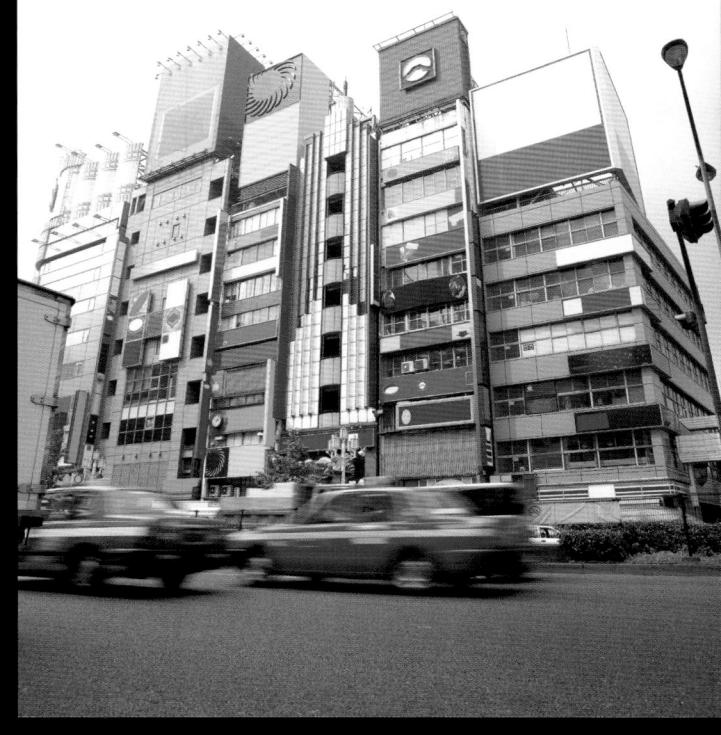

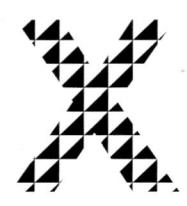

'X'mas'

Christmas identity for department store Selfridges in London. Park Studio designed the Selfridges Christmas 2004 logo. The brief was to create a logo which went back to the essence of Christmas. The theme set by Selfridges was 'Christmas Stories.' The designers took the idea with their frequent use of drop caps and embellished the letters with Christmas symbols to give it a magical, traditional feel with a modern and playful twist. The design concept was then applied in-store on all displays and all promotional materials.

T:Selfridges Christmas Identity D:Park Studio C:Selfridges W:Seasonal identity, Retail graphic L:English Y:2004

'Yellow'

Branding for D&AD Global Awards Nominations Exhibition 2007.

D:Build C:D&AD W: Print L: English Y: 2007

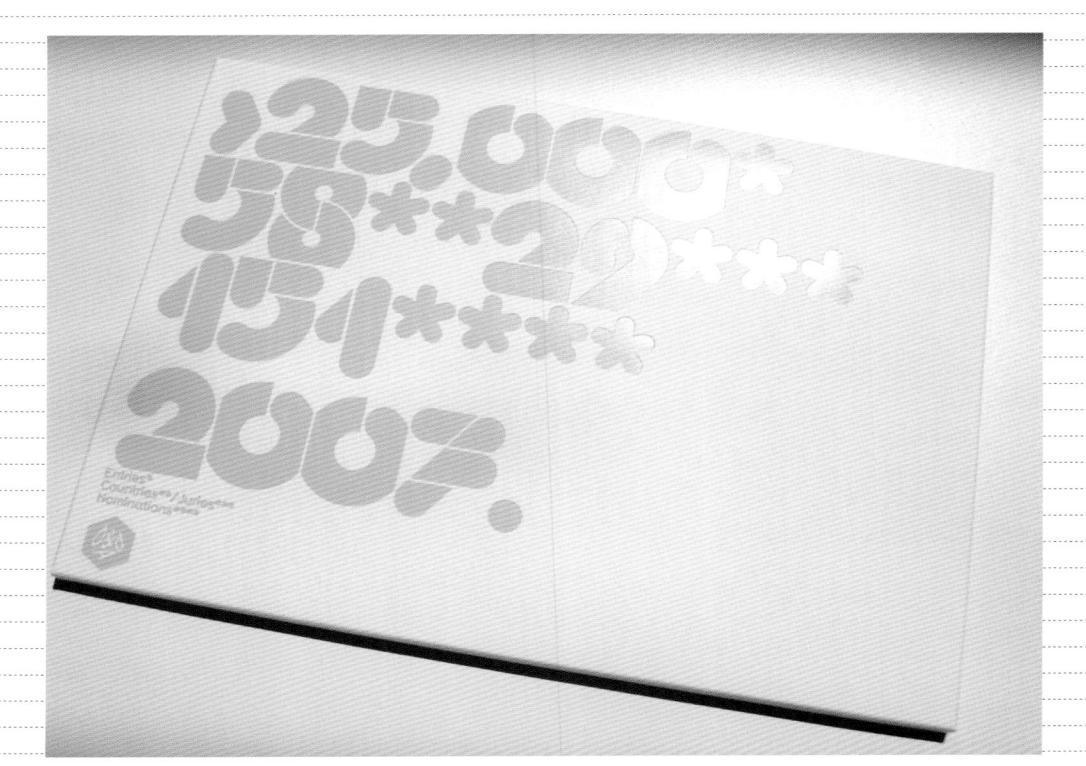

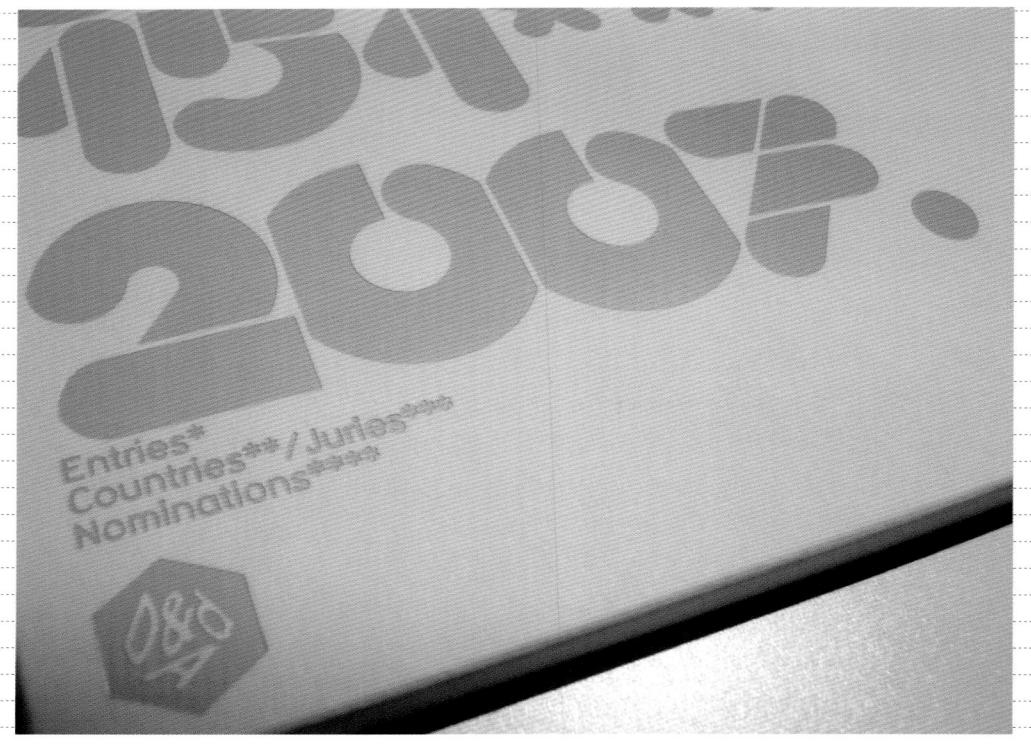

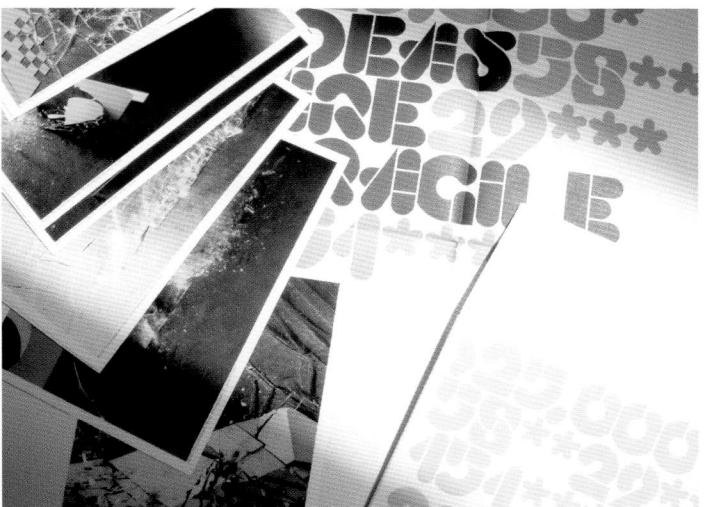

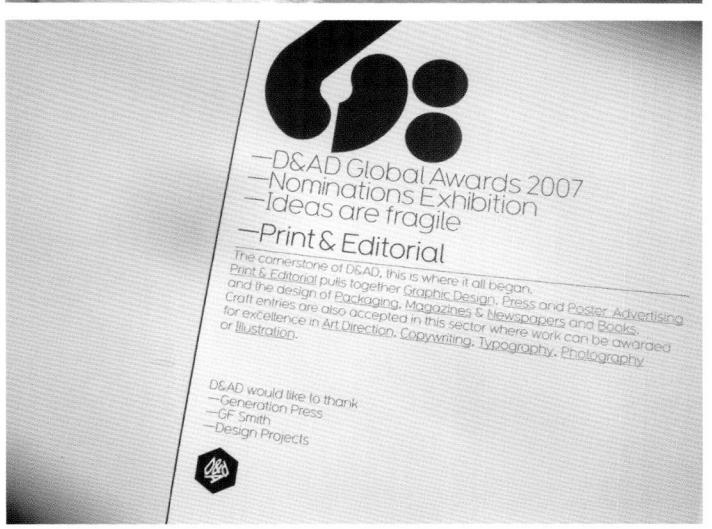

'Zines'

02 is a free contemporary art magazine that issued quaterly. The designers were the artistic directors for 2 years. First the designer created a simple and legible layout. As the iconography was from artists and visual creators, the designers decided to work with a layout that would not interfere with the photos so that there would be no confusion and also decided to create a new alphabet for each issue. The titles are always at the same place, but in different type, each time with a big personality. It is always printed in full black on white paper.

T:02, contemporary art magazine D:Sylvia Tournerie C:02, contemporary art magazine W:Editorial L:English Y:2004-6

12.dossier Filmograpf du personn

- 231 -

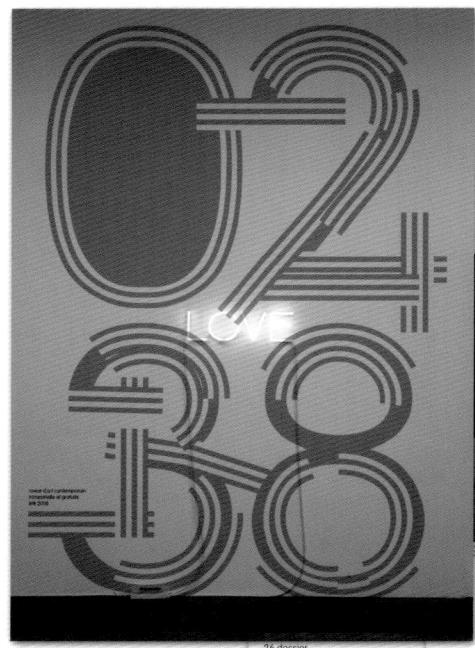

SWKKT AND SOUR

As consistency to the Constant and Constant

LE PERÇU & LE NON-PERÇU @ PIERRE BISMUTH

common en mente en 2000 cinto fino common en reference è formonere del mor and top anne propare fill, sur ratio de la Section se del section se del section del s

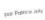

AU TRAVERS DU The date of the second ROBERT SMITHSON

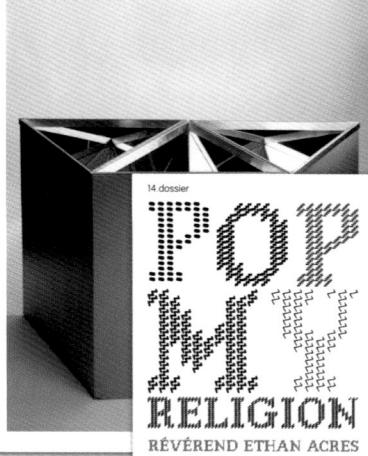

soft otherwise as an enterpolate from the control ground and the stopping of the stopp ADEL ABDESSEMED

mount of the competition is face interest. And Advanced control is a sea of a male of production is face interest. And Advanced control is a male in an off production is face interest. And Advanced control is a male in an off production is a male in an off production in the control is an advanced control in the control in the control is an advanced control in the control is advanced control in the control is an advanced control in the control is advanced control in the control in the control in the control is advanced control in the contr

P234 BIOGRAPHY

THS THOMAS SCHOSTOK DESIGN

Thomas Schostok was born in 1972 and started his career as a salesman for bathroom tiles in 1989. He never studies design because he always thinks that studying design is to be brainwashed. He spent his time working for different design agencies but soon left slavery and founded '(ths)' in 1999, working in his own studio for international and national clients. (ths) has no anger or hate, because it is fondness for Elvis Presley and Barry White records, that is being continuously played during work and thus make him nice and merry. (ths) defines its work as trash urban warfare porn dirt style pop.

Page 046-

3 DEEP DESIGN

- 3 Deep Design is a design and image agency based in Australia with representation in New York. Tokyo and Europe.
- 3 Deep Design was established in 1996 by Brett Phillips and David Roennfeldt and has since established a reputation of uncompromised design excellence, commitment, passion and design innovation. The 3 Deep group of companies include 3 Deep Design, 3 Deep Publishing and Everything in Between.
- 3 Deep constantly assembles teams of photographers, illustrators, fashion designers, writers, artists, type foundries, architects and technical developers to realize complex and benchmark projects. 3 Deep's products and services are called upon by the finest bookstores, galleries, private clients and institutions around the world.

Page 158-9, 162-5

ADAM HAYES

Adam Hayes was born in 1981 in Stoke-on-Trent, England. After graduating from the Royal College of Art in 2006 he began working from his desk in East London on projects for himself, his friends and clients worldwide

A great lover of the outdoors, Adam often enjoys fell walking, mountain biking and camping in the UK's beautiful countryside. This is reflected in his work where his designs are founded upon hand drawn and organic forms that mix with his interests in typography and lan-

Page 141

ALEX TROCHUT

Alex Trochut was born and lived in Barcelona. He loves drawing and he spent hours in drawing when he was a child.

Alex studied in Elisava, Barcelona and had worked with Alexander Branczyk at Xplicit and Moniteurs. After 2 years working in Toormix, Alex joined Vasava. Right now Alex is freelancing for clients from London, New York, Amsterdam etc. and projects like Nike, Coke as well as some small projects. Alex has been working for companies like Non-format or Weiden and Kennedy as a freelance.

Page 202-3

ANDREW BYROM

Andrew Byrom was born in Liverpool, England. In 1997 he opened his own studio in London designing for various clients including Penguin Books, The British Academy of Composers and Songwriters and The Guardian Newspaper.

Byrom moved to America in 2000. He now divides his time between teaching, designing and playing with his sons Louis and Auden.

His work has featured in design magazines like Frint, Creative Review and Architectural Record; and books including AIGA Annual 2003, G1: New Dimensions in Graphic Design, American Corporate Identity 22 and New Typographic Design.

His type designs have been exhibited across the US including The National Design Centre in New York and he has been recognized with a Certificate of Excellence from the American Institute of Graphic Arts.

Page 068-9, 89, 124-7, 154-5

APIRAT INFAHSAENG

Apirat is a 25 year-old visual artist and designer working in New York City. He is an incessant form maker and experimenter with a fondness for plaid, video games, music, science fiction, and trying to play the drums. Apirat is constantly absorbed in projects; self-initiated, collabora-

tive, and client-driven, and is a participating designer at OgilvysMather's BIG (Brand Innovation Group) in NYC. He lives in Brooklyn with his girlfriend and 3 cats.

Page 010, 057, 128-9, 145, 171

ARTLESS INC.

artless is a design group based in Tokyo. Active in the field of visual communication, the unit's broad activities include CI, branding, graphics and product design, interactive installations, space production and video. In addition to client-driven projects, the unit places great importance on its own original works, and has produced both graphic and interactive art, as well as having its distinctive works published and exhibited in various places. Although based in Tokyo, their activities are not limited only to Japan, they also participate in projects overseas.

Page 096-7

ARTROOM - COMMERCIAL RADIO PRODUCTIONS LTD.

In the little Artroom under the Commercial Radio Productions Ltd., 6 fiery designers give themselves in the designs of the Radio (FM881 and FM903) as well as related parties. From 2-dimensional graphic designs, huge settings and stage designs for events and concerts, to miscellaneous designs like events props, stickers and signage, endless design verve makes Artroom@CRP an unforgettable place to create.

Page 088, 166

ATELIER TÉLESCOPIQUE

Stéphane Meurice, Sébastien Delobel, Xavier Meurice, Guillaume Berry and Baptiste Servais are the creative brains behind Atelier télescopique and its companion type foundry, AinsFont. This close-knit team of designers, based in Lille - France, opened its studio in 1998.

Along with their groundbreaking work in multiple media - print, video, web and art exhibitions, they also create unique type-faces. This eclecticism can be found in their clientele, which is composed of big industries and institutions as well as members of the culture scene.

Page 024, 034, 059, 076, 136, 178

▼ BUILD

Build is a graphic design studio which prides itself on its craft-like approach to print. It was founded in 2001 by Michael C. Place and Nicky Place, and has since established itself as a studio with an almost obsessive attention to detail.

Build is Michael, Nicky, Brock-mann and Betty.

Build. Print With Love.

Page 120-121, 228-229

BYGGSTUDIO

Byggstudio works with a combination of self-initiated projects and commercial work focusing on graphic design and illustration. The designers see graphic design as a way to communicate ideas beyond visual expression where strong aesthetics, colours and humour play an important part. Recently they have been developing graphic profiles, exhibition design, posters, typography, web design and editorial magazine work in Scandinavia specializing in photographic illustration. Byggstudio was founded in 2006 by Hanna Nilsson, Markus Bergström and Sofia Østerhus.

Page 030-3

CLAIRE SCULLY

Studied BA Graphic and Media design at London College of Communication (2001-4) and Central Saint Martins (2004-6) for MA Communication Design, as well as continually working on many personal projects and frequently collaborating with various artists, London-based Claire works works as a free-lance illustrator.

The Quiet Revolution is the body of work by Claire inspired by the conflicting and harmonious relationships the urban environment has with the natural world. With a mix of playful humour with sinister undertones of conflict and mutation, the Quiet Revolution is a visual exploration into the relationship between the natural world and the urban environment. The illustator shows the significance of nature within a cities' surroundings and the struggle for power human has with it by using a combination of printed illustrations with moving image.

Page 073-5

CODESIGN LTD

Hung Lam established CoDesign Ltd with Eddy Yu in 2003. Lam has been actively participating in international design, cultural and art projects. He has won a number of prominent design awards during his career advancement.

Recent years, Lam has extended his creativity and vision from graphic design across media and has participated in various exhibitions and installation shows.

Page 111

CONOR & DAVID

Conor Nolan and David Wall are designers working on print and interactive projects in Dublin, Iroland

Page 050

CORP.UNIT

Corp.Unit started off in early 1999 with the simple plan in mind - operating as a design studio that navigates disciplines in graphic design, web design, product design, film and music for the greater good. Corp.Unit collaborates with different talented artists in order to handle a variety of small to big projects. Strongly following the notion that things can always be approached and done differently, Corp.Unit tries to explore the untouchable, alter the recognizable and create the irresistible in order to communicate ideas and solve problems.

Page 142

DAINIPPON TYPE ORGANIZATION

An experimental typographic team that established in 1993. From the Japanese to English alphabet, the designers deconstruct, shape, and form fresh typography that without the lost of irresistible Japanese feel. Their work is available as font packages and motion graphics.

Page 043, 103, 198-201, 224-5

DAVID LANE

David Lane graduated from BA Graphic Design at St Martins. He then went on to freelance and worked for Multistorey and Wolff Olins. He has created reord covers for Bands such as cossip and the Noisettes, and worked on projects such as the condon 2012 Olympic logo. He low works from his own studion East London.

⇒age 072, 140

DESRES DESIGN GROUP

desres is a design and consulancy studio and is active in a wide range of projects across a growing variety of media. desres projects feature concept, design, illustration, interactive design, typography, and art direction along with experience in film, installacion and moving image. desres works for corporate, cultural and private clients as well as advertising and event agencies. desres also engages in collabocation with other companies and professionals.

desres is based in Frankfurt

⊋age 137, 180-1

ROMKTOJ/FROMJTOK

romKtoJ/FromJtoK is a grow.ng and often frazzled workshop organized around JK Keller
and Keetra Dean Dixon. The
luos push their focus towards
non-commissioned work, but ocasionally find the lure of a
shiny client job too seductive
to resist. Voted most likely
to meander, JK & KDD straddle
wide set of mediums in the
pursuit of 2D & 3D projects. A
yow to follow their obsession
keeps the two running endlessly
on new paths. Most recent obmession: the prolific power of
computation!

age 086-7, 100, 172-3

GGRAFIK

Nith Niklaus Troxler as his diploma mentor and a degree in Communication Design from the Darmstadt University of Applied Sciences in his pocket, 3ötz Gramlich formed gggrafik in 2005.

Besides working for major clients and agencies in Germany and Switzerland, Gramlich has arned international critical acclaim for his poster designs both for commercial and non-profit purposes — and magazine covers. Bold, fearless and universal in their graphic vocabulary, Gramlich's designs speak an easy-to-understand, eye-

catching language that can be termed iconographic in its simplicity and impact of message.

Page 056

GRANDPEOPLE

Grandpeople is a Norwegian design studio. It is run by Magnus Voll Mathiassen, Magnus Helgesen and Christian Bergheim who met at art school where they started to work together. Grandpeople has been a full-time studio since 2005. They work with small and large clients in the fields of advertising, art, fashion, music and exhibitions mostly. Dedicated and haunted by their preferences.

Page 018-9, 052-3, 058, 066-7, 110

GUY HAVIV

After a few years working as a software developer, Guy thought computer science might be too boring and finally went on to pursue interest in graphics (and mostly, interactive) design and went to design school. The designer fell in love with typography and print.

Page 130-131

▼ GYÖNGY LAKY

Gyöngy Laky, (b. Budapest, Hungary 1944) is a sculptor. Her work is exhibited widely both in the US and abroad and is in many permanent museum collections. Laky studied at University of California, Berkeley, and was a professor at UC, Davis, until retirement in 2005. A past recipient of a National Endowment for the Arts Fellowship, she was also commissioned by the US Federal Art-in-Architecture Program. In 2003 a book about her work, 'Portfolio Series: Gyöngy Laky,' was published and UC, Berkeley, released her oral history. The Smithsonian Institution maintains a collection of Laky's personal papers at the Archives of American Art.

Page 176-7

HAMLET AU-YEUNG

Hamlet graduated from the Hong Kong Art School in 2007 and currently works as a graphic designer in 84000 communications.

Page 81, 132

HAWAII DESIGN LONDON

HAWAII is a London based design/illustration agency set up by Paul Mcanelly. The aim of the studio is to stay small and build a close relationship with each client.

The studio has a diverse mix of clients to date including, MTV Europe, BFI, Arts Council, Gap Europe and Universal Music.

Page 223

MARTA SMÄRTA

Hjärta Smärta works with graphic design and illustration since 2001. The designers live and work in Stockholm, Sweden.

Page 45, 118-9

ICELAND ACADEMY OF THE ARTS, GRAPHIC DESIGN GRADUATION CLASS OF 2006

The group is the graduation class of 2006 in graphic design, studying at the Iceland Academy of the Arts.

Page 92-4

JO RATCLIFFE

Jo Ratcliffe works with illustration, typography and set design. Her work has been featured internationally in publications such as the Guardian, British Vogue, Vogue Nippon, Dazed and Confused, Another Magazine, Carlos and GQ.

She has been involved in working on branding and advertising projects for companies including Rimmel. Orange. Sony and MTV

Other work includes illustration for t-shirts, album covers, comics, books and exhibitions working with Channel 4, Stussy, Levis and more.

Jo lives and works in London.

Page 194-7

KHAKI CREATIVE & DESIGN, INC.

Born and raised in Northeastern China, Nod gave up his factory job and moved to Beijing to pursue his dream in incorporating art into his life.

Today Nod is the creative director and co-founder of his own creative group, Khaki Creative & Design. Home-based in Beijing, Khaki Creative & Design focuses on creative brand-

ing services for clients in China, US and UK as they look to explore the rest of the world.

Nod's personal works have been displayed in exhibitions in the UK, Germany, Japan, Mainland China and Taiwan.

Page 026, 160-1

KOKOKUMARU,CO LTD.

Yoshimaru Takahashi is the visiting professor of Osaka University of Art Graduate school and the superintendent of KOKOKUMARU, Co Ltd. with numerous awards like the Silver Award at New York Art Directors Club and the Best Work at Japan Typography Association Annual. Yoshimaru is a member of the Japan Graphic Designers Association Inc., Japan Typography Association Inc., Tokyo Typo Directors Club and New York Type Directors Club.

Page 048-9, 186

LIZZIE RIDOUT

Lizzie tends to avoid working in one particular discipline, believing the form of any outcome should be suggested by the theme or idea at its heart. The majority of Lizzie's work stems from the desire to discover: a fact, a story, an object, an image, a ritual, a process, a history. These discoveries then inspire projects that borrow working methods from graphic design, fine art and illustration.

The designer graduated from the Royal College of Art in 2002 and has since been involved in various commissioned and self-initiated projects. Lizzie has exhibited nationally and internationally and lecture in graphics at universities across the UK.

Page 217

MADE

Made is a multi-disciplinary design studio based in Oslo, Norway. They can be found far up in the mountains, in the middle of the fjords or deep in the forest. Made was established in 2004/5 by 3 partners, and constantly grows. Made works with a diverse range of projects, and believes in the strength of a good idea. The client list is impressive, di-

verse and so as the work produced. Made is part of the worldwide TBWA group.

Page 210-3

MANUEL KIEM

Born in 1981 in Silandro, Italy, Manuel Kiem studies Graphic Design at the University of Applied Arts Vienna. Since 2003 he also works as a freelance graphic designer in Vienna and Berlin.

Page 040-1

MICHAEL PERRY

Michael Perry runs a small design studio in Brooklyn, New York, working with clients like MTV, Brooklyn Industries, Dwell Magazine, New York Times Magazine and so many more. Perry just finished his first book titled 'Hand Job' published by Princeton Architectural Press that will be on book shelf near fall 2007. Doodling away night and day, Perry creates new typefaces and sundry graphics that inevitably evolve into his new work, exercising the great belief that the generation of piles is the sincerest form of creative process. He has shown his work around the world, from the booming metropolis of London to Los Angeles to the homegrown expanses of Kansas.

Page 042, 064

MILKXHAKE

Milkxhake is a young Hong Kongbased design unit co-founded by graphic designer Javin Mo etton Research and Communicahe re-initiated Milkxhake with Wilson as one of the most energetic design collective based in Hong Kong. Their works have ation Awards (2005/7). In 2006, Javin was awarded as the Young Gun 5 from the New York ADC. In 2007, they also received merit from 86th New York ADC and British D&AD Awards. Their works have been widely published in international design magazines and journals.

Page 062, 101, 108-9, 143

MISPRINTED TYPE

Eduardo Recife is an artist/illustrator and designer from Brazil. You can check some of his works on www.misprintedtype.com.

Page 116-7

MYLIFESUPPORT™

Michael Kosmicki is a 21-yearold aspiring designer from
London. Born and raised in Poland, Mike has moved to London 5 years ago where he has
been studying and working as
a freelance designer. He usually operates under the names
of mylifesupport[™] and hoodlumbranding. In 2006 after years
of printing t-shirts for his
friends, he has started a small
t-shirt label called RFUTM.
Mike is obsessed with sneakers,
coffee, skulls, typography and
iazz music.

Page 187

NB: STUDIO

Established in 1997 by 3 passionate, creative and highly motivated designers Alan Dye, Nick Finney and Ben Stott, NB Studio is an award-winning design consultancy with reputation for simplicity and clarity of communication. They do not follow trends. Inspired by new challenges, problem solving, and tea and biscuits, their approach to design has enabled them to build strong relationships with clients including Knoll, Land Securities, Mothercare, and the Tate.

Page 036-7, 098-9, 156-7

NEUBAU (NEUBAUBERLIN.COM)

Neubau was founded by Stefan Gandl in 2001. It works in the fields of screen design, print & video design and typography. Gandl's work is published in countless international publications. In 2005 Neubau released the bestselling book 'Neubau Welt' which is followed by 'Neubau Modul' in 2007. Since 2006 Neubau is Stefan Gandl and Christoph Grünberger.

http://www.NeubauBerlin.Com

Page 016-7, 104-5, 182-5, 192-3, 204-5

NOA BEMBIBRE

Noa was born in A Coruña, Spain in 1981. The designer lives and works in Helsinki, Finland since 2002. Being graduated from MA Fine Arts in the Basque Country University and MA Applied Art and Design in the University of Art and Design Helsinki, Noa worked as freelance for different companies and creative studios from 2003-6 and established own company Noa Bembibre Oy Ltd in the year 2005. Noa is now a graphic designer of Design Studio Muotohiomo in Helsinki. The designer's work 'Cats Let Nothing Darken Their Roar' gained Honorable Mention Vuoden Huiput 2005 (Anual advertising and graphic design prizes in Finland).

Page 014-5

NON-FORMAT

Non-Format is a creative team comprising Kjell Ekhorn (Norwegian) and Jon Forss (British).
They work on a range of projects including art direction,
design and illustration for
music industry, arts and culture, fashion and advertising
clients. They also art direct
Varoom - the journal of illustration and made images.

Page 025, 052-3, 063, 133, 153, 188-9

ODED EZER TYPOGRAPHY

Oded Ezer is an Israeli typographer, type designer, typo experimentalist and design educator.

Graduated at the V.C.D dep. of the Bezalel Academy, Jerusalem, Ezer founded his own independent studio in Tel Aviv, Israel in the year 2000, specializing in typographic aspects of branding and publication designs.

As a member of the DCI (Designers Community of Israel), Ezer teaches in several academies in Israel, among which the Shenkar College of Design, one of the most distinguished design academies in Israel.

While constantly working as a commercial designer, Ezer runs experimental typo art projects, where he explores non-conventional solutions in Hebrew and Latin typography.

Page 208-9

PARK STUDIO

Park Studio is a London-based graphic design studio founded by Linda Lundin and Nina Nägel in 2002. Park Studio is the place to come to if you want a solution which is friendly but sharp, challenging and always on brand, whether it is for an identity, publications, retail or exhibition graphics. Park Studio works with a wide range of clients from the Design Museum and the British Council to Selfridges and Oasis.

Page 226-7

PAULO GARCIA/LODMA. LOCATION DOESN'T MATTER ANYMORE

Lodma. Location Doesn't Matter Anymore was founded by Paulo Garcia in 2005. The studio is dedicated to innovative thinking across a wide range of different media, such as motion graphics, print, identity, brand consulting, interactive, illustration and experimental work.

Page 027

PLEASELETMEDESIGN

pleaseletmedesign (PLMD) is a duo of young graphic designers comprising Pierre Smeets (b. 1981) and Damien Aresta (b. 1979). They set up their own small design studio in 2004 after graduating from Saint-Luc Higher School of Arts in Liège, Belgium and spending almost a full year in ERG (Graphic Research School) in Brussels, Belgium.

The projects of pleaseletmedesign range from graphic design, books, posters, identities and stationery to exhibition design, signage, titles sequences, website and everything else in cultural sectors as diverse as music, architecture, cinema and advertising clients. PLMD is based in Brussels, Belgium.

Page 035, 174-5

POST TYPOGRAPHY

Originally conceived and founded in 2001 as an avant garde anti-design movement by Nolen Strals and Bruce Willen, Post Typography specializes in graphic design, conceptual typography, and custom lettering/illustration with additional forays into art, apparel, music, curatorial work, design theory and vandalism. Their work has received numer-

ous fancy design awards and has been featured in publications such as Ellen Lupton's Thinking With Type and D.I.Y.: Design It Yourself, The Art of Modern Rock, STEP Magazine, Metropolis magazine, and Taschen's Contemporary Graphic Design. Post Typography has appeared in multiple design and art exhibitions, and their posters are collected by high school punk rockers and prominent designers, whom they consider equally important. Strals and Willen currently teach classes in design and typography at the Maryland Institute College of Art, and have lectured at the Cooper Union, Minneapolis College of Art & Design, and Harvard University among others.

Page 029, 078-9, 102

R2 DESIGN

Lizá Defossez Ramalho and Artur Rebelo founded the R2 design studio in Oporto, where they have since undertaken projects in the field of visual communication design, mainly for contemporary art, architecture and theatre.

Since 1996, their work has also included teaching design in various Portuguese colleges and served on various juries, gave lectures and participated in different national and international exhibitions. Their projects have received many awards such as the 'Grand Prix' at the 22nd International Biennale of Graphic Design in Brno and the 'Gold Prize' at the 7th International Poster Triennial of Toyama, Japan in 2003.

Page 020

ROBERT J.BOLESTA

Graduated from Pratt Institute in May 2007.

Page 114-115

▼ SERIAL CUT™

Serial Cut[™] is a Madrid based studio that established in 1999 by Sergio del Puerto, licensed in Visual Communication in the UCM (Madrid) and graphic design. The studio works on great variety types of projects although it mainly focuses on the following:

Art Direction - Graphic solutions that aims to provide clients with a special and personal way of communicating their product. Graphic Design - Branding, editorial projects, record labels and web projects.

Illustration - A versatile and experimental style based on the 'cut&paste' technique: a mix of vector shapes, photo collage, pixels and pencil strokes. In most cases, typography has a special role to reinforce the idea and generate more impact.

Page 028, 060-1, 065, 112-3,

SI SCOTT DESIGN

Photography is used as one working method rather than separate elements.

Page 139, 148-9

SIGGI ORRI THORHANNESSON

Hordur Larusson, Siggi Orri Thorhannesson and Sol Hrafnsdottir all graduated from The Iceland Academy of the Arts in June 2006 with BA in graphic design. Siggi Orri and Sol are currently working as freelance graphic designers, individually as well as a team while Hordur works both freelance and in a small design studio run by Atli Hilmarsson.

Page 082-3

SIXSTATION

Founded by Benny Luk, a 28year-old graphic, web, font designer and illustrator. Sixstation is first started as a personal experimental website in 2000. Design style is mainly mixed with modern contemporary and rich traditional Asian culture.

From 2004 to present Benny has changed into a soho style freelancer. He mainly works with international clients such as Nike Asia, MTV Asia and SonyX-Levis etc.

Page 021-3, 080, 134-5, 138,

STUDIO8 DESIGN

Studio8 Design is an award-winning independent graphic design studio with reputation for delivering intelligent and engaging creative solutions. Based in central London, Studio8 was established in 2005 by Matt Willey and Zoë Bather, formerly Creative Directors at Frost Design London. Working with clients both large and small, in the UK and overseas,

Studio8 produces a diverse range of work across multiple disciplines. With over 15 years of industry experience between them, Matt and Zoë bring a wealth of knowledge and enthusiasm to every new project and offer a scope of capabilities that includes editorial, exhibition, signage, corporate literature, websites and brand identity systems.

Page 012-3

SYLVIA TOURNERIE

Sylvia is working as an independent graphic designer since 1996, especially for music industry and pop rock electro with close collaborations with some bands like Bosco and Mirwais, as well as some independant music labels such as Source. As things went along the designer has been working also for fashion like Levi's, visual identity of AndA (a Japanese brand) and images for Clarks. The art direction of the contemporary art magazine '02' leaded the designer to more typographic work and also logically to the world of art gallaries like exhibition posters and catalogues.

Page 084-5, 230-3

TASTE INC.

Toshiyasu Nanbu graduated from the Osaka High School of Industrial Arts in 1969. He established the Design office Taste language. Nanbu designs based on typography now. The designer won numerous awards like the gold prize of 'The 7th Tokyo section in 1995 and the 'HKDA AWARDS 05' in 2005. Nabu is selected by China as the young designer who represents Japan in 2000, and his work collec-Designer/Toshiyasu Nanbu' is published. The one-man show is held in Tokyo designer's space (Roppongi AXIS building).

Page 039, 144, 152, 214-5

TJEP.

Frank Tjepkema and Janneke Hooymans officially joined forces as Tjep. in 2001.

Frank is a Dutch designer based in Amsterdam. He graduated in 1996 from the Design Academy in Eindhoven. Following this he obtained a MA degree from the Sandberg Instituut Amsterdam in 1998. Frank developed a strong interest in brand related design issues and worked on a variety of projects for well-known brands. He was the head of the design department at the Rietveld Akademie in Amsterdam from 2001 to 2004.

Janneke brings in expertise in the field of interior design and styling. Before joining Tjep., Janneke worked for Neonis, Marcel Wanders and started up her own design company Zus&Zus with Carlijn Kriekaard. Noteworthy projects are: the interior of the Unox Soup Factory and the contribution to the design of the Glasgow Science center.

In 2004 Tjep. won the Dutch Design Awards in the categories interior and fashion design.

Page 106-7

TOMMY LI DESIGN WORKSHOP LIMITED

Tommy Li is Hong Kong's master designer in this generation renowned for his 'Black Humour' and 'Audacious Visual' designs. Spanning Hong Kong, China, Macau and Japan, he is one of a few designers to have penetrated the international market.

Over the years, Tommy received almost 500 awards. His most distinct achievement to date has been record owner to 4 awards from New York Directors' Club, which honours outstanding results among Chinese designers.

Page 216, 218-221

TOPOS GRAPHICS

Topos Graphics calls home the place where thought and form meet, and they live and work with graphics in New York City. Specializing in ideas for print, they are interested in projects that both raise questions and point towards answers. Small or large in scale and intimate or public in sentiment, their work is propelled by a desire to see words and images actively participate across multiple platforms. Led by Seth Labenz and Roy Rub, their doors have been open for business going on one year.

Page 077, 190-1

TSANG KIN-WAH

Graduated from the Chinese University of Hong Kong in 2000, Tsang Kin-wah received his master degree from Camberwell College of Arts, the London Institute in 2003.

Tsang's works mainly focus on investigating the specific meanings created by combining the swear words with the elegant image and by presenting this as a form of wallpaper, he specifically create different installation works for different sites and venues. Among these years, he has taken part in various group exhibitions in Europe and Asia, and has his solo exhibitions in various cities like Tokyo, Barcelona, Madrid, etc.

Tsang has received awards likes Tokyo TDC Prize 2007, 2005 Sovereign Asian Art Prize, Prize of Excellence - Hong Kong Art Biennial 2001, etc. His works are collected by Sovereign Art Foundation, Museum of Design Zurich (Switzerland), Shu Uemura (Costa Mesa, California), etc.

Page 122-3

VAULT49

Graduating together from the London College of Printing, Jonathan Kenyon and John Glasgow launched Vault49 alongside their final year degree show. The collaboration quicklemerged as one of the UK's leading and most innovative design companies with a broad portfolio spanning typography, illustration, photography and web design.

Following their relocation to New York in 2004, Vault49 continue to achieve sustained coverage in the best of the UK, US, and worldwide design press by virtue of the breadth of their ability across all fields of design, and reputation for creating consistently innovative work for an international client list

Page 222

WHAA

Whaa are 3 independent graphic designers graduated from the University of Arts of Lausanne Ecal (Switzerland) in Visual Communication, Graphic Design in 2006. They decided to create Whaa in order to share their

skills and interests. Illustration, photography, experimental typography, book layout and animated gif are their media choices. Please visit www.whaa.ch, they love fan

All work designed by ecal/ visual communication graphic design/design student/David Stettler, Lyne Friederich or Florence Tétier

Page 011, 146-7

WIDMEST

Widmest is Eric Ellis, a Chicago based designer. When he is not colouring or playing with blocks he likes to make big posters.

Page 090-1

WILL PERRENS

Graphic designer based in London Page 044, 070-1

WYETH HANSEN

Wyeth is a freelance designer and artist based out of Brooklyn, working in video, audio, and printed material.

Born and raised in the armpit of California and relocated to the northeast, Wyeth's work is a blend of west coast vibes and east coast rigor. This mix is evident in his work, which oscillates between geometric minimalizm and psychedelic naturalizm, yet which remains somehow unified.

Wyeth has exhibited work on both coasts and across the pond; clients include MTV, Vhl, the AIGA, Sundance, 2K by Gingham, Ghostly Records Intl., and a legion of design studios throughout the city and various publications.

Page 051

YOKOLAND

Yokoland is a graphic design and illustration studio that was started by Espen Friberg and Aslak Gurholt Rønsen sometime between their graduation from High School in 2000 and from The National Academy of the Arts, Oslo in 2004/2005. In the beginning there was no intention that Yokoland would be a graphic design studio (it sorted to happen along

the way). Yokoland was just the place to experiment various small projects. In 2006 the studio grew, and Thomas Tengesdal Nordby became the third inhabitant of the country. Yokoland also run the record label Metronomicon Audio together with the label's musicians, and have been doing all the design for the label since 2002. Yokoland is based in Oslo, Norway. A monograph about the studio, 'Yokoland - As we go up we go down,' was published by Die Gestalten Verlag in 2006.

Page 206-7

ZION GRAPHICS

Zion Graphics is a multifaceted design agency based in Stockholm, Sweden. Founded by Ricky Tillblad in 2002, Zion's work crosses over vast disciplines including corporate identity, fashion, interactive media, packaging and print. Their clients are J. Lindeberg, Adidas, Sony BMG, Universal Music, EMI Music, Pee&Poo, Peak Performance and more.

Page 038